ART OF THE
CHOPPER II

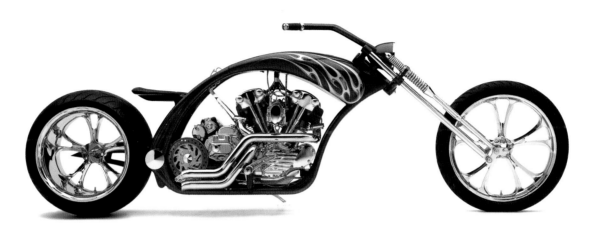

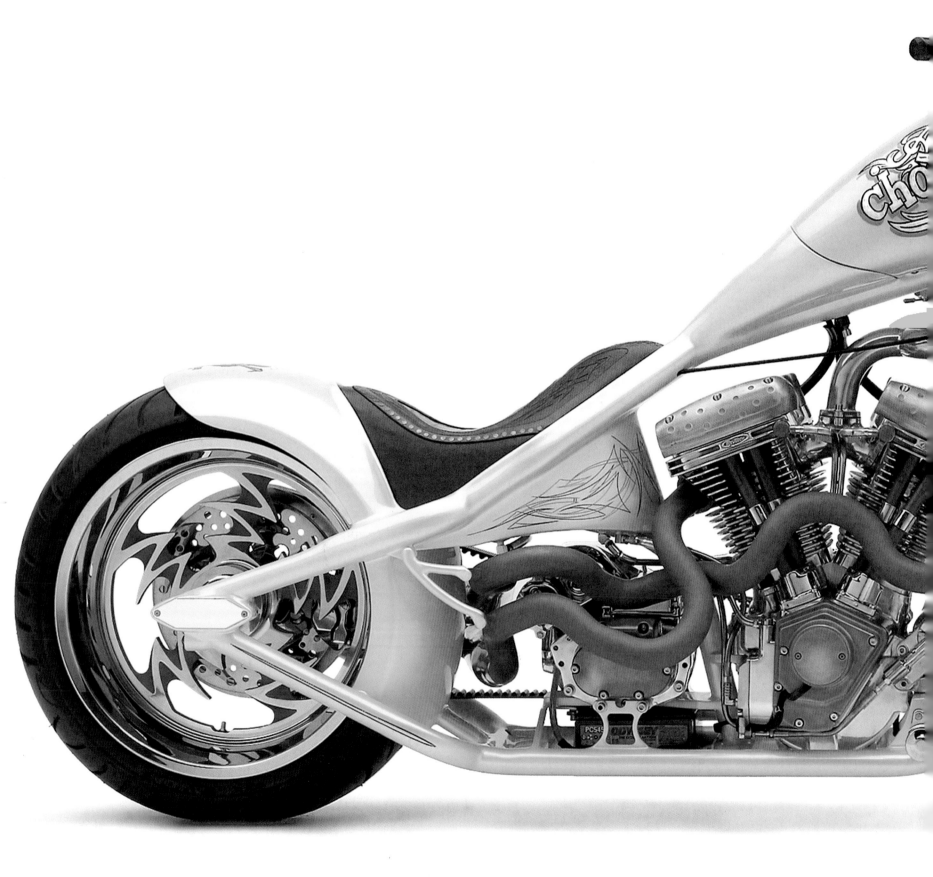

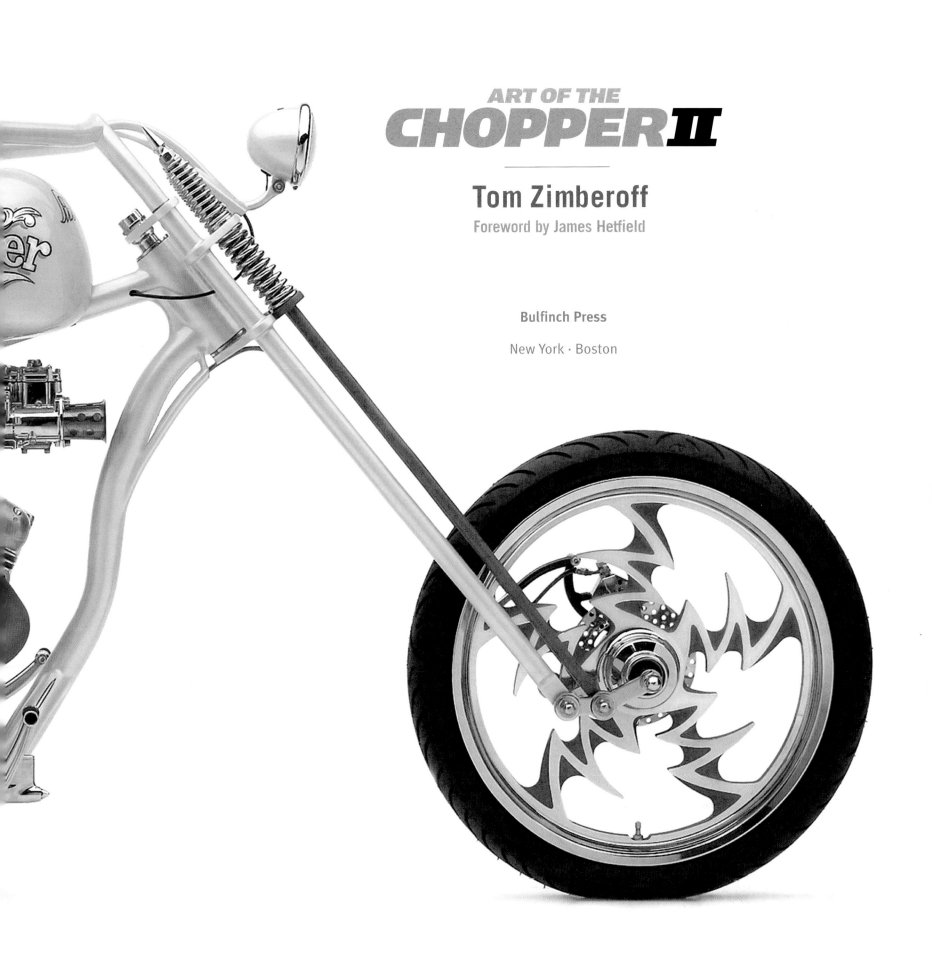

ART OF THE
CHOPPER II

Tom Zimberoff

Foreword by James Hetfield

Bulfinch Press

New York · Boston

Bulfinch Press
Hachette Book Group USA

1271 Avenue of the Americas, New York, NY 10020
Visit our Web site at www.bulfinchpress.com

First Edition: October 2006

Library of Congress Cataloging-in-Publication Data
Zimberoff, Tom.
 Art of the chopper II/Tom Zimberoff; preface by James Hetfield.
 p. cm.
 ISBN-10: 0-8212-5815-X (hardcover)
 ISBN-13: 978-0-8212-5815-6 (hardcover)
 1. Motorcycles—Customizing—United States—Pictorial works. I. Title: Art of the chopper two. II. Title: Art of the chopper 2.
 TL439.5.U6.Z563 2006
 629.227'50222 — dc22
 2006002800

Design by Roger Gorman, Reiner Design NYC
Printed in Singapore

contents

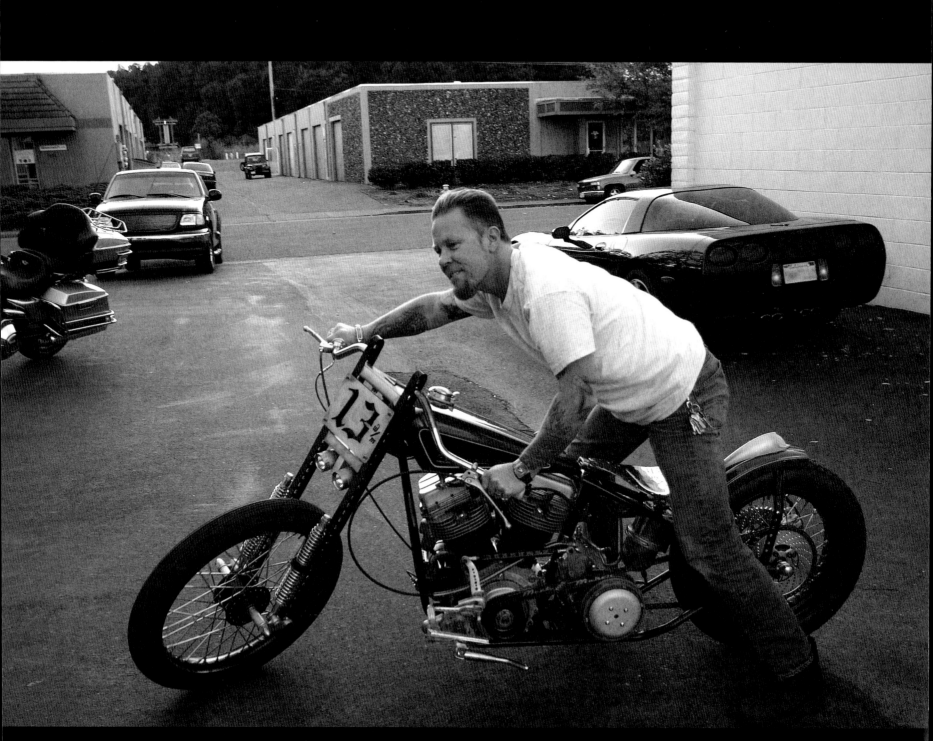

foreword by James Hetfield

What is a chopper? Ask ten people, get ten different answers. Whose answer is correct? No one's and everyone's. Depending on your personality and exposure to life's hairpin turns and straightaways, your vision of a chopper could be miles apart from your brother's. And so what! It's about what I appreciate.

I'm not sure if anyone can entirely appreciate a bike as much as a builder can. To appreciate the care and attention to detail that dictate how the lines flow and how each part fits and works with every other cog in the machine, you almost need to know what it takes to hammer them out yourself. And though mind-blowing, sometimes the simplest piece, the tiniest element, will get the most attention from the showgoers. If they're sophisticated enough, they will get past the paint. It depends on what your goal is: unique craftsmanship or bling-bling.

When a vision of the Widowmaker would not leave my head, I knew it was good. My experience building bikes is not unlike building songs. You start with a solid base and add parts that work together, eventually even complement each other. If a part or idea doesn't add something integral to it, scrap it! No fluff. Logic and function can be limiting but also create a challenge to build through. Getting over this hump gave me even more respect for the fabricators who constantly break the rules of bike building.

For myself, it certainly was a "learn as you go" process; burnin' through about forty cutting disks, five pounds of drill bits, ten yards of copper pipe, two seats, fifty cassette tapes, one leather jacket, eighty burritos, but only one first aid kit! I am missing about 2,000 brain cells and some arm hair, though. Sweat, grease, and thankfully not too much blood were the lubricants I used to get her done. The most gratifying thing for me, besides starting it up for the first time and riding into awestruck traffic, is the fact that other builders respect it and like it too. It is my version of a digger-cum-chopper. Chopped of all unnecessary items—including arm hair.

So, back to the question: What is a chopper? Here's what I can tell you is undeniable. When you ride a chopper you ride a statement. You ride a vision. Blending in is not on my things-to-do-in-life list. We don't live in a society where you're told what you can and cannot ride. Not yet, knock on wood!

The pages you are about to turn depict artists whose freedom of expression cannot be denied. They create not just because they can but because they must. They are driven to go way beyond "not regular." They see things that others don't. They think spontaneously. Actually, they don't think, they feel. They shoot from the hip. They eyeball measurements. They might even use dangerous power tools without proper eye protection. (Good Lord! Tell us you're kidding!) They try, fail, and try again. They ask, "Why not?" And they exclaim, "Why not!" And without a doubt they build it because they love it.

Maybe you love it too. And maybe you don't. Maybe your vision of a chopper is not in this book; or maybe you can't live without the bike on page 246. No matter what your opinions or preconceptions, after you get to know the builders in this book by reading their biographies and gazing at their rebel art, you can't deny the passionate craftsmanship of a God-given talent like this.

With love and respect,

James "Papa Het" Hetfield, 2006

preface

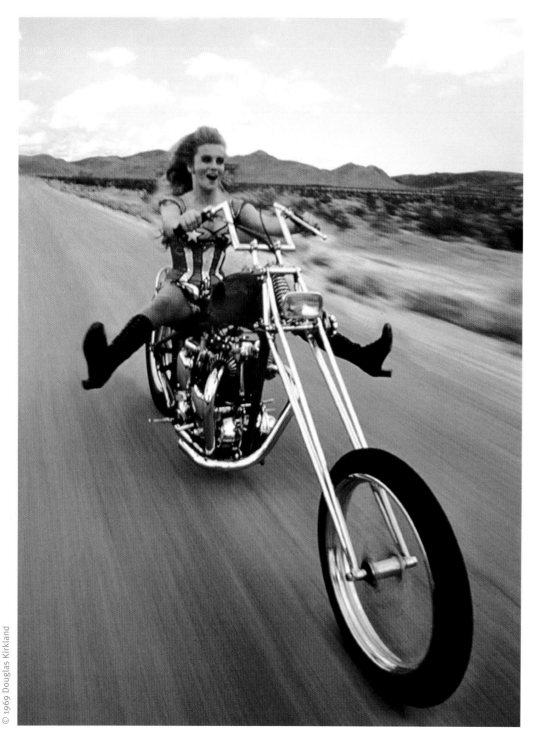

The first choppers I remember seeing in person thundered across the scorched and shimmering pavements of mythological Las Vegas, a small but not insignificantly hip retreat long faded into memory since the 1960s and my high-school years there. It was the age of the Rat Pack and rodeo, glamorous women wearing scarves driving pastel-colored convertibles, slot machines, swimming pools, and an eighty-nine-cent breakfast served by a waitress who always called you Honey. Rough-and-tumble three-patch clubs passed through town like Wild West posses rambling through the desert, slowing down to make a visual statement on the Strip. I was particularly fascinated by the wretched excess of their motors. Maybe I was susceptible to these loud convolutions of pipes and pig iron as a teenage boy because, in spite of their attraction, they made my blood run cold under the hot desert sun, mimicking the antipyretic attributes of oil flowing through their infernal plumbing.

These were primitive machines compared to today's glitzy bikes, but in a way that choppers-as-art invoke the same kind of gut response as the prehistoric paintings of prey animals on the walls of antediluvian caves in Europe, striking awe in the beholder. I recall walking by and staring at bikes leaning in choreographed rows in casino parking lots, their chrome and alu-

minum parts rendered no less lambent by a patina of oil and road grime, and wishing I could ride off into a desolate desert landscape on one of them myself.

The first photographs of choppers I remember seeing appeared in *Look* magazine. In 1967, I saw a series of portraits depicting the startling and new San Francisco counterculture, which included Irving Penn's perfect portrayals of Hells Angels and their Harleys in a studio setting. Then in 1969, again in *Look*, I saw a young Ann-Margret of *Viva Las Vegas* (the movie) and Elvis Presley days wheeling down a desert byway just outside Sin City on a perfect, red Triumph chopper with tank scoops and a chrome girder, wearing a stars-and-stripes bustier that mimicked Peter Fonda's characterization of Captain America on the silver screen that same year. The latter publicity picture, made by my friend Douglas Kirkland, has stuck in my mind for decades, since long

before I met and became friends with him. Older and securely established in the photo biz, he unselfishly helped me get one of my first important photo assignments. Unconsciously, perhaps, my fascination with his and Penn's photographs was a catalyst for my interest in choppers later on. Now, I seek them out as a personal predilection and to record them for posterity as artifacts of a cultural insurgency.

Builders abound. Artists do not. That is to say, there are hundreds, if not thousands, of competent mechanics and fabricators who can build a really tight, beautiful motorcycle. But only a few can go beyond imitation, to meld function and style into something never seen before. With each chapter in this book and in the previous volume, I have tried to shed some light on the gestalt of the best and most influential artist-builders. Limitations imposed by the calendar to arrange an interview or a portrait session here or there precluded a number of established artists from being portrayed in this volume. After all, not even the late, great Indian Larry was available until shortly before this volume went to press. Therefore, I have plans for a third and final volume of *Art of the Chopper*.

introduction

Motorcycles. Choppers, in particular. Why do we love to ride these retrograde contraptions, obsolete from every practical consideration? I believe it is a primeval compulsion.

Even before language, tools were the first expression of human cognition. As tool-making and gadget-loving creatures, we celebrate our intellectual prowess by calling it *technology*. We hold it up as evidence of our advancement and use it, for right or wrong, to extend our dominion over nature. It was an inevitable evolutionary leap from cognition to ignition.

Technology also affords us opportunities to take calculated risks that enhance our experience of life's adventure. The thrills and rewards associated with risk-taking behavior are catalysts for humanity's developmental march through time. In the spirit of derring-do, exemplars of our species have become evolutionary entrepreneurs, from the first prehistoric person who dared to ride a horse to Chuck Yeager's epic flight beyond the speed of sound. But too much technology dilutes day-to-day challenges by lulling us into complacency. Life can be too easy. That is why we still enjoy, say, camping out, even though we have no real need to forgo the comforts of home. An atavistic compulsion kicks in and we throw a bit of ruggedness or, sometimes, danger into the mix. Those who live life large embrace just enough technology to get by without dulling their emotional responses to adventure. They crave reminders of a more intrepid past.

Riding a motorcycle requires a modicum of courage. It takes us back to a time of individual human control, allowing us a sense of personal responsibility for our own destinies. Motorcycles reinvigorate the thrill of high-speed travel without reinforced roll cages, geo-positioning satellites, stereophonic entertainment, air bags, and climate control. We become oblivious to the weight of our woes while attuned to our immediate environment and the skills which keep us going forward and balanced upright. But mindlessness on a motorcycle will kill you. In other words, we all want our bikes to be dependable, but no one rides because it's safe.

Choppers epitomize a time when there was just enough technology to accommodate a more daring lifestyle, a time before speed limits in wide-open spaces. We feel special on our redoubtable machines, with or without helmets, because we are a minority of lane-splitting libertarians with a lust for life and a consummate sense of style.

As for style, few fundamentally sound motorcycle designs have run their courses into historical oblivion. What is old becomes new again when you skip a generation. It is now common, for instance, to see bikes that resemble the bobbers of bygone days featured on contemporary magazine covers. Diggers and board-track racers of an even earlier era have made comebacks, too. A spanking-new chopped scooter on the street today might be mistaken for a museum piece. But that does

not mean it looks out of place in traffic. Such bikes are grace notes in a chorus of similitude.

Choppers and, generally speaking, modified motorcycles are enjoying a renaissance that has transcended their initial popularity in the heyday of the twentieth century. Even so-called "body bikes," those clad in an overabundance of sheet metal, and low-slung "pro-street" styles are celebrated more widely today than they might have been without the media exposure afforded to raw choppers. Young builders are once again chopping British Triumphs, BSAs, Nortons, and Vincents — Japanese Hondas, too — just as their fathers and grandfathers did back in the day. Italian Moto-Guzzis and Ducatis get makeovers, too. Still, the all-American, heritage-driven style of Harley-Davidson is the prevailing influence around the world. That said, there is a rule of thumb in the custom-motorcycle industry: There are no rules.

The popular revival of choppers began in the late 1990s when American men of a certain age realized how much they had always wanted a big, honking Harley-Davidson, but had not had either the financial means to buy one or the freedom from familial responsibilities to ride one. They had invested their youth, instead, to attain a measure of social standing and financial security later in life. Now liberated and determined to make up for lost time, they have indulged their puerile and profligate fantasies of becoming "bikers" with the impunity of middle age. Because they are no longer compelled to suppress their inner outlaw, the motorcycle industry has burgeoned at a high-octane rate for more than a decade. But that alone does not account for the influence of chopper style in the marketplace.

Wannabe bad boys who started out with various models of new and used Harleys got sucked into the routine of buying "Taiwanese, bolt-on chrome crap," as one builder refers to their collective quest for individuality. By the time any number of sorry dudes spend from $5,000 to $15,000 on parts and paint on top of what they paid for a stock motorcycle and black leather chaps, they still can't find their own bikes in a parking lot at the weekend poker run.

Choppers appeal to those who have already succumbed to *chronic-chrome syndrome*, a psychological affliction that stems from the proliferation of and easy access to highly reflective bolt-on baubles. No one wants to be the low man on the scrotum pole of ostentation; however, the unfettered acquisition of such gleaming goodies is often associated with the onset of clinical delirium. Consequently, as billet-addled addicts recuperate, they fortify their still-fragile egos with content-rich magazines, therapeutic visits to bike shops, and attendance at consciousness-raising rallies. Once rehabilitated, they may find themselves in possession of an elevated aesthetic sensibility; hence the chopper connoisseur.

Watching *Biker Build-Off* on TV will not educate the hell-bent hoi polloi, but the exposure of custom motorcycles to a television audience has broadened the base of enthusiasts. Some of these proto-devotees have become zealots who proselytize the chopper gospel while committing to hell those sinners who ride mass-produced motorcycles. As this coterie of converts swells, ever-younger novices are indoctrinated who are unwilling to wait for middle age to throw a leg over and give the throttle a twist.

Despite the ebb and flow of their popularity for almost fifty years, there are probably no more than 40,000 examples of true choppers worldwide, according to the empirical consensus of experts in the industry — in other words, a guess. Choppers are exceedingly loud motorcycles, stripped of everything but what they need to go fast, stop fast, and look cool — minimalist machines. Nonetheless, the impetus for creating choppers has grown beyond hacking bikes apart to make them lighter and faster for the sake of competitive sports adherents and outlaw clubs. (Incidentally, *outlaw club* did not start out to mean a band of hoodlums on wheels. It was the media, more disposed to entertain than report the news, that tarred bikers with that image. Outlaw clubs began as kindred groups of professional and semi-pro riders who didn't abide by rules that governed engine-displacement sizes or accessories sanctioned by national racing associations. They rode non-conformist or "outlaw" bikes.) By the time the practice of modifying motorcycles had become commonplace, choppers acquired an additional and compelling appeal just for the way they looked. The criteria that define a chopper evolved from a process involving the attrition of parts into a broader and more imaginative construct. They became art.

There is little about art that complies with motor vehicle codes. By virtue of its own best points, a chopper will flout at least a dozen or so state and local statutes, speed limits notwithstanding. Choppers are bereft of turn signals, horns, gauges, mirrors, idiot lights and rear suspension. They bristle with racing motors, loud pipes, ape hangers, velocity stacks, and whatever additional gimcracks a builder sees fit to flaunt. Pass an emissions-control test? I don't think so. But neither will a city bus. Neither will your barbecue! And there are more barbecues and buses fouling the air than all the motorcycles on the planet. In that sense, choppers are the only remaining outlaw bikes. There will always be lawmen who have little tolerance for these machines, let alone the hirsute, leather- and tattoo-covered civilians who ride them. But some police let the best examples pass by with a wink and a nod in tacit admiration.

All motorcycles have two wheels, a frame, a seat, plumbing, controls, and a motor. But choppers are made of parts that no longer look the way they were designed, parts that are used in unconventional ways, and parts that never existed anywhere else to begin with. They are eccentric, one-of-a-kind machines. If its unique nature does not evoke an immediate visceral response, it is not a chopper in the sense of being a work of art. Therefore, the word *chopper* has come to mean as much about how a motorcycle makes you feel as what it looks like.

The mission of transforming the chopper into an iconic fashion statement fell first and serendipitously upon the shoulders of Jesse James and the Teutuls, simply because their works were first to be "discovered" by television. The Teutuls in particular, whose combination of kitsch and curses delights a broad-based audience of Americans, have created a dysfunctional family framework in which motorcycles are the stars of a situation comedy, while the men who make them are foils. The entire motorcycle industry has benefited from the their shameless shenanigans and resulting celebrity. For that matter, who would have thought that a tat-

tooed ruffian like James with a rap sheet and grease under his fingernails would nab one of America's sweetheart movie stars at the altar? Ah, the flickering limelight of television. Ah, what we don't know about America's sweethearts!

Before *Motorcycle Mania* and *American Chopper*, the public at large knew little about the roots of custom motorcycle culture. And little did they care. Choppers and their devotees had been written off for decades as a fringe element. Thanks to the movies, most people believed that only gangs of violent, drug-dealing lowlifes rode choppers. Thanks to the homogenization of the six o'clock news, people thought we were talking about helicopters, which are *helos* to the pilots who fly them. But it's a different story now. Your daughter wears tattoos and has a pierced tongue! Choppers have become part of our mainstream ethos, so it has become relevant to look at the phenomenon from a cultural point of view.

The rationale for owning a chopper is no longer limited to middle-age men in search of their lost youth. Choppers epitomize the use of technology and style by exhibitionists as a ritual animal display of virility. Call it chopper machismo, if you will. Women wear high-heel shoes; men ride choppers. Same thing. Anyone who doubts the association between choppers and sexuality needs only to get next to one.

Some might accuse such exhibitionists of hauteur. I call it *haut moteur*, in the fashion sense of *haute couture*. Whatever it's called, choppers are hot because they've got motorcycle style down cold. Few other things draw attention more readily. If you are sitting astride a chopper, that attention is yours to command.

Such flashiness is what first catches your eye before that which is greater than the sum of its parts draws you in closer and grabs your soul. Flash is an inherent aspect of every chopper, without which there would be little more than a stripped-down bike and a rider with no libido. Flash is more than shiny chrome and dazzling color. It is more than the decorative frosting on a cake. Despite the minimalist approach shared by all proponents, no mere motorcycle can be a chopper without adding a unique and personal touch — you have to actually *make* something that becomes integral to its design. It may include a dollop of kitsch, a touch of tradition, a proud statement of metallurgical prowess, a consummate paint job, or, most desirably, all of the above.

Flash is also responsible for the paradoxical nature of every chopper, because if its design is carried off successfully, the polarized dynamics of flamboyance and minimalism will have fused in an implausibly beguiling manner to create a motorcycle that is at once both garish and sublime. When flash does the trick, a chopper is said to be "cool." That means getting something wrong just right. It confers a one-of-a-kind identity on both the machine and its rider. It is a manner of being different that can be imitated but never copied. A chopper is as a chopper does. Not every builder succeeds. Therein lies the art of the chopper.

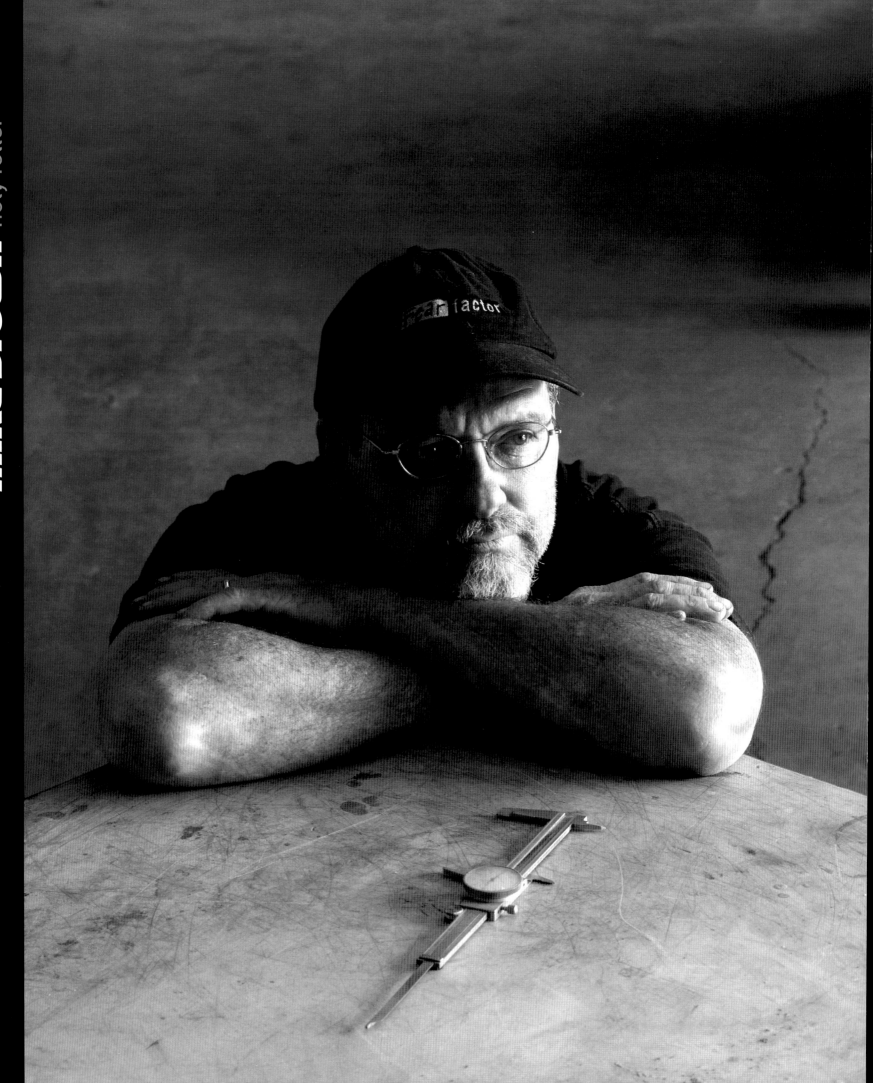

mike brown holy roller

If a science-fiction film director wanted to dress up a set with a startlingly futuristic motorcycle, he could do no better than to look in the Tennessee town of Rogersville, where, in a modest and cluttered workshop, he will find the most improbable-looking prop anyone ever laid eyes on. A motorcycle, to be sure, but it has no readily discernible brakes or suspension, no driveshaft, no belt drive, no chain, and no downtubes to support the engine in the frame. Most striking of all, there are no *axles* — no hubs to hold the wheels on. There is nothing to prevent a large dog from walking through a wheel. Not only does it look incapable of going down the road, but just the fact that it can support itself upright seems like a miracle. "Amen!" says the bike's architect, Mike Brown. And that is what he calls his company, as though every bike he builds were an offering of prayer.

The name, Amen Chassis Works, is a devout token of thanks to Mike Brown's maker for not having taken him out of circulation any number of times when his irrepressible behavior warranted the separation of his soul from corporeal existence. Brown is passionate about both God and, as he says, "motorsickles." At the drop of a helmet, he will expound on either topic. You might say he has a divine sense of style. He gave some of his bikes biblical names such as Savior and YHWH, the latter a reference to the inexpressible Hebrew name for the creator.

Brown ruminates obsessively about his implausible designs, chain-smoking his way from one idea to the next. He once smoked wood shavings from the stock of his shotgun when he ran out of cigarettes. (This is one guy you never want to see quit smoking.) Until he is ready to focus his thoughts and his hands on the same plane, he feels compelled to amble about nervously, once driving, he says, "to durn near Lake Michigan for no reason but just to think." But when he comes back from such excursions, he is ready to sketch a new motorcycle and then transfer its design to a computer to make engineering calculations. "I take my sketches as gospel. It ain't to be changed!" he declares. "Because if she looks that good on that sketch, then I'm going to make that design work." He is likely to be struck by a flash of inspiration almost anywhere at any time, so he takes his projects with him in the back of a truck or in a trailer as he roams around in search of his elusive muse. He completed the manufacture of Hubba-Hubba, the hubless wonder, during one of his fits of peripatetic

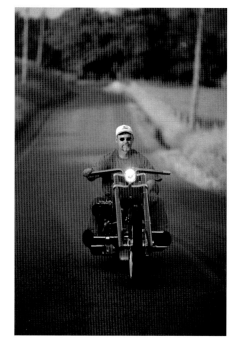

hubba hubba

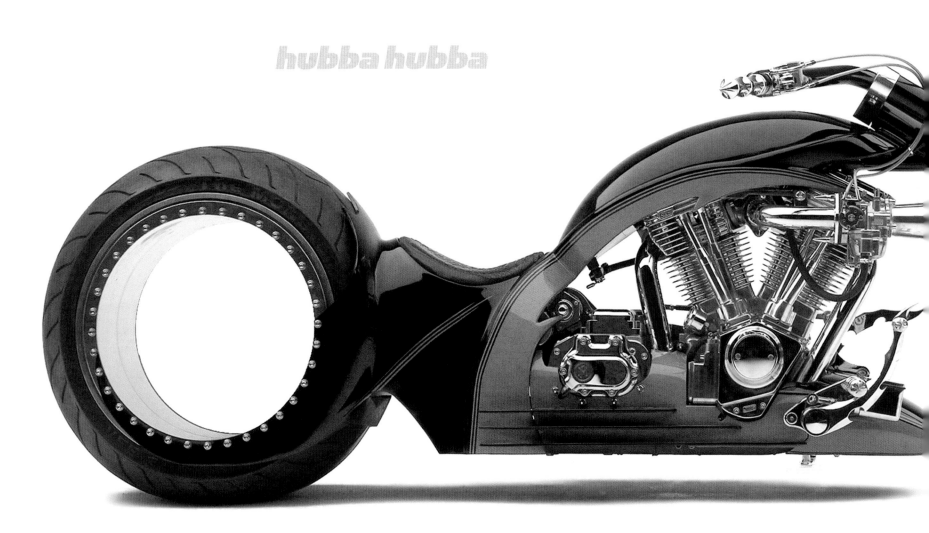

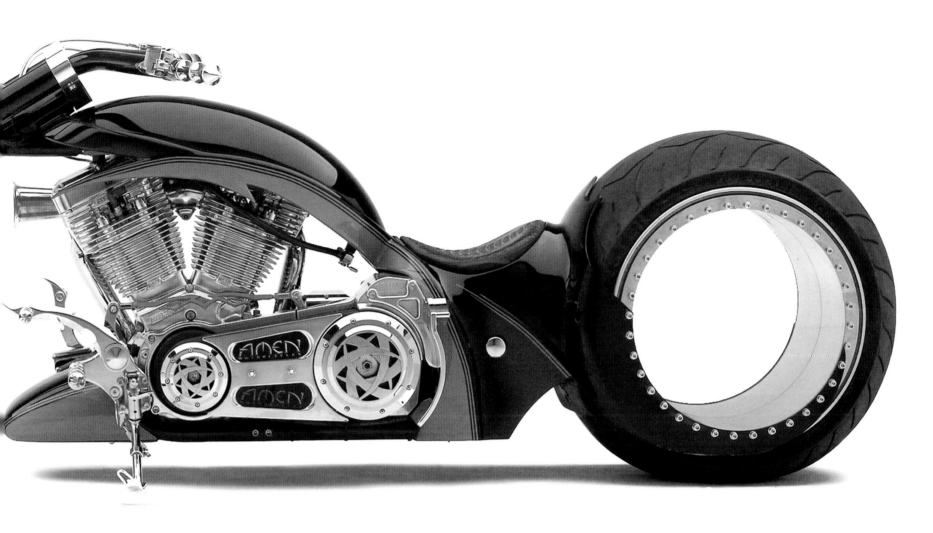

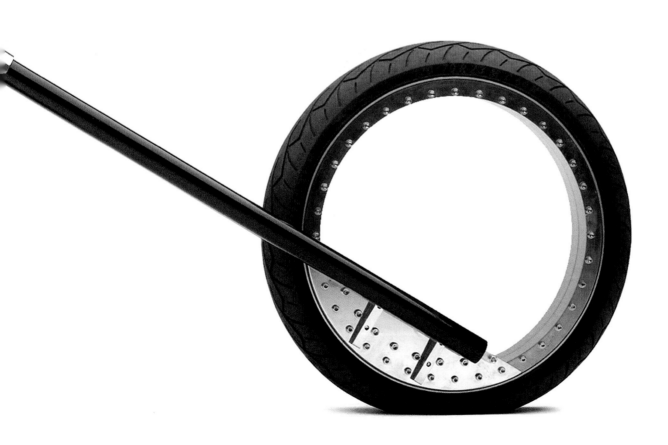

ingenuity at a rest stop on the South Carolina interstate.

Brown builds no more than a single unique design each year, to be unveiled in Daytona Beach during Bike Week, and it is always a whopper of a chopper. He puts months of thought into each project before he first picks up a tool. But when he gets down to work, he barely comes up for air, operating on a schedule of "sleep two and work six." Hours, that is. He knows how senseless it is to endure such self-abuse and that he is bound to reach a point of diminishing returns, but that is just the way he "stabs at it," so to speak. He is determined to ride a new bike onto the boulevards of Daytona Beach. "It's got to be a fully functional riding boy," he proclaims.

Mike Brown does not coddle his one-of-a-kind bikes. There are trailer queens, and there are bikes that are meant to be ridden. Some are meant to be ridden hard. "After the shows, I jack 'em up and beat 'em up around here in the mountains." Brown built and has rebuilt the bike called Savior three times because it has spent so many miles on the road.

Brown is under doctor's orders to ride every day. The doc took one look at him during one of his around-the-clock building binges and told him to blow off some steam. Mike told him to put that in writing. He now keeps that prescription to ride on his desk as a reminder. Except during business trips and winter storms, Brown is in the wind every afternoon by four o'clock, snicking gears through long and winding hollers with scenery as sublime as anywhere else in these United States. The roads leading to and from the town of Tazeville, about forty-five miles away from Rogersville, are his favorites. "It just tickles me to death to do that ride." When he's on YHWH, he may do more than tickle any critters too slow to avoid the mucronate protrusion covering the air cleaner in front of his, well, perhaps it could be called a carburetor on a stick or, more aptly Down South, a possum skewer.

Brown understands the compulsion to own a chopper and wants to make such motorcycles available at reasonable prices to those who crave them. Nonetheless, while his avocation is to create art, he makes his living by the manufacture and sale of "rollers" — almost complete motorcycles composed of chassis, wheels, tanks, fenders, and fasteners — that ordinary people with extraordinary taste can afford. All you need to do is bolt in a drivetrain and some pipes, pick out a seat, then plumb it, wire it, and paint it.

Amen's rollers are constructed with parts entirely engineered by Brown himself and handmade by a small group of craftsmen right in Rogersville. To keep costs down, Brown thoroughly researches third-party vendors that provide the best-fitting supplementary parts and tests every item before integrating it into his recommended package. All else considered equal, if the shrink wrap is more difficult to remove from one manufacturer's product than another's, the easier one will get the nod.

If Brown manufactured and assembled every component himself, an Amen motorcycle would be unaffordable for all but

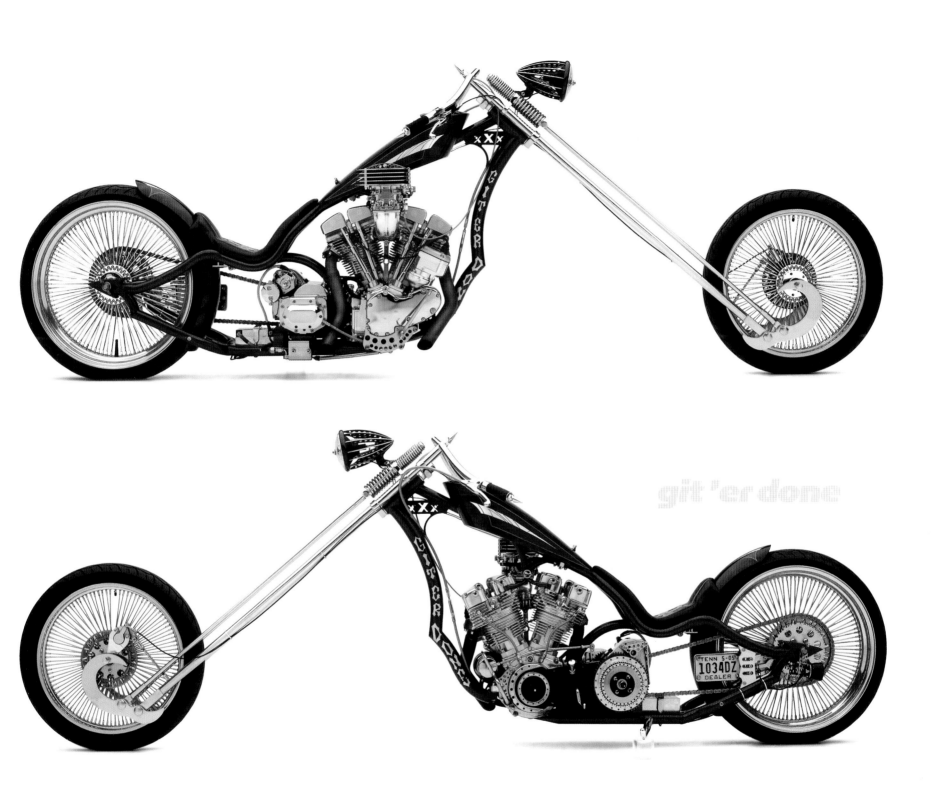

git'er done

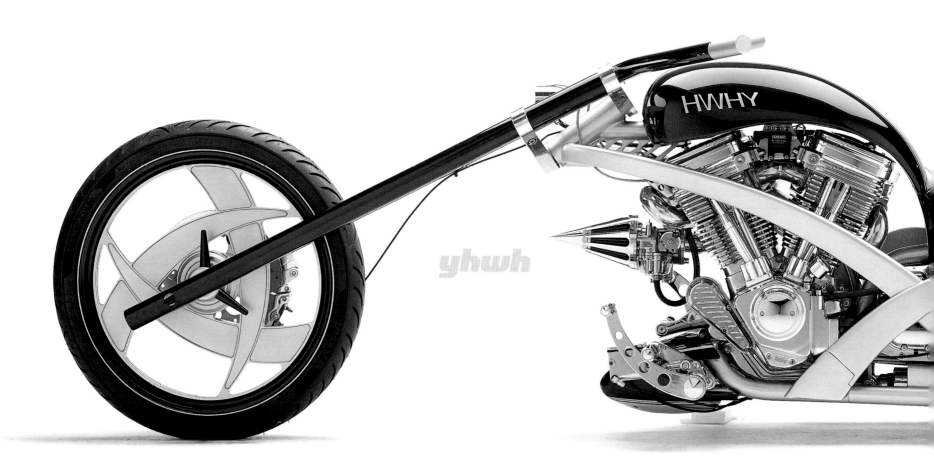

the very rich. Brown figures that the people who buy one of the one hundred or so rollers Amen sells each year save between $13,000 and $17,000 by either finishing construction themselves or hiring local mechanics to help them. Although he enjoys nothing better than pushing the starter button on one of his bread-and-butter bikes after having put it together all by himself, he generally discourages customers from letting him do it. He even offers bike-building seminars to help them become self-sufficient. In spite of the extra time it takes the average Joe to put the final touches on a roller, Brown insists that his customers enjoy the process, although most of them have never done anything like it before.

Brown frets about the perpetuation of chopper culture. He is determined not to let it stagnate in a monotony of parts that are patterned, copied, and bolted on by so many self-professed master builders riding on the coattails of other people's talents. For himself, he tries to shake things up. "It definitely helps to create these crazy one-offs to get the folks, including myself, thinking what could be next or what is possible." The downside is that he has too many prototypes racing around in his head — "up in the attic," as he puts it. He is loath to divulge his ideas because he doesn't want to be nagged to manufacture them. As it is, people want copies of the bikes he has already built, a desire filled to some extent by his rollers. But if he tried to implement every design he comes up with, he fears he would be producing one-off bikes and nothing else, turning himself into the proverbial starving artist.

It is essentially a dream that makes a chopper *custom,* notes Brown. Artistic integrity comes from his ability to articulate dreams. Moreover, he adds, "you can personalize the crap out of a Harley-Davidson, but it still looks like *that.*" Handmade bikes,

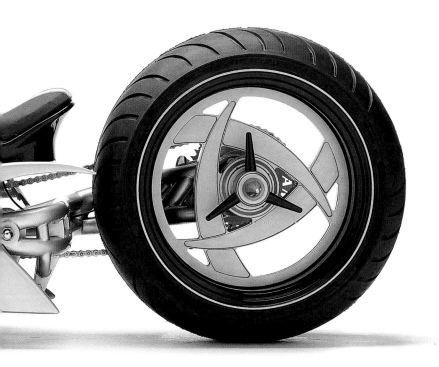

those that start with an entirely clean sheet of paper, are made for only one reason. Regardless of their cost, including adverse effects on personal relationships, they represent his soul-deep identity as an artist. People may love them or hate them, but they are what he dreams.

As an engineer, too, Brown thinks Hubba Hubba is "the silliest thing devised by man." He cannot think of any reason in the world to produce hubless bikes. However, he says, "if it doesn't make any sense, then I have to have it on the motorcycle!" For that reason, it is an expression of the motorcycle as art. He does have a modest criterion for success of sorts: "to build a motorcycle that a three-year-old young 'un can walk up to and say *ooh* and *aah*. Or a grandma can actually set and look at that motorcycle and get excited about it." He continues, "We don't never have to know why we like things. We can't even say in studying it for ten minutes why. But you know within three seconds if you like somethin' or ya don't."

Artistic value notwithstanding, a Mike Brown bike might be worth upward of half a million dollars for insurance purposes, considering its hand-wrought nature. Brown uses no standard round tubing in constructing his own frames; he tapers and contours each section by hand as he welds them together. Each frame embodies more than two hundred feet of welds laid down. It would cost hundreds of thousands of dollars in tooling to make machine-extruded tubing look this way. He would have to sell thousands of frames to make the investment pay off. If Brown were to count his own labor on top of his hard costs, he says, he could not afford his own motorcycle. "But I have to say," he boasts, "not bad for eighty-eight dollars' worth of steel!"

Sometimes tires are prototyped by other manufacturers to match Brown's one-off wheels. He was first to employ a 360-

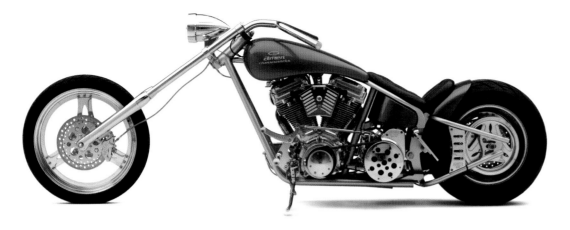

millimeter-wide back tire and first to stretch rubber around a narrow, twenty-three-inch-diameter back tire, too. From short and wide to tall and narrow, he and Roger Goldammer, independently, have transitioned the wheel war into a battle over rim diameters instead of widths. Mike Pugliese has also recently joined the fray. All this has taken Mike Brown in a new direction, away from *Star Trek* designs. His latest chopper, although no less extraordinary, has a traditional flavor.

Brown tries not to be the motor man or the painter. "I'm really a chassis and suspension guy. It's my first love," he says, adding, "My daddy slammed his cars in the 1960s." Obviously, young Mike paid attention. He also says, "The day my daddy told me I couldn't have a motorcycle was the day I said that I shall."

As a young man, Mike worked on the assembly line at the local TRW steering-systems plant, just up the hill from his home in Rogersville, making rack-and-pinion assemblies for the automobile industry. Feeling stuck and bored to death, he spent his nights with a T square at a drafting console made out of a card table jacked up on one side with a bunch of catalogs, and produced a complete schematic for the automated assembly of a task he had had to perform manually on the production line. He presented it to the factory bosses, and "they kinda flipped out," says Brown. "They came and got me and put me in product engineering." That's a metallurgy lab where they try to break things. He stayed there stressing metal

granddaddy

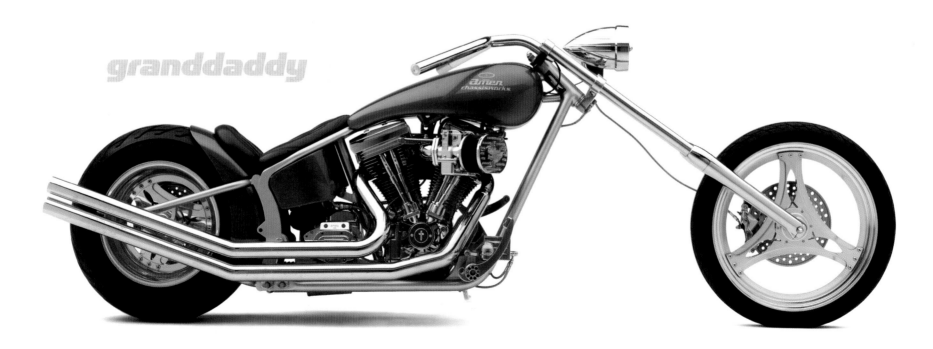

parts and stressing himself out for eleven years.

Throughout those years at TRW, Brown rode a '76 Harley. After a while, it became weathered, so he sent some parts out to be rechromed. He was disappointed with the results that came back and said to himself, "I can do better than that!"

Brown set up a plating line in his home workshop. Trying to be at least somewhat practical to make his effort pay off, he placed classified ads in firearms periodicals and began moonlighting his chrome- and nickel-plating services to gunsels. At first, he was borrowing chrome wrenches from his pals at the TRW plant, and, well, you've heard the expression about sucking the chrome off a trailer hitch? Chemically speaking, that's just what he did, wiring up the borrowed implements to his electrolytes to plate pistols. The fellows back at TRW felt a bit put out when they got their tools back and they were pink. So as his sideline grew, Brown's production line became self-sufficient in the chromium and nickel departments. Because of his advertising, jobs came in from everywhere. He received whale guns from Alaska and "top-secret" ordnance from private gunsmiths for which they sent him only one piece of a project at a time. To this day, you may hear what sounds like cannon fire behind Amen headquarters, as Brown kills beer cans and plinks flotsam in the local tributary with a .44 Magnum.

By 1989, one year after he began his dip-and-dunk operation, he founded Met-L Tek. He ramped up his operation to solicit industrial accounts and quit TRW altogether. His metal-plating business lasted for another eleven years.

Met-L Tek was, Brown says, "either massive money or starve to death." During the slow periods, he customized his prized 1949 Hudson and a 1973 DeTomaso Pantera. He chopped and sectioned the Hudson, a former rust bucket, nineteen and a half inches until it was "purty." He modified the Pantera so extensively that it has a virtually new chassis and suspension. Once he realized he could slam an exotic sports car clean down to the ground and still keep the wheels straight up and down, he acquired a new self-confidence about customizing. He says, "I can slam, cut, slice, and dice *anything* and make it ride down the road perfectly. And it's just a blessing to me." Brown, who is not usually an adherent of subtlety, says, "It looks like a good haircut. You can't tell I did anything to it until you put it next to a stock one." Incidentally, he *has* a stock Pantera, a 1971 model. But it was cannibalized by the '73, which came along years later. He bought his first when he was just twenty-one years old, by virtue

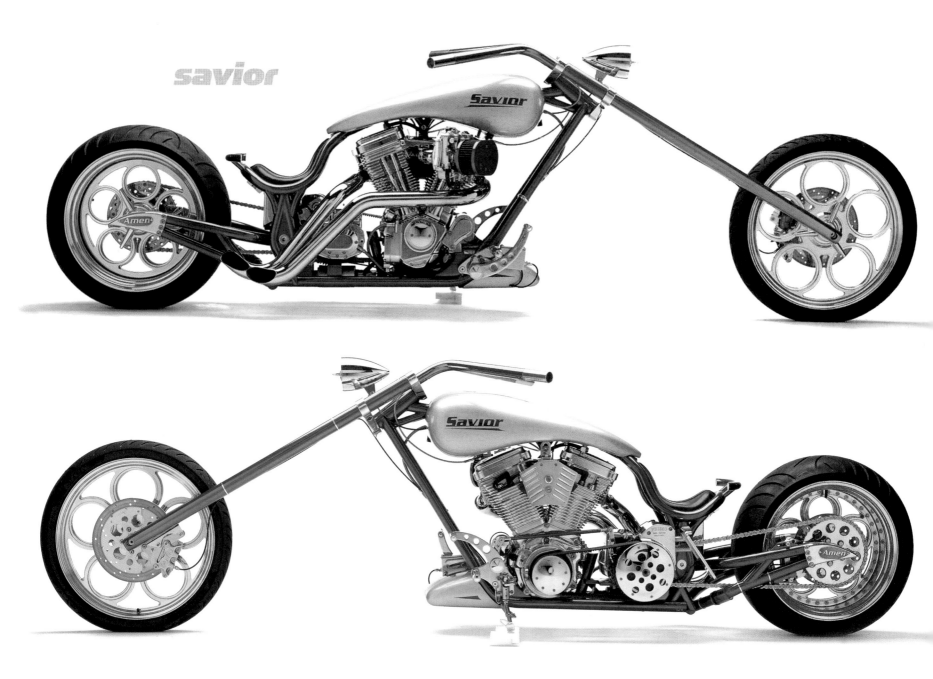

of his steady job at TRW and a loan cosigned by his mother. The car lasted three whole days. Having already outrun every vehicle in town — small town — Mike passed a Dodge Dart so fast it swerved out of control and fishhooked his fender. He totaled the Pantera.

Eventually, cars proved to be too much work for a lone customizer. Mike thought motorcycles might be more manageable — at least he could finish a project within a reasonable amount of time. So he bought a bike frame. He paid a lot of money for it, too, only to discover that it was so poorly made it required substantial modifications to make things fit. "If you squinted your eyes, it looked like a motorcycle frame," he says sarcastically. And once again, he said to himself, "I can do better than that!"

Brown decided to build a jig and bend his own frame. But where to start? He figured he might explore a recently defunct

machine shop for salvageable equipment. The place looked as if it had already been picked clean, but off in a corner of the building was a pile of tarpaulins — "tarpolians" in Mike's delightful vernacular — covering a couple of forklift skids. He peeked underneath to discover two naval-quality surface plates, impossibly heavy, super-flat, solid steel tables with perfectly straight lines etched down their centers. He bought them both for fifty bucks.

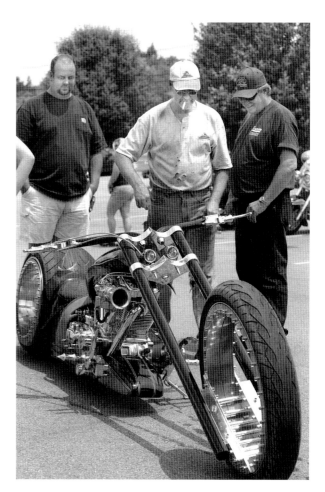

Brown took his fortuitous discovery as a sign, an affirmation of his faith. He was already fed up with the feast-or-famine of jobs in the industrial plating business. Now, having found something that roused his passion, he took the plunge, dumped the plating business, and became a motorcycle manufacturer.

Before any revenue started flowing, however, Brown had another idea up his sleeve to conserve his existing cash. He enjoyed a taste for moonshine every now and again. With a glass refractory column connected to a still he built, he could boil off half a glass of sour mash at home faster than it would take to drive thirty miles to the liquor store. Soon he worked up to a fifteen-gallon rig and got it down to about $4.30 per gallon. "I've always been a process man," he says facetiously.

By 1995, Amen was a going concern. But for a number of years, the company had problems with the federal Department of Transportation, trying to get classified as an *official* motorcycle manufacturer. "Oh, God, it's you again!" was what Brown heard when he called Washington. The authorities refused him permission to sell a motorcycle with a certified Vehicle Identification Number because his company did not manufacture "all thirty-thousand parts," so to speak. Finally, with a change in government policy, Amen received the same status, at least formally, as the Harley-Davidson Motor Company. Now his customers can get an MSO with a DOT VIN they can take to the DMV to "title" their bikes legitimately.

Michael Brown never fell far from the tree. He was born in Rogersville in 1954. His father worked in the shipping-and-receiving department of a company that manufactured playing cards. His mother was a homemaker. A brother died some years ago. Mike went through high school and on to a community college in another town not far away. He never took the time to earn a formal degree, but his formidable engineering acumen, acquired through home-study courses, innate talent, and common sense, put him in good stead.

Brown and his wife, Angela, have raised three children, one from Mike's previous marriage. As for having remained in Rogersville all these years, he says, "I've just got the opinion that if you do good work, you can do it in a tree house. People will come."

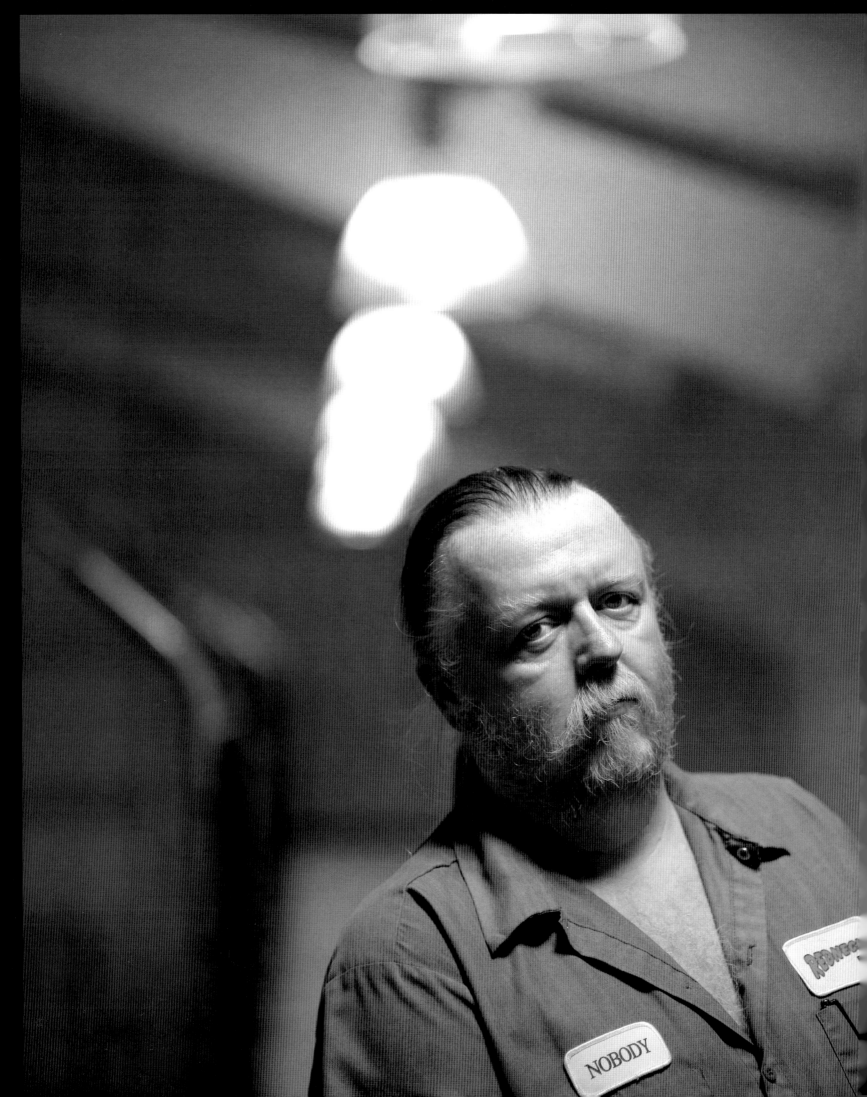

If you ride to Daytona Beach, Sturgis, Hollister, or any other hamlet hosting a rally, the streets will be thick with people on fancy motorcycles. You can't see the forest for the triple trees. But in the end, they all disperse and go home. Vince Doll's promise to those who ride away from the arterial clot of customized chrome on one of his Redneck choppers is to make you a hero in your hometown. On your own turf, he assures, "You are the man."

Doll calls his company Redneck Engineering with the self-deprecating cheekiness that is a hallmark in this corner of the Carolinas. He means no disrespect, though, for his brethren who speak slowly, drive fast, and share deep-rooted conservative values along with, perhaps, that proverbial crimson tan line at the nape. Tan lines notwithstanding, what makes a Redneck bike not only enviable but unmistakable are the lines of its frame. That is not to say they all look alike. On the contrary, the variety of Redneck frames is extensive. But they do share an unambiguous family resemblance characterized by horizontal six-sided axle boxes, an idiosyncratic swoop above the transmission that supports a slammed saddle, a fender so close to the tread that you can't insert a silver dollar, and rarely any rear suspension, unless it is integrated into the seat itself. Although Doll has designed a springer front end that is in great demand by other builders, the only shocks in back, for the most part, are the ones you get hitting a rail crossing at eighty miles per hour. Then again, hardtails aren't what they used to be in, say, 1947. Today, alloy frames flex, broader tires absorb impacts better, and drivetrains run more smoothly. Doll says, tongue in cheek again, he might build a softail someday, when he has time to cater to "candy asses."

Vince Doll does not subscribe to any particular notion about what is or what is not a chopper. If a bike has that ineffable quality of "cool" and is simply made, it'll do. He will go so far as to say, "Don't need all that bunch of garbage on it. Just the bare necessities. Just to get down the road. No hoopla." A plainly subjective opinion, open to various interpretations depending on the time of day, but you can tell just by looking at his work that he favors traditional accents without resorting to old-fashioned kitsch. Some profiles are downright radical — look at the progressive lines of Ugly Bike and Sore Dick, which, nonetheless, run Panhead motors and springer forks. Old-fashioned doesn't always ring the old-school bell.

Hoopla aside, Doll's mission is to build *affordable*

custom bikes — the Everyman chopper, if you will. With typical Southern graciousness, he wants to share his fantasy and let it become one and all y'all's dream come true. (The first thing you learn in the South is that *y'all* is singular and *all y'all* is plural.) Vince Doll is the egalitarian chopper vendor. His customers include testosterone-addled teenagers as well as corporate, sports, and showbiz bigwigs. Vince swears that a sixty-four-year-old woman, a retired schoolteacher, was seen laying rubber on a Redneck Rocket as she launched out of Daytona Beach after Bike Week, leaving an acrid cloud of smoke in her wake.

Although Doll firmly asserts that Redneck will build no two choppers alike, he puts each one of his exotic prototypes

into limited production on an order-by-order basis, because, in his words, "I can't see keeping that away from people who want it." But he swears you'll never see them lined up in rows outside his shop as if it were a factory.

A great chopper builder has no reason to duplicate his best efforts. Think of a master builder as the patriarch of a family and his body of work as progeny — each individual motorcycle will have similar and recognizable family traits, but all will possess distinctly different personalities. Part of their heritage is the family name or, in this case, a brand name. There are plenty of ways to combine custom Redneck parts and paint so that critical enthusiasts can appreciate similarities as they evolve from one model to the next and from one bike to the next without becoming jaded.

The prototypes themselves, the "show bikes," remain in Doll's personal collection and tour with him around the country. He has an enduring, anthropomorphic affection for each one and a hard time choosing which to ride on any given day. On rare occasions between the frenzy of public events, when the bikes are resting shoulder to shoulder in the quietude of his garage, he enjoys sitting in there just looking at them with his grandson Devon. "Dang, Poo, these are cool," says the little boy. "When I get big, can I ride *that* one?" It already has his name on it; there's one earmarked for another grandson, too.

Redneck produces at least four completely new prototypes each year to debut at major rallies. This is the company's bread and butter. New orders are solicited by showcasing the latest designs where connoisseurs congregate. Is that a lot of pressure? "Damn straight!" says Doll. "It's hard to be innovative knowing you have to do it," he says. But as soon as he conjures up a new idea, he'll make a sketch and subject it to an informal poll by walking it through the shop to get each employee's opinion. "It's not a vote," he clarifies. "I'm still the boss." If a consensus is reached about a potential new product's appeal, it will get built. But first, Doll has to pull some hocus-pocus with his computer.

Vince Doll has mastered the three-dimensional rendering capabilities of CAD/CAM software (computer-aided

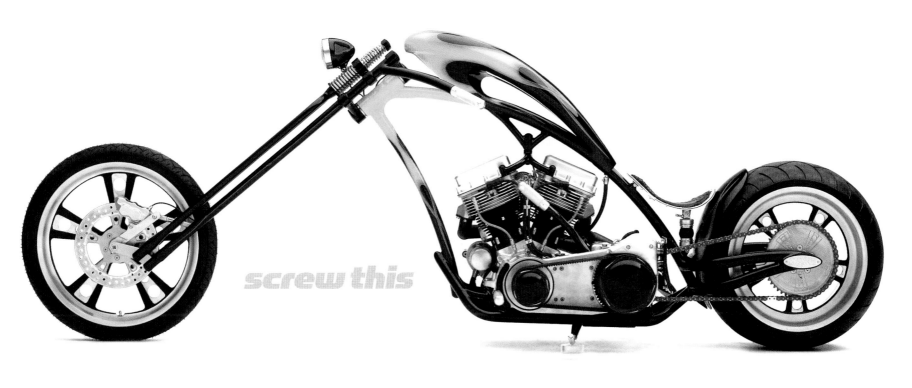

screw this

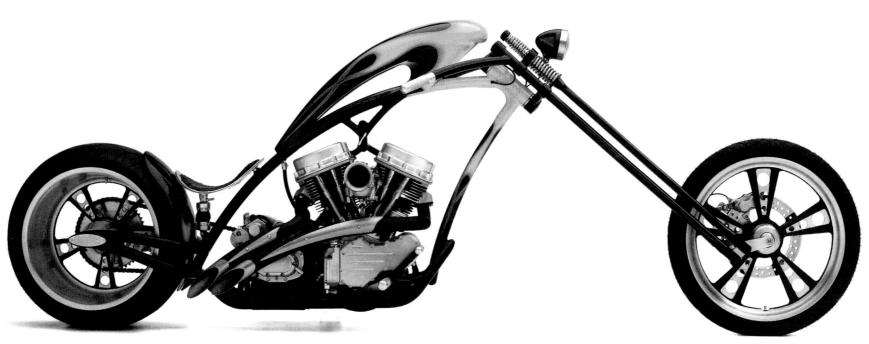

design/computer-aided manufacture), which allows him to create new designs directly on the computer screen as easily as on a restaurant napkin. These detailed blueprints help move products from concept to concrete lickety-split. They are neither blue nor prints, though; they are electronically digitized numerical instructions that translate Doll's sketches into data that are programmed directly into computer-controlled machines, which, in turn, carry out the precision manufacture of individual parts by automating tooling processes that are often either too complex or too time-consuming to do manually. Sometimes the data are simply e-mailed to an off-site supplier. It's the kind of science fiction that Silicon Valley geeks have turned into reality so that a small company like Redneck, in business for only a few years, can exploit the imaginative musings of its prime human resource to become an influential and competitive force in the motorcycle industry. However, the precision machining capability afforded by this technology is of less importance to Doll than the speed with which it allows him to bring new products to market. After all, he is making motorcycles, not cruise missiles. When Doll is asked to specify a precise machining tolerance, he may reply, "Oh, about that much."

Lest anyone think Vince Doll takes himself too seriously, he calls himself Nobody. It is also his company title, stitched above the breast pocket of every shop shirt he wears. He's got a clothes closet filled with them, and you are just as likely to see him wear one at a formal dinner as at a country diner. But don't let the good-ol'-boy modesty

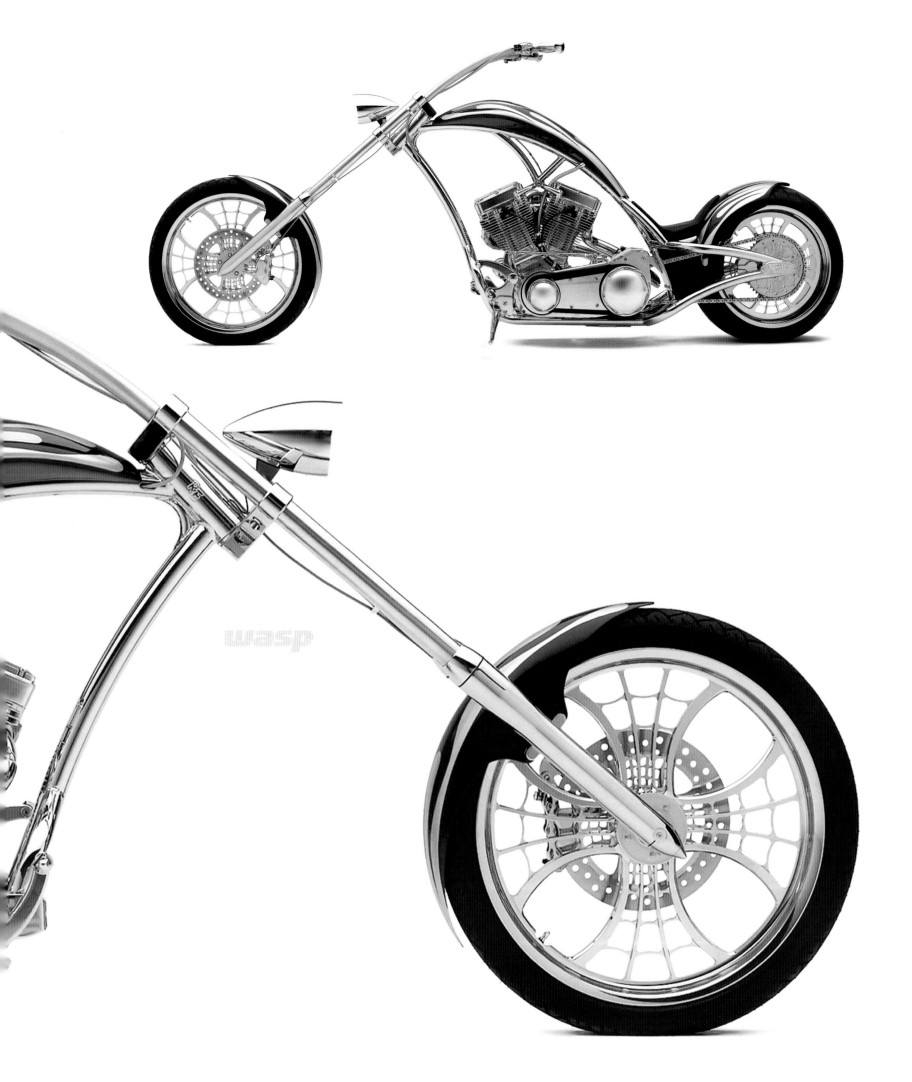

wasp

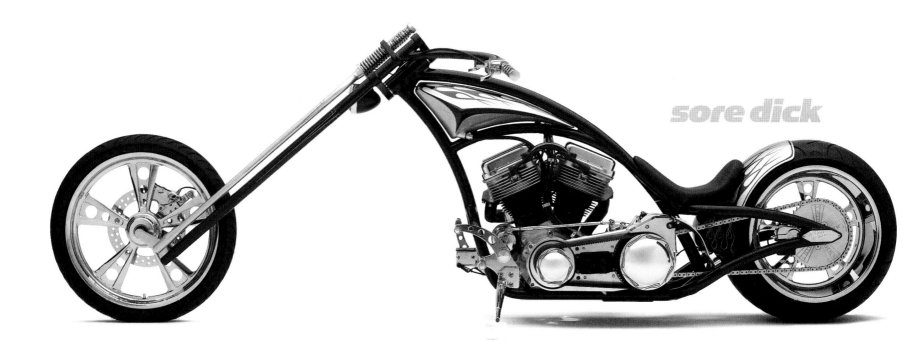

sore dick

and the occasional speechifying fool you. Doll may act like a laid-back son of the South, a model of congeniality and hospitality, but he is just as shrewd and ambitious as any Yankee with a type A personality. Once, a jealous executive from a competing motorcycle manufacturer, a rather larger company, tried to belittle Redneck by telling customers that Vince Doll built bikes in a barn. Just for that, Doll erected an imposing new assembly plant high atop a hill, designed to look exactly like a big red barn.

Doll is a late bloomer with regard to motorcycles. He began riding only a few years ago, after catering to a self-diagnosed middle-age crisis. "I went and bought me a Fat Boy on my fortieth birthday," he says with self-satisfied authority. But he kept it for two weeks before attempting to go down the road. For a while he thought about hanging it on the wall in his workshop, "just to say I had it, I guess," he says. Finally, once he got on it, he rode it around for only two months before he realized it was not what he was looking for. He saw Fat Boys everywhere. "It bored me to no means," he says, "so I cut it in half and built me a cool bike out of it." He knew how to weld, thanks to a friend, an inveterate tinkerer who introduced him to metalwork as a hobby. Soon Doll began to rehabilitate some of the hotrod cars in his existing collection, cropping tops and dropping fenders. But he had never so much as perused a motorcycle magazine before.

Soon after Doll's impetuous initiation into the realm of custom motorcycles, the proverbial light bulb went on above his head. He recognized that the market demand for custom choppers and parts was increasing and that there were other people like himself who wanted to step up from the conformity of Harley-Davidson but did not have the means to discombobulate and

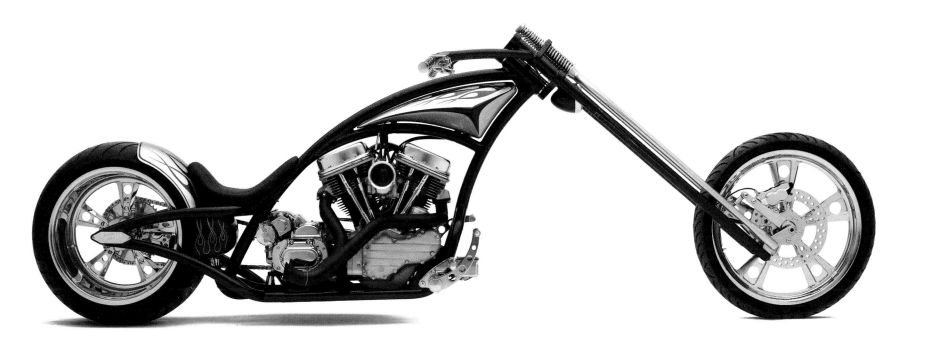

refabricate a perfectly good motorcycle. He believed he could have fun helping them realize their dreams and make money at the same time. He already had had enough success with his previous career as a flooring contractor to retire gracefully. He knew he had the creative talent to make his pipe dream a reality. Moreover, he owned plenty of land adjacent to his house in Liberty, South Carolina, where he could build a shop and expand it, if need be.

So in 1999, he jumped in headfirst and founded Redneck Engineering. It was just himself and a couple of other guys helping out at first, all of whom took turns hammering out gas tanks and fenders, cutting and welding frames. Vince joshes that he had to fire them once in a while, but they always came back once they got their heads screwed on right. The company started out modifying existing Harleys, just the chop-shop stuff, no motor work.

"I don't do motors," says Doll. "For some reason, it's hard for me to understand how a V-twin works." He shrugs it off. "Big Ford motors, big Chevy motors, blown motors don't bother me. But a motorcycle motor I don't know anything about," he says. Sure enough, he tends to his cars as well as any devoted motorhead. It's a paradox. But he has no trouble stuffing either a Tom Pirone or a Kendall Johnson powerhouse into a Redneck frame.

Now that Redneck is a mainline enterprise, no longer a retiree's avocation, Doll's time has become more valuable. With

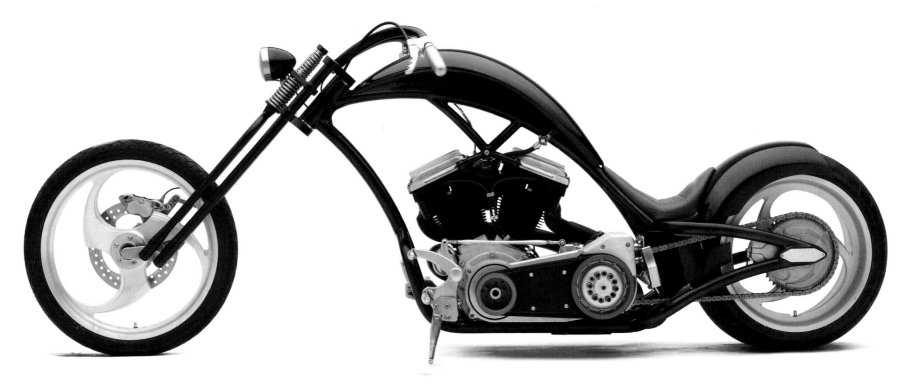

ugly bike

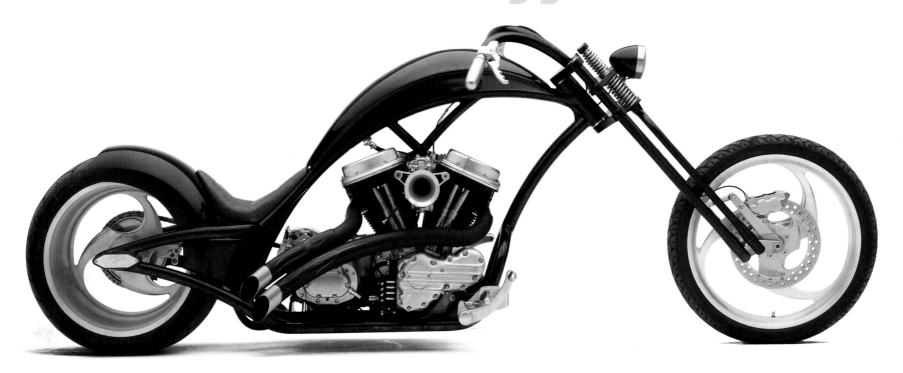

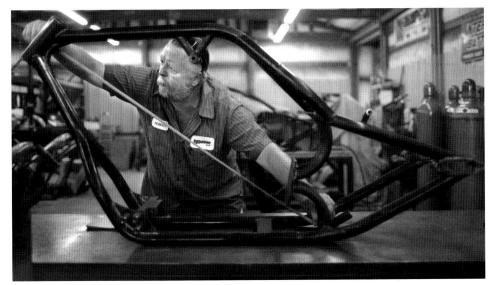

lots of employees and subcontractors to help him, he is now devoted exclusively to product development, glad-handing customers at public events, and making sure there is enough business to help feed all those extra families.

Vince Doll was born in 1957 in Greenville, South Carolina, just a stone's throw from his current home and workplace in Liberty. His father was an enlisted man in the Air Force. His mother was a part-time restaurateur and housekeeper. But his folks separated early on. Depending on who made the biggest fuss over the kids, Vince, with his two brothers and a sister, would shuttle between the two parents, from South Carolina to Pennsylvania and back. All in all, Vince spent about seven years growing up in Pennsylvania. There, at the age of nine, he entered an art contest for high-school students. He lied about his age to qualify, claiming to be seventeen. He placed fourth overall statewide. He still keeps his Pennsylvania painting, a landscape, hanging on the wall in his home today.

By the time Vince was actually old enough for high school, he did well but dropped out only two months shy of gradua-tion. He keeps his reasons under his hat, referring only in a roundabout way to an incident involving hotrod cars. Soon after he left school, he took a job operating heavy equipment for the phone company but tired of that after a while and moseyed around, eking out his livelihood by hustling pool. He wound up working as a flooring installer and carpet layer. By the time he was nine-teen, he felt ready to start his own flooring company. He bid on every job he could. Then, as now, Doll lived by the credo that if you're going to do a job, you should do it well — and then some. By the time Doll was twenty-four, he no longer had to submit bids; clients laid jobs right in his lap, because they knew he would deliver a job well done, on time, and at a fair price. As time went on, larger accounts came his way, including department-store chains and government institutions. He acquired a security clearance to work at the Pentagon. Throughout his career he listened to the advice of the financially successful people with whom he had became acquainted. He continued to work hard and invest his earnings wisely. By the time he was forty-three years old, he retired.

Vince's wife, Carla, has always been there for him. He won't call her a driving force, because she'd still be happy if he was making the five bucks an hour he earned when they first met, just as long as they are together. He thrives on her unequivocal support. "It's just there's someone to lay their arm

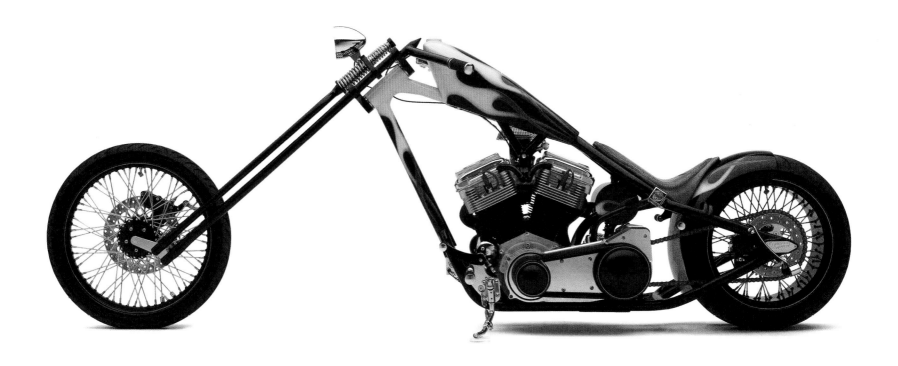

west coast killer

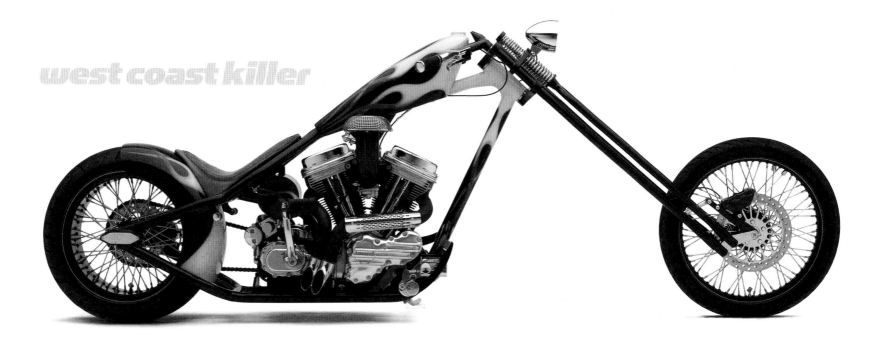

on your back and make you feel good," he says. They were married when he was twenty and she was nineteen, and have lived together since the first week they met. "It was lust at first sight," chuckles Vince.

Basically, by building a motorcycle factory in his backyard in Liberty, Doll made Redneck a family business. Along with Carla, who handles a number of administrative chores, their son, Chris, works at Redneck, too. The neighbors had no idea at first what was going on. Scandalous gossip abounded. Doll, his family, and his associates kept strange hours and drove around in fancy sports cars, big trucks, and on flashy motorcycles. For a long while, rumor had it that Doll was a drug kingpin. "There's no boredom on this hill," he jokes. But now the neighbors are proud that Redneck has put Liberty on the map.

According to Doll, the world is too big to fill with choppers — no matter how many of them he and every other builder can possibly make, they will still be something special. His job is to make as many people feel special as he can.

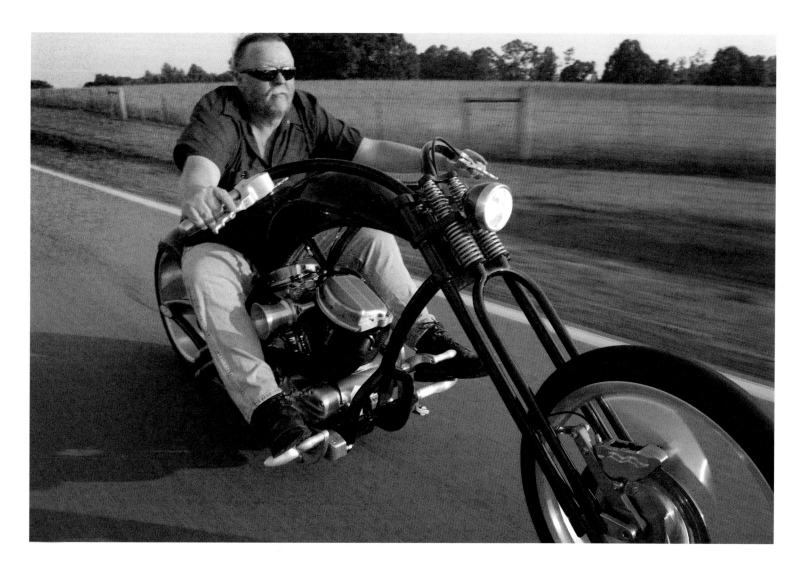

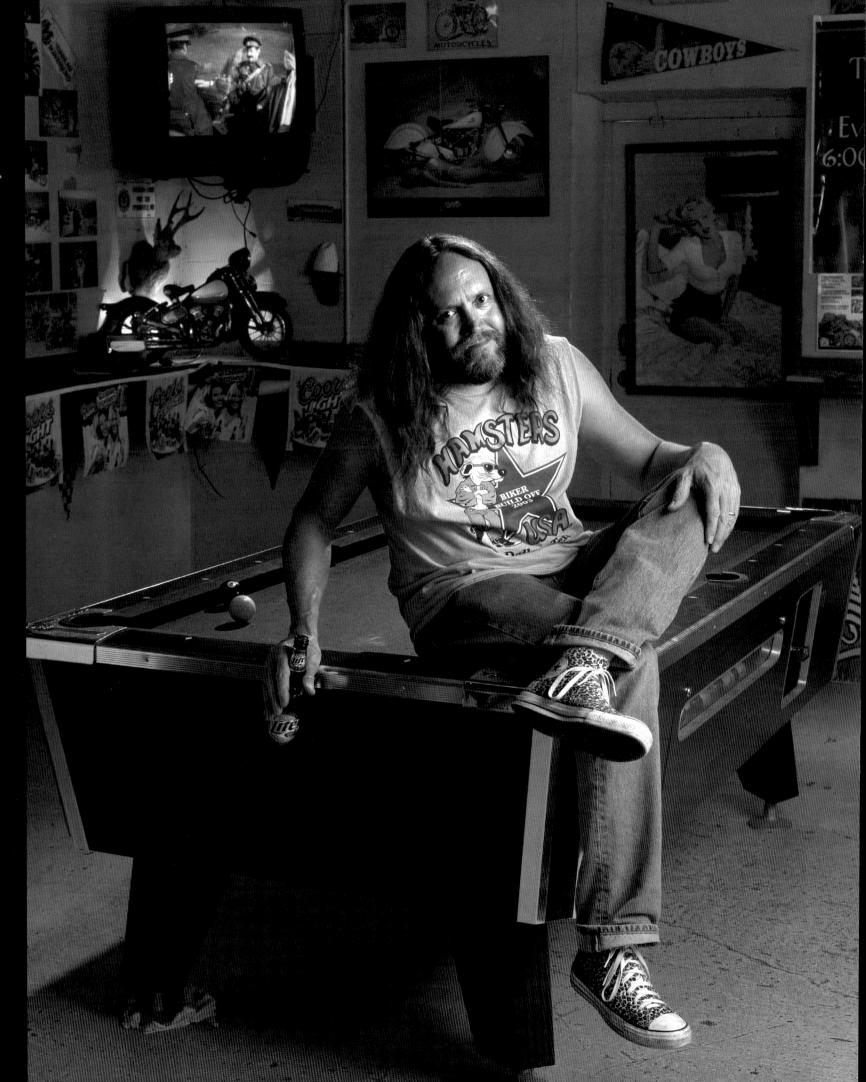

"What attracts people to a bike is the paint," says Rick Fairless. Color is the first thing that your mind registers when you look at a motorcycle: *the red one with purple pinstripes.* And color brims with emotional connotations: *red with rage; green with envy; yellow coward; got the blues; passionately purple.*

Ultimately, a paint scheme is the most obvious and personalized expression of adornment on any motorcycle. Once lured by the paint, you begin to notice the other salient aspects of its design.

A person who might ordinarily spend a minute or so admiring a conventional yet gorgeous paint job might spend hours examining the decorative veneer on a Rick Fairless custom bike, not because it is better done but because its intricate detail beckons onlookers with an entertaining story.

Fairless is the Beatrix Potter of choppers, though his illustrated themes are more eclectic and sophisticated than *Peter Rabbit,* to be sure. He has no compunctions about illustrating so turgid a topic as a history of the twentieth century from fender to fender; in fact, he relies on such lavishly executed chronicles to thread their way through the conversations of motorcycle enthusiasts far and wide. The paint is part of his marketing plan. "When I take these bikes to shows," says Fairless, "people crawl all around them, looking and pointing and laughing and saying, 'Holy shit! Look at that! Hey, he's got the Blues Brothers on it. Alfred E. Neuman! You remember Alfie Neuman, honey? He's right here! You know, *Mad* magazine, honey!' " He has caught many an admirer red-handed, conniving to come up with the green for such a bike. It may be a fantasy for all but one lucky buyer, if the bike is for sale at all; but while you're pondering the possibilities, there are many other things Rick Fairless can sell you.

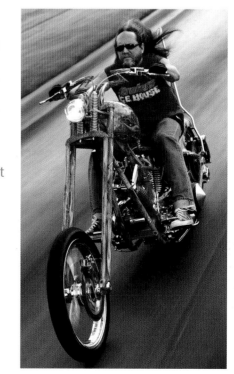

"One of the things that's different — what I do versus all the other builders — is look at everything through the eyes of a merchant. I don't just sell choppers. I sell beer, parts, Big Dogs, American IronHorse, and used Harleys," says Fairless. Ever since the first of his nineteen trips to Sturgis, he realized he couldn't just hang out to ogle the bikes and bikinis; he had to look at every bit of merchandise with an eye toward selling it himself. He may not like everything he sees, but if he thinks he can sell it, he'll take it home in quantity.

In his shop, Fairless is the commander-in-chief, but not the guy wearing a welder's hood, wielding a torch to do personal battle against the forces of iron. "I've got

what I like to call my little empire to run," he says, alluding to his bar business and retail showroom. "But, just like Arlen Ness and those other talented guys," says Fairless, "I can see a bike in my head before I ever start building it." With that in mind, quite literally, he instructs his minions in what to do and how to do it. He spends as much time in the shop as the other guys with grease on their hands and grinding dust in their lungs. But he readily admits, "I'm not back there physically turning the wrenches." Instead, he gives orders to the troops. "I'm the guy that's over their shoulders saying, 'No, no, no, *no!* We've got to do *this,* or we've got to do *that!* '" It's not that he doesn't have the mechanical skills to torque a few bolts himself, although he never did so professionally. He worked extensively on his own bikes, though. Cutting up bikes and, as Fairless says, "messin' with 'em," was a wonderful pastime he shared with his buddies while drinking beer and swapping yarns at home in the garage. He gave that up entirely in 1996 when he opened Strokers, his fab shop and dealership-cum-biker bar, on the outskirts of Dallas. At first, there were only four employees. Now there are forty.

When a customer comes to Rick Fairless with an idea for a bike, it's a business transaction just like any other, with one difference: you have to write the check. You can't buy a custom chopper on layaway or an installment plan. Still, his great joy is creating a "bad-ass bike" for a customer who can't believe his good fortune when he sees it for the first time. He also builds them to satisfy his phantasmagorical imagination.

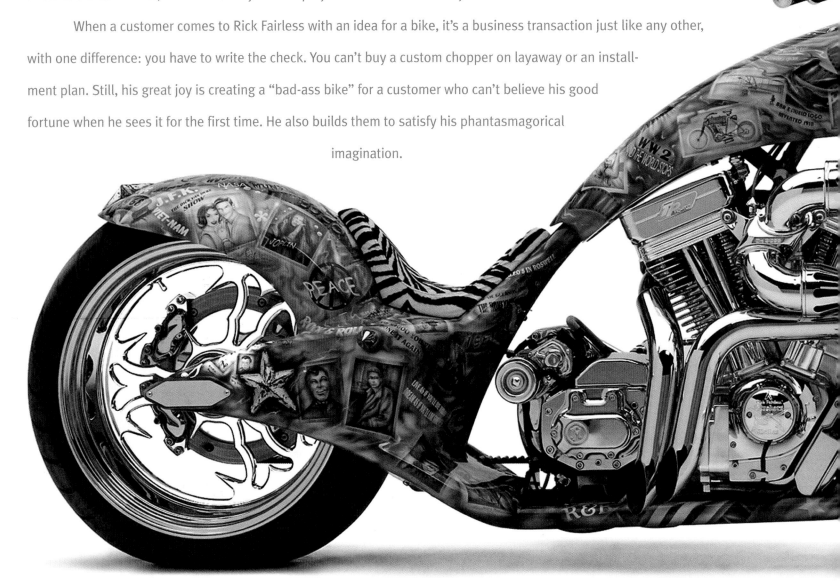

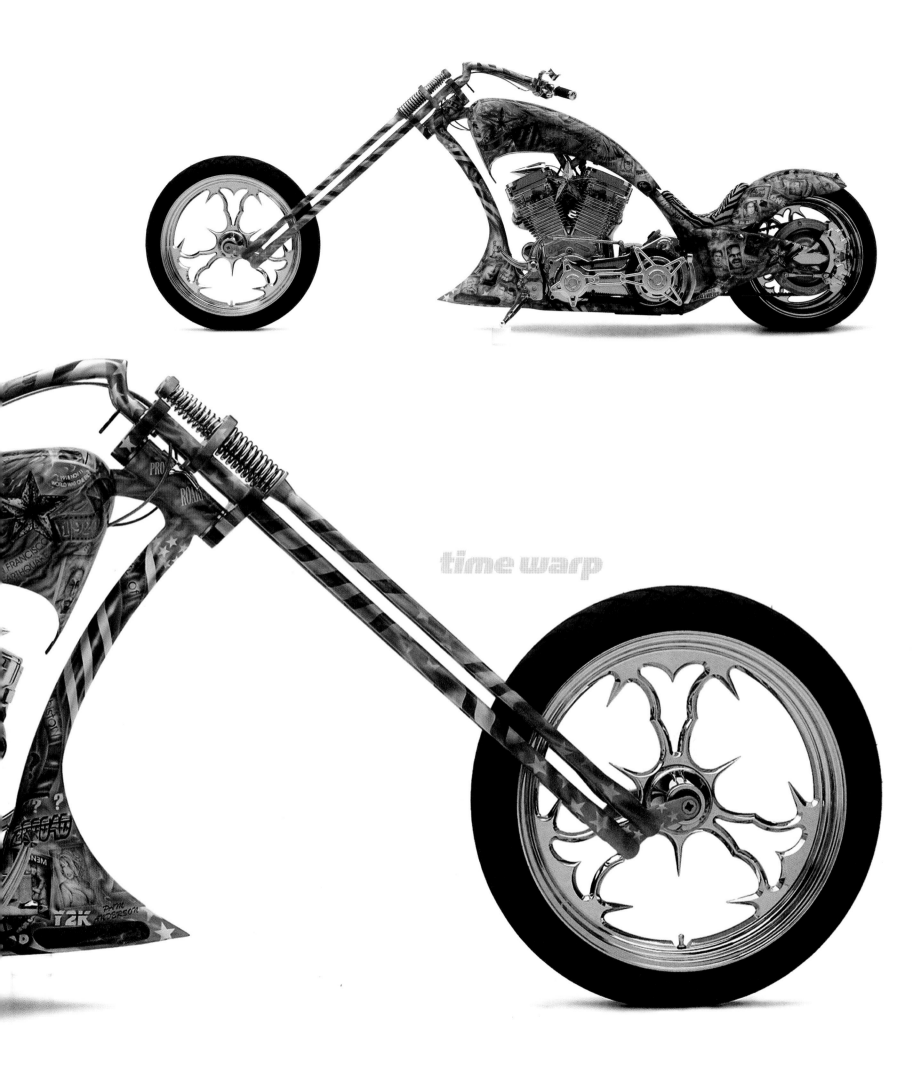

time warp

Brainstorms occur where they will but usually where he can best find privacy. "There's no 'Hey, Rick!'s on an airplane," he chuckles. There are no cocktail napkins in the shower, either. So Fairless creates sketches at forty thousand feet that become the informal blueprints for his bikes. While he is no Picasso with a ballpoint pen, he can execute an idea well enough for Trent Fairchild, who has been his go-to guy for a decade, to start construction on a rolling chassis. What begins with Fairless and Fairchild ends up with Gary Queen, the most meticulous man with an airbrush Rick Fairless knows.

These are the bikes for which Fairless pulls out all the stops. These are the ones he cannot sell. They are family to him. Besides, he recognizes their value as customer magnets, bringing people into his retail establishment. Those crazy-ass murals on wheels represent his chance to sell you a beer or a Big Dog.

Fairless knows a lot about paint for a guy who doesn't actually paint anything. In fact, paint has had a tremendous influence on his life. In 1976, at age nineteen, Fairless began working for Glidden, a manufacturer of house paint. He stayed with the company for twenty years, working his way up from warehouse chores to become the top retail manager in the country. His paint store was situated in the community of Irving, Texas. Rick realized that contractors who lived in this Dallas suburb didn't necessarily work there. Construction sites sprang up all over the county, and beyond. So painters would often pick up their supplies at other locations in adjacent communities en route to job sites. Rick persuaded his boss to let him open up at four-thirty in the morning, and before long, every contractor in the county found his way to Rick's establishment. They learned that he was willing to make deliveries, too. "My philosophy is get up early, work hard all day, and good things will happen," he says. Not one day did he call in sick, even though he had had numerous critical bouts with asthma as a teenager that kept him in the hospital for weeks at a time. He still carries an inhaler.

For his ambitious efforts, Fairless earned the privilege of maintaining his offbeat persona on the job. Whereas his associates had to abide by a formal dress code — conservative suits and tasseled shoes — he got away with blue jeans, cowboy boots, and shoulder-length hair. Ultimately, to the chagrin of everyone else, his boss told him he could wear a loincloth if he wanted to, having become by then Glidden's number one sales rep nationwide.

Ever since his last prolonged hospital stay, Fairless has felt feverishly driven to accomplish his goals. A doctor told his mother that he wouldn't live to see thirty. Fearless Fairless, as he has been known since boyhood, was determined to beat the odds. "If you've ever taken the cover off a golf ball," he says, "there're all those rubber bands under there. That's how I am." It is

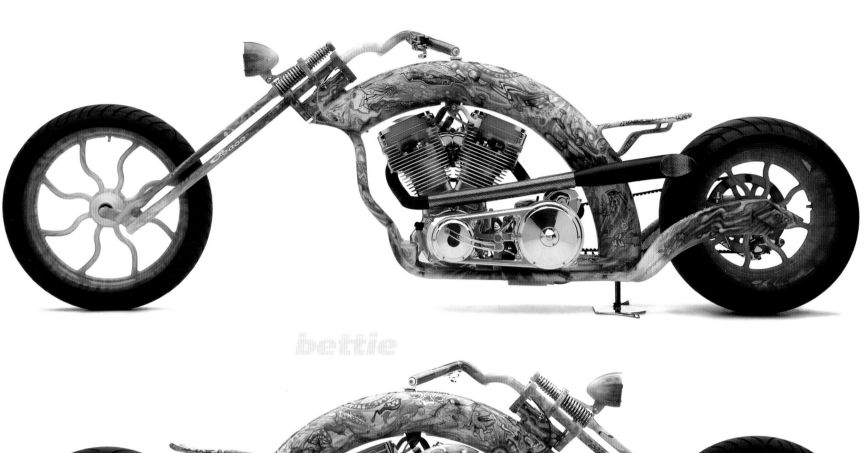

bettie

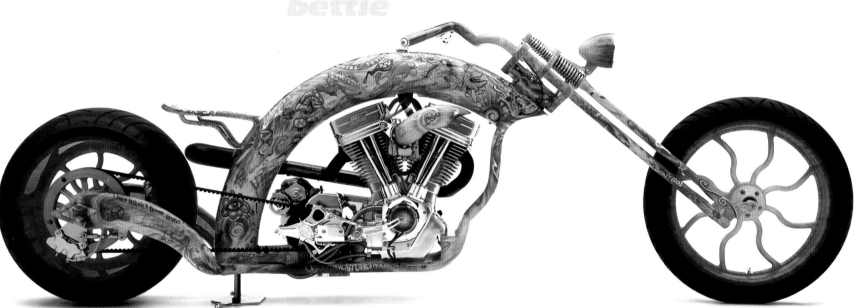

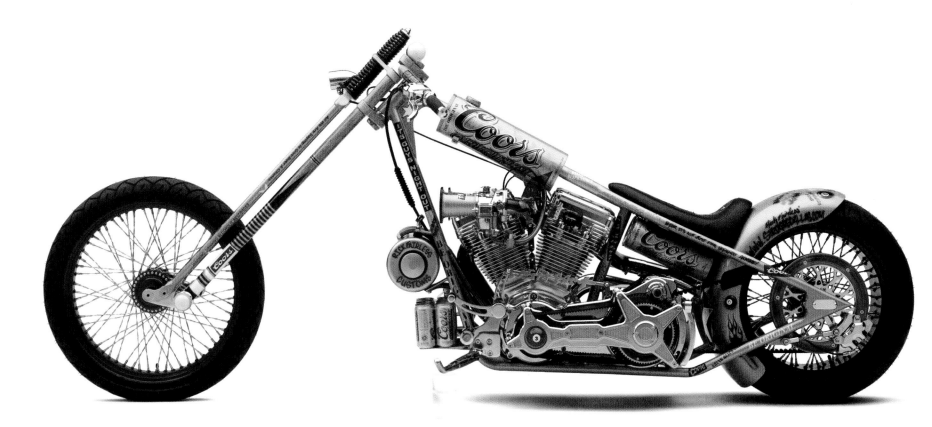

an apt self-appraisal. He calls himself a "goofball from Irving, Texas, who worked his way up." Without a college diploma, however, he had done as well as he could expect in corporate culture. There was no higher rung to climb on that ladder. He had ambitions of his own, anyway, encouraged by his father, who had given up a welder's job at union wages to open his own sheet-metal shop. He harped on Rick to start his own *paint* business. It made sense. But one day, Rick realized, "I'd been standing at the craps table for twenty years watching the dice roll by." He told himself, "Throw the dice!" He felt that he could always get his old job back in the paint business if he had to. But if he was going to take a gamble, he would follow his heart and go into the motorcycle business.

"I grew up riding motorcycles. I've had them forever," Fairless recounts. He remembers being fourteen years old and thinking, "I don't want a Harley. I'd never want a Harley. I love to ride on the dirt. You can't do wheelies and stuff on a Harley." Then, of course, at fifteen or sixteen, he took his first good look at one. Subsequently, he figured out that he could cut them up and hop them up much more substantially than a dirt bike.

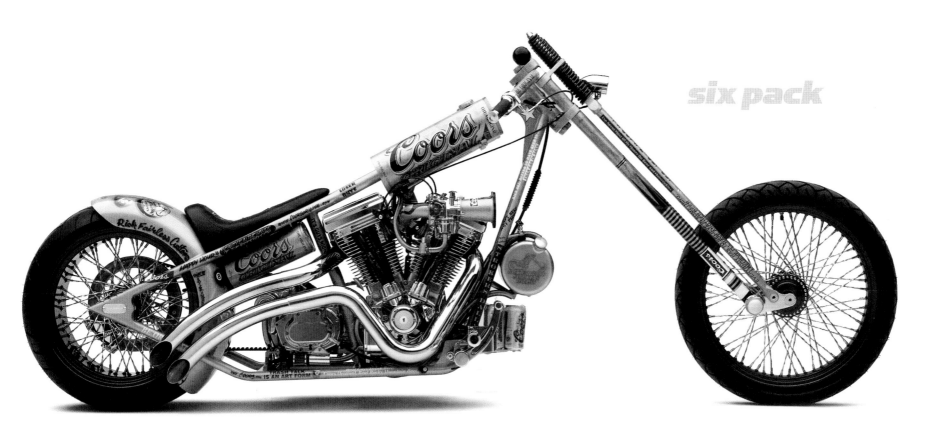

six pack

Rick Fairless was born in 1956, in Dallas, not six miles away from where he lives and works today. He has a younger

brother and two younger sisters. From the time he was eight years old, he remembers regular visits to his great-uncle's six-

hundred-acre farm in East Texas. There he could chase steers while riding a dune buggy with his young cousin. There was

also a Honda 50 to share. The boys took turns riding a closed course through water, sand, and woods. Initially, they timed

themselves so neither one got a longer turn than the other. Then the timing became competitive. Fairless remembers it as if it

were yesterday. "Whoa! I'm comin' to the sand. I got to hold on now 'cause it's gonna get all sideways on me. You're goin' and

your hair's blowin'!" He thought it was the greatest sensation in the world. By the age of nine, Rick had his own Suzuki 90

back in Irving.

One day in late 1969, when he was ten, Fairless remembers coming out of a Polar Bear ice cream store with his father

and brother as an honest-to-bad-ass biker rolled into the parking lot on a Panhead chopper, blipping the throttle. Young Rick

stood mesmerized, as frozen in his tracks as the ice cream in the cone he was holding, as the brooding biker dismounted with

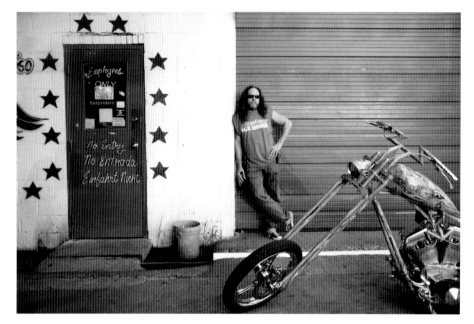

no small measure of aplomb and swung his jacket over the saddle. Rick's father and brother were already out in the parking lot beckoning him to get a move on. But as Rick rather woodenly moved toward their voices, he had his eyes on the rider and his chopper and walked smack into a concrete lamppost, dropping his ice cream cone splat on the ground. The other Fairlesses were laughing their heads off. His father said, "I told you motorcycles were going to get you!" From that day forward, they got him all right.

Rick's first ride on a Harley-Davidson came at the age of nineteen, just after he started working at Glidden. He already had his own Yamaha 650 twin by then, a Triumph knockoff that didn't leak oil. One of his buddies at the warehouse had a 1974 Sportster, rarely ridden. Rick took it off his hands after a test ride during which he realized how much it did for his self-esteem, seeing as other folks paid him lots of attention he didn't otherwise get. It was 1977.

"As popular as choppers are now, they're not mainstream," says Fairless, accounting also for production-line bikes that look like choppers. He means to say that the market will continue to exist as long as individualism reigns in the motorcycling community and as long as those who build and ride the real deal set the fashion. Fairless is bemused by people who tell him that choppers must be hard to ride. He knows it's only a question of whatever you get used to. After you've rolled astride a stretched-out chop for any length of time, an ordinary Harley will feel odd to go back to, "like riding a tricycle all scrunched up," says Fairless. He is confident about the continuing popularity of choppers. Choppers are cool. People know they're cool. "A chopper can't suddenly *not* be cool anymore," he says. Besides, if it is a fad, there are enough die-hard chopper fans who'll be pleased to see it end so they don't have to compete anymore with poseurs. As Fairless says, "They know *they're* going to be cool." He gauges interest in choppers by the number of job applications he receives each week. People are willing to work for free just to get their feet in the door, young and old alike. Of course, Rick agrees that they're probably influenced by the phony glamour and hype on TV. Some of the applicants accepted for a job become impatient after several weeks of sweeping floors. They complain that they're not learning enough about how to build bikes. But that's the price of tuition. For himself, Fairless continues to pay his dues. He has never lost his tireless drive to work harder than everyone else. Every day, if he's not promoting his business and his bikes on the never-ending Bike Week circuit, Fairless shows up for work at six o'clock in the morning. Saturdays, Sundays — it doesn't matter. He is usually the last person to leave at night, too. Everyone knows his "twenty-years-never-

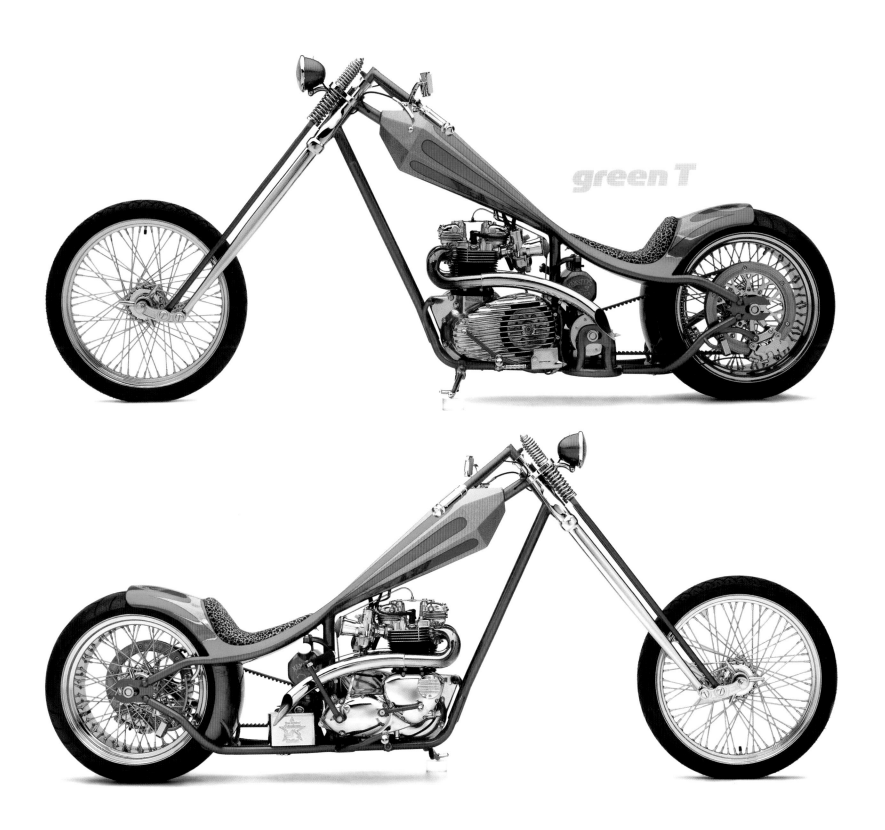

green T

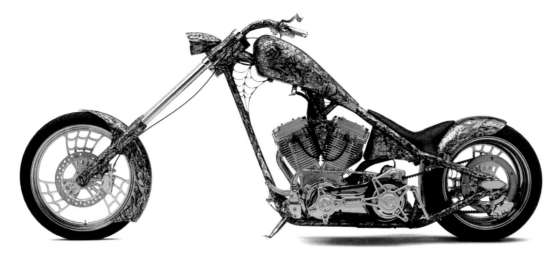

missed-a-day" speech by heart.

It's big business these days at Strokers. Fairless's dealership sells three hundred bikes every year plus accessories, both the kind you wear and the kind your bike wears. And that's nothing when you take the bar business into account. Strokers Ice House, next door, is a destination for riders far and wide. Part of the attraction, in addition to good vibes, plenty of bike parking, music, and big girls wearing little bikinis, is Rick's mom. She rules the joint on Mondays, Tuesdays, and Wednesdays. Mama smokes cigarettes and drinks beer all day long. She has a raspy voice like that of Janis Joplin, whose music and personality are another of Rick Fairless's obsessions. "She's crotchety, and she's mean," warns Rick. "She'll run you out of the bar if you rub her the wrong way." She made Rick sign a contract scribbled on a bar menu promising not to get any tattoos until after her demise. Rick has been pressing her to let him get a Hamsters tattoo. But she reminds him, "A contract is a contract!" He'll find another way to memorialize his association with the Hamsters motorcycle club.

Rick tells everyone who will listen that "getting inducted into the Hamsters is right up there with getting married and having kids. It was huge." His connection with the Hamsters has to do with his affinity for loyal friends and amazing

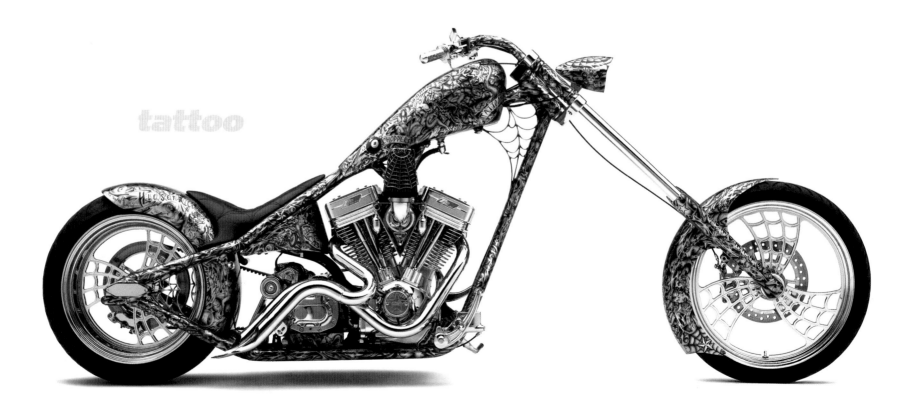

motorcycles, one criterion for membership being ownership of a ground-up custom bike. Moreover, the club allows its members to have fun doing good deeds and is epitomized by the outstanding personal character of its three founding members, Arlen Ness, Donnie Smith, and Dave Perewitz. And the bikes! The parking lot at a Hamsters affair is the best bike show in the world. That leads Fairless to say, "If I wanted to ride a raw, sexy, in-your-face, screw-you, screw-society chopper, there's only one guy: Pat Kennedy. If I wanted to ride a chopper and put some miles on it and have a state-of-the-art machine, there's only one guy, and his name is Arlen Ness." Fairless puts Ness on a pedestal as tall as the one reserved for his other hero, former Dallas Cowboys coach Tom Landry.

After motorcycles, the biggest part of Rick Fairless's life is family. He's got three kids and two stepkids. Rick and his wife, Sue, got married in 1979. But Sue's mother didn't take a shine to the goofball kid running a paint store who had run off with her daughter. So she basically ran him off. In 1981, they were divorced. They had no children.

Both Rick and Sue remained in Irving. From time to time they ran into each other on the street and remained cordial. Sue even came in to buy paint once in a while. Rick would carry it out to her car. They hugged, and they cried. They had been childhood sweethearts, after all. But Sue eventually remarried and had two kids. Rick remarried, too, and had three kids. Their kids went to the same school.

Just a few years ago, Sue's best friend telephoned Rick to tell him that Sue wanted to speak with him. Rick said to have her make the call herself. But it became evident that she was afraid to do so because she didn't want his wife to intercept the call. As it was, that was no problem, since Rick was in the process of getting a divorce after eighteen years. In fact, Sue had only wanted to tell him that she had just been divorced herself after nineteen years of marriage. Rick called. They set up a lunch date. Guess what?

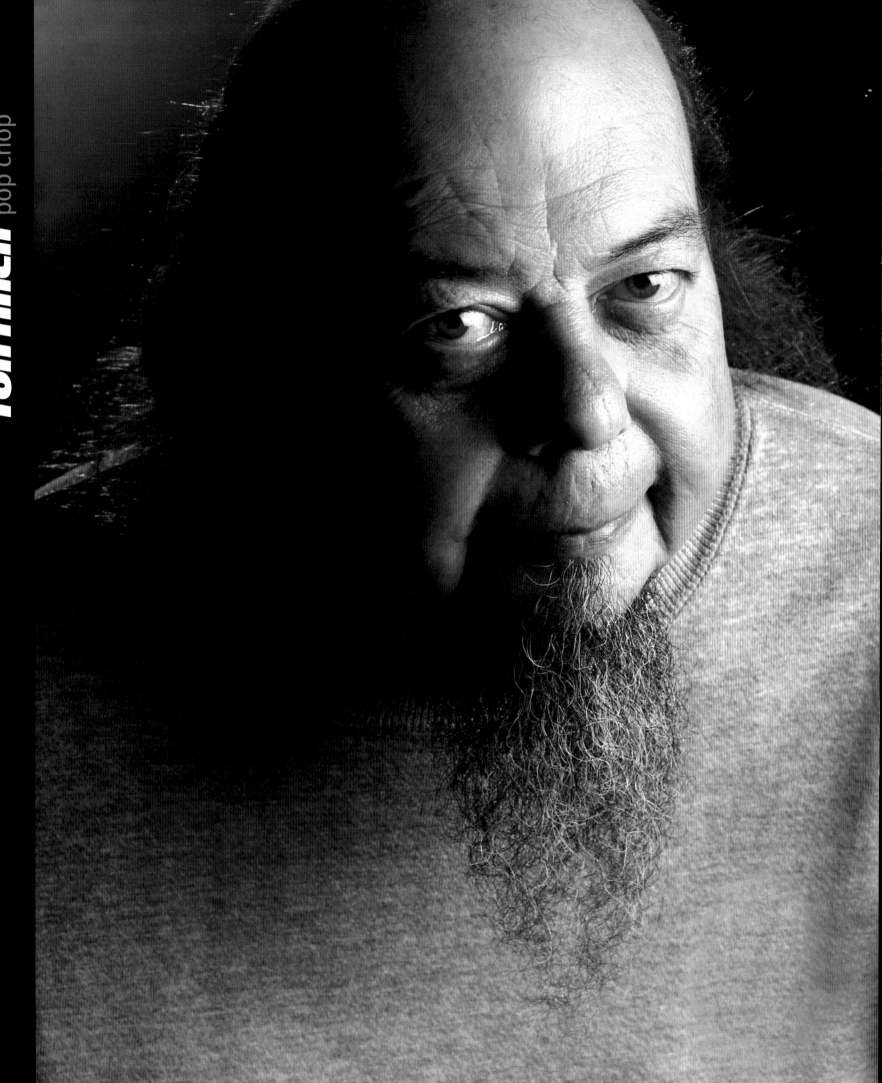

There are some who believe that choppers represent a new dementia in motorcycle design.

But that "new" belief actually goes back forty years, to when Ron Finch first epitomized that school of thought — that "*old*" school" of thought. Arlen Ness hadn't quite abandoned bowling for dollars and driving a furniture truck when Finch began plying his fortune with a welder's torch and a pinstriper's brush. He was a strange bird then, and his flights of fancy haven't been grounded yet. But for many years, until the recent revitalization of chopper culture, Finch had been a forgotten figure. All he can say is that he wasn't much of a self-promoter. But Finch's early innovations were instrumental to the evolution and history of custom motorcycles. He stands right up there with Ness, Donnie Smith, Dave Perewitz, Indian Larry, Mondo Porras, and Pat Kennedy.

When Finch first got into the act, the practice of customizing motorcycles had existed solely for practical purposes within racing culture and bad-ass biker clubs. If anything mounted on a motorcycle didn't make it go, it made you slow. So off came redundant parts. The result was called a bobber, simply a stripped stock bike. Thumbing his nose at the authorities who told him it wasn't supposed to be done, Finch virtually reinvented the bobber by turning it into a fanciful affront to effete society for no practical purpose at all. Such flamboyant motorcycles had begun to be called choppers all across the country; his were the first to be called art.

Ron Finch is a scion of the 1960s counterculture, a time when bikers were "hip" and choppers were "groovy." The girls who posed seductively on his trophy-winning rides are grandmothers now. And it's been a long while since Ron rode up to a motel and was refused a room or denied service in a diner simply because the proprietor had once spoken

with someone who had a friend who had heard from someone else's cousin who had not actually seen the movie *The Wild One* but had heard all about "bikers." Many people in those days were determined to fear and loathe anyone who rode a motorcycle. None of that rings a bell with young, present-day enthusiasts who drop their jaws when they see those rare old iron sleds painted like psychedelic Easter eggs, let alone the modern, whacked-

out permutations of, say, Billy Lane or Roland Sands. And Finch is once again flying high.

Back in the day, Ron Finch was one of the first builders to design and manufacture trapezoidal handlebars, commonly called Z bars today. He first typified another technique called frenching or scoop work, the practice of overlaying sculpted pieces of metal on existing surfaces, often using it in a manner he describes as "controlled asymmetry," whereby he would sculpt the sheet metal on either side of a bike in a dissimilar fashion. (Some old-timers actually call it "finching," since the style was so identifiable with Ron's work.) Today, though, frenching has a different meaning: the mounting of accessories flush with body-work so the surface of the combined elements is perfectly smooth. For example, a brake light can be frenched into a rear fender to become virtually invisible until lit. Frenching also refers to the practice of mounting, let's say, a speedometer into a concave recess in a gas tank. Finch also applied asymmetrical designs to his paint jobs.

There were no parts catalogs when Finch began his business, so if he didn't make something from scratch, he modified whatever existing pieces he could lay his hands on, from Honda to Husqvarna. He could prep and mold a chassis for paint using almost no body putty, preferring brazed-brass fillings instead, a practice considered hard-core cool by today's standards. Brass

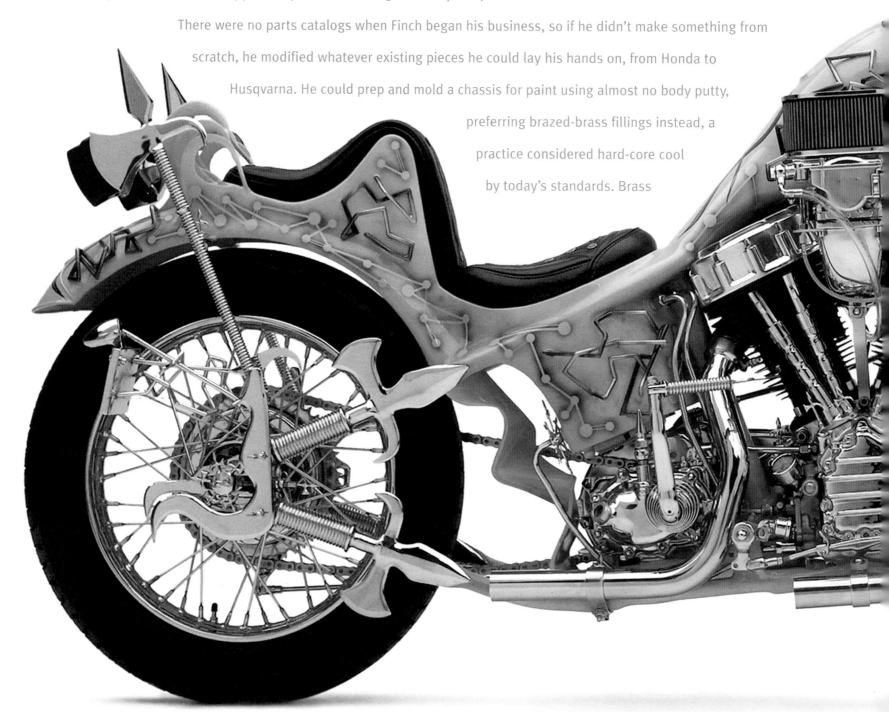

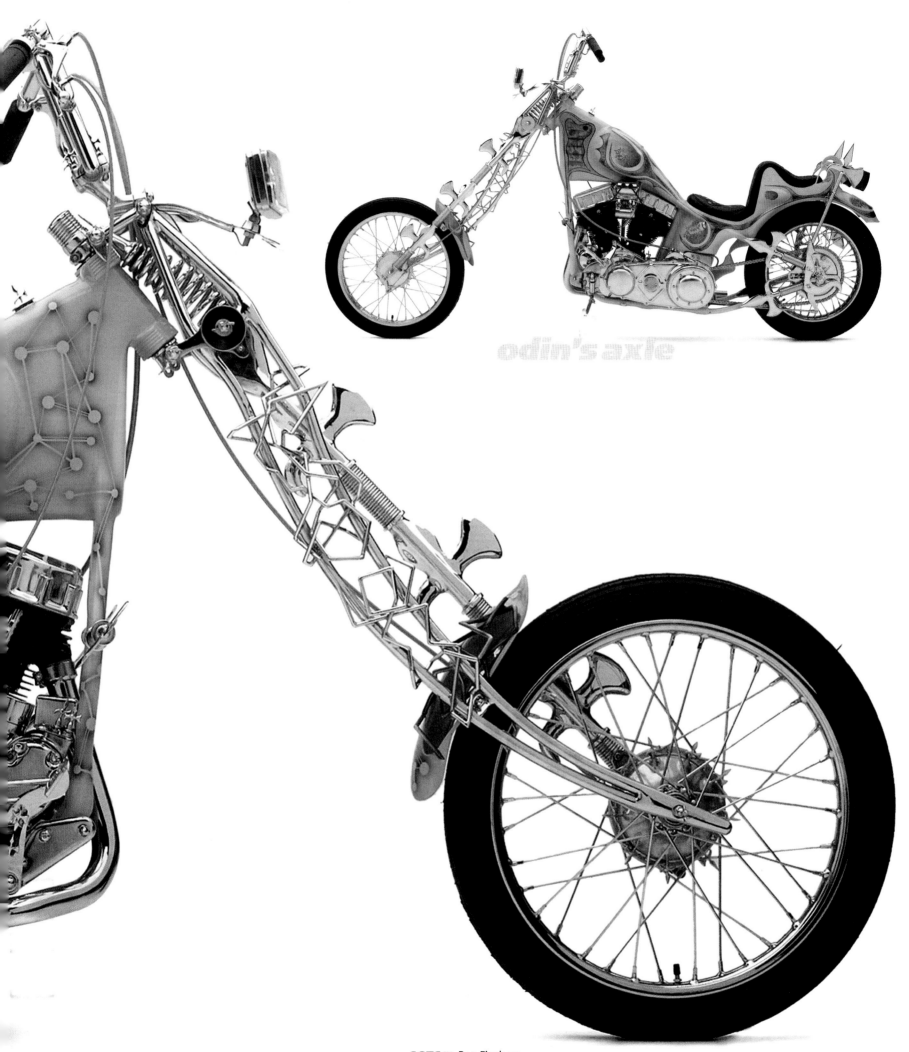

odin's axle

doesn't expand and contract under the paint from heat and vibration, so paint applied on top of a smoothly brazed surface will never crack, as it can with today's conventional putty.

Finch was as likely to use a BSA or Triumph mill to power his choppers as a Harley-Davidson. But regardless of the marque, extravagance prevailed in 1970, when, valued at $10,000, a Finch sled was the most expensive custom motorcycle in the world. One of his customers was the patent holder for, of all things, the strapless bra. His cups runneth over with cash. That year, he asked Finch to build a chopper for his son. As money was no object, Finch accepted the job as a personal challenge. He fabricated literally every tiny nut and bolt by hand to include a tiny ax, hence the theme of this bike — the first theme chopper? — which was based on Odin, the Norse god of war. (Odin actually carried a spear, not an

ax, but who's grading term papers?) No one has ever counted those itsy-bitsy hatchets, each one of which was chromed. The bike took on fuel unconventionally through the downtube and included a number of additional innovations that are taken for granted today.

In 1972, Odin's Axle and another bike dubbed Kaleidocycle were the first ever to be exhibited in a legitimate art museum, the Heard in Phoenix, Arizona. It was controversial at that time for motorcycles to be displayed as art. Many people felt there was no place in such an institution for a "functional thing." Art was not supposed to have had practical roots. Time has proved that notion wrong.

One difference between choppers today and those of yesterday is the better quality of materials available with which to construct them. Chopper builders in the 1960s found that reworking the fatigued metal in bikes that were already relics by the time they got their hands on them could lead to dangerous stress fractures. Extending the length of front fork tubing, for instance, could send you on a high-speed header into the asphalt. So home builders and professional mechanics alike began to rely on the bolt-on fabrications of men such as the late Tom McMullin of Auto Electric Engineering in Anaheim, California; Mardo Bennett of Bronx Motorcycle Circus in New York; and, of course, the still-kicking Ron Finch in the Midwest. Finch, the only surviving pioneer of the long bike, had been flattening extension tubing and then splicing it onto old Harley-Davidson springers for years before he began to manufacture and distribute his forks commercially.

It is Tom McMullin, by the way, who is generally credited — and acknowledged by Finch — as having invented the catalog parts business in the motorcycle industry. Finch was hard on his heels, though. These were the days when a custom raked-and-stretched frame cost "$260 cheap," as advertised, and almost half of that price was profit. The banana

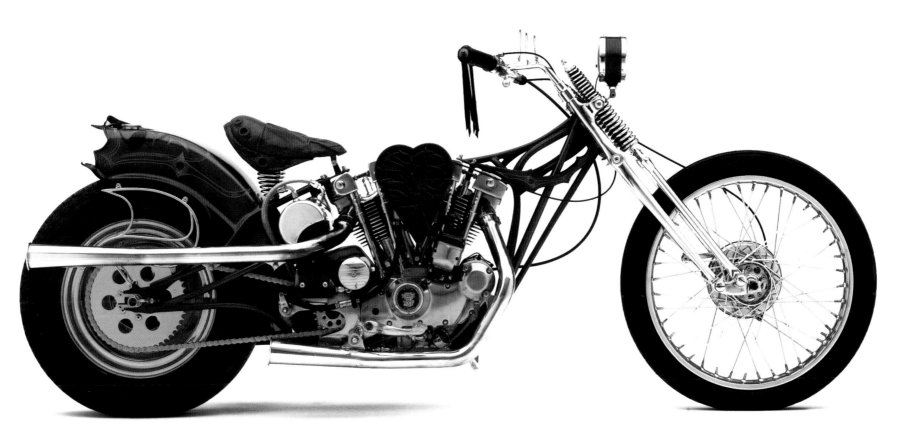

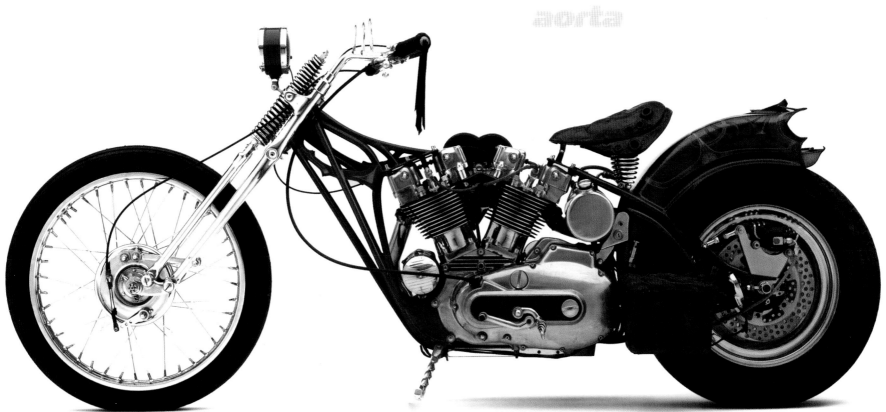

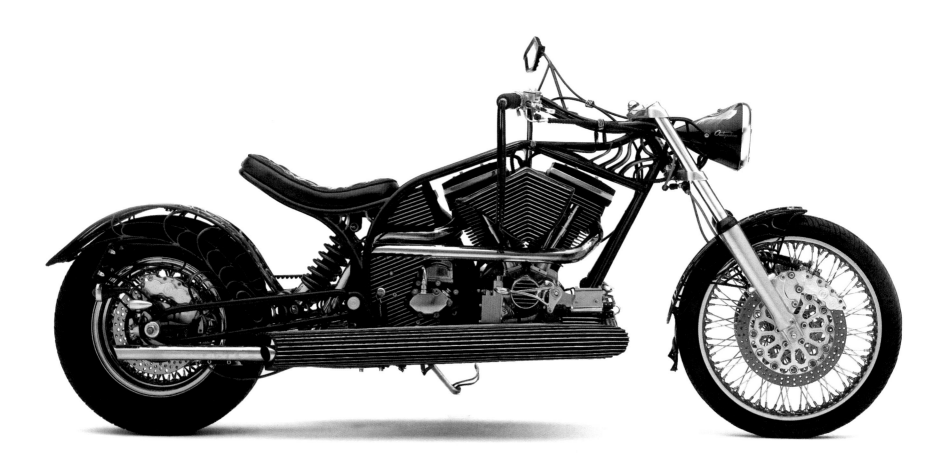

seats made by Finch could be sold by the pound today at 1960s prices. But whereas McMullin was dealing with retail customers and ultimately farming out his manufacturing to Taiwan to undercut Finch's prices, Finch was fabricating higher-quality, locally manufactured parts to wholesale distributors.

For his own catalog business, Finch would design the frames, and a subcontractor in another shop across the street would assemble them. Everything was manufactured locally with the exception of imported peanut gas tanks from England, of which he bought and sold hundreds. This was no hippie hop-up chop shop. Finch took advantage of a surfeit of automotive engineering and machining resources available to him in Motown — Detroit, that is.

Despite his role as an early proponent of prefabricated parts sales, Finch has mixed feelings about the advent of three-inch-thick, seventeen-hundred-page catalogs hawking a cornucopia of ingredients. "In a way, it's kind of bad," he

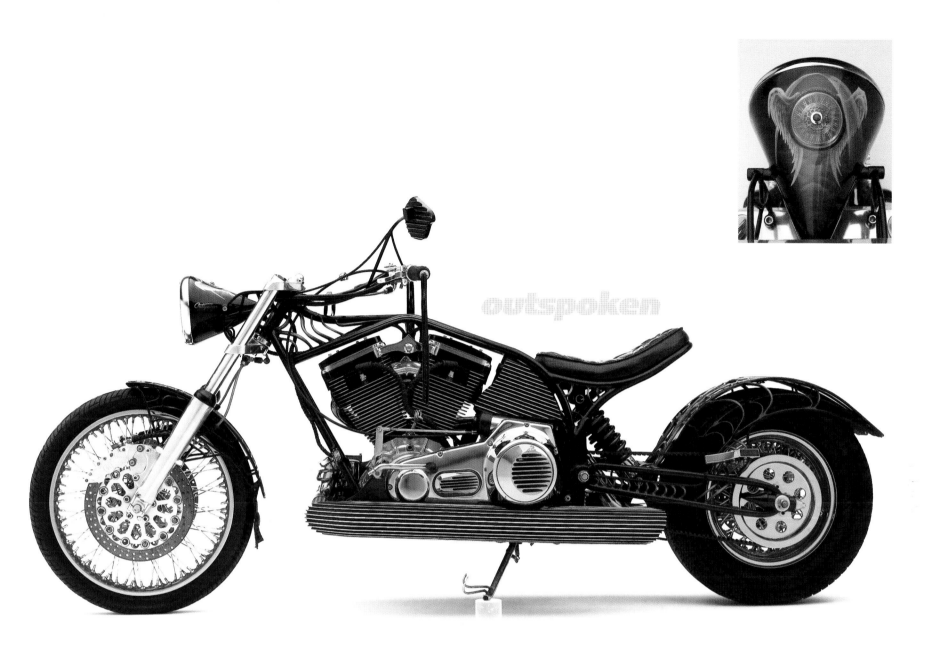

outspoken

muses in a deep vocal rasp produced by five decades of cigarette smoke. "If you don't hand-build it, it's not the same. The whole thing about any custom chopper is its individualism." He means the individualism distinguished by using hand-wrought components. Finch feels that the ethos that binds riders to one another and to their choppers is diminished by the ease with which one can, in a sense, buy his way into this rite of passage — or *ride* of passage, as the case may be. When fewer hardships are endured as a condition of acceptance, membership in the tribe of *chopperistas* becomes less special, and when the tribe itself becomes too big, individuality is trivialized. Change is inevitable, of course, but the scale of the commercial enterprise today confounds Finch the artist.

Still, Finch believes that any bike worthy of being called a chopper should exhibit a long front suspension and a small gas tank. He further mitigates that opinion: "The rigid look is still the chopper look. But the way my body is at age

sixty-six . . . the roads around Michigan are really bad, and I just can't stand that banging anymore. I've put shocks on the bikes lately."

Ron Finch lives in a beautiful and whimsical little world he has created for his own comfort and amusement. It surrounds the house in which he has lived for thirty-four years in Pontiac, Michigan, with his wife, Ruth. There they have raised four children and now entertain their grandkids. When he accepted a compelling offer just a few years ago from Home Depot to sell the property on which his former shop was situated, thoughts of retirement entered his mind, but with a resurgence in the popularity of choppers, those thoughts were quickly dispelled. He bought another, smaller house behind his existing residence and turned it into a workshop-cum-gallery. He acquired additional acreage with a large pond in which iron fish now swim and populated the adjacent woodlands of his estate with fanciful metal facsimiles of vertebrate and invertebrate life forms. There is a garden where spark plugs bud from flowering plants, and sunflowers that were once clutch plates loom large; gas tanks have transmogrified into flocks of pink flamingos, and a carousel of horses hangs from the sky. There are bowling balls scattered hither and yon, commingled with large and irregularly shaped blocks of translucent aquamarine glass, the byproducts of an automotive-window-manufacturing plant. Finch's workshop, too, contains a menagerie of anthropomorphic metal mutants scuttling about on a floor painted with vibrant-colored flames. Ferrous vines creep along the walls in defiance of the two-dimensional conflagration below. Not the least peculiar of the denizens in this fantasy realm are his motorcycles.

There is no more over-the-counter trade for Ron Finch. He's had it with the typical customer "who's got to talk to me personally," as he used to complain, "just to buy two lousy spark plugs." If you want to see his private collection or talk to him about custom paint

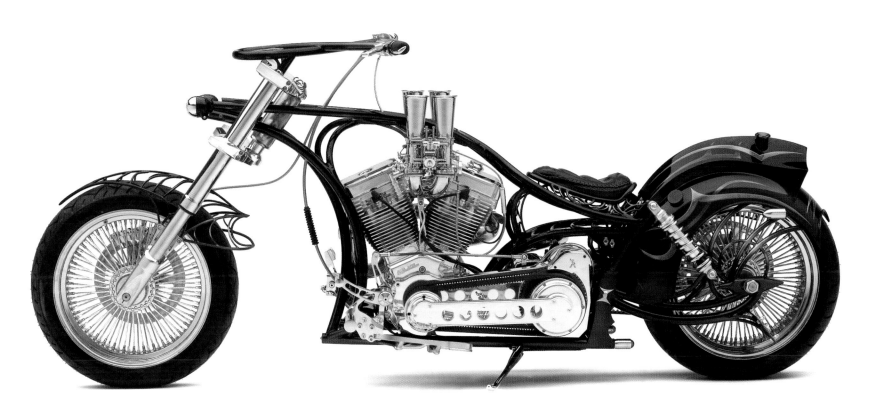

double cross

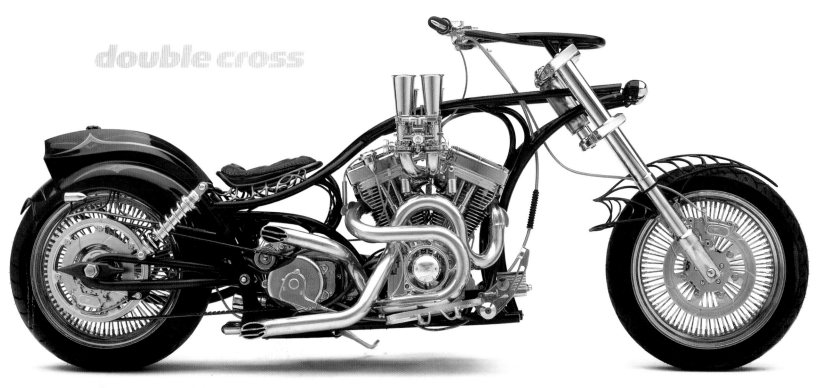

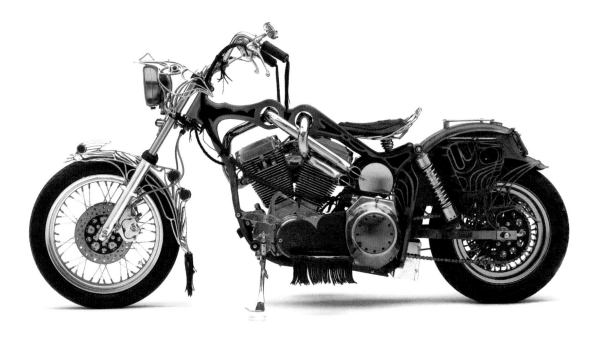

or a new bike, it's strictly by appointment.

Finch built the biggest chopper in the world, fit for Paul Bunyan to ride. It stands about ten feet tall and is sixteen feet long, the headlight is fashioned from an old beauty-salon-style hair dryer, the wheels were taken off a farm tractor, the counterfeit engine is cobbled together from old washing machines and electrical generators, and the giant exhaust pipes are rigged to shoot flames. It doesn't actually run — at least, not under its own power. Finch tows it on a trailer to the occasional grand opening, charity event, or hospital to entertain kids young and old.

Ron Finch was born in 1939 in Ferndale, Michigan. He grew up less than three miles away in Royal Oak with his younger brother, now the pastor of a thriving congregation. His father worked at Chrysler Corporation as an export expediter, making sure that specially produced automobiles destined for potentates and mucky-mucks around the world were shipped on time and to the right destinations. His mother, ninety-five years young now, was a seamstress.

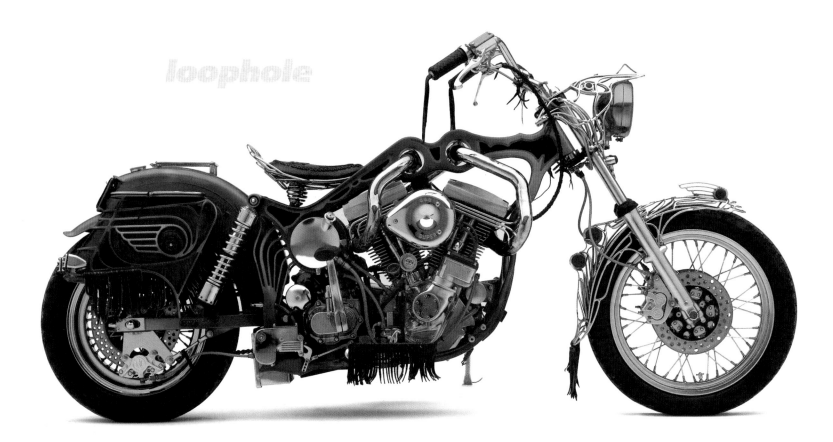

When Ron was fifteen, his parents gave him the choice of a car or a scooter, thinking he would forgo the scooter and wait until he was sixteen to have a car. Ron chose the Cushman scooter he had long coveted, paying for half of it with his paper-route earnings (his father loaned him the other half, to be repaid over time). Ron rode his Cushman regularly through sleet and snow to Birmingham, eight miles away, where he had a job as a delivery boy at a grocery store. He nearly froze his arms and legs off twice a day. "Michigan winters are fairly harsh," Finch reminds us.

In 1957, when he was a senior in high school, Ron was likely to be wearing the radical uniform of the day: white T-shirt, blue jeans, goatee, and ducktail haircut. He rode a used 1952 BSA to go with his greaser image, which didn't put him in good stead with the faculty. He left before graduation. He was nineteen years old and installing car-seat covers at Montgomery Ward by the time he received his final credits for graduation with a D-minus average. Not much later, and already thinking entrepreneurially, he set up shop with a young partner in a 160-square-foot industrial cubbyhole in the town of Warren, fifteen miles from home. Ron repaired motorcycles, and his partner worked on go-karts. But they feuded and parted ways, ostensibly because Ron spent too much time bench-racing with the customers. By the time they split up in 1960, Ron wound up with a job driving a car hauler, a job he had done part-time before.

On Saturdays, Ron would drop by a Detroit auto-body shop to watch the pinstripers whose work had caught his eye, admiring their graceful brushstrokes and concentration. After acquiring his own set of brushes, he practiced the tech-

nique of arching his wrist and twisting the tip while slowly and steadily following a freehand contour. A lot of household appliances and friends' cars got a taste of his handiwork during this course of self-study. Before long, he was good enough to moonlight striping jobs for a local Honda bike dealer. But his self-confidence had grown to a higher level.

In 1961, Finch got married, took a leave of absence from his job, and opened his own paint shop. He had no capital, and the real estate company helped out by deferring a down payment to help kick-start the business. But the marriage didn't

last. He had few assets to begin with but survived a divorce by hanging on to his toolbox, air compressor, and spray gun. He slept on the workbench in his shop for three years, scratching around to survive. Once the paint jobs started coming in, he quit the car-hauling gig for good and befriended a welder who taught him how to use a torch. Soon enough, he was

chopping bikes as well as painting them. It was 1965, and Finch's Custom Styled Cycles was open for business.

By 1971, industry pundits were already referring to his metal work as "sculptural art." Carl Caiati, editor of *SuperCycle* magazine, wrote a column that year in which he praised Finch for his inclusion in an exhibition of sculptors and painters at the Detroit Institute of Arts. In 1972, Finch founded the first showroom in the country devoted exclusively to custom fabrication and sales of choppers, on five and a half acres of former farmland in Auburn Hills. A bowled-over Larry Kumferman of *Custom Chopper* magazine wrote in May 1973, "This is beyond doubt the finest showroom display ever devised in the biking world."

With the advent of the 1980s, choppers took a turn toward obscurity. As Finch recalls, "It was a trend, like any other. There's always a phase. As far as fashion, you had your polyester suits, hot pants — and choppers. They went away, too." For more than two decades, although some people kept the torch burning, choppers hibernated in the collective subconscious of motorheads. While the genre withered at home, the underground biker movement overseas received a sustaining transfusion of motor oil, especially in Sweden, still infatuated with American culture.

For decades, Finch bristled at being called an artist, but you will no longer hear him complain. "I'm at a point in my life where I'll take what jobs I want to take," says Finch these days about a host of potential patrons on a waiting list. He enjoys painting and pinstriping bikes as much as ever, though, and accepts a greater number of those kinds of jobs than the three or four bikes he builds each year. And still he finds enough time to complete the fine-art commissions that come his way and don't have anything to do with motorcycles. "The other artwork — that's kind of therapy," he says happily. "While I'm welding or painting, I can let my mind wander and be three inches off on a piece of art, and nobody knows the difference; whereas if you're building a bike, you've got to be precise." That kind of precision will set you back about one hundred grand, if you're lucky enough to climb to the top of the waiting list.

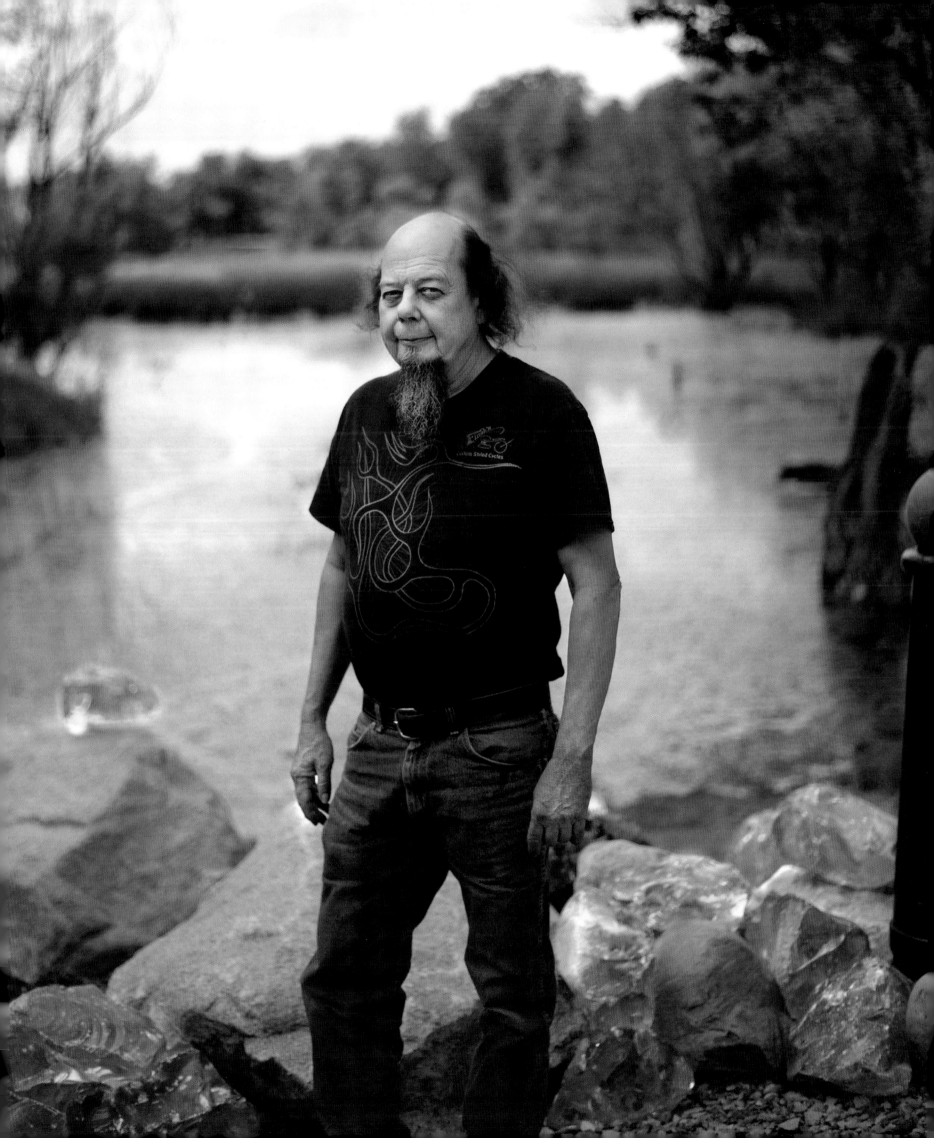

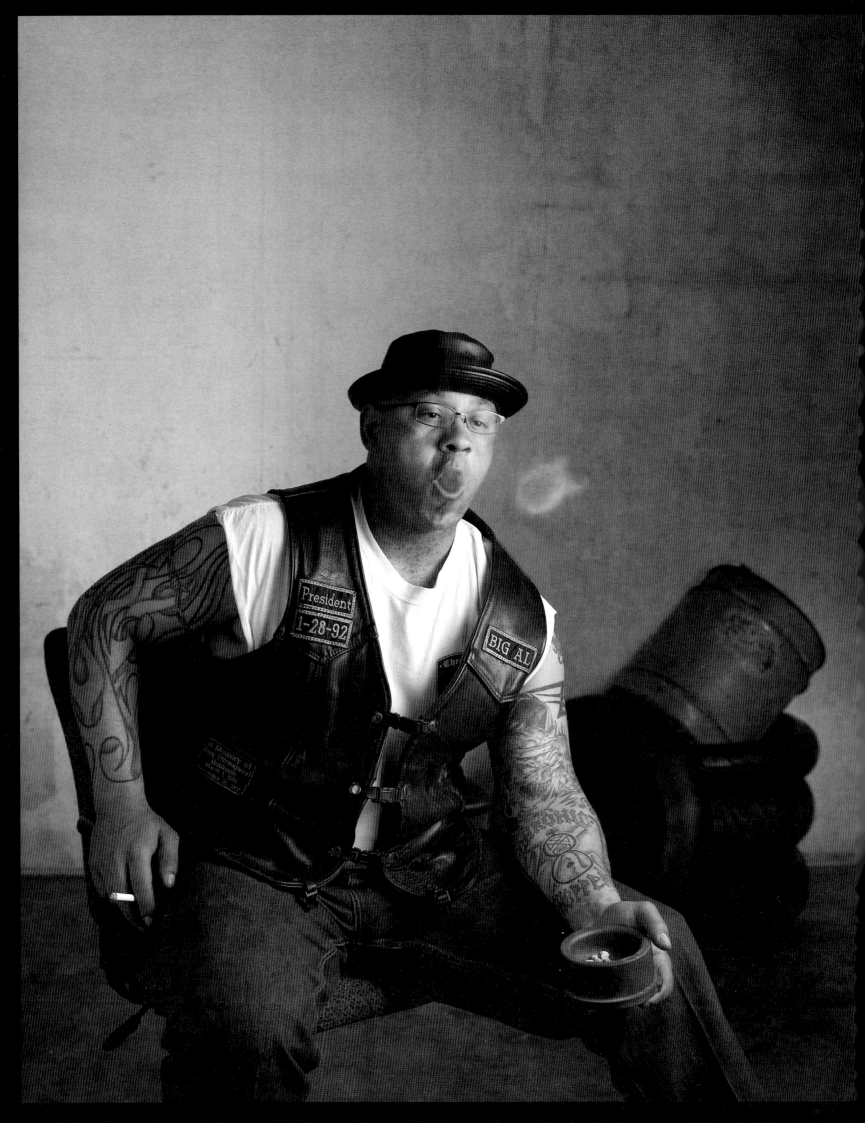

A ride through Kansas may leave you flat, but if you stop in Wichita to visit the shop of Al Gaither, it just might be the highlight of your trip.

Big Al, as Gaither is known, has some tightly torqued opinions about choppers. "To me, a chopper is a radical custom bike that's *been* modified by some *body,*" he emphasizes. That means specifically a one-man, personal, hands-on effort. Gaither is adamant about the distinction, but he won't argue if you've got your own opinion. "I don't downplay anybody's idea of what a chopper is," he says, "because the world is full of great ideas and great builders." For all he cares, you could call a Honda with training wheels a chopper. For himself, he is more dogmatic and quite specific. "A chopper is at least six inches up in the frame with a forty-degree rake, most of the time a rigid bike. I don't look at softails as being choppers myself." He sees a difference between a chopper and simply a chopped bike.

Big Al's idea of the proper chopper is bad to the bone and just as clean. It must say something about its rider, too: "I'm a tough son of a bitch; I got a rigid-frame bike!" Does that mean no one but a tough guy should ride a chopper or that anybody can ride one and thereby acquire the stature of a tough guy by association? At any rate, just as surely as a chopper will always be more spare, if not more stylish, it will imbue its rider with an inexpressible attitude — or as they say in daintier social circles, "The dude has a certain je ne sais quoi." Gaither himself says, "I like to build illegal fucking motorcycles." His take on the guys who ride them: "He doesn't have to be an outlaw to have a chopper; but a chopper needs to be an outlaw."

Al continues, "Back in the day, the bikes were radical, and they *were* dangerous. Today, we can build the same-looking bike that will ride up the road straight." Some laws still enforced today in various regions of the country were legislated to protect riders from their own ignorance. Unfortunately, the law hasn't caught up with technology. As for Big Al's style, "Hey! It's wide open, man — whatever." He'll be working on an old-school chop at one end of the shop and a low, fat bike at the other. "I jump around. That's what it is," he says. Nevertheless, he puts the company's seal of approval on every bike he makes. Chronic

Choppers is the name of the company, not Chronic *Cycles.* He doesn't pay much attention to current fashion trends in the motorcycle world, unless a customer asks very specifically for something, such as hanging saddlebags on a lowered, raked, and stretched Road King cruiser.

Al's own ride is a stretched-and-raked number with a rubber engine mount for long hauls across the Kansas plains. He is not embarrassed by the rubber mount — comfort counts as miles

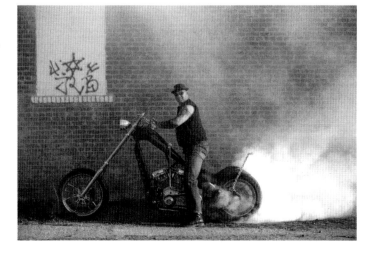

add up. Although, by any less rubbery definition, it isn't a chopper because of its cushier ride. Some people think riding a chopper is supposed to be a Dostoyevsky experience: suffering is good for you. But it looks like a chopper because of its frame modifications. Even the guys in his club think so. Gaither will not contradict them. "Heck, no! When you start splitting hairs," he admonishes, "you wind up stepping on people's toes."

Typically, choppers are for the short haul, not cross-country adventures. But Gaither is clear about his own predilections. "I try to build my bikes to ride; you know, to really get ridden," he says. He cares less about "the show side of things," preferring to win smiles before trophies. To him, a bike looks better in the wind than on a kickstand. Gaither wants his customers to feel secure about jumping on a bike in Wichita and riding it to San Francisco, and his own riding experiences have taught him how to keep critical parts from breaking under such hard use. He will build toughness into it, even if the buyer tells him it will be hung from the rafters of a rumpus room. Besides, the guy who does not ride it may later sell it to someone else who beats it to hell.

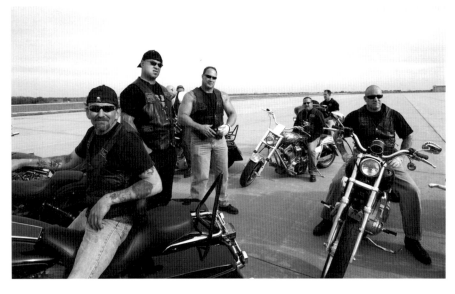

Big Al relies on old-school sensibilities and techniques; he prefers the process of taking apart a stock bike and rebuilding it, instead of starting from scratch with a new frame and motor. He would rather modify an old Harley-Davidson than build a new *Hardly*-Davidson. There is nothing old school about a new chopper. It is an impossible contradiction for Big Al to reconcile.

As much as he enjoys working under a welding hood splicing bits and pieces into rolling chassis, Gaither knows a lot about motors, too. Early on, he spent three years at Big Dog, a motorcycle manufacturing company based in Wichita, helping to set up its engine and transmission production lines. But he prefers to concentrate these days on sheet metal. He can bang it out and paint it, too. One extraordinary example, rather a diversion for him, is worth noting.

His favorite road bike, the rubber mount that looks like a chopper, has a novel finish. Al knew how often he would have to repaint a bike that would be ridden for thousands of miles each year behind big rigs and farm equipment. So he took it apart and delivered its frame and sheet metal to a local truck dealer to receive a coating of jet-black spray-on bed liner. "You can take a hammer to it, and it's not going to come off," claims Big Al.

Al says he comes up with some pretty funky ideas at night when he drinks too much coffee. But he doesn't start a project with plans or drawings; he starts out with no more than an inspiration, which will be conveyed to those of us who appre-

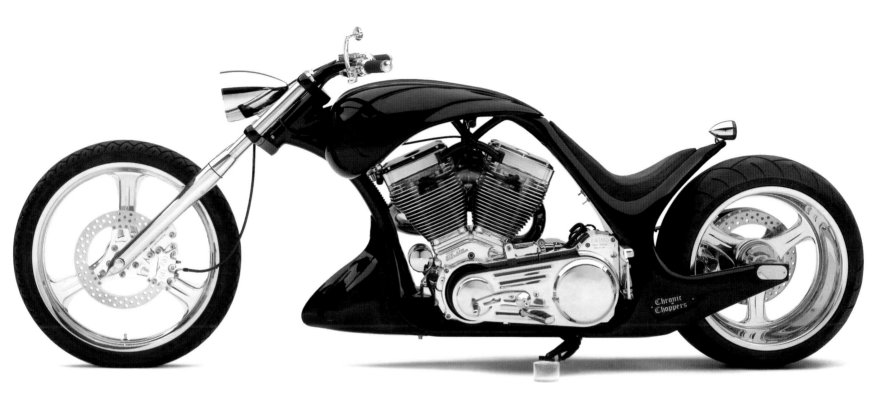

basic black

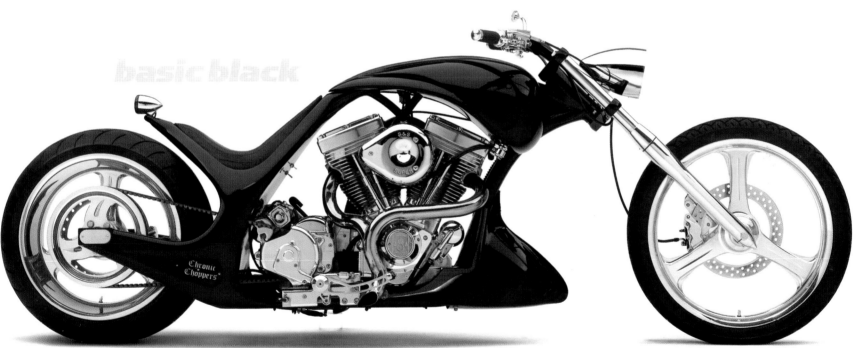

ciate his work in the manner of a jazz musician who improvises riffs on a familiar tune. "I just kind of roll the dice," he

says, "and hey! This is what we've got. This is what I built."

Al Gaither was born in Germany in 1966 and raised by adoptive parents. He had not searched for his

biological parents, because the couple who raised him were so loving (it was reciprocal) that he was afraid to

offend them. Now that the woman who brought him up has passed away, he has taken time to learn more about his

history. His father was African-American, and his mother was German; he came to understand how Germany in

the 1960s was not the place for having "brown babies" in the family. He was adopted by a white cou-

ple. The dad who raised him was career Air Force. Mom was a nanny. They took good care of

Little Al, but he had a propensity for trouble.

"I committed my first felony in kindergarten," he confesses. He had already

figured out that money sometimes came through the mail, so he began

boosting mailboxes at the age of six. He got caught by his mother,

who grounded him for an entire

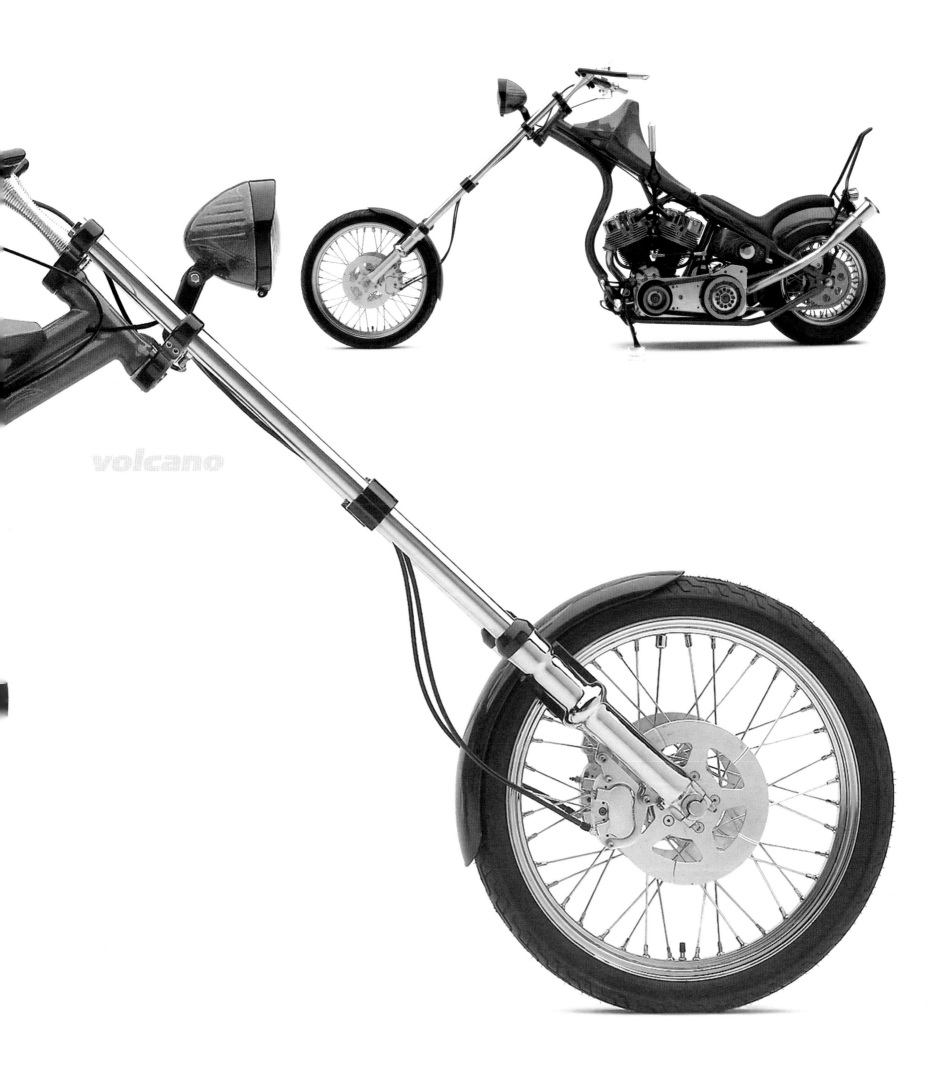

volcano

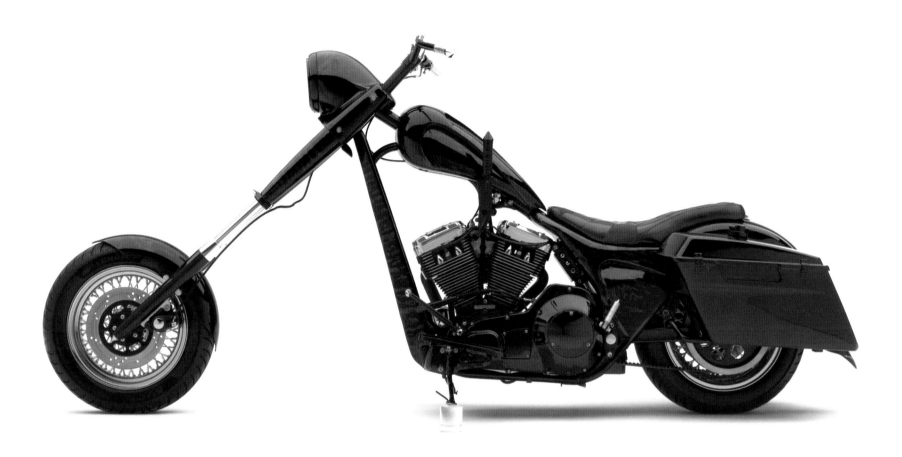

summer. "It's just the way it was. I did a lot of things that I'm not proud of today. But it's kind of funny to look back and

laugh at." He grew up a middle-class military brat. The family moved around with various postings until they settled in

Wichita. When his dad retired from the service after twenty-two years, he took a job with Federal Express that lasted for

the next fourteen years.

Besides his genetic father, Al reminisces that he had two real fathers growing up. One was the father who loved him,

tossed baseballs, and put a roof over his head. The other was a man named Jinx Cole, for whom he had a tremendous fondness.

Cole, the father of a childhood friend, was a Boeing employee in Wichita who took a bunch of kids under his wing and taught

them a thing or two about tools. Jinx kept a Harley in the garage, filled with machines, and jars of everything curious kids would

want to tinker with. The neighborhood boys hung out at Jinx's garage. He let them work on whatever projects they could dream

up, chopping bicycles and such. Jinx also taught Al how to ride a dirt bike. Al's own home was reserved and comfortably conser-

vative; Jinx's house was a mess, strewn with car parts and back copies of *Easyriders* magazine. "I was thumbing through them

and looking at the chicks, checking out the bikes," he recalls with a grin. But at eleven years old, he insists, he was more inter-

ested in the bikes. He and his friends started "double-stacking" the forks on their Schwinns, which means extending the front

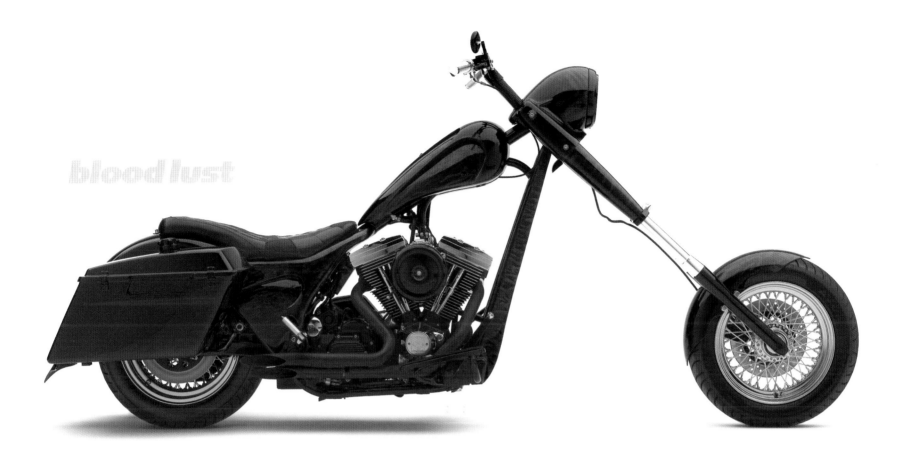

blood lust

forks to look like the choppers they read up on. They had plenty of material to work with. "We kiped a couple of extra bikes to get the forks," admits Al with a chuckle. The hollow tubes were made of a cheap, stamped alloy and tapered at one end. One set of forks was hacksawed and then crimped flat. The crimped ends were inserted into the larger opening on one end of the purloined forks and pounded flat with a hammer. It was hoped that that would hold them fast — without welding, it was a dicey proposition. But all the boys survived without incident.

Today Big Al rides with bigger boys, the Newcomers, a motorcycle club with roughly a twenty-year history. "We're a bunch of junkies and psychotic dope fiends who ride together," he cracks facetiously. On a more serious note, he explains, "We're all clean today. We are a motorcycle club that's clean and sober, not a clean-and-sober motorcycle club. A lot of people get that confused." Theirs is a brotherhood of reciprocal dignity and shared experiences, both good and bad. They don't look back. They watch one another's back instead. It's the real deal, as far as clubs go, so Al won't divulge too many details. Nevertheless, some of the guys are full-sleeve tattooed, hardcore motherfuckers from back in the day who put on their suits and go to work because they have families to support now. Some of them have even earned positions of authority as business owners and community leaders. Al was chosen to be their leader. But, he says, "when you accept a leadership position, you're

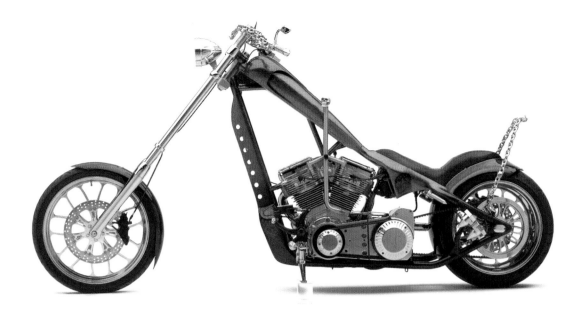

working for the people who put you there. You're not their boss."

Other than their families, the most important aspect of life for each Newcomer is riding together. They do that a lot. Al puts down about twenty-five thousand miles per year on his black road bike alone. The club maintains a rigorous schedule of runs throughout the season. Al hasn't missed one in eleven years.

Following a straight and narrow path means something more literal to the Newcomers. For example, the club rolls at night when they head out of town, because they don't care to look at the desolate highways and boring byways of Kansas. By the time the sun comes up, they're in a different, less dreary-looking place. Both literally and figuratively, they've put the past behind them. "Besides," poses Big Al, "what's an outlaw? They're finally figuring it out: white-collar crime." Incidentally, the

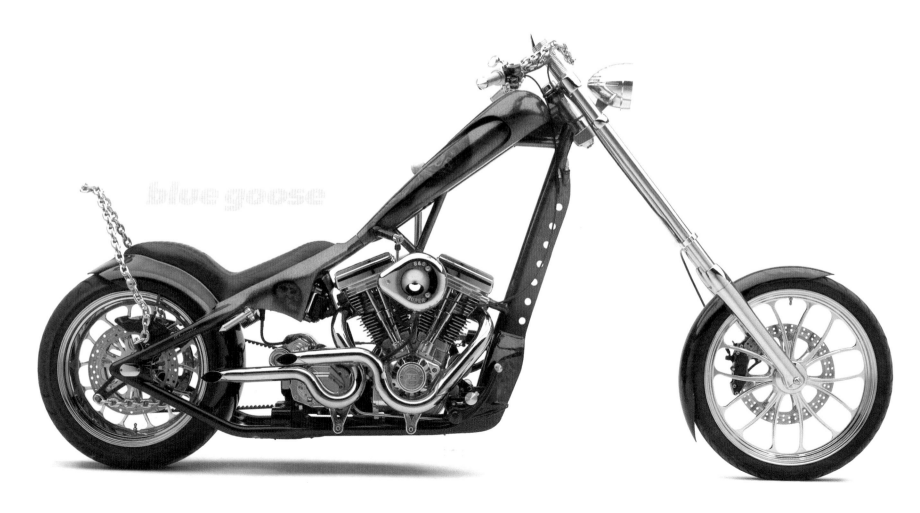

characteristics of Kansas roads allow Big Al to build bikes that are slammed to the ground, because he can ride for hundreds of miles without a tight turn. These roads are straight and *flat* — and fast. He has his share of 100-mph-plus tickets.

Al's personal chopper is dubbed the Blue Goose — too hard-ass to be a swan, but with its long neck, it certainly is avian-looking. The Goose is a one-man bike. "I tried to make the bike hard to ride for an average guy," Gaither says, "because I wanted to have a bike I could fall back in love with." Big Al is six feet, four inches tall with brawn to match his torso. The Goose has a hair-trigger hydraulic foot clutch with a jockey shifter that a smaller rider would be hard-pressed to reach. He'd be stretched out tighter than a banjo string just trying to hang on, assuming he could get it out of gear. Its rigid frame embraces a polished 113-inch motor with racing heads, big valves, high compression, and a hot cam, and it stores oil in the downtube instead of a conventional, and visible, oil tank. Those and many more bells and whistles are lovingly enumerated by Big Al Gaither at the drop of a head gasket.

A love affair with a chopper may be hard to grasp for anyone who hasn't tried to build one. When Al was a teenager, he succumbed to the lure of a material object he wanted so badly he would sacrifice anything else a boy might want to have it. He knew he couldn't afford to buy a motorcycle or expect such a munificent present from his parents, so he set out to make one, learning his skills as he went along. With no budget to speak of, he scrounged for used parts. When he needed brakes, he salvaged an old Hurst Airheart from a go-cart, anything to make it go, or stop. Such a bike could break your heart if it broke down on the road. But your intimate knowledge of every nut and bolt, every weld, every wire, every gear, and its circulatory system of oil and gasoline, of every gulp of air sucked into the carburetor lets you rise to the occasion by using your hard-won dexterity to make it go again. The trials and tribulations of building his own chopper and riding the hell out of it will surely establish a bond between a young man and his machine. "Don't fucking touch it! This is my bike," was the way Al Gaither felt about it.

Real heartbreak occurs when somebody else covets what you've created and offers cash to take it away. You realize you need the money and that you can build something new — even better — with the profit. You have no choice but to sell. In that way, bike projects accumulated one by one for Al until they suddenly snowballed. Now, every time he builds a chopper,

somebody offers to buy it. But the Blue Goose, born of his own blood, sweat, and tears, he plans to keep.

Al shies away from riding big cruisers, or "geezer glides" as he calls them. He avoids any combination of "the three Bs": bags, boards, and bug screens. He enjoys blowing off steam, though, by squirreling through the mud on, well, a "mud bike." Although the cost of competing at the track on a regular basis is prohibitive, he loves drag racing, too. He was gearing up at one time to build a true "pro-mod" bike, a ridiculously fast sled for the drag strip, but that project is on the back burner now. For the time being, he runs a small-bore, low-ten-seconds Harley while "squeezing a lot of nitrous." He street races. "I'll take it out and fuck with the Jap bikes," he says, "just to have fun." Those Hayabusas and their ilk are wicked fast. But Big Al, his girth also a factor, can still take out inexperienced riders on the basis of his racing skills alone, speed notwithstanding. "Most of them don't have the nuts to run their bikes at full potential anyway," says Al.

Big Al acquired his comprehensive knowledge of motorcycles by taking as many different kinds of jobs within the industry as he could while coming up. He learned about every aspect of motorcycle design and construction, to avoid, as he puts it, "having the wool pulled over my eyes." By the time he opened his first professional shop, he could look malingering employees in the eye and measure their excuses with his own "bullshit meter." He knew exactly how long it would take and which procedure was appropriate to execute any given task and could diagnose a problem caused by the use of poor materials versus the poor manner in which good materials were applied. "You're not a builder unless you can build a whole bike," Big Al asserts. He can do it all himself. But "glory is glory," he says. "I give my guys one hundred percent props."

Gaither's customers come primarily from right in his backyard, within the Wichita area, and from all walks of life. Al does not make presumptions about the people who buy his bikes based on stereotypes. "We live out here in farmland, you know. A guy could walk in with bib overalls smelling like pig shit. You're wondering why waste time on this character; he ain't got no money. And you're dead wrong!" Not only populated by prosperous farmers, Wichita is also a locus for the high-tech aviation industry, a fact that provides a serendipitous fringe benefit for Gaither. "I'll show you the Dumpster where I find most of the sheet metal I use to make these *magnificent* motorcycles," he says, making fun of himself. He really does visit a local dump site for some of the high-quality raw material sheared off and left over by the local aircraft manufacturers. "Nice stuff," Al says with a grin.

"Hotrod culture — cars, bikes, tattoos — everybody thinks California. Wrong answer!" insists the big man. Al believes there is a general misunderstanding about the historical role of Midwestern builders. "There was a lot of stuff that got built here when I was growing up that influenced me." Al concedes that perhaps a number of Midwestern builders moved out to California. Still, not enough credit is given for the tremendous output of original work done in the Heartland. That is reason enough for Al Gaither to remain happy in his own space, dead center in a vast continent contributing to Midwestern culture. "Besides," he says, "I don't need to go to any highfalutin place, because I'd get into a lot of trouble there."

Faster than a speeding ticket; more powerful than a billet crankcase; able to leap tall women with a single bound! It's Jerry Graves, the motorcycle maven of Boynton Beach, Florida. An imposing man, tall and tattooed, with a polished pate, he makes a striking first impression, just like the choppers he creates.

A chopper is a machine that pushes the characteristics of a motorcycle to the limits of style and performance, but when you consider the work of Jerry Graves, there *are* no limits. Well, there's only one criterion that can keep a bike from being a chopper, according to this prince of pulchritude on two wheels: saddlebags. Otherwise, the ideal chopper exists, he says, "in each individual's own mind." Jerry's mind is off somewhere the rest of us haven't been yet.

"I've got building motorcycles on my mind *all* the time," says Graves. "Generally it's the last thought on my mind before I go to bed and the first thing I think of in the morning. If I get up in the middle of the night to pee, a lot of times I wake up with sketches of what I couldn't get out of my head on the mirror the next morning." Presumably, he's not using his own lipstick.

When Graves envisions a new project, he tends to think about taffy; yes, the sticky, chewy stuff that can yank out your fillings. Only he pictures it between his fingers instead of his teeth. "As you pull the taffy," he says. "it's going to get fatter where you're holding it, skinnier as it's coming apart, and then fatter toward the tail end." Of course, sheet metal doesn't work that way on this planet, but by stretching his imagination, he can make bikes that look as if they were fabricated in outer space.

Most builders speak about the "fluid lines" of their bikes. With Graves, we're talking about Brobdingnagian bends and more curves than Betty Boop in a corset. Carburetor intakes jut out like the trumpet section of the New York Philharmonic. These bikes look all wound up and ready to explode with speed. Imagine Wile E. Coyote on a motorcycle chasing Road Runner. That would be a Jerry Graves bike. He tries to make them look "as cartoonish as possible" — his own words. In fact, Graves's inspirational model is the Rat Fink monster created in the 1960s by Ed "Big Daddy" Roth. R.F. is a splendidly filthy, guilty-looking little caricature who drives preposterous street rods with two-story-tall motors erupting from beneath their hoods and shifters that look like the trajectory of a Nike missile launch. And he's hanging on for dear life. That's what you would look like, too, on board a Jerry Graves rocket. But for all the flash and gizmos protruding hither and yon, he keeps loose ends tucked away. Incidental wires, lines, cables, and tubes need not muck up the interstices between major components if

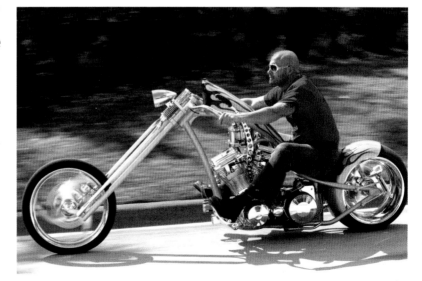

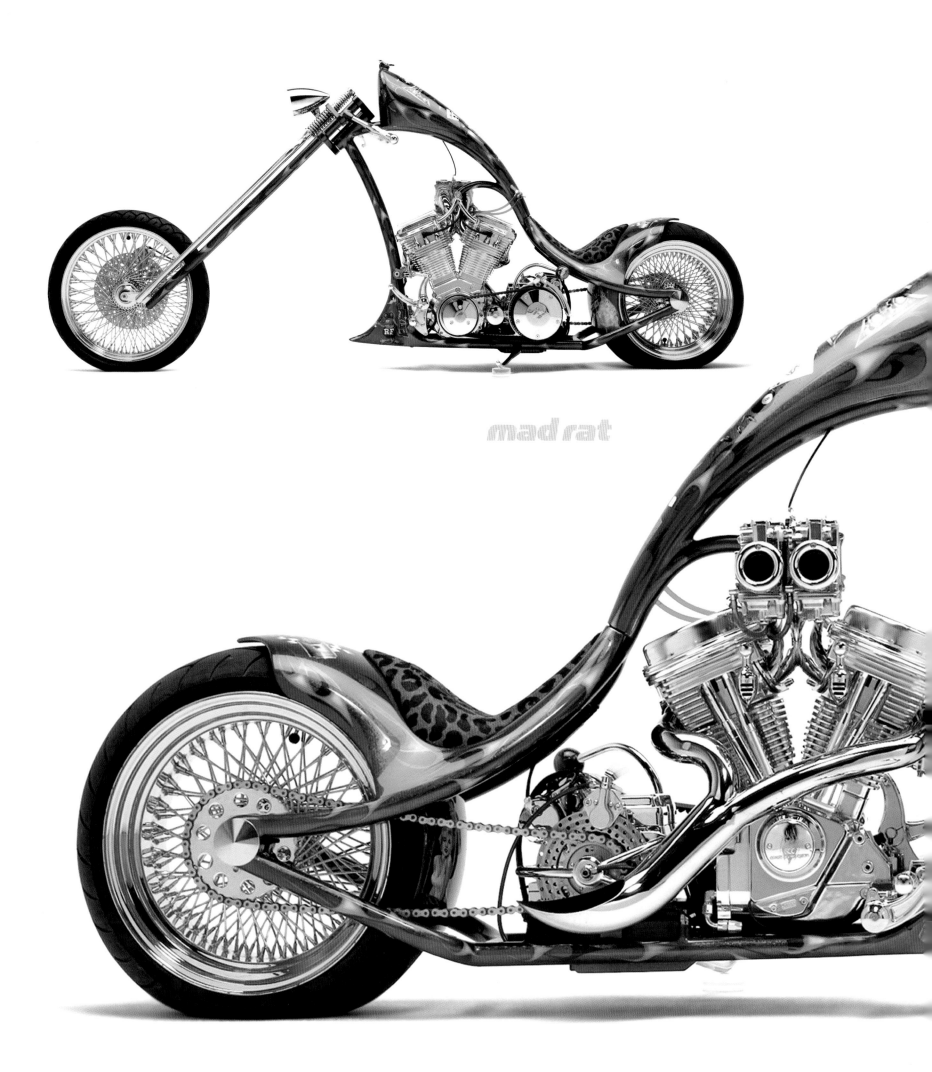

mad rat

their purpose is not to induce shock and awe. What doesn't make it go need not show. And in spite of all the hooptie, Graves tries to make his bikes as rideable and safe as ten-and-a-half-foot-long motorcycles can be.

Graves produces no more than fifteen to twenty bikes each year. He does all of the fabrication and assembly in a small, inconspicuous shop with the help of just one man, John Whaley. "Two guys can get a lot done working eighteen hours a day, seven days a week," deadpans Jerry. He qualifies his statement by admitting that only six bikes per year may go through the taffy puller of his mind's eye to become "show bikes." The remainder, only slightly less nuts but of no lesser quality, represent state-of-the-art choppers constructed for practical riding on a daily basis. Jerry claims any one of them will put trophies on the mantelpiece for its owner. These are the bikes that bring home the bacon. The nuttier ones are just bait. They attract publicity that, in turn, attracts new and often wealthy customers like moths to a flame. Since Graves spends no money on advertising, he relies instead on kudos from the enthusiast press and word of mouth for new commissions. Graves shares some of the kudos with his in-house painter, Seth Paton, and freelancers Bones and Sonny

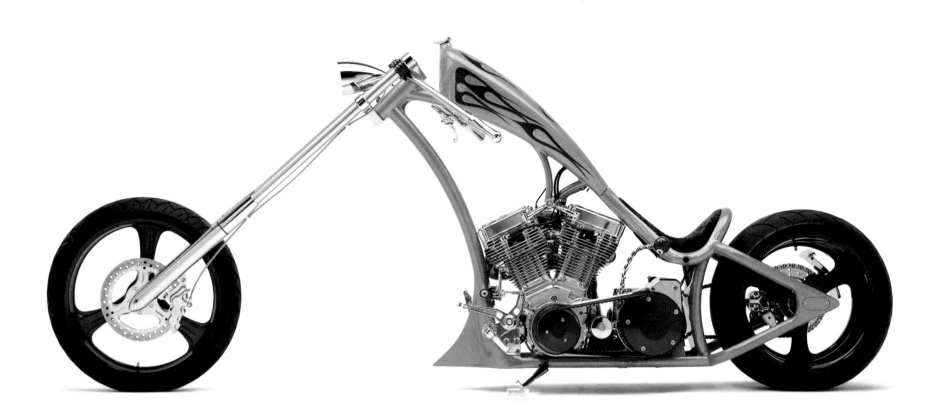

DePalma, who do the airbrushed graphics. Saddles are contracted to Jeffrey Phipps. Referring to his over-the-top chops, Graves says, "Those bikes bring me the business. The simpler ones *keep* me in business." A loyal base of customers is the force continually pushing Graves further as an artist. They also become his best friends, or vice versa. It's a chicken-or-egg thing. Either way, Jerry believes, "it's much more important to my customers than it is to me that I win the shows."

Each of Graves's show bikes utilizes a scratch-built, hardtail frame that can never be exactly duplicated because he bends the tubing over hand-wrought wooden jigs. "You use a wood form one time, it's not going to give you the same bend if you try to use it again," he explains.

Until just a few years ago, Graves didn't know what a ring roller was — a device that facilitates sweeping curves with thick steel tubing. "Since I was a kid," Jerry says, "when I wanted a big curve, I bought an eight-foot-long two-by-twelve from Home Depot, cut it at the radius I wanted, heated my tube, and bent it over." Today he figures he can buy an awful lot of two-by-twelves for the price of a $9,000 ring roller.

Graves favors hardtails over softails. After all, the whole idea of a softail is to make it look like a hardtail. The biggest chal-

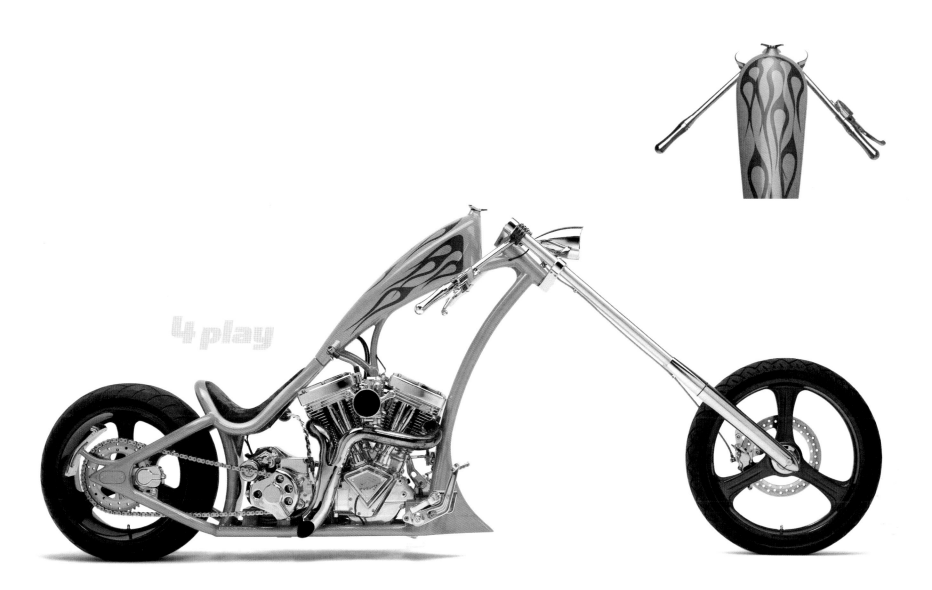

lenge for anyone building softail choppers is hiding the suspension. "Aesthetically, it's never going to be as pretty," Jerry opines. "In order to get a softail looking good," he says, "you have to have it so low that you've virtually taken all the suspension out of it anyhow." As for riding comfort on a hardtail, he claims, "With the safety beads on the rims these days, you can get the tire pressure down around fifteen pounds in the back. That'll give you all the suspension you need." He would rather be comfortable for, say, four thousand miles and let the rubber run out than beat up his kidneys for ten thousand miles between tire changes. Besides, today's alloy frames will flex a little bit, approximating an illusion of suspension for some riders.

Jerry Graves has even reinvented the wheel. When he couldn't find a motorcycle hoop tall and wide enough to fit the then newly introduced 300-millimeter tire, he mated a cycle hub to a large automotive rim. He spent two extra months cutting one hundred twenty individual spokes in four different lengths and then lacing them up one by one in a "cross-nine" pattern, whereby each spoke is laid across nine others instead of the usual two. Since nobody at that time manufactured a truing stand wide enough to spin a gargantuan eleven-inch-wide rim, to make sure the wheel was perfectly round and balanced, Graves had to make that, too. Finally, the entire assembly was plated with twenty-four-karat gold!

The inevitable heartbreak of every custom builder is the "got-bought" bike. It's supposed to be a keeper, the one with all the bells and whistles he makes for himself. As it happened recently, a patron dropped by the shop while Jerry was just three weeks into fabrication for his personal pièce de résistance. The inevitable question arose: "Whose is it?" Jerry replied, "It's mine." And the customer said, "No, it's not yours. Who do I make the check out to?" What's a builder to do if he has bills to pay? Jerry believes that episode represents one of the simple joys of the very rich. They get to buy *his* bike. They get to buy bragging rights.

As recently as 2003, Graves was still struggling to get his radical designs seen by the public. "As a virtual unknown," he explains, "I got stuck building whatever I could, while allowing customers to hold my hand through the build." They held on so tightly that it revoked any artistic license he might have been free to exercise. But everything changed after he won the Rat's Hole show in Daytona Beach that year. "All the questions stopped," said Graves, "and nobody asked anymore, 'Does the kid have chops?'"

Born in 1971, in Frankfort, Indiana, Jerry Graves is a corn-fed boy from Middle America. However, citing his parents' early divorce, he muses, "My mom wasn't really around; I was pretty much raised by a biker." His sister went away to live in Detroit with their mother. Dad was a "hotrod hippie," a hale-and-hearty participant in the drag-racing subculture of the '50s and '60s who has worked — still does — as a manufacturing lab technician at the same company for thirty-five years. A lot of rubber rubbed off on Jerry, along with smoke and the smell of high-octane fuel, as he grew up in the '70s. These days, he races bikes himself. You'll find him staging at the local drag strip on most weekends, professional obligations notwithstanding. Several times each year, he participates in national drag-racing events. Incidentally, Graves runs a Kawasaki motor in his drag bike, because the only way he could get a Harley motor to approach speeds over 180 mph in the quarter-mile would be to drop it from the top of the

Empire State Building. Well, admittedly, he could spend more than $100,000 on engineering improvements instead. Nevertheless, it is obvious that speed is more important than style at the racetrack.

Graves says there's a real rivalry between guys who do the quarter-mile in cars and those who do it on bikes. Car guys hate to race him because he's so much lighter and faster — and they think he's a psychopath anyway for doing triple digits on two wheels. Graves thinks the car

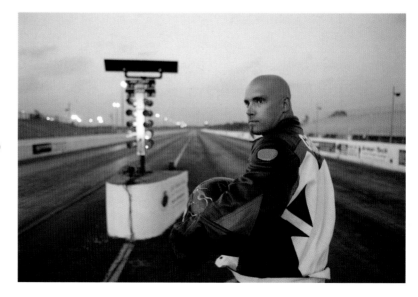

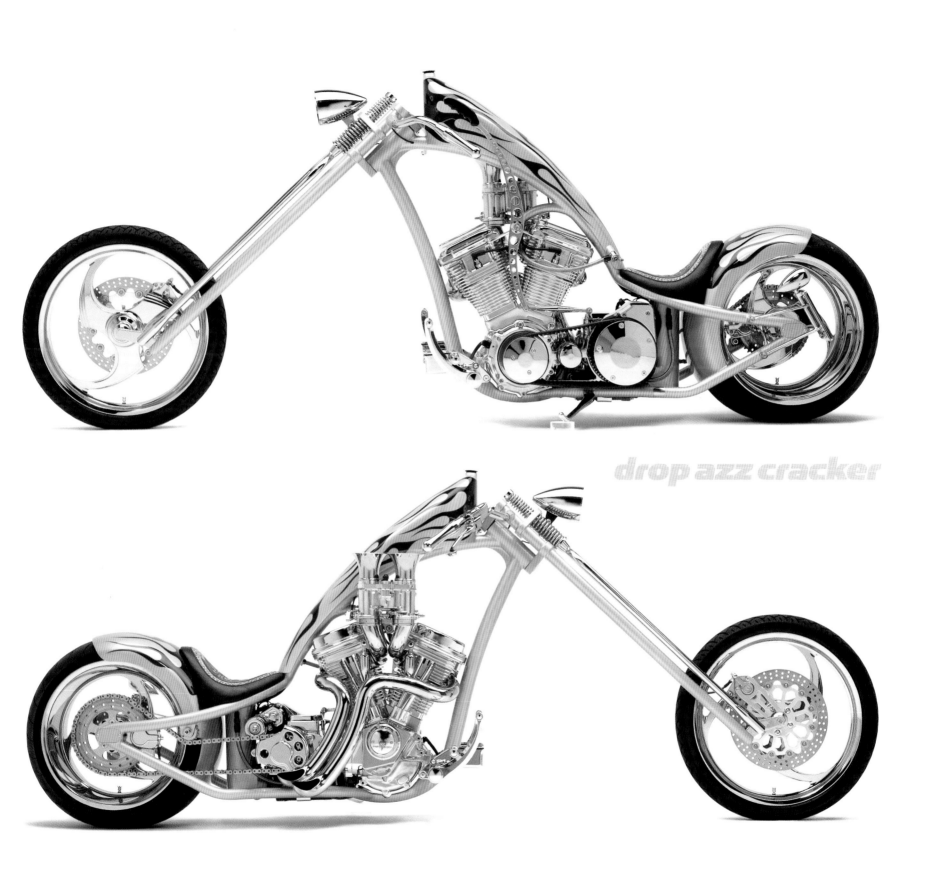

drop azz cracker

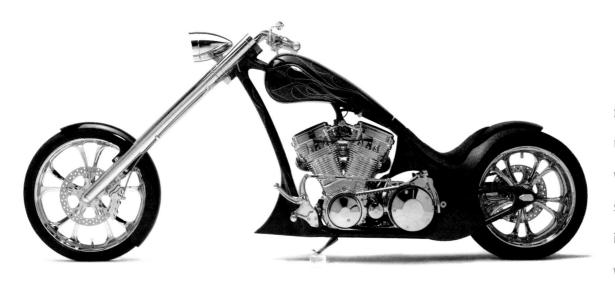

guys are "pussies" because they race inside a cage. At 180 mph in well under eight seconds while straddling a 300-horsepower motor in a 400-pound chassis with a wheelie bar, the car guys have won the debate, if not the checkered flag.

Jerry was enthralled with motors as a boy. But his hands-on enthusiasm for building them, if not his expertise, has waned over the years. Once he knew how to do it, he thought there wasn't much to it. He acknowledges with great respect that some of his colleagues — Indian Larry and Kendall Johnson come to mind — have wrung astounding gobs of horsepower and torque out of V-twin motors. For Graves, however, calculating head-flow quotients and measuring minute distances from piston skirts to cylinder walls became too cut-and-dry; there was no spontaneity. Exterior cosmetic flourishes aside, building motors is more like painting by numbers than art. He would rather let someone else play with the pistons. He'll stick to shaping sheet metal, because no rules apply.

As a youngster, Jerry could only see fancy motorcycles in magazines. There was nothing local to look at in Frankfort and, later, Lafayette, Indiana. Years after, on his first pilgrimage to Florida during Bike Week in Daytona Beach, he caught a glimpse of a

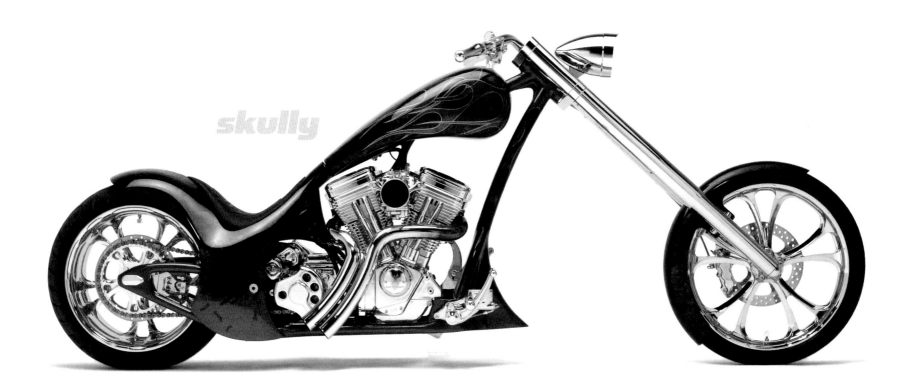

"real live chopper — and the dirtbag that was riding it," he adds goodheartedly. At the time, he thought it was a pretty cool sight. "Those were the guys thumbing their noses at 'the man,' " he reflects. "It's bizarre that it's become so accepted. It really is."

While still a teenager, Jerry was invited to become a "prospect" for a hardcore bike club back home in Indiana. However, one weekend at their "retreat," these reprobates threatened to take Jerry's bike away — one he had chopped himself — because he had complained about empty beer cans being thrown at other prospects for not providing refills fast enough. He managed to leave under power and in one piece. "Up until that weekend, I really did look up to those guys," Jerry remembers. Besides, a few earlier visits to the clubhouse had already begun to arouse his suspicion that he was being groomed to become their "little fabri-cator slave." So he took a pass and has had no interest in clubs since then. In fact, Jerry is so averse to the image of the "outlaw biker" that he will not even wear a leather jacket. If the riding weather is cold, thermal underwear will do the trick.

The first bike Graves cut up was a late-'70s-vintage Ironhead Sportster, which he bought used for $4,000 in 1987 when he was sixteen years old. His dad signed for the loan when Jerry came up with the down payment. Jerry stretched the swing arm, lowered it, changed out the tank, and fabricated an oil bag from scratch. He rode it for one year back in Indiana and then sold it for only $1,500 with all the mods included. Two years later, while Jerry was away at college, his dad bought the chopper back from the same guy, again for $1,500. But Dad kept it for himself this time. He sold the same bike a year later, this time for $7,000. It was early in 1992, and the market for Harley-Davidsons, especially customized ones, had just heated up.

Around that time, Graves was working as a welder for a truck-trailer manufacturing company in Lafayette. They paid for his two-year college tuition and promoted him to a managerial position. In his spare time, he continued to work on bikes. He had already built his first ground-up custom by age eighteen. That first trip to Florida came during a vacation break while Graves was in his early twenties. When he returned home to an ice storm in March, he decided that was it. Done with bone-chilling cold, he returned to Florida for good. He found a job in West Palm Beach managing a plastics-manufacturing firm. But he was back in his garage chopping bikes again in his spare time and soon buying parts from Eddie Trotta at Thunder Cycle in Fort Lauderdale. When Eddie saw the work Jerry was doing, he offered him a job. Graves honed his talents at Eddie's skunk works. He also learned how to run a motorcycle business.

After a while at Thunder Cycle, despite good pay, Jerry felt he wasn't receiving enough credit for the work he did. Since he wasn't offered an opportunity to take a bow, he bowed out instead. It was 1999, and Graves began his solo career. He opened his shop in Boynton Beach in 2003.

Graves got married at twenty-seven. "I was a bit of a womanizer before I met my wife," he admits. "I caught a lot of flak for that. But not a lot has changed!" Five years later, Jerry thought it was better to break her heart quickly rather than slowly over the course of thirty or forty years. "If it didn't end badly, it would never end," he says with a sigh. He and his ex, Nina, remain cordial. In fact, she handles the administrative work for Jerry's shop. They have a son named Michaele.

Since the divorce, Graves has become reclusive, spending as many of those eighteen-hour days in his shop as he can. He sleeps just one flight of stairs above the machinery, with only a piano, a trap drum set, and a TV for entertainment. Of course, clients and friends — once again interchangeable — come by to visit. They're even successful once in a while in tearing him away from work to go for a ride. Anonymous admirers are always stopping by to pay their respects or just gawk. But Graves still finds time to spend with his son and, without shortchanging that cherished responsibility, to squire a voluptuous vixen occasionally between the drag strip, the strip mall, and the strip club.

There aren't too many great places to ride in the flat state of Florida. Graves enjoys the South Dakota Badlands he discovered during his first Sturgis experience. There's also a stretch of road he enjoys in Indiana from West Lafayette to Rosemont, with lots of curves and gorgeous scenery, where he's never seen a cop. Graves, who rides fast, says that when you're "railing" curves on a long bike, you've got to have a lot of faith in your tires, the engineering you've put into your bike, and "big marbles." When he lived in Indiana, there were days when he'd head out on the highway and ride from daylight until dark, then find a place to sleep. He'd wake up and do it again. "In Florida, though," Graves says, "you're not going to ride more than fifteen or twenty minutes before you get a close call with a grandma in a Caprice. Makes you want to pull over and have a drink!"

Since the advent of the idea of choppers as art, people look differently at Jerry Graves. He enjoys some additional respect now. Instead of being looked upon as a local grease monkey, people now recognize him as an artist of fine repute — if not still the kind of guy who occasionally wakes up after a short lull between long nights feeling as if his tongue needs a shave. What other denizens of the neighborhood set out on routine jaunts to the local gentlemen's club with fists full of dollar bills to hurl at the dancers? The owners have probably nailed a brass plaque with Jerry's name on it to one of the booths by now. Hell, if he runs out of gasoline to prime a carburetor, he just might pour in a little tequila if there's some sitting around the shop. *If?*

It is not an expression of Gard Hollinger's philosophy to mix drinking and driving, although some wits, dim or otherwise, think riding a motorcycle is too perilous to consider doing while sober. Nevertheless, his is a motorcycle shop where Petite Syrah is more likely to be poured than Pabst Blue Ribbon, and you just may hear an employee quoting Proust or whistling Paganini. This is an erudite bunch.

Hollinger acknowledges that to the average enthusiast, the word *chopper* means a motorcycle with a rigid frame, a high tank, and a long fork. In the '60s and '70s, that is, of course, what most custom bikes looked like, especially in Southern California, where they attracted the most media attention and spawned a rash of wanton biker movies. Consequently, the widespread notion of what a chopper looks like is Hollywood's perpetuation of what was, essentially, a local fashion statement made decades ago. It got stuck in people's minds. Since then, however, progressive designers have continued to transform the look of motorcycles from coast to coast and across the seas and have come up with more liberal interpretations of what "chopping" a motorcycle actually means. High-neck, stretched bikes are popular again today, after a long hiatus, but they are now considered traditional, or even nostalgic. More to the point, they represent just one of many new species in the phylum of choppers, which has evolved to include a multitude of new examples pioneered by forward-looking — and retrogressive — practitioners of the art.

Gard Hollinger belongs to that exclusive clan of avant-garde practitioners. He has coined the term *retro-modernistic* to describe his role. Just as present-day musicians sample earlier recordings and embed snippets within contemporary compositions, Hollinger pays homage to older motorcycles by applying classical accents to radically engineered machines and using familiar parts in unfamiliar ways to emphasize their unconventional relationships with the rest of the bike. For instance, he will mount an automotive oil filter where you might expect to see a carburetor or fit a gas tank that looks like a lunch pail between a top tube and a motor mount. He has also improvised the use of bicycle shock absorbers on a girderlike fork. On top of all that, literally, Hollinger enjoys the effect of blending textures. The surfaces of one bike, Il Pazzo, are powder-coated, anodized, and shot-blasted. No liquid paint was used.

Long before choppers, motorcycles looked like bicycles with small engines. When riders began racing them, they became more aggressive-looking. Hollinger's bikes evoke the board-track racers of yore — on steroids. They're the motorcycle equivalent of comic-book caricatures,

superheroes with square jaws and pumped-up brawn. The front end of Il Pazzo, while inspired by the leaf-spring suspension of an august Indian, projects an undoubtedly contemporary quintessence. There is no doubt that Hollinger's are modern machines, despite the fact that he takes his cues from an earlier era.

Gard Hollinger won't quibble that business is a priority, but for as long as he can remember, there has been a grease monkey on his back. When it became clear that motorcycles had become more than his means to earn a living, he became more than a mere mechanic. He had indeed become an artist.

While the look of a motorcycle is of preeminent importance to anyone with a highfalutin' bent, Hollinger does not neglect high performance. Nevertheless, his goal is not to engineer machines agile enough to take on crotch rockets through twisty

canyons; his bikes are made to turn heads, not corners. The winner of a beauty pageant is seldom any competition for the gold medalist in a 400-meter foot race, but sometimes it is more fun to be seen with Miss America in a string bikini than some stringy chick in track shorts.

An art bike must still be roadworthy and reliable. "When you ride it, I want you to get a thrill," says Hollinger. "I don't want it to just be scary." He concedes that a custom-built chopper is never going to be as dependable as a production-line Harley-Davidson Twin-Cam cruiser. But with his tongue poked firmly in his cheek, Hollinger comes clean: "Guys like me who build bikes . . . they're breaking all the time. The worst thing you could do is go on a ride with five or six other bike builders, because you're all going to spend most of the time fixing each other's crap."

What gets Gard Hollinger's motor running is the challenge of coming up with something new and different without wavering from his core vision — the "nucleus," as he calls it. Ideas for bikes come rapid-fire and at odd times. "I have a tremendous amount of noise in my head, and I don't sleep soundly. My mind is always cookin' and burnin'. The trick," he says, "is to weed through all these ideas and keep only the ones I think I can apply and then see what I'm after."

Like a patient on an operating table surrounded by surgeons, each new bike project rests on a hydraulic lift, an object of undivided attention for trained and dedicated specialists. However, unlike a doctor, Hollinger reluctantly relies on a "succession of calamities" to occur, try as he might to head off the inevitable snafu. "The only way to get things done," he declares, "is to persevere, to just keep plugging away." In spite of the fact that he has been plugging away for so many years, it seems amusing that the occasional dumb-ass mistake will still turn an expert into a hapless idiot, neglecting something so basic as to insert a *plug* into an oil line before he starts pouring in quart after quart of oil. With his characteristically droll delivery, Hollinger explains,

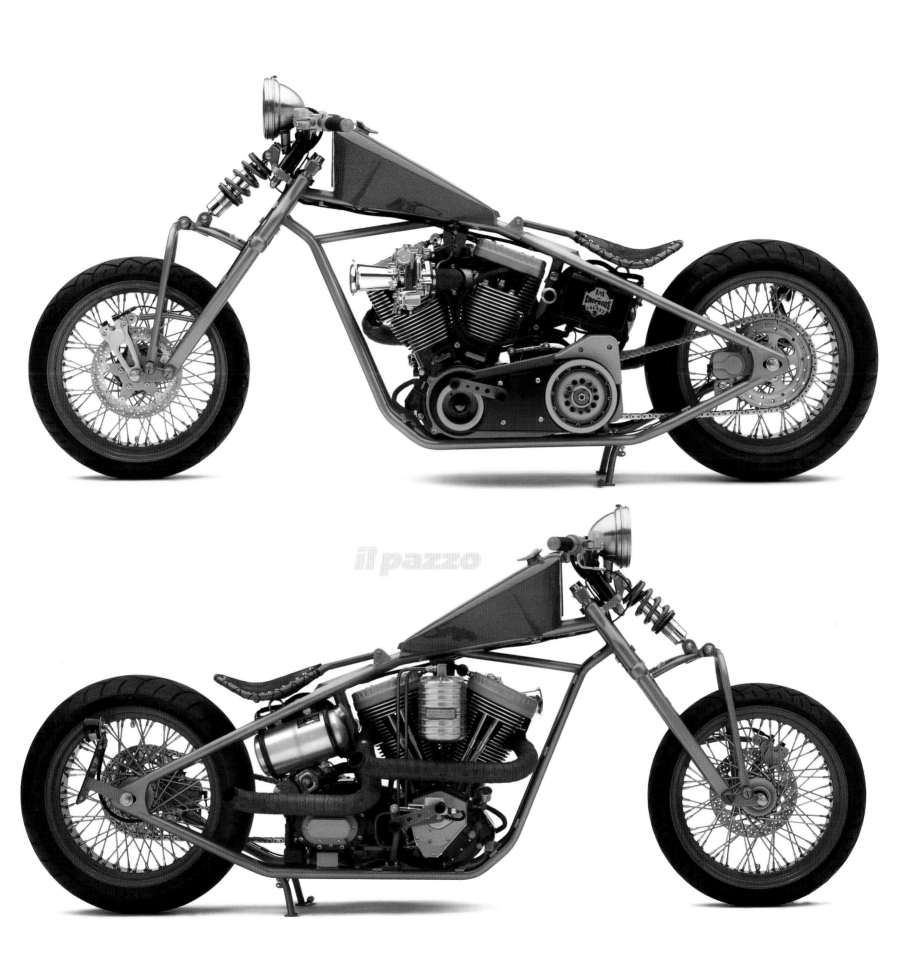

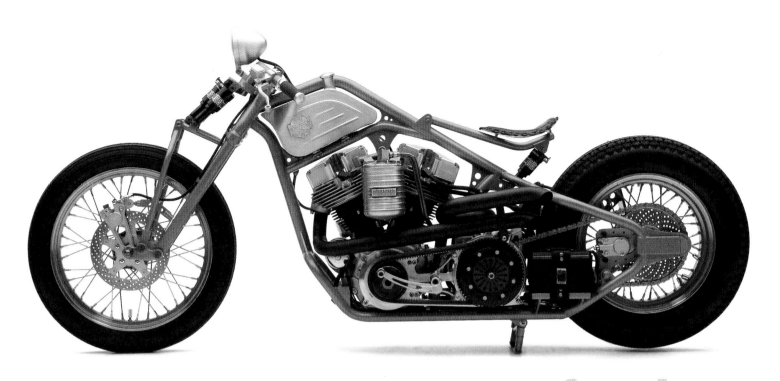

funcula

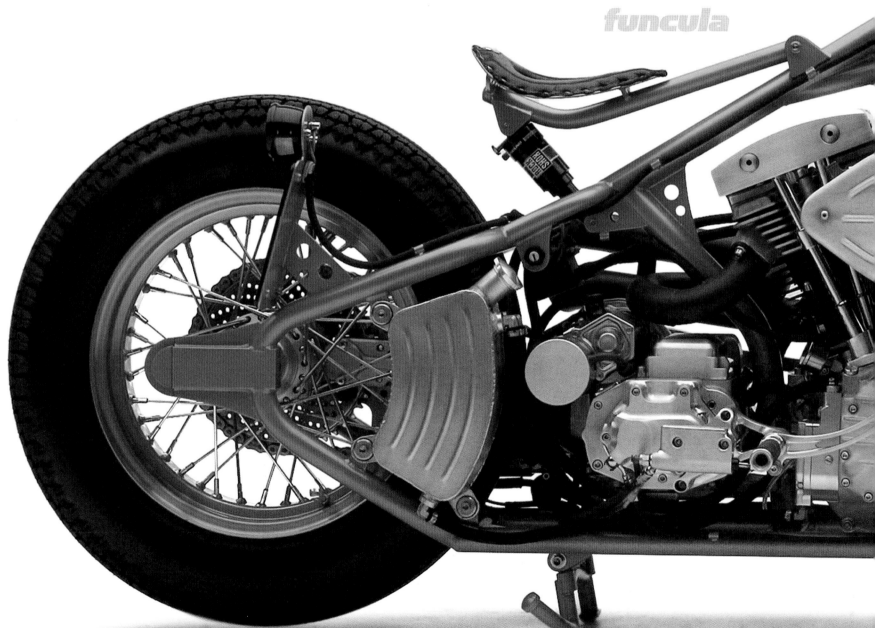

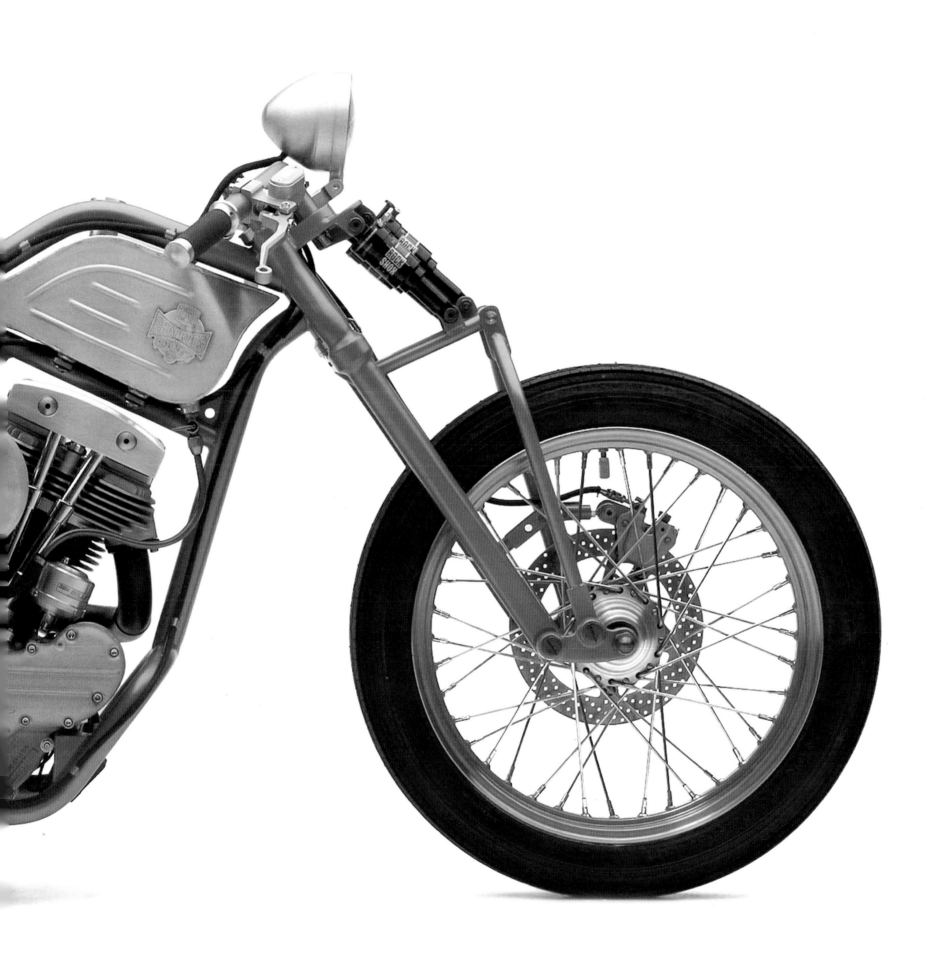

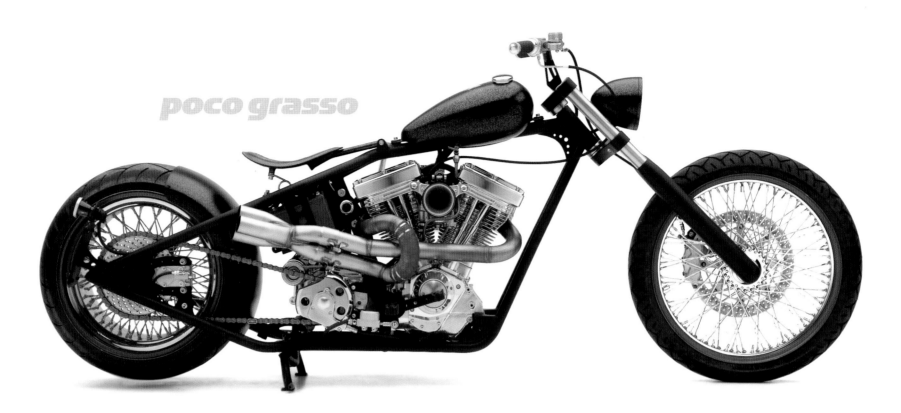

poco grasso

"Your brain doesn't register what's wrong because you're so tired. And you start wondering, why the hell is oil burbling onto my shoe? Oh! I forgot to put the drain plug in."

Hollinger the artist will never create two identical bikes; Hollinger the entrepreneur sees no principled contradiction in creating production-line motorcycles in the *fashion* of a chopper. He has already designed a chopperesque model for one boutique bike manufacturer, Saxon Motorcycles. Still, he respects the difference between a one-off work of art and a product that is mass-produced.

Initially, not too long ago, there was more of a self-serving desire to build choppers than there was a demand in the marketplace to buy them. But once riders outside the insular "Kustom Kulture" got a gander at these things for the first time, and since this particular blip on the radar screen appeared just as riders with a flair for individuality became jaded by Harley-Davidson's massive resurgence in the marketplace, choppers acquired a new class of admirers. The second coming of the golden age had arrived. As for how long the boom will last, Hollinger says, "I hope we're not fourteen minutes into our fifteen minutes of fame."

Hollinger notes that the current chopper craze coincides with the public's interest in reality TV. Certainly, the exposure has been good for the industry, although there is nothing real about it. Hollinger thinks most of what we see is just plain silly. In fact, some builders who have received publicity through the incandescent glare of the boob tube have mixed feelings about their luck.

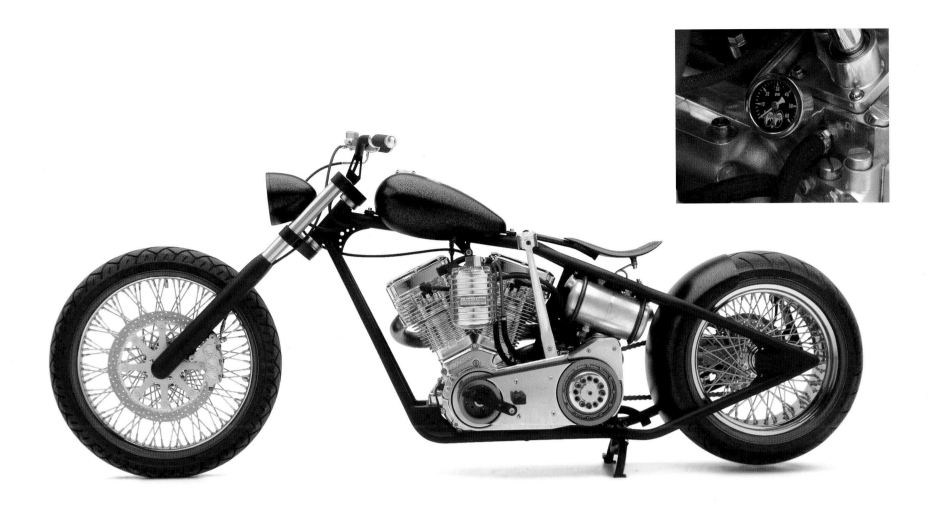

If one hasn't got the chops to back up such exposure with entrepreneurial aptitude and a business plan that explains more than how to use a planishing hammer, it is no longer an opportunity but a diversion. Selling T-shirts and signing autographs don't help grow a business, they just take time away from building bikes. Hollinger, who has himself been a recipient of this kind of televised attention, already feels that his life has become more complicated and that the admonition "Be careful what you wish for" is apropos to having second thoughts.

It is worth mentioning that Hollinger, in addition to his extensive mechanical and business experience, has studied both Method acting and oratory and has even performed Shakespeare. He had agents and toughed it out in Hollywood auditions for years, but even his Johnny Depp good looks did not put a star on his garage door. "It was such a huge crapshoot," he remembers, "that you were lucky to get *anything*." (If you watch very closely, you can see Hollinger in movies such as *Waterworld* and *Heat*. "But don't blink!" he warns.) For someone like him, whose wife also happens to be a network television director, it seemed like a no-brainer when the opportunity arose to host a program called *Build or Bust*. He doesn't make a big deal about it. He is just going with the flow. And if it carries him in the wrong direction, he will bail out. Besides, he says — and as we all lament — "everybody in LA is an actor." A chopper! A chopper! My kingdom for a chopper!

Years after he had given up his quixotic quest for the silver screen, which only temporarily interrupted his motorcycle career, Gard's grown son, Trevorr, told him about a classified ad he'd seen on the Internet. A producer was looking for a "real bike

builder" to cast in an American Express commercial. Needless to say, Gard got the gig. Having all along played the thespian card

close to his chest, he was rewarded to hear the director gush, "Boy! He's better than most professional actors we work with."

Gard was born in 1959 in San Francisco. He has an older brother and an older half-sister. When he was four, his

mother left his father and fled with the kids to Hawaii. Gard's father, who passed away when he was still very young, was

the son of Chinese immigrants, raised in Trinidad. He owned a couple of service stations and was himself a mechanic; Gard

didn't know that until he was older. His mother was a bit of a bohemian, strong and independent, with eccentric ideas, a fol-

lower of the Baha'i faith whose résumé ranged from cigarette girl to office manager. She went to great lengths with little money to make sure her kids lived and went to school in good neighborhoods. They rented an apartment in Beverly Hills when they came back from Hawaii, then spent the better part of a year in the foothills of the Andes in Argentina on a Baha'i pilgrimage but returned for a spell to — of all places — the East LA barrio of Lincoln Heights.

Gard's mother remarried. His stepfather owned a radio station and an advertising agency. Gard took his stepfather's surname. The family moved into the Hollywood Hills, off Mulholland Drive, into a house designed by architect John Lautner. Gard's first experience with motorcycles came around this time, when he was eight years old. He sat on the curb and watched, fascinated, while a teenager did wheelies up and down his block on a Honda Z50. One day, he took the older boy to see a dirt bicycle track that the neighborhood kids had built on a vacant lot. Once there, the older boy let Gard ride his Honda. If he hadn't been hooked then, it happened for sure the next time.

In 1969, at the age of ten, while he was riding in the family convertible on an LA freeway, two choppers blasted by, hair in

the wind. No helmets in those days. The lead bike had a lone rider. The guy behind had a chick on the back. "It was a king-and-

queen setup," Gard remembers. "The guy in front takes his hands off the handlebars, pulls his shirt off, and throws it up in the air.

And the guy behind him reaches up without missing a beat and catches it! I just thought that was the coolest thing I'd ever seen."

It was "Choppers forever!" after that.

Unfortunately, Gard's mom did not take to her second — uh, third — marriage, either. She took Gard and his brother

north to the Puget Sound, where she had bought a house. Gard did not appreciate the switch from big-city life to a rural setting. There weren't many other kids to play with, so he kept to himself most of the time. He did learn to race motocross, though. His first bike was a purple "Taco" (Bultaco) minibike. Gard graduated from high school in the town of Friday Harbor on San Juan Island in Washington. In 1977, it was the largest class to date: forty-eight students. Then came junior college. "I have an associate's degree in automotive technology — whatever the hell that means! — but I knew I never wanted to be a car mechanic." As it happened, he got a job as a *marine* mechanic and service manager, working at the local dock.

In 1980, Hollinger founded a company, since sold, called Devol Engineering in Seattle, which still manufactures accessories for motocross bikes. His next enterprise was a multiline, off-road bike dealership, followed by a limousine company and a wholesale car business, selling vehicles from dealer to dealer.

During a bohemian stage of his own, Hollinger made several trips to Jamaica and seriously contemplated chucking life back in the States to stay in the Caribbean. He settled for growing dreadlocks instead and came home to roost in Seattle. After that, he was known to his friends as Ziggy. The reason was obvious to anyone who had ever seen a picture of dreadhead Rastafarian Ziggy Marley, son of Bob. Gard's wife, Sharon, jokes about his having violated their only prenuptial agreement when he sheared them off. However, Gard denies that the loss of his locks was meant to evade an otherwise inevitable comparison with Marley, but instead with Billy Lane.

In the early 1980s, Hollinger saw an opportunity to take over a struggling Harley-Davidson dealership in Seattle for pennies on the dollar. But in those days, the Motor Company was in bad shape. It would have been a tough proposition. Furthermore, he had just divested his off-road dealership because he was fed up with cheapskate customers and a disagreeable partner who turned his passion for motorcycles, for a while, into a dreary *job*. He reasoned, "What could be worse than a bunch of moochy motocross guys? A bunch of moochy biker guys, which, at the time, is what it was!" So he passed the opportunity along to a friend, Russ Tom, for whom he occasionally performed some fabrication wizardry. The Seattle Harley franchise, which cost Russ only about fifty grand, grew into a business that grosses ten to fifteen million dollars a year.

Although he had a son, Gard had never been married before he met Sharon on a bike trip from Seattle to LA for the aptly named Love Ride of 1993, an annual charity event. He and his cohorts were, well, rather lit in a Malibu bar when Sharon came through the door. Although he had never laid eyes on her before, Gard confidently declared to his buddies, "That's my future wife." He stayed in LA. Their other "child" is Ratso, a fourteen-year-old singing Chihuahua.

Meanwhile, ensconced in So Cal with his bride-to-be, Hollinger responded to a newspaper ad looking for a mechanic. He started working at a shop called Bad Bikes in Culver City. But he was used to being his own boss, so he left and took a couple of employees with him to a seven-hundred-square-foot cubbyhole he rented in an industrial park in the San Fernando Valley. With

retired LAPD motorcycle cop Gary Sidell as his partner, they opened Ziggy Harly — no *e* — Custom Motorcycles in 1997. Within the first month of operation, the walls were bursting with work. The partners rented more and more units in the same complex. Nonetheless, it was very much a hobby shop, run casually and without regular business hours, while Hollinger tangentially pursued his dream of becoming an actor.

Having kicked himself for years about missing that once-in-a-lifetime chance to grab a lucrative Harley-Davidson franchise, he became intrigued by the apparent rebirth of the Indian marque. He resolved to get in on the action, this time through the back door, by taking on a service contract for an established Los Angeles Indian dealer. As Hollinger began to make suggestions about service-related issues to the factory bigwigs, he found them receptive. His relationship with Indian grew, but instead of digging deeper for intelligence about why three LA showrooms had already closed their doors, Hollinger let the factory talk him into becoming the exclusive Indian dealer for all of LA County. He opened for business in Marina del Rey in late 2001 — right across the street from the biggest Harley-Davidson dealer in the area — and closed three years later after Indian's second collapse in the marketplace. He changed the name of the company to LA County Choprods and went on to specialize in both custom and limited-production motorcycle sales.

Gard Hollinger is an oenophile. That does not mean his name should be placed on an Internet watch list. He likes wine. He *really* likes wine. He is a self-professed "cork dork." But he hasn't always liked wine. He had certainly drunk the stuff before. "But I just didn't get it," he says. "I thought it was nasty and vile. Of course, it was probably Mateus or Annie Greensprings." Then someone poured him a glass of the good stuff. He does not remember what it was, but he was bowled over. He tagged along on a motorcycle trip to the Napa Valley with a buddy who knew a wine distributor, and after a round of exclusive tastings, he was hopelessly hooked. Hollinger has since amassed an envious collection of fine wines, but not only to drink — the collection has also financed the remodeling of his home. He still keeps more than one thousand bottles in a private wine locker in an unmarked warehouse designed specifically for storing fine wines.

Incidentally, Gard and Sharon have a dream: to retire and build bikes in a sleepy Italian town. His penchant for things Italian works well for the bike-naming convention he has adopted, too. For instance, so far, we have Il Pazzo, Poco Grasso, Tatsio, and Funcula. He wanted names with a musical ring, like the Hispanic names used by some other builders, but he did not want to copy the trend outright. So what other languages, he wondered, are both mellifluous and sexy in that way? He came up with Italian. Take *Poco Grasso,* which means "Little Fatty." French wouldn't work: *Gras Minuscule.* German is worse: *Kleines Fetthaltiges.* Ukrainian? *Malyj Hrubas.* You get the idea. As for his own name, he says, "I quite like it that Brits and New Yorkers call me *God*."

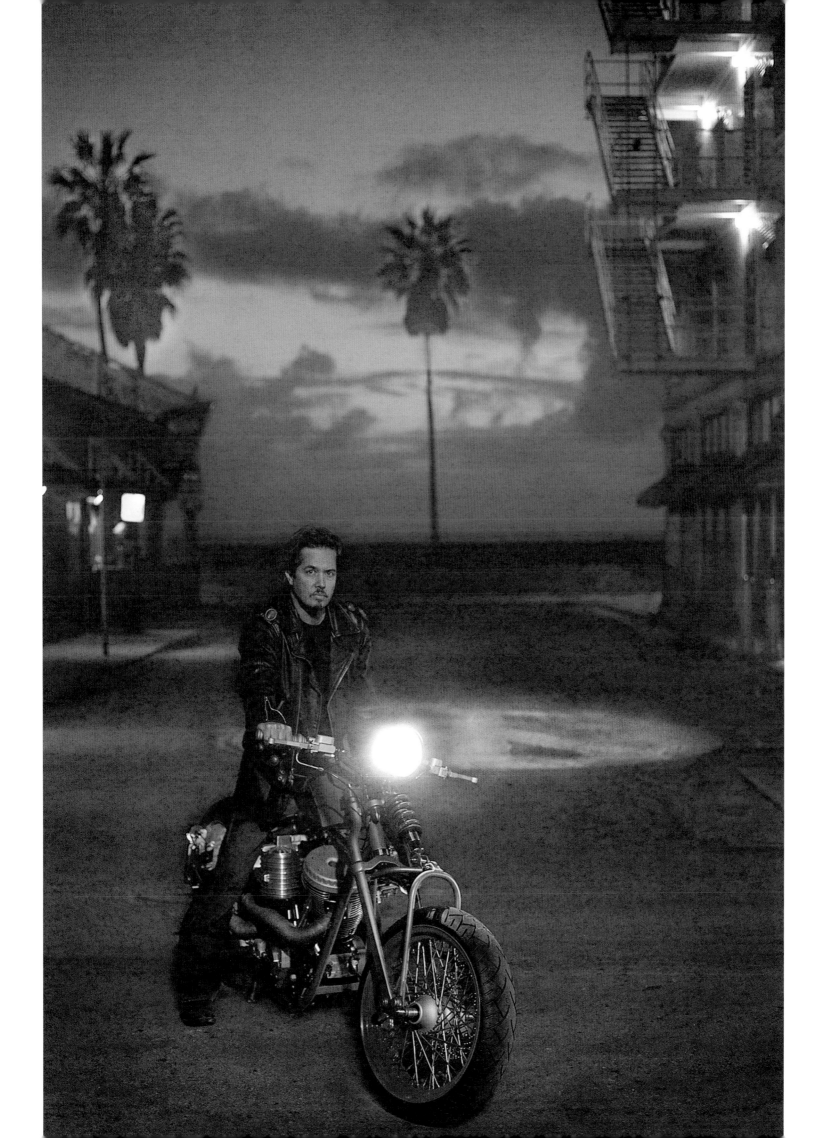

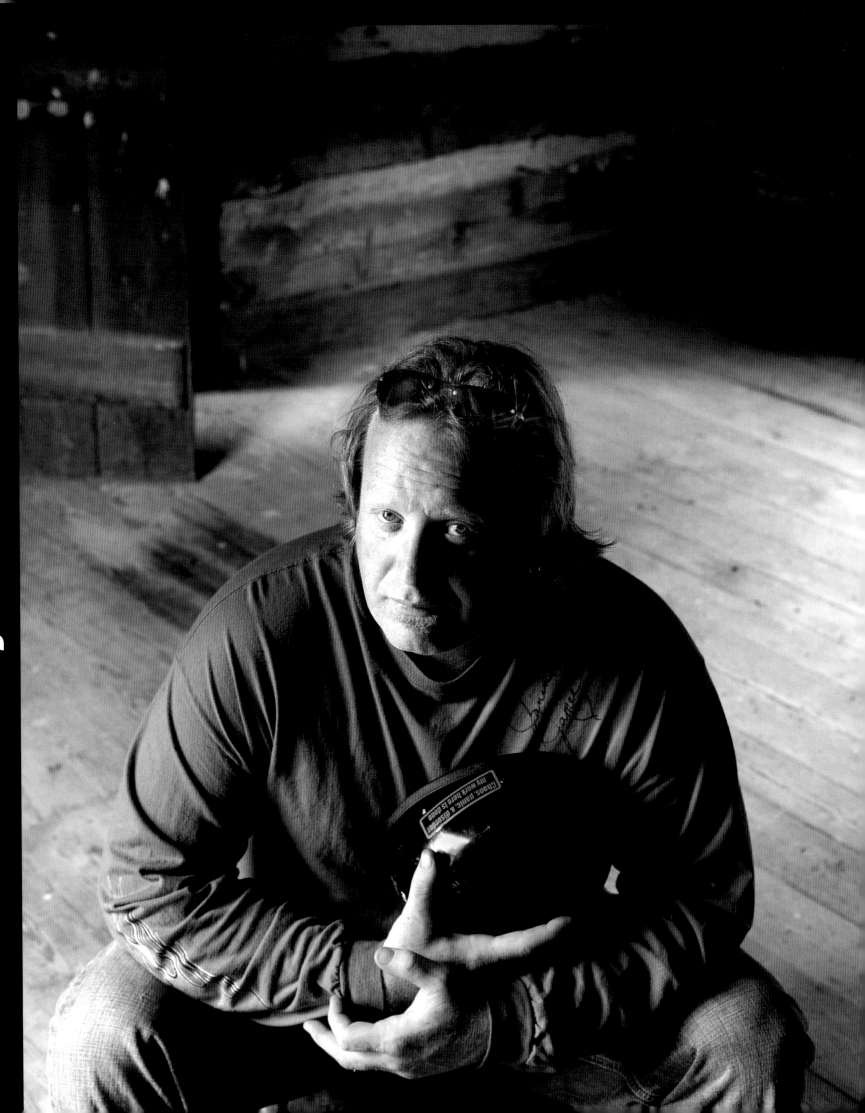

kendall johnson clown prince of horsepower

If you're not speeding, you're impeding. That credo is a driving force in Kendall Johnson's life. He can and will pass everything on the highway except a gas station.

Instinctively exploiting the mellifluous inflection of his voice, Johnson conveys an opinion about his favorite vehicle of self-expression: "I think a lot of guys think a chopper's got to be way up, way out." But he doesn't see it that way himself. "I think anything out of the norm, anything that's got an individual signature on it, I will probably consider that as a chopper." His critical imperative is the stamp of one person's hands on custom-made components that, once assembled in just the right fashion, lend conspicuous distinction to a motorcycle. No matter how many different configurations of parts from a catalog can be jerry-rigged to put Humpty Dumpty together, custom fabrication is the essential nature of a chopper. Sheet-metal molding, "the way we roll the lines and turn stuff," Johnson says, is indicative of his own exceptional signature. But that alone does not account for his contributions to the equation of cool. One seldom sees a Kendall Johnson chopper standing still long enough to contemplate its physical beauty because of the gut-thumping combustion of its preeminent power plant.

The old motorhead adage "There's no replacement for displacement except more displacement" was taken to heart by Kendall as a boy. His engines have always been the biggest and the fastest on the block, with bigger cylinder bores, longer flywheel strokes, and meticulous tuning. He couples his gleaming dynamos to stout frames and wide rear tires complemented by tall, slim ones up front. He doesn't like the look of a fat front wheel at all, not even on a traditional cruiser. Then again, up to a limit, even the big-rear-tire trend has worn thin; to his way of thinking, if the trend continues, kickstands will become sarcastic anachronisms. At one time, Johnson vowed not to mount any tire wider than a 250, but he now believes the 280 has a nicer tread pattern and curve — it handles the road well, too. A tire beyond that size diminishes both form and practicability in his estimation. "Chocolate, vanilla, or strawberry; everybody will pick what their taste is," he concludes.

Profiles, wheels, and talking to the painter are the only three options Johnson allows his patrons. There may be as many as twenty customers altogether in any given year — actually a record number. "That's a lot of one-off parts to fabricate," he says, without complaint. "I used to let my customers be involved in a build," he says, and then punctuates a pensive pause with a staccato "They will drive you absolutely nuts!" He takes no guff anymore — it's either his way

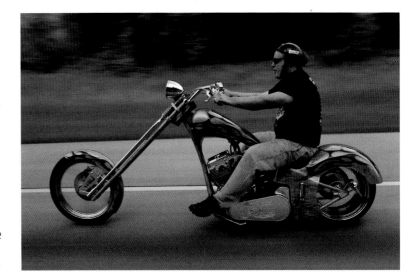

or get out of the way. Johnson now screens new customers for specific character traits he feels will be compatible with both riding and maintaining one of his babies.

A number of Kendall Johnson customers come back year after year. Some ride the rubber off, and some merely collect. Others keep a bike for a while and then flip it for a profit. Johnson doesn't care, as long as his craftsmanship is appreciated. As for his personal influence in the market, he says, "It used to make me mad, but I think it's probably the greatest form of flattery to see how many people have knocked off parts that I've designed." Since his reputation is sustained by one-offs, he doesn't worry about knockoffs anymore. After all, the "clones," as he calls them, are not signature pieces. They are obvious imitations. Such a form of flattery, however, cannot be allowed to affect him adversely in the pocketbook, so he manufactures a commercial line of parts based on his custom designs and lets other builders do with them what they will — at a retail price. While others are literally applying what he has already done, Kendall Johnson is experiencing the "rush," as he describes it, of setting the next trend.

When Kendall dropped out of high school at the age of sixteen, he found work in an automotive machine shop. The owner was reluctant to take on motorcycle repairs, but Kendall had no such compunction and moonlighted the bike jobs himself. That kind of confidence in a young man comes from the experience of having rebuilt his first

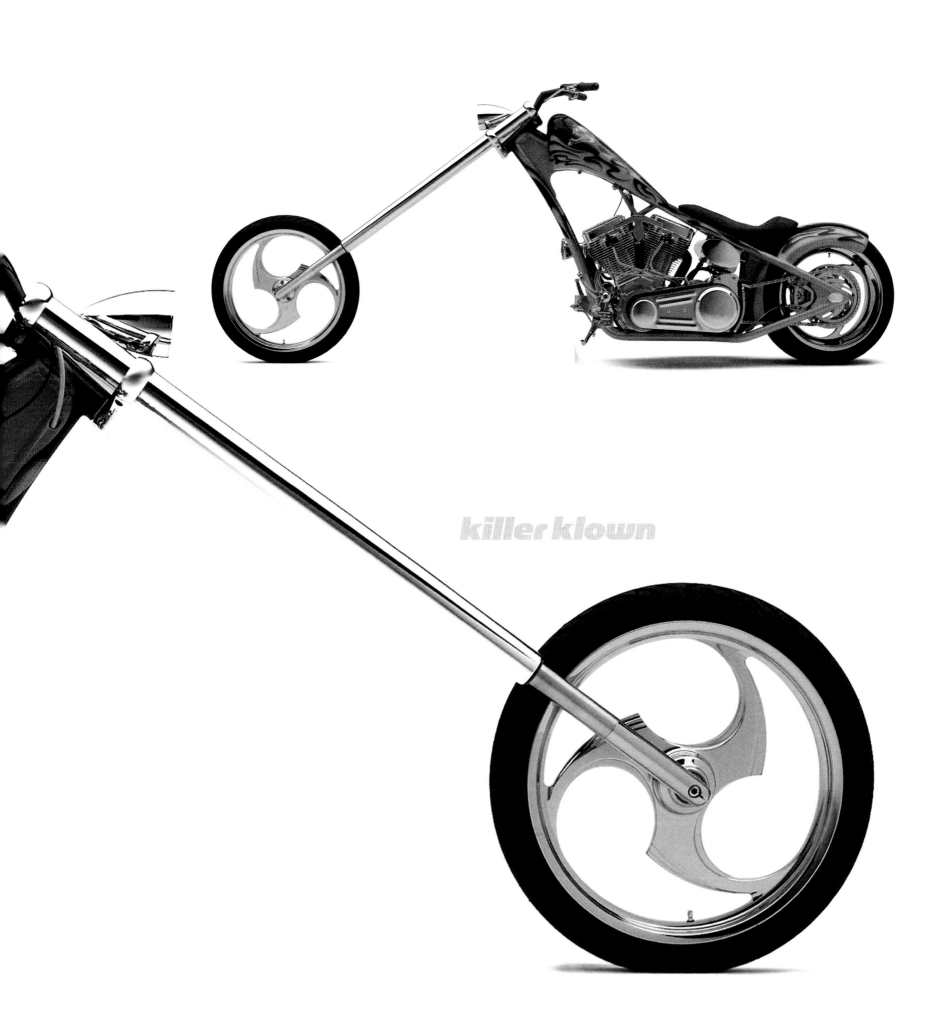

killer klown

engine at the age of nine. It was a little Honda XL 70. No one showed him how to do it. "I just tore it apart," he remembers, "looked at it, saw what it was made of, and went to work." Johnson acknowledges that he was lucky that first time. After all, a lot of curious kids have torn things apart to see what made them tick without being able to put them back together. "It was kind of like a jigsaw puzzle, building the gearbox on it. Once I got it all together and made sure that it shifted, I had the engine running in a couple of days." Eventually, he got his education back in gear, too. Having earned his GED, he enrolled at a community college to acquire the mechanical engineering skills he would need to make machines go fast. But he found he could learn at a faster pace on the shop floor than in the halls of academia, so he left.

Johnson no longer relies on luck, although it does play a role in building a custom chopper. The bad luck comes with the good. Once, having just put the finishing touches on a bike the night before loading it up for the annual Daytona Beach Bike

Week, Johnson was taking it off the lift. "I put it down on the floor," he says, "flipped it up on the kickstand, and was going over everything, fixing to pour the fluids in it." He concludes laconically, "It fell off the stand." The gas tank hit, not yet fastened down, and slid across the floor. Apparently, there was enough protective clear coat on the tank that after resanding and buffing, the paint remained nearly flawless. Either the handlebars or the foot pegs took the brunt of the impact. Another time, he let a customer ride his drag bike the day before heading to Sturgis. It went flying off an embankment and flipped head over heels — *thirty* *times*. It was torn all to pieces. Johnson and his crew beat out all the dents in the sheet metal, painted it overnight, and had it running the next morning. Minutes later, it was loaded on a trailer and rolling toward South Dakota. "I've had a few other little setbacks," Johnson says facetiously. By the way, the fellow who rodeo-ed the bike had jumped off just in the nick of time and saved himself from more than a little setback. As for Johnson, his own laid-back style means a friend is a friend. That guy probably deserved a little overnight pounding himself. But Johnson was just glad he was all right.

For each new bike project, Johnson sets the chassis up on a jig himself and outlines the profile. After that, thirty to forty percent of the work is a hands-on, personal performance. He'll do ninety percent when given a chance. Only two things get in his way: the availability of parts and his personal schedule. It can take months sometimes just to get wheels and brakes, for instance, which are not manufactured in-house. And even though he builds every motor and transmission himself, he still has to wait for castings and gears to arrive from a factory far away. On top of that, every bike builder has to take time out to promote his business. "When I'm being drug up the road to go to all the events and all the shows, I've got to have competent guys there

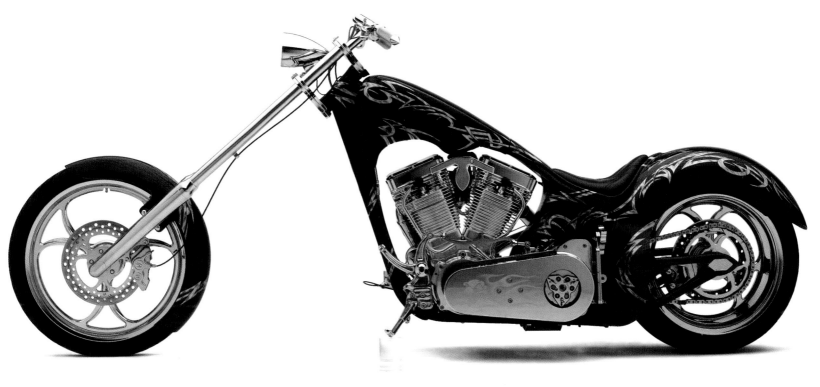

camel II

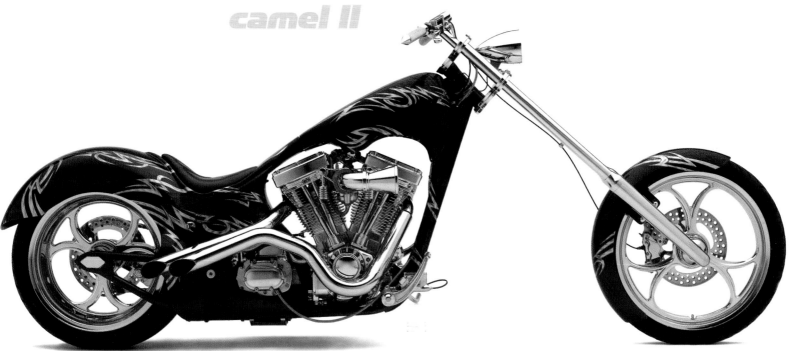

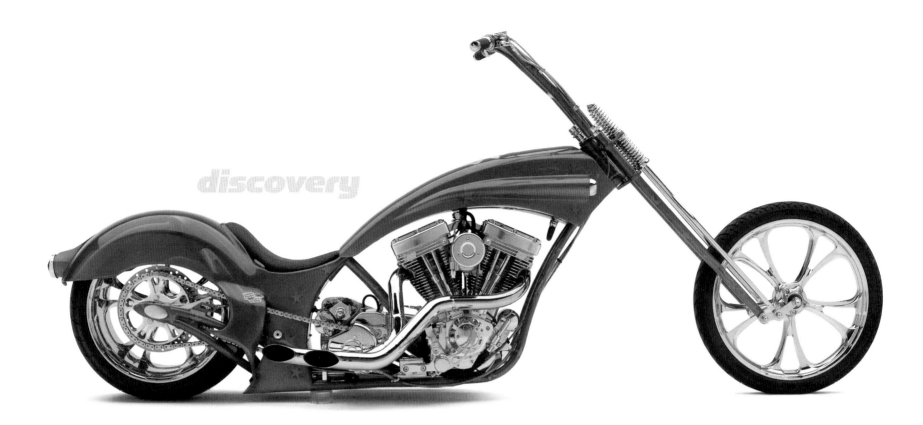

discovery

at the shop who can fill in where I left off. But I would say, hands on, I've got a minimum of two hundred hours in every bike."

Going great guns, including all the custom fabrication, Johnson has built a bike in as few as seven days. That's still one day

longer than Genesis. One has to assume there was little eating or sleeping going on during that time — but a lot of praying.

Nevertheless, delays are inevitable. There is so much demand placed on certain suppliers that they are "chasing their asses,"

as Johnson puts it, trying to keep up with the demand from top builders, let alone every imitator.

Kendall Johnson knows *everyone* in the business. And words of praise for his colleagues flow like hot motor oil. They

depend on each others' talents for help with one thing or another at one time or another. With so many motorcycles and parts

in various stages of completion shuttling back and forth in boxes at any given time, it seems they might get more mileage that

way than by being ridden. Friends provide inspiration and occasionally the labor needed to avoid taking years to build a single

chopper. Incidentally, many builders transplant Kendall Johnson's engines into the bowels of their beasts.

He doesn't mean to be unkind when he says that Kendall Johnson Customs are not so much for regular Joes as for cor-

porate CEOs. Most get shipped to wealthy clients out of state. Even though Johnson believes his business would thrive even

more if he were set up on either coast, he remains in his digs near Winston-Salem, North Carolina, because that's where he was

born. He likes it there. "I've traveled all over the world," he says, "and I've never been anywhere I liked even close. I'm pretty

happy where I'm at."

Johnson built his own house, even dug and dammed his own lake. One thing all builders have in common is the mind-

set that there is no task they cannot accomplish with their hands. Even if it's something with which they have had no prior

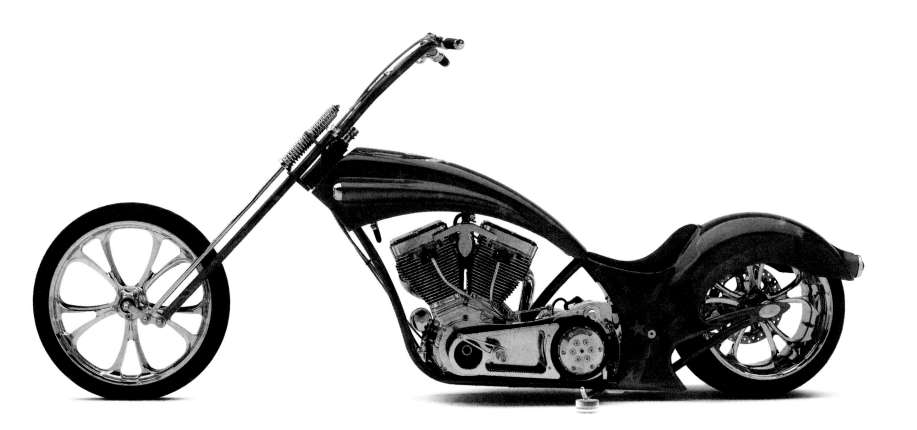

experience, they will figure it out as they go along. "A person is born with that kind of talent," Johnson asserts, just as a great musician, poet, athlete, or mathematician. If something needs to be manufactured or fixed, whether hydraulic, electrical, or mechanical, no matter how complex, folks such as himself with innate skills will find an innovative way to get it done.

Almost a decade ago, Johnson airbrushed a maniacal and depraved-looking clown on one of his drag-racing bikes, stylized graphics being a traditional ploy to intimidate racing opponents. The Kendall Johnson Customs Clown stuck and has become his official logo, a fine alternative to the overabundance of skulls that embellish other bikes. His motto is "Start Clownin' Around." But there's nothing funny about being smoked by Kendall Johnson, except to his buddies taking bets. The Surgeon General never warned him about smoking the competition, and where there's smoke, there's tire. Well, there was, until the tread disintegrated before your watering eyes.

In recent years, Johnson has acquired friends in law enforcement who ride. That has made his life easier. But he'll bet dollars to doughnuts — not the rubber-on-asphalt kind — that he has been stopped and cited for more motorcycle traffic violations than anyone else in the industry. "I didn't get outrun much," he boasts, "especially when I was younger and a hundred pounds lighter." Ever the responsible father now, he pleads with his son to race at the drag strip instead of on the street. When asked how he keeps his own license, he replies, "I spend a lot of money — a *lot* of money." Whether it's lawyers or crooked cops — and he's run into many of the latter whose crookedness was of no benefit to him — there's always a price to pay.

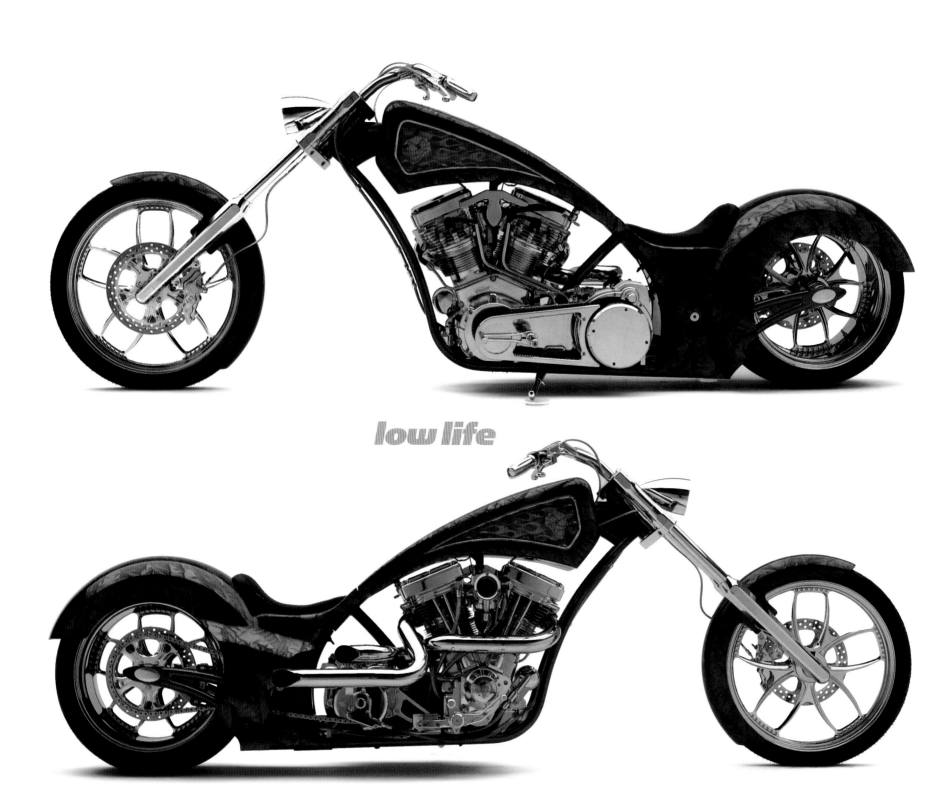

low life

"There's a fine line between a police officer and a criminal," Johnson muses. For example, he has paid off South Carolina state troopers in Myrtle Beach who have had their hands out, extorting hundreds of dollars at a time, in cash, just to fend off unwarranted and very expensive fines for no more than the privilege of parking his truck — legally — just long enough to load a couple of bikes. Incidentally, Johnson is fond of saying, "A friend will always bail you out of jail. A *real* friend will be in there with you."

Johnson started building motorcycles after he had already developed a reputation for customized — and very fast — sports cars. Now, since the commercialization of the chopper theme, he wants to head in a different direction once again. Bucking the trend, he wants to go long but low and with "whacked-out" frames that cannot be easily cloned. He thinks companies distributing mass-produced motorcycles that merely look like choppers are ruining the ethos of riding the real McCoy for a small cadre of dedicated enthusiasts. But bigger numbers drive the market. "Choppers won't disappear; the market is flooded with them now," says Johnson. "But the trendsetters will be making different-looking bikes for the guys with deep pockets who are wanting to stay in style." However, unlike high-dollar hotshots who acquire choppers as mere status symbols to go along with their Gulfstream jets, Cigarette boats, and Ferraris, Johnson believes there will always be buyers who are attuned to a lingering, almost nostalgic attitude of rebellion against authority. Already, it seems, chopper buyers *are* the authorities. But few are authoritative about anything in particular, least of all motorcycles. "For years they hated us," says a bemused Kendall Johnson. "Now they want to *be* us. So I don't really understand. You started out doing this thing because your parents didn't like it. Now that it's socially acceptable, it's not quite as fun as it used to be." When your in-laws can play outlaw riding fake choppers, it's time for a change.

In 1994 Johnson opened his first professional shop, specializing in speedy street rods and Corvettes. In those days, V-twin hop-up jobs were not as lucrative as eight-banger automotive work, and he could get only five hundred bucks to paint a motorcycle. To make ends meet, he freelanced as a landscaper. Just a few years later, as the tide turned, he focused for good on two wheels.

"I really had no self-confidence at all, until the first year that I went to Sturgis," admits Johnson modestly. That was only as recently as 1997. He had been reading magazine articles for years regaling him with the exploits of one builder after another claiming to have cranked out mega-horsepower motors. Until he went to Sturgis, he thought he was behind the curve of innova-

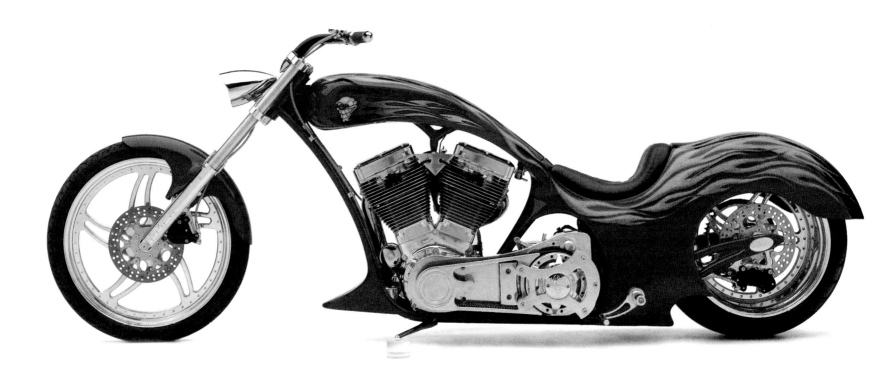

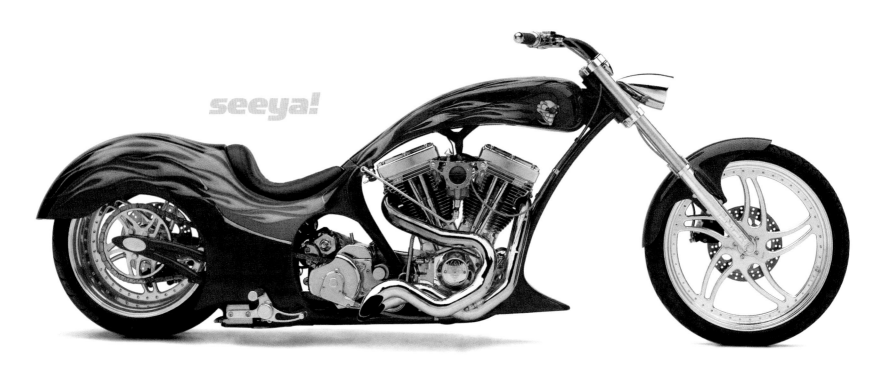

seeya!

tion and technology. When he arrived, he was surprised to see builders running combinations of components that were incompatible with the physical stresses applied by big-inch motors sustaining high rpm. "Hell, I can look at the clutch, I can look at the drive unit, I can look at the pieces and see that most of these guys don't have a clue." He knew that the builders he met were incapable of documenting their claims on a dyno, because he was sure that their clutches would blow out if they tried to get such cobbled-together contraptions up to speed. So Kendall Johnson, an unknown entity who had almost been psyched out at the starting line, began to challenge bikes in every power contest he could enter and won them all hands down. His engine-building prowess is real, unlike the prevarications of pulp-press pundits. He can wring more ponies from a pair of pistons than there is all the chrome in Korea. And he can harness them through the drivetrain and onto the ground. "A lot of these bikes that were supposed to have been so fast in magazines were junk," says Johnson. He put his money where his mouth was. It was a transformational experience.

Kendall Johnson was born in 1965 in Kernersville, North Carolina, just twenty miles from his current home in Germantown and not far from his shop in Winston-Salem. "I've always enjoyed riding," he says, "since I've been old enough to sit up. I was born into it." Both of his grandfathers rode Indians and Harleys. His mother keeps home movies of Kendall in diapers held up on those old bikes by an uncle.

Johnson has two grown children of his own now. He was only eighteen himself when he and his wife, Missy, were married. Life is good. His only regret is for having spent too many eighteen-hour days, seven days a week, in the shop for a dozen years and not watching his kids grow up. No vacations. Too many Bike Weeks.

He doesn't have time for hobbies per se, beyond putting a few hundred miles on each of his bikes before delivery. The shameful truth of this one self-indulgent delinquency is that the way Kendall Johnson builds motors, they only need, as he tells it, "three or four heat cycles and forty miles, and they're ready." Shaking the bike out is part of his job, though. And he is thorough. He also warily whispers that he will sneak off to go to the lake now and again to chill out with friends on fast boats. It goes without saying that he likes *anything* that goes fast. Don't be dawdling at the speed limit when he comes up in your rearview mirror doing triple digits, blaring on a diesel horn with his forty-foot-long big rig full of motorcycles!

The veneration of ancestors is a well-established teaching in Japanese culture.

It is also true that Japanese mythology holds material and spiritual existence inseparable. Therefore, objects as well as people of impressive character inspire the lives of many Japanese. In consideration of these ideas, Shinya Kimura gratefully pays his respects to the antecedents of modern Harley-Davidson motorcycles, whose enduring legacy inspires him to revitalize the moribund and resurrect the obsolete.

Kimura rescues old Harleys from their postmortem fates as saloon decorations, museum attractions, and — worse — from having their dissected parts dispersed throughout a backwater of garages to become paperweights, ashtrays, and doorstops. His company, Zero Engineering, based in Okazaki City, Japan, is comprised of a small group of adherents who are loyal to both Kimura-san and his vision. True to the chopper way, Zero's motorcycles also embrace contradictory philosophies of design, in this case a blend of Western and Eastern paradigms.

The Western view of civilization reflects a history of man's ascendancy over nature, bending it to suit his own demands. Eastern philosophies do not see nature as something to be subjugated. Eastern art tends to synthesize nature as much as Western art may turn it into a trophy. With regard to custom motorcycles, Kimura believes that an imbalance of Western influence allows quality to slide downhill as builders take obdurate aim at perfection, as though nothing less will do, yet knowing it cannot be achieved. Consequently, their work may look forced, less real, more fake. Instead of admiring the nature of, say, an old gas tank with imperfections attributable to its history of use, it may be smoothed over with putty and repainted. Alternatively, and with disregard for its patina, a shapely aluminum part may be polished to such a high luster that this alone leads to exclamations about its beauty, in the same way that a jazz musician's interminably held high note at the end of a solo is a hackneyed trick but one to which audiences are conditioned to respond with applause.

All of this is to say that there is a faction of builders who enjoy motorcycles that look faultless and new, even if they are patterned after the "old school" of American style. They aspire to a look known alternatively as clean or sterile. While that interpretation of the art of the chopper is as valid as any other, it makes Kimura cringe. He prefers the imperfect aesthetics of a motorcycle that *looks* as if it will dump oil any minute and is that much more beautiful for it.

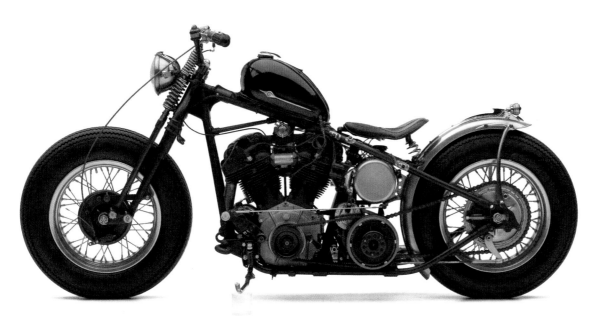

bullet bug

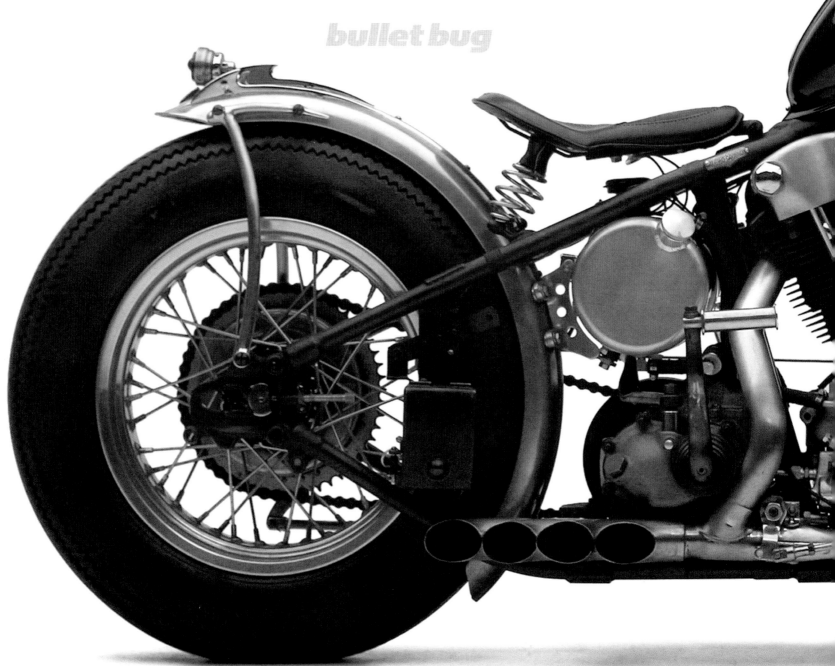

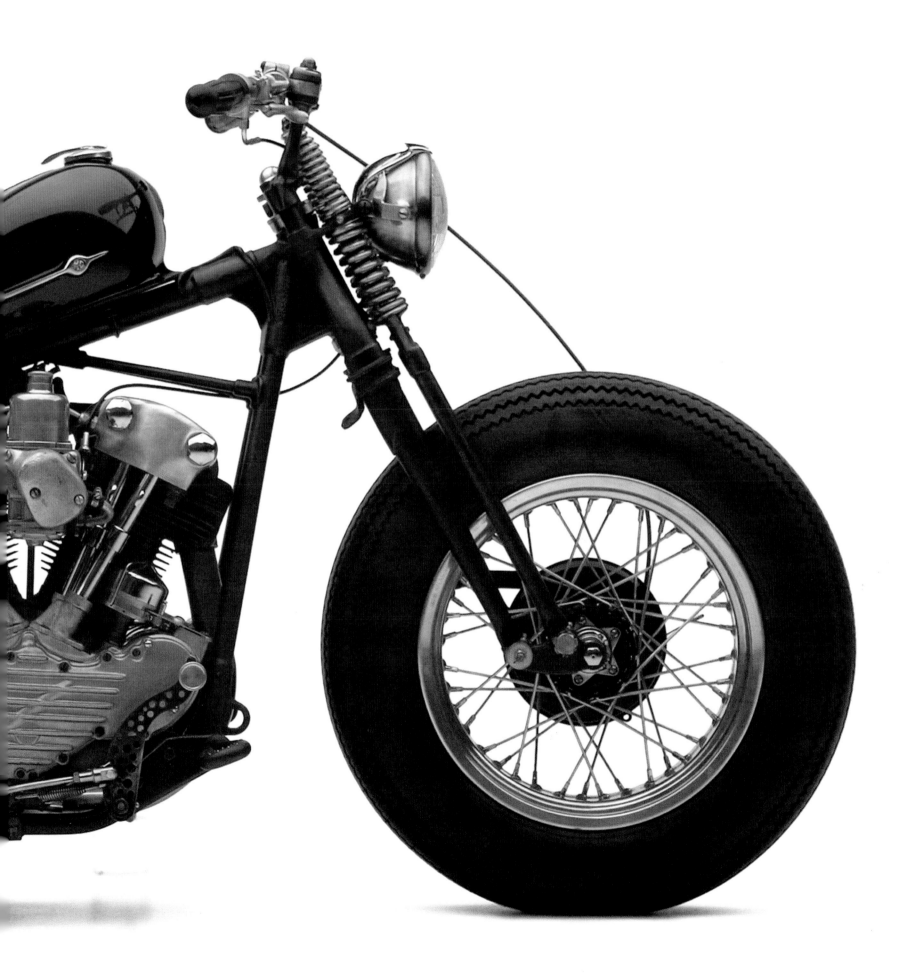

Most chopper builders in Japan were influenced by American magazines and, of course, the movies of the '60s and '70s. They tried to copy what they saw. But Kimura has always believed that mimicking the American vision of customization would be unworthy of respect. Yet he was determined to venerate that most American of motorcycle marques, again Harley-Davidson, by reviving the glory of its past and at the same time infusing it with *wafu,* or "Japaneseness." Such a confluence of cultural diversity represents the idea of *wa,* or "harmony." In his case, it also means "cool."

As far back as 1995, Kimura chose not to follow the parade of shiny, chrome-plated, technologically freighted, and extravagantly painted bikes. Instead, he unearthed an antediluvian engine and stuffed it into a chopped, rigid, gooseneck

frame with an itsy-bitsy purple peanut gas tank, a leather bicycle seat, big fat balloon tires, wire wheels, and a kick-starter. He exposed the mechanical guts of this precursor bike and virtually shone a spotlight on its prehistoric parts, including a drum brake and a Linkert carburetor. Finally, he added an electrical system that looks as if it were wired by Nikola Tesla. Every piece of this machine was either rebuilt or originated by Kimura's hand. It flaunts its age, but don't let the richly patinated façade fool you. It is put together like a fine Swiss watch — okay, maybe a Seiko. And it no longer looks like the 1950 WL Flathead it once was. Its new form blends seamlessly into the Japanese landscape, as natural-looking in front of an ancient Shinto shrine as the steed of a Tokugawa samurai warrior — out of time but not out of place, reincarnated.

Kimura knew he was on to something when, living up to its given name, King of Custom was voted best of show at the influential Harvest Time contest in Japan. On the heels of that success, he launched a number of additional choppers, culminating with a 1941 U-type Flathead that garnered even more notoriety at the 1998 Cool Breaker competition. That showing was enhanced by subsequent publicity in both the Japanese and the American press. By bucking the predominant customization trends and following his muse, Shinya Kimura put himself and Zero Engineering on the map.

By coincidence, a fitting way to describe the current crop of Zero choppers is by comparison with a Japanese garden, because for both every detail has a significant value, but not when taken away from the context of the whole. Each aspect of the design relies on and supports another. Nonessential elements are eliminated, and jarring colors are eschewed. Asymmetry indicates a preference for imperfect over perfect forms and thereby achieves a sense of slight disproportion, or unevenness, that imitates nature by breaking up faultless shapes. Simplicity speaks to the achievement of *mu,* a Japanese word expressing the ideal of "nothingness" without implying negativity, a response to unanswerable questions. Another

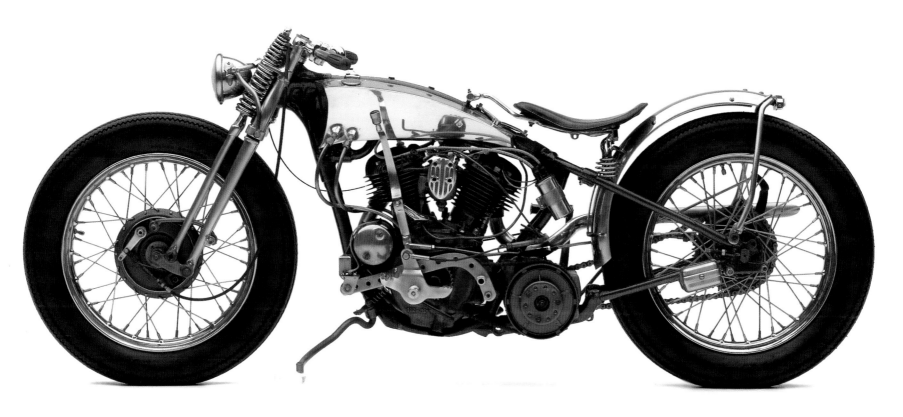

amber trophy

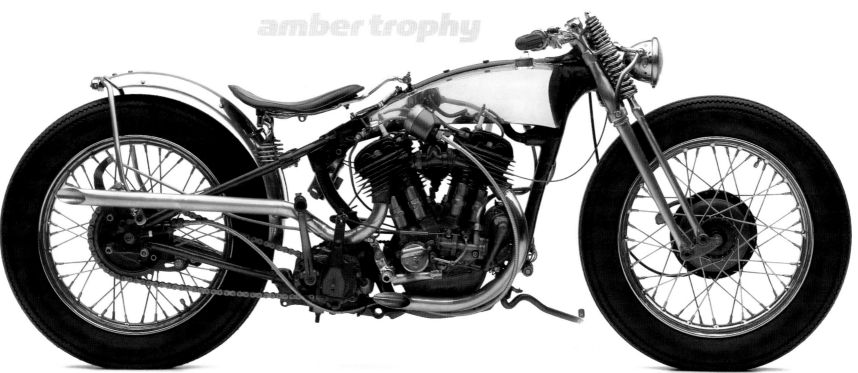

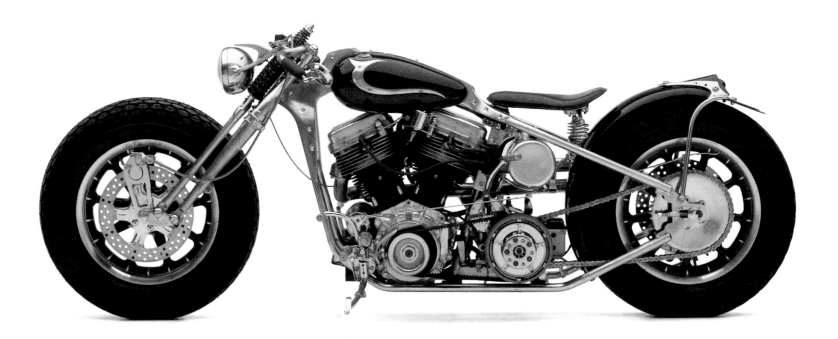

Japanese word, *kokou,* signifies maturation, or quality attained over time. *Shizen* refers to avoiding anything that smacks of too much artificiality, that which makes a design look forced. Finally comes the idea of *miegakure,* which represents an avoidance of full expression too quickly. In other words, if you allow an experience to unfold at an agreeable pace or view it from multiple perspectives, surprises will ensue. These are not "in-your-face" choppers. The only gardening metaphor that does not apply is *seijaku,* or the attainment of stillness, quiet, and tranquility. These are motorcycles, after all!

Shinya Kimura, obviously a die-hard proponent of older Harley-Davidson designs, believes they have a metaphysical power to transport contemporary riders into the past. In deference to his affinity for old engines, he strips away what a bike does not need to show off its power plant. The fact that old motors and frames are made of less malleable iron and steel, instead of aluminum, often dictates the forms that Kimura must follow and how a bike will ultimately look. And that look is one of "tough beauty."

Furyo is the Japanese name for young tough guys. Kimura prefers riders with an edgy attitude to adopt his bikes. "The bikes they ride cannot be taken lightly or frivolously," he says. "The bike itself should be *furyo*." He wants his motorcycles to look grimy and rough, but not actually dirty, with a tarnished patina of age like weathered skin. But he has nothing against integrating the smooth complexion and curves typical of a shapely woman here and there, as he seems to be able to achieve without incongruous effect.

Encouraging the renewal of these machines may be thought of figuratively as an expression of mechanical ancestor worship. Perhaps Kimura could create similar bikes with modern parts. But they would not be real, in the

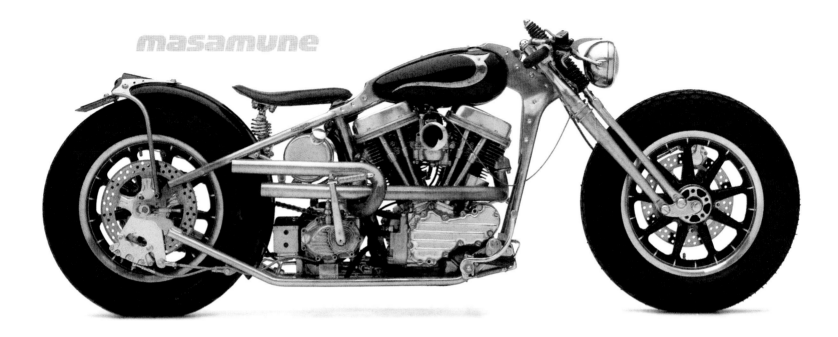

masamune

sense of having had a life in another era. They would be recreations, not reincarnations.

Kimura cites three additional reasons for his love affair with old Harley engines. First, they are beautiful, durable, and easy to maintain with readily available spare parts. They have excellent quality. Second, he appreciates the corporate ideals of the Harley-Davidson Motor Company, which tries to keep its customers happy within the culture it has fostered for more than a century by avoiding contrived obsolescence. Finally, "the brand's mystique works its magic on the sound whose vibrant rhythm goes well with the kind of image that I have for motorcycles."

To the Japanese enthusiast, riding and maintaining an older motorcycle confers prestige. Typically, Zero customers ride hard and take pride in their skill. Their relationships with their bikes are not practical ones but love affairs that require work. They feel a sense of accomplishment both for enduring the challenge of riding these retrograde machines and for personally maintaining them. In fact, Kimura encourages customers to watch routine mechanical repairs firsthand at his shop, until they learn how to take care of their bikes themselves.

Throughout Japan, Zero riders share a bond. A clique of about thirty of them, representing roughly ten percent of the total number of Zero bikes produced so far, often ride together. Once a year, Kimura participates in a weekend ride through the country with about a dozen of his patrons. It is a disappointment when someone buys a Zero bike for display and not to ride. He tries to screen out such people.

Kimura tries to ride every day. Sometimes he will do ten laps around a nearby racetrack both to clear out his cobwebs and to test the performance of a bike. He goes really fast, so these oldies-but-goodies must be kept in tip-top shape. In the

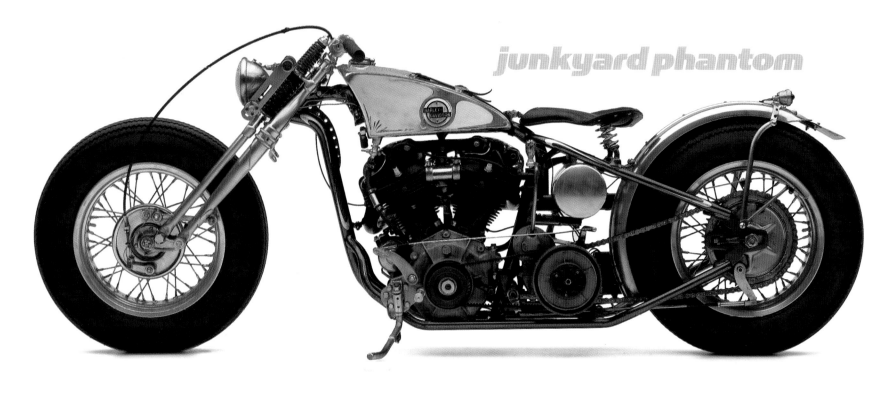

junkyard phantom

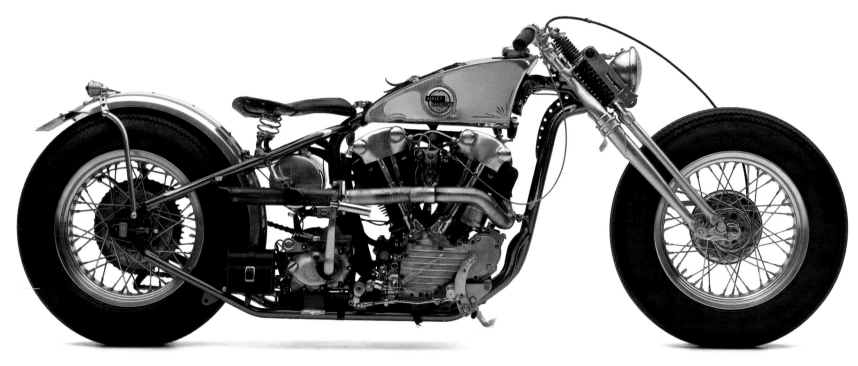

early '90s, he personally began to race vintage Harleys competitively, not just for the thrill of it but because he ardently believes durability and aesthetics are equally important. The Zero Engineering team routinely participates in races throughout Japan to measure and improve the techniques they use back in the shop.

Shinya Kimura was born in Tokyo in 1962, a pleasant surprise, considering his closest sibling is fourteen years older than he. His parents moved the household, including his brother and three even older sisters, to Okazaki City in Aichi Prefecture, deep in the heart of Japan. His father managed a small machine shop, or *machikoba,* and enjoyed writing haiku in his spare time. His mother kept the household in order and was an accomplished calligrapher. The fact that Shinya grew up in a neighborhood that harbored many *machikobas* and craftsmen gave him an interest not necessarily in motorcycles, at first, but in building things with his hands in general.

Shinya's brother reminds him to this day how continually distracted he was by automobiles — parked, passing, turning, speeding. He loved to look at them. At the age of five, Shinya himself vividly remembers cutting out pictures of cars from newspapers and magazines to put in a scrapbook. When he was thirteen, he took his father's camera to the giant motor expo in Harumi, Japan's equivalent of the Detroit auto show, to add to his collection of admired designs.

Cars taught young Shinya lessons about design and helped him form a philosophy about how an automobile — and later a motorcycle — should reflect the persona of a Japanese man and vice versa, whereby a man takes on certain aspects of the vehicle's nature. This represents his ideal of being more than one appears to be on the surface, adding depth to one's character. For example, it would be phony to drive an exotic-looking sports car without pushing it to the edge of its envelope of speed and agility. And if you want to feel like James Bond, a Honda Civic will not do the trick. But Shinya might daydream about buying an Aston Martin DB5 if he is inclined to feel like a secret agent. It's all about indulging one's fantasies to enrich the quality of one's life. Some automobiles may be beyond Shinya's reach, but he cherishes his fantasies nonetheless.

When he was twenty-three, Shinya bought an Isuzu 117 coupe designed by the legendary Giorgetto Giugiaro of Italy. It had an elegant body, but it was slow. It satisfied him, however, because it performed its intended function. It was beautiful without being designed to perform like a sports car. It suited his ideal of driving along a boulevard with an elegant woman seated by his side. On the other hand, if he were shopping for or dreaming about a sedan, it would have to be a "sleeper," something with a surreptitiously hopped-up engine under the hood that would surprise all contenders, including cars that looked as if they were meant for speed.

Also at twenty-three and just out of university, Shinya interviewed for a job in response to a newspaper ad. He became

a mechanic for a large dealership of Japanese motorcycles in his hometown of Okazaki. He stayed there for a few years until he gathered up his experience and left to became manager of a small repair shop called Chabo in a rural and mountainous area near a town called Mikawa.

Chabo, whose name means "rooster," specialized in the restoration and maintenance of vintage motorcycles, mostly British, German, and Japanese models. He had a little business going on the side, too, buying full-dress FLH-model Harleys from local owners — some were basket cases — for about $5,000 to $6,000 each, restoring them, and reselling them for a profit. One day a man came into the shop and asked Kimura for help with his vintage Harley-Davidson, which had been standing unattended in a garage for a very long time. Kimura cleaned it up, changed the oil and the points, and overhauled the brakes. That more or less describes his job at Chabo, anyway. But word spread about his ability to breathe new life into over-the-hill Harleys, and before long, he had ten classic hog owners coming to see him regularly.

One of them asked Kimura to lower a Harley in the manner of a hotrod. Another asked him to make the tank smaller. Still another asked for an open-belt primary. These were all firsts for Kimura and maybe for Japan, too. His ten customers initiated a de facto competition among themselves to create the most unique Harley. Kimura did all the work for them. His job had now become that of a customizer with design responsibilities, as much as a repair mechanic. "Thinking back," says Kimura, "it was very rough customization work. But some cool bikes resulted with the collaboration of their owners." He believes he was lucky that all ten of his clients had good taste.

Kimura enjoyed his work at Chabo. It gave him new ideas about the direction his career with motorcycles might take. However, for the couple of years he was employed there, he found it hard to make ends meet. Now that he had found a way to express his creativity, he began to think about how to make more money by becoming his own boss. After putting his capital and savings together, the next step for starting a business would require a change of venue and a name.

Kimura moved back to Okazaki and set up shop in 1992. As for the new name, Kimura says, "I chose the word *Zero*. Whereas it can literally mean 'nothing,' I believe the word holds an endless possibility to it. It is, indeed, meant to remind me not to conform to the paradigm but to always challenge a new way of

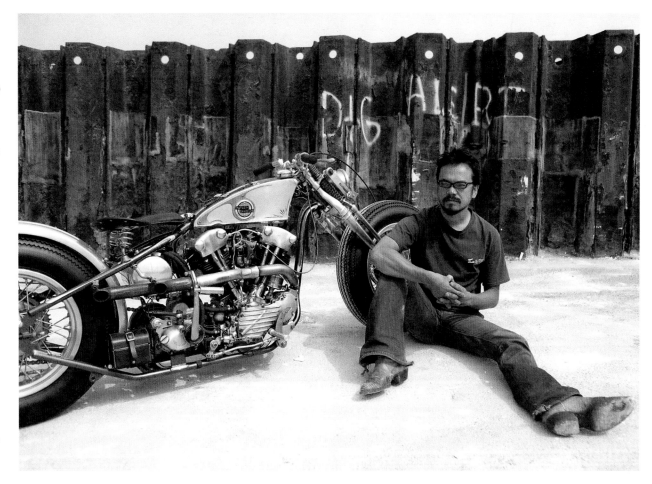

thinking." Of course, it also alludes to that infamous Mitsubishi marauder of the skies from World War II. But it is as fair a symbol to use today as any other for *Bushido,* the code of behavior of the samurai warrior, emphasizing self-discipline, courage, and loyalty. Zero choppers are often referred to as "samurai bikes from Japan."

In his first couple of years in business at Zero, Kimura was still taking care of customers who migrated from the Chabo shop, including his ten loyal Harley devotees. Business grew slowly until the King of Custom bike kicked things off. As a result of his subsequent success, there is a four-year-long waiting list today for a Zero chopper.

There are a number of craftsmen employed at Zero Engineering. Each has sought the honor of working under Kimura-san. As founder, he directs the manufacture of all bikes and takes a hands-on approach to many projects entirely himself. It is said by one of his friends and a chronicler of Zero's history, Kaz Yamaguchi, that "the plethora of creative visions that pour out of his personality even baffle the staff members frequently. His visions are sometimes simple like a child's, sometimes satirical, and almost always reflect his philosophies."

Shinya Kimura believes that people in the United States often call themselves artists too easily. In Japan, the extraordinary stature of an artist is not easy to come by. Kimura feels he is still trying to become an artist. He is aware that others see him that way already. Regardless, it can be said unequivocally that his work is completely original. "I cannot think of anyone in particular who had an influence on my work," he acknowledges. "It is rather my Japanese roots in which the idea of beauty, as well as my identity, was formed."

Some unenlightened people may look at Kimura's work and see funky old motorcycles. The same people might also regard a Zen garden as merely a sandbox. It is of no consequence to him. He only cares that the owners of his bikes will be increasingly delighted with them and continue to ride them.

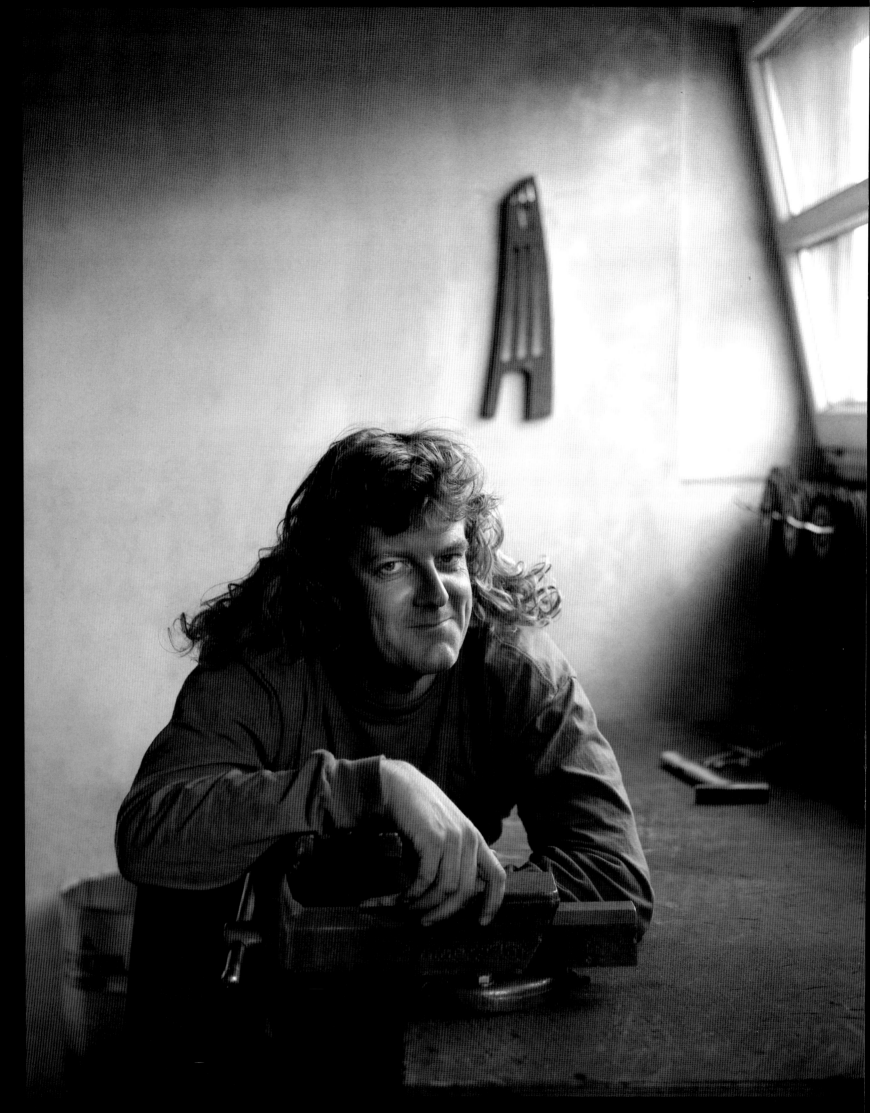

fred kodlin hellacious hessian

German builder Fred Kodlin is a big fish in a small backwater; so small, in fact, that its inhabitants know him only as "Fred, the guy who fixes motorcycles." Curious locals, every once in a while, ask him what it would cost to buy a one-of-a-kind, tour-de-force chopper like those they see in his showroom. If Fred is feeling diffident, as he often is, someone may proffer a guess of, say, 5,000 euros — that's about $6,000. Fred will come back with a straight face and admit furtively that it is closer to 8,000 euros (just under ten grand). Astonishment ensues at such an outrageous sum. *Ein Motorrad ist ein Motorrad gerecht. Jawohl,* homeboy! Whereas enthusiasts from elsewhere in Europe or America may journey thousands of miles on a pilgrimage to Kodlin's shop in the middle of a German pasture just to see his bikes, the neighbors might bring him an oil-burning, claptrap *Motorrad* from Hell for a valve job. But Fred will make the repairs with a smile. By the way, any bike in his showroom would be a bargain at *80,000* euros.

If you ask Kodlin what the difference is between a chopper and a regular motorcycle, he will tell you that a chopper *is* a regular motorcycle. As far as he is concerned, he makes motorcycles, and, well, people call them choppers. He sees no distinction at all. For others, perhaps, it is simply a question of stock versus custom. It is hard to get him to address the topic. "I am shy," he feigns. He is nevertheless a soft-spoken fellow who is reticent to describe his work, preferring to let it speak for itself. The bikes are quite articulate.

"I see all the motorcycles," Kodlin says omnisciently, pronouncing it "mootazykles." "But I don't look at them, I stay to my work." He admits one exception, though. He says that he and Eddie Trotta from Florida have influenced each other's work. He is sure that his good friend Eddie agrees. Kodlin also acknowledges that there are strict rules in Europe that apply to the manufacture of all motorcycles, whether they are made by hand, one at a time, or spewed out of a BMW factory. These rules have influenced European custom-motorcycle design significantly. For example, since bikes with an open primary are *verboten* on German roads, nobody builds them.

As a young man in 1980, Kodlin had already been experimenting with building bikes at home for several years when he decided to open a retail shop. He learned he was legally obligated to study for two and a half years at a special school to qualify for a manufacturing business license, or *meister brief.* He endured that and was permitted to open officially in late 1982. Then, after a short period of unregulated bliss, new government rules were imposed. They are enforced by a long-standing independent testing organization known by its acronym, TÜV (Technischer Überwachungsverein, "Technical Inspection Association"). Kodlin has to submit each prototype frame, even each new foot peg and handlebar design, to the TÜV

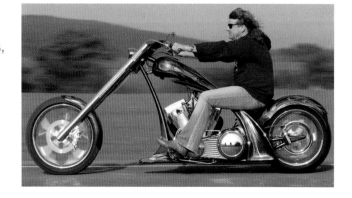

along with carefully drafted blueprints for approval. The TÜV's task is to try to break stuff. And Kodlin has to pay for the tests! Every manufactured part must also be labeled, corresponding to its TÜV registration number. Kodlin says that if he submitted his technological hat trick for certification, the hubless bike called Shine, men in white coats would cart him off to an asylum.

Periodically, Kodlin has to recertify the same parts with new paperwork, even if nothing has changed in their manufacture over the years. It costs Kodlin's business 120,000 euros each year for such testing. And here's the rub: other builders can avoid jumping through these hoops, saving tons of money, because by actually copying Kodlin's work, they are free to use the same approval certificates. Kodlin's salvation is his wife, Christa, who handles all of the administrative rigmarole, leaving him free to follow his creative whims.

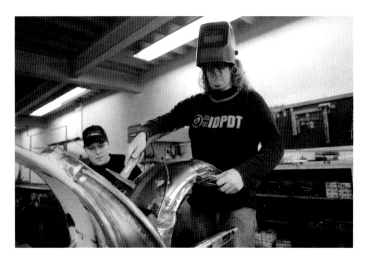

Additional governmental mandates are also imposed, much like those from our own Department of Transportation. They include installing special exhaust systems, carburetors, air filters, lights like a Christmas tree, and so on. German bikes, even custom-made ones, are required by law to be warrantied for two years. "Honestly," says Kodlin, "I don't care." Apparently, he ignores regulatory impositions on his personal bikes. "When I get pulled over, I pay. But I love it!" As far as he is concerned, it is a tax on fun. If he gets stopped in the States by a traffic cop, as long as he is not speeding feloniously, the dialogue usually goes something like "Wow! Cool bike. Can I take a picture? Don't go too fast now! Have a nice day." And off he goes. If he gets stopped in Germany, however, it is not because the *Polizei* want to wish him a nice day. First, you do not have to be caught speeding to be pulled over; loud pipes or the wrong handlebars will do. In Europe, motorcyclists are still hounded by cops just as they were during the '60s and '70s in the States. Even if you have the proper muffler installed, they *will* find something else to cite you for and, maybe, find cause to confiscate your bike. It can take six to eight weeks of cutting through red tape to get it back. Kodlin is so dead set on riding with the pipes and sound appropriate to his art that he will travel with a chase truck and several different sets of interchangeable exhaust systems to accommodate the rules of whatever country's border he has to cross during his journey. Traveling internationally is as common in Europe as interstate driving in America, given the political geography. If you ask Kodlin why he decided to build choppers in the first place, he will tell you, "Because we were outlaws. That's why." His only concern was — and is — to be different.

With the help of his loyal and competent crew, Kodlin builds approximately forty custom bikes each year. No two are identical. "I'm always behind," he worries, even though he does not accept direct commissions from buyers. That's because no one tells Fred Kodlin what kind of bike to build. In that sense, he is rather more ahead than behind, because someone will always commit to

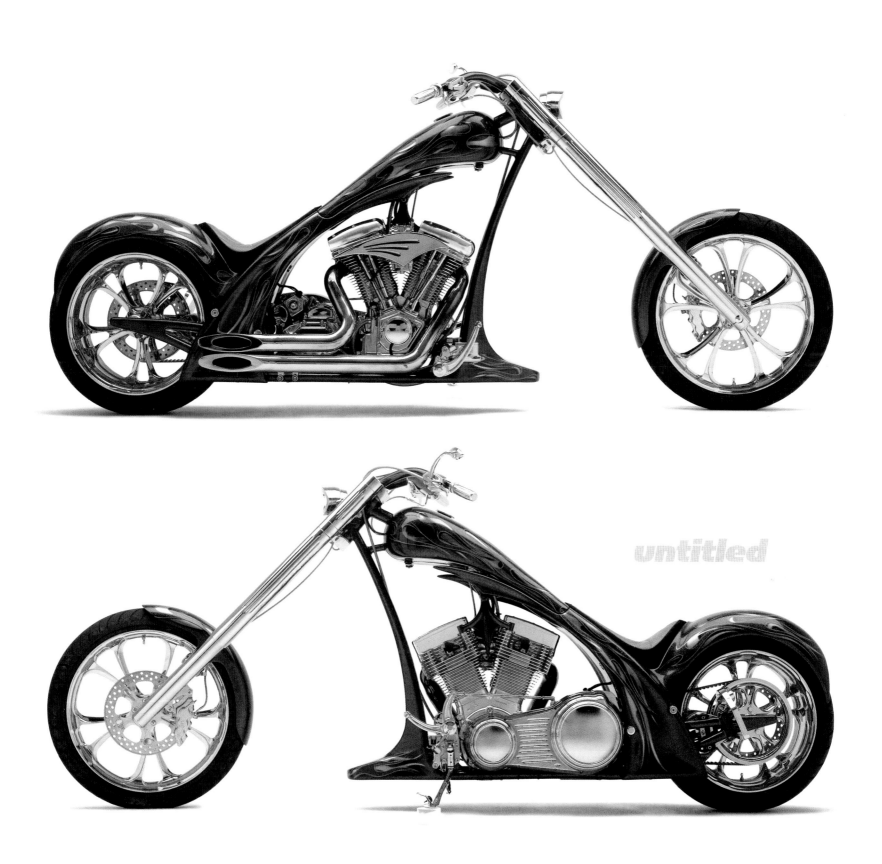

untitled

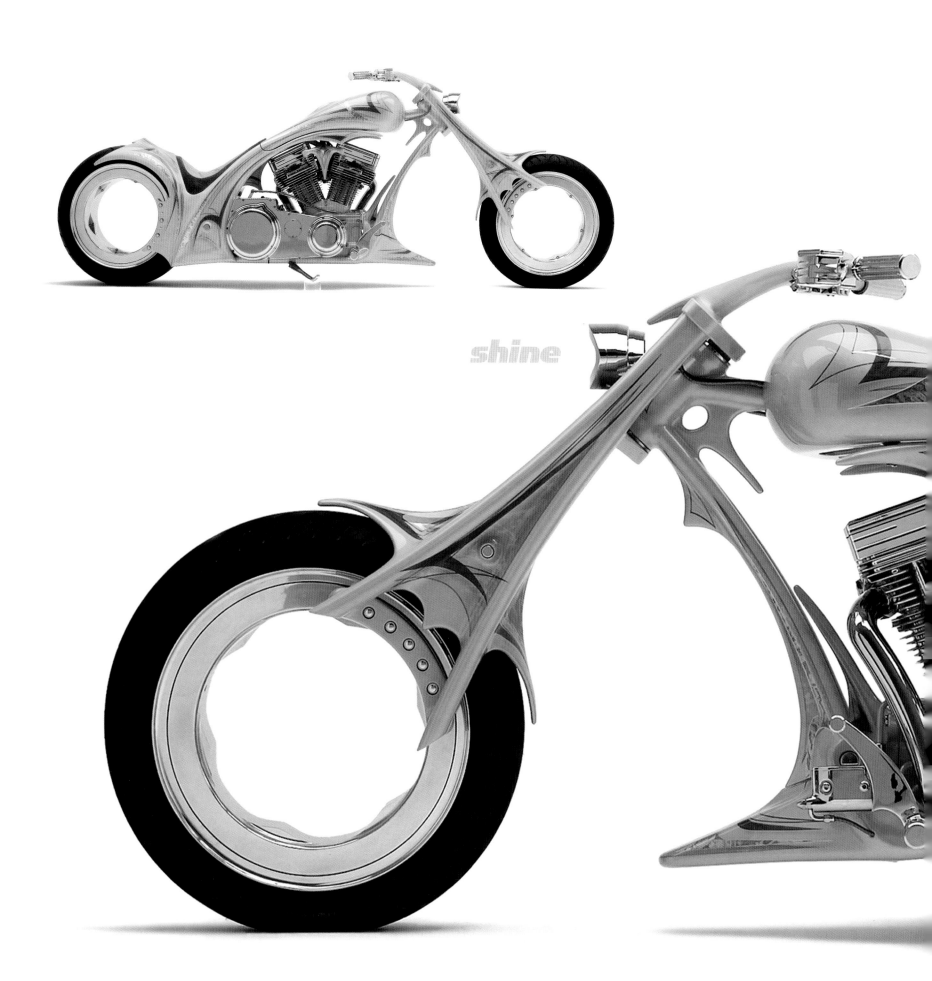

shine

buy his next bike, sight unseen. But Kodlin sizes up each prospective Sonny Barger, and if it turns out he is accustomed to riding a cushy European or Japanese cruiser, Kodlin suggests that he look into a modified Harley-Davidson with a less harrowing stock engine and practical ergonomics, so he doesn't kill himself or complain all the way to his chiropractor.

Kodlin has easily accommodated such customers. He had a brisk business importing used Harleys from Texas, about three hundred every year during the '90s. Once they arrived in Germany, he spruced them up, added some trick custom parts and paint, and resold them. But this market eventually dried up as a result of the economic pressures of German reunification and the substitution of euro currency for Deutschemarks. By the way, if someone has plans to put a scratch-built custom chopper next to his big-screen TV, Kodlin will show him the door.

"Absolutely!" Kodlin snaps right back when asked if he is making a fashion statement. He is proud to see magazines from around the world featuring his work, even when they include pictures of bikes that are obvious copies. "The difference on my bikes," he says, "is that you can't buy them out of a catalog, because I make every part with my hands." He also mixes colors and sprays exotic patterns of paint himself. His famous bike Sodom is coated with an inventive cerulean hue appropriated from the local depart-

ment of public works. It

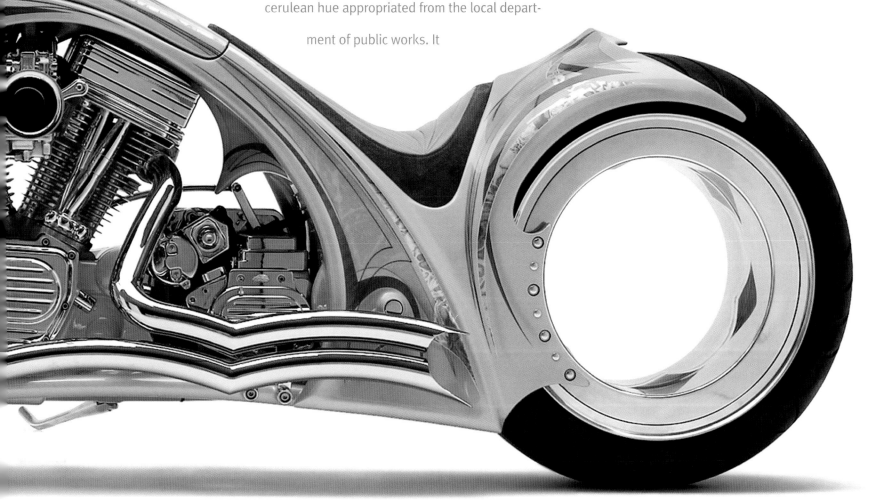

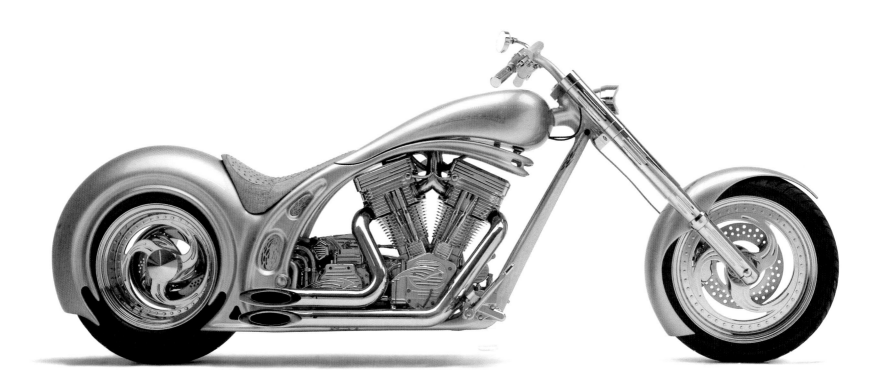

costs practically nothing and is used to paint garbage cans. Kodlin adds a little bit of what he calls "icebergs" (probably pearl) to give it a spectacular specular luster.

You can often find Kodlin sweating like a blacksmith, either wielding a TIG welder or pounding incandescent iron into imaginative shapes with a hammer and anvil, red-hot metal hissing viciously as he dunks it steaming into a bucket of cold water. One of his signature features is the unitized construction of frame and rear fender. He often integrates a parallel decorative rod on each flank, which soars forward in a fluid arc, tracing the lines of the swing arm to the top tube, where they flare off beneath the gas tank. It is a styling accent that creates an illusion of momentum.

While it is true that each running motorcycle that comes out of his shop is totally unique and handmade by Kodlin himself, you can indeed buy Fred Kodlin-trademarked parts from a catalog. You can either put some cool Kodlin accents on a stock bike or create a decent knockoff by starting from the ground up with one of his frames. But it will not be an original work of art. Knockoffs are okay with Kodlin. Besides offering the public an affordable way to have a distinctively beautiful motorcycle, Kodlin the businessman wishes every rider and builder in the world would follow his fashion cues and buy his parts.

"I don't care about the motor; the motor must simply run," Kodlin avers. He would rather breathe acrid dust and soot in the fab shop than bolt crankcases together. Regardless, he installs big, American-made, ground-pounding mills, because his customers all have cubic-inch envy and compete for bragging rights. But a dyno might explode, so to speak, before you could redline the ponies in a Fred Kodlin bike just for the sake of self-indulgence. Everyone already knows they are Panzer-tank tough and fast.

Fred Kodlin was born in 1959 in Jesberg, Germany, just ten miles from his current home in Borken, a community of about thirteen thousand people surrounded by farmland in the German federal state of Hessen. He was raised there and schooled at

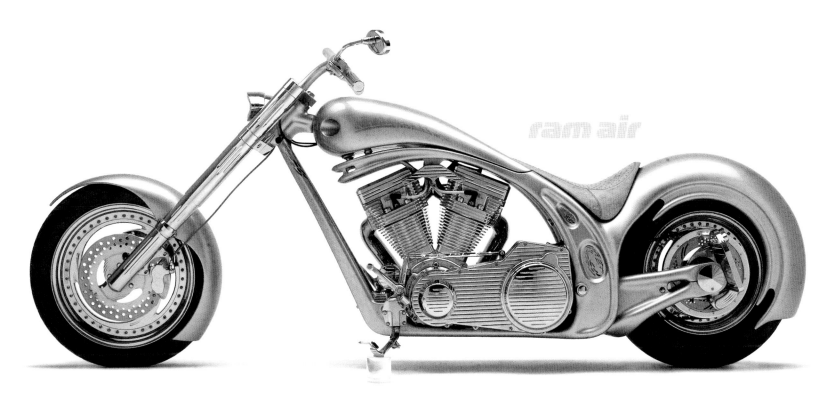

ram air

home until he was ready for high school. His father was actually a blacksmith of sorts, who manufactured wrought-iron architectural fixtures. "I always had to work since I was that little," says Kodlin, gesturing at the height of his desk. He was six years old when he was inducted into the family workforce, and not too pleased about it. He often had to abandon his friends and work with his father, even during holidays. At least he learned everything there is to know about working with metal. Fred's mother took care of the household, including his two sisters and a brother.

In Europe, you must be eighteen years old to obtain a motorcycle license. Fred got his at sixteen. The train station in his rural community closed down for lack of enough passengers, and there was no other transportation for him to get to classes ten miles away. But Fred saw a very old 150-cc Miele motorcycle, a moped for all practical purposes, at a nearby farmhouse. He was able to buy it for the equivalent of about ten bucks American. Incidentally, Miele makes vacuum cleaners and washing machines today. "Of course, I customized it," Fred declares. He made a custom front end out of plumbing fixtures! In fact, after high school, Fred trained to go into the plumbing and heating trade. He made his living that way for three years before he opened his shop in 1982.

When Fred was twenty-four years old in 1978, he was riding in Germany with the Eagles Motorcycle Club on a four-cylinder Honda he had bought used. He chopped the frame and added a wide rear tire. He then sent a letter to Jammer Cycle Products, a wholesale parts outfit in California. He introduced himself and said he wanted to build choppers. He requested a catalog and price list. He especially wanted to know how much he would have to spend to buy a girder front end. A company rep wrote back to say that Fred would have to buy a minimum of $20,000 worth of wholesale parts and become a dealer if he wanted to buy directly from them. "Oops," said Fred. At that point, he decided to improvise his own girder, fashioned after pictures in the *Easyriders* mag-

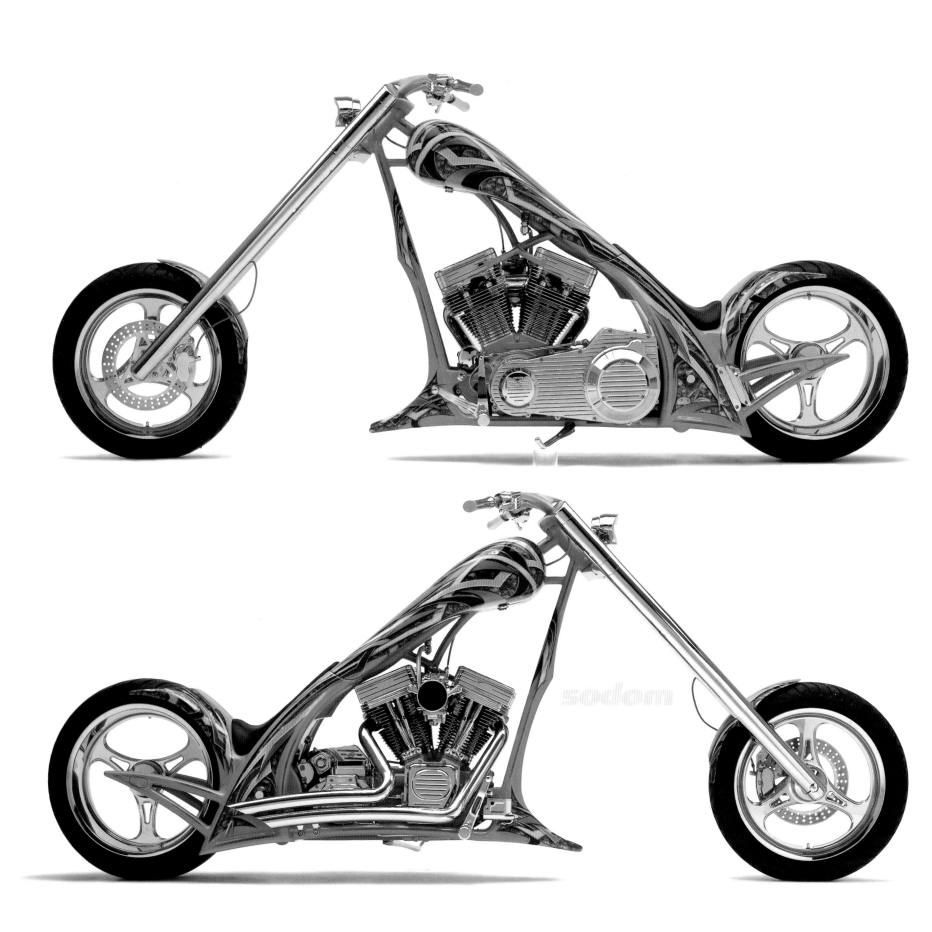

azines that came from a U.S. Army base close to his home. He found them discarded in bars and shops around town. Fred did a lot of riding in those days, including on a trip to the United States, where he wound up spending one night in a Sturgis jail for disorderly conduct. Today, the catalog that features Kodlin's own parts is Jammer's parent company.

In 1999, Kodlin moved from his original small location to a seven-thousand-square-foot shop, showroom, and office facility just outside the center of Borken. He lives close by with Christa and their son, Len.

Len likes to draw. At the age of seven, he designed an air cleaner that Fred actually built and used on a chopper. At thirteen, Len sketched an entire bike that included an original idea for a front swing-arm suspension system. It was so revolutionary and yet practical to build that his father used it on the hubless Shine. Kodlin built his son a scaled-down chopper around a small Honda motor. Len painted it himself, complete with flames.

Kodlin says he got so busy in the mid-'90s that he did not ride a bike for ten years! Now he is making up for lost time with a vengeance. He rides as often as he can and particularly enjoys tooling through the Swiss Alps. Not long ago, he had a bike shipped from Germany to Idaho to catch up there with the Hamsters, who were bivouacked in Sun Valley on their way from the San Francisco Bay Area to Sturgis. The bike arrived without a seat. And being a one-of-a-kind bike, nothing stock would fit. Considering all the master-builder talent on this ride, they should have been able to improvise a new seat. Time was of the essence. Of course, it was a weekend, and some otherwise useful proprietorships were closed. One of the Hamster bros donated a leather jacket to the cause, and they pilfered a pillow from a hotel room. Kodlin and company went from house to house, knocking on strangers' doors until they found someone who had a pair of electric scissors with which to cut the jacket into pieces. They found some spray-on fiberglass at a hardware store to give shape to the pillow. With a knife and a screwdriver as leather punch, some shoelaces and adhesive — presto! — they had a seat. It was called the Samuel L. Jackson seat, because the sacrificed leather jacket looked like one worn in a movie by that actor.

There are always emergencies or, at least, urgencies in a master builder's life. Someone always wants Fred Kodlin's attention. He programmed his cell phone to ring with the sound of a very strident crying baby. To get away from it all, he may suddenly climb into his heavy duty Dodge Ram dualie and head for the hills — the Alps, actually. There, in Switzerland, he enjoys snowboarding and powerboat racing on Alpine lakes, depending on the season. It is very unusual to see an American monster truck barreling down the autobahn.

One last thing: always a man of style, Fred Kodlin has cut the Kentucky waterfall down to a trickle, having shorn his locks to a length that can no longer be mistaken for a mullet. He is tonsorially tricked out with his new do and looking good to ride.

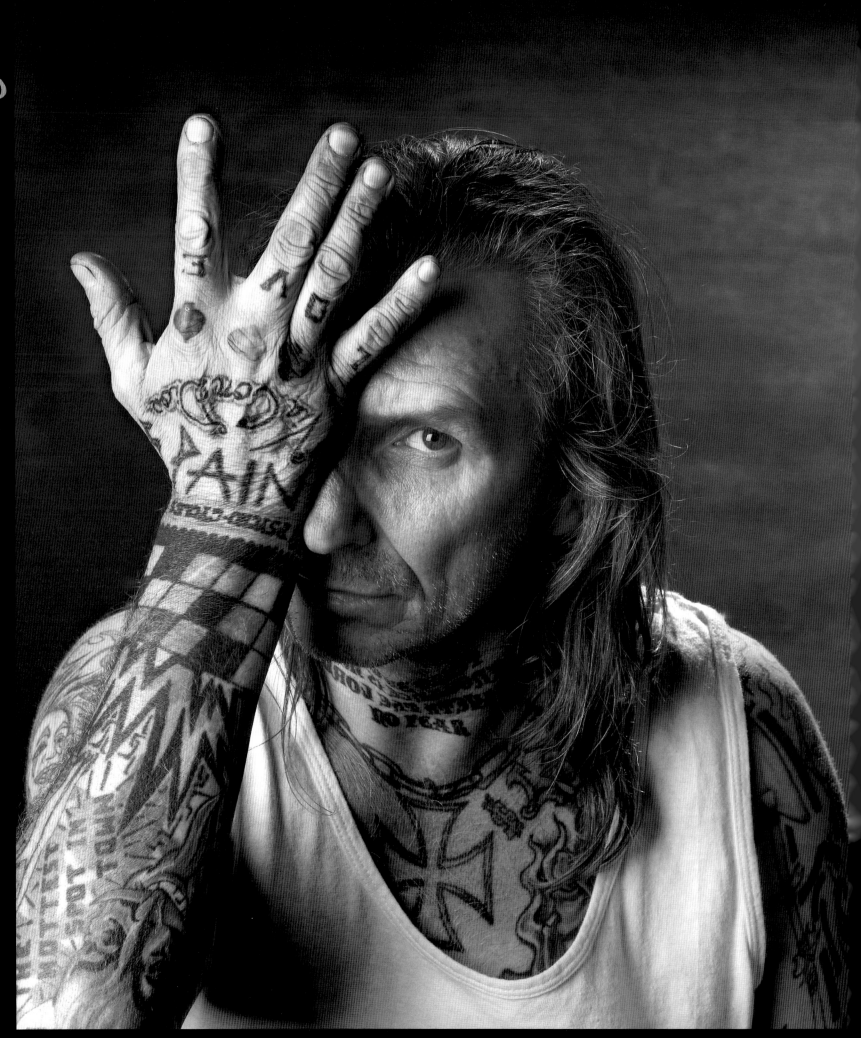

Larry was no Indian.
As a young mechanic in New York City, he was renowned as the go-to guy for wrenching on Indian motorcycles. That's all there was to it. As fortune goes, the moniker stuck; the motorcycle company did not. But would we remember Indian Larry as fondly if his nickname had been Harley? Clearly, no matter what he might have been called, no one with an eye for custom motorcycles and certainly no one who ever met Larry could forget him. Although he suffered a fatal accident at the peak of his career, his legacy lies in the bikes he built and the friendships he forged.

Born Lawrence Desmedt in 1949, Larry preferred the nickname he acquired later in life. After a 1987 photo spread of his chopped 1950 Indian Chief appeared in *Iron Horse* magazine, he used it exclusively. The family name is of Belgian descent, although his parents didn't talk to him about his roots. Larry and his two sisters grew up in farm country, Cornwall-on-Hudson near West Point, New York. They had goats and chickens to look after, and there were woodlands to explore, but early on, Larry was more interested in things of a mechanical nature. His fascination with motorcycles began with a Hells Angels film clip he saw on television — so many riders; such raucous machines! Subsequently, as he began to thumb through biker magazines, he fantasized about becoming a character like those inhabiting the illustrations of David Mann, whose portrayals of a stereotypical and unabashed lifestyle on two wheels were inspirational. He began his career by stuffing a lawn-mower motor into his sister's tricycle. He added ape hangers, and while perched on the step between the two rear wheels, he could putt up and down the neighborhood streets. A few years later, still in his teens, he scraped together two hundred bucks to buy a basket-case 1939 Knucklehead and spent nearly a year learning how to put it back together. He was itching to ride.

Larry's father was a maintenance supervisor for the United States Military Academy at West Point. As an establishment sort of fellow and ardent fan of clean-cut sports, he did not abide Larry's grimy passion for motorcycles. Although his mother "had a halo around her head," as Larry later reminisced, the senior Desmedt continually reprimanded his son for being a disappointment to his family. The boy began to believe him.

Larry was obliged to attend a Catholic school where the presumption of disappointment was emotionally and sometimes physically beaten into him. By the age of sixteen, he wasn't trying so much to rebel against his tormentors as to desperately demonstrate that he was broken. The natural desire of a son to please his father had consequently taken a perverse turn toward the dark side. Since he was expected to do no good, Larry set out with a vengeance to do bad. It was a puerile attempt to condemn his father's sanctimony by confirming the old man's predictions. Larry

weighed his options: "Let's see. Criminals, cons, drugs, guns . . . outlaw biker culture! Like perfect. I'm home." But he had become

such a social insurgent he couldn't even conform to the rules of the motorcycle gang he sought to join, so he kept to himself. And

he made his predilection clear after that by sporting a prominent tattoo on his arm: "No Club Lone Wolf." As he explained later in

life, "I just can't have people telling me what to do! Society's got all these rules. Your family has rules. Your wife has rules.

Everybody has these freakin' rules. I'm going to join a club that has *more* rules?"

Nevertheless, Larry's charisma attracted other malcontents, and he found himself running with a pretty nasty crew. They

began to follow *his* rules. Together they did drugs, committed armed robberies, and hijacked trucks. They went back and

forth across the country on a crime spree. "The worst thing," he said, laughing sardonically, "was that those guys were

dirtbags, and I was their ringleader!" Larry was once chased in a car through

several states by a police helicopter. (He was apprehended in

Oklahoma.) All told, he was

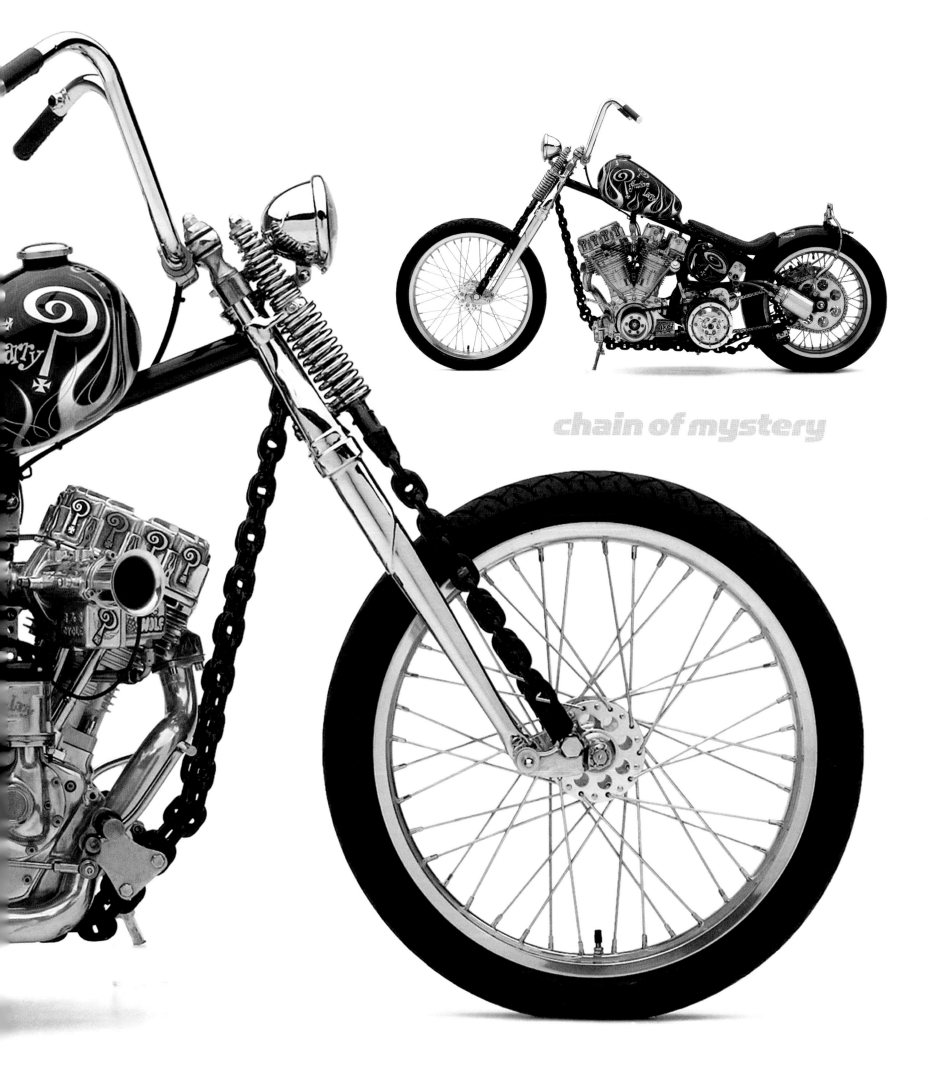

chain of mystery

arrested thirty-five times, with rap sheets in Oklahoma, California, New Jersey, and New York. "I can laugh about it now," he said about serving hard time, "but there was nothing funny about it then." When he was just eighteen, Larry was sent up the river to the notorious Sing Sing prison in Ossining, New York, after recovering from a gunshot wound to the head he incurred during a bank robbery. Once locked in his cell, it was "pure Zen instinct" that compelled him to take a detour from the road to perdition and seek a path to redemption. Deliberate though he had been about his criminal career, he never felt good about it. He resolved to stop punishing himself and others and transform his life. Larry would recount time and again the fundamental realization he made in prison. "I was *not* destined to be a disappointment in the eyes of God," he said. "I'm here to enjoy my life! Those early perversions of religious teachings were complete bullshit."

In the slammer, he started a regimen of reading and was blessed with access to a good library. He had been expelled from high school but earned his General Education Diploma behind bars. He went on to college-level studies and pursued them for a while after he got out. But before long, he was distracted once again by his passion for motorcycles. Although he left both prison and school behind, Larry maintained a disciplined course of self-education throughout his life by reading.

Larry Desmedt was smart. He enjoyed books about science and art. He particularly read biographies, but no fiction. His musical tastes favored classical and jazz, but he also listened to rock and roll. He could engage anyone from any walk of life in conversation and not only hold his own ground but posit imaginative opinions about many different topics. Still, how did such a transformation from convict to intellectual occur so successfully?

Larry had determined to build a career in the motorcycle business before he got out of prison. After his release, he found work as a journeyman mechanic, picking up new skills wherever he could. He ignored the stigma of being an ex-con and adopted a new circle of respectable friends. During a brief stint working in California, Larry sought out a childhood hero of hotrod fame, Ed "Big Daddy" Roth, who gave him some experience painting cars. Back in the '60s, Roth originated what might best be described as the real *Monster Garage*, creating bizarre automobiles as art and popularizing them with airbrushed sketches of oddball ogres behind the wheel. His Rat Fink character still survives as a two-dimensional cult icon. In California, Larry also met Ken Howard, a.k.a. Von Dutch, the legendary pin-striping artist. Larry knew by then that he would be an artist himself. When he came back to New York, he settled in the legendary enclave of eccentric creatives in Greenwich Village.

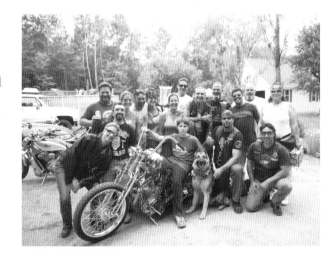

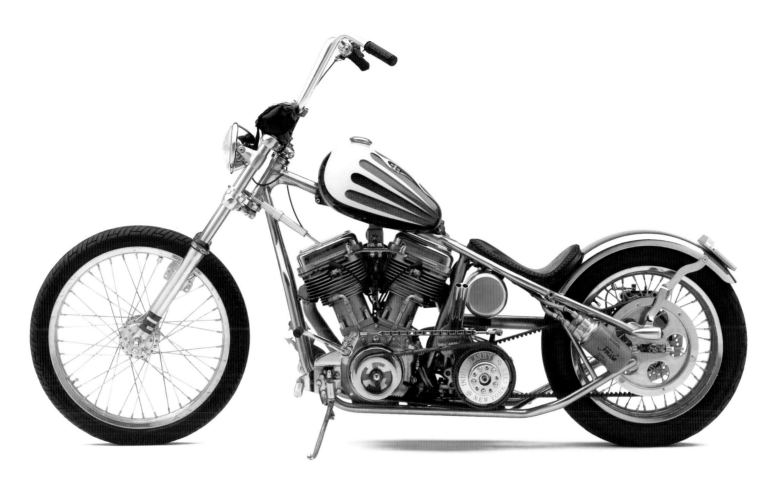

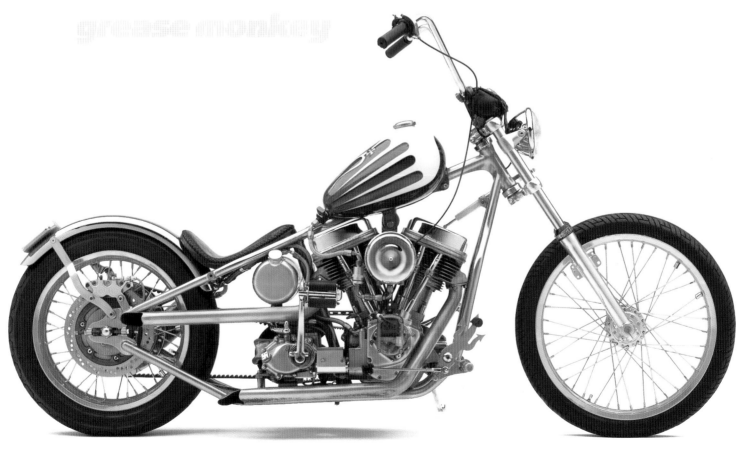

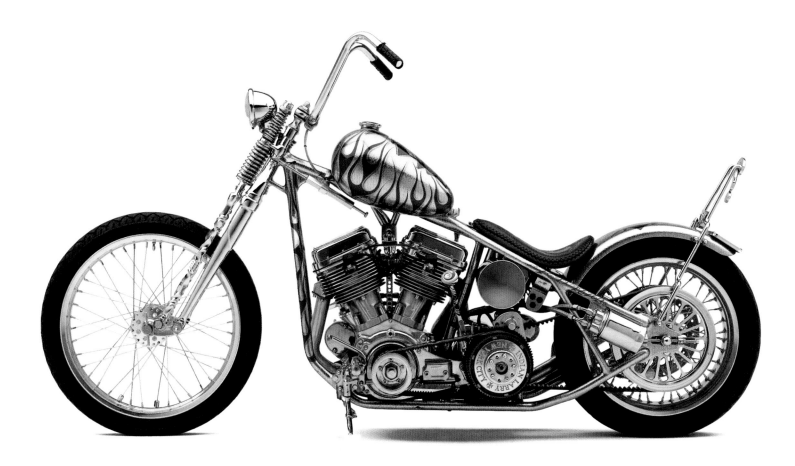

Larry fancied himself a kindred spirit of the movie character Forrest Gump. He implied that life, imbued with lyrical serendipity, had overpowered his worst impulses and carried him along as if on a wave. Having survived many bizarre turns of events, he thrived on his hope, anticipation, and wonderment. Larry embraced the idea of not contemplating his own fate — he didn't care to know what might turn out to be. In that frame of mind, he adopted a stylized question mark as his personal symbol and company logo.

One of a series of Larry's providential episodes began at the famous Woodstock music festival in 1969, when he shimmied up a scaffold to get a better view of the concert. He was photographed from below by an attractive girl to whom he waved hello. The resulting picture was published prominently in *Life* magazine with the caption, as Larry recollected, "The Highest Person at Woodstock."

By coincidence or by luck — or call it networking — Larry made acquaintances over the years with famous painters and photographers, some of whom depicted his tattooed demeanor in their own work. For instance, he met Andy Warhol through Robert Mapplethorpe, who was a neighbor in the Village. His modeling led to work as a Hollywood stuntman, with appearances in movies and on television. Larry became a virtual fakir who would as readily lie down on a bed of sharp nails to entertain his friends and create notoriety as hop on his chop and go for a ride. Larry made one exception in his contempt for clubs: he joined the Polar

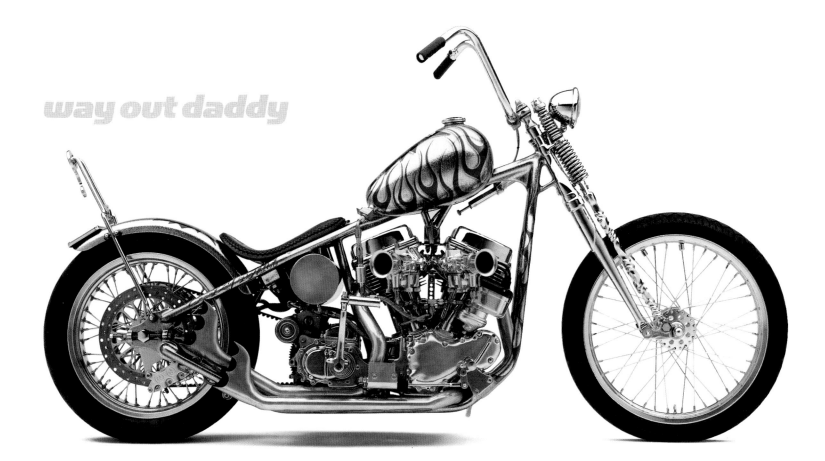

Bears of Coney Island to satisfy a penchant for swimming in icy-cold water. And he had been seen riding with groups as diverse as the Hells Angels and the Hamsters, although he was not a member of either club.

By the early 1990s, Larry foresaw a bright future in custom motorcycles, and his prescience about choppers in particular paid off. Larry recognized his work as art and nothing less. He was so confident that the issue for him was not what defines art but what defines a chopper, specifically an old-school chopper. That was his partiality. So what does it mean exactly?

Historically, according to Larry, extending the front end of a motorcycle was the rationale some riders used to gain speed with greater stability for drag racing in a straight line. For others, the extended rake meant greater ground clearance for tight cornering and off-road riding. Regardless, early customizers who cared less about cosmetics and more about competitive advantage, began to install antique Harley-Davidson XA-model forks — scavenged from World War II military surplus bikes — on more modern stock bikes to extend their length. The result was a bike frame that was not only longer but also higher off the ground. Ironically, many modern choppers are notable for how *low* they can go before their parts start to tickle the tarmac.

Despite this pattern of form following function, it turned out that function also lent itself to good looks. With the next logi-

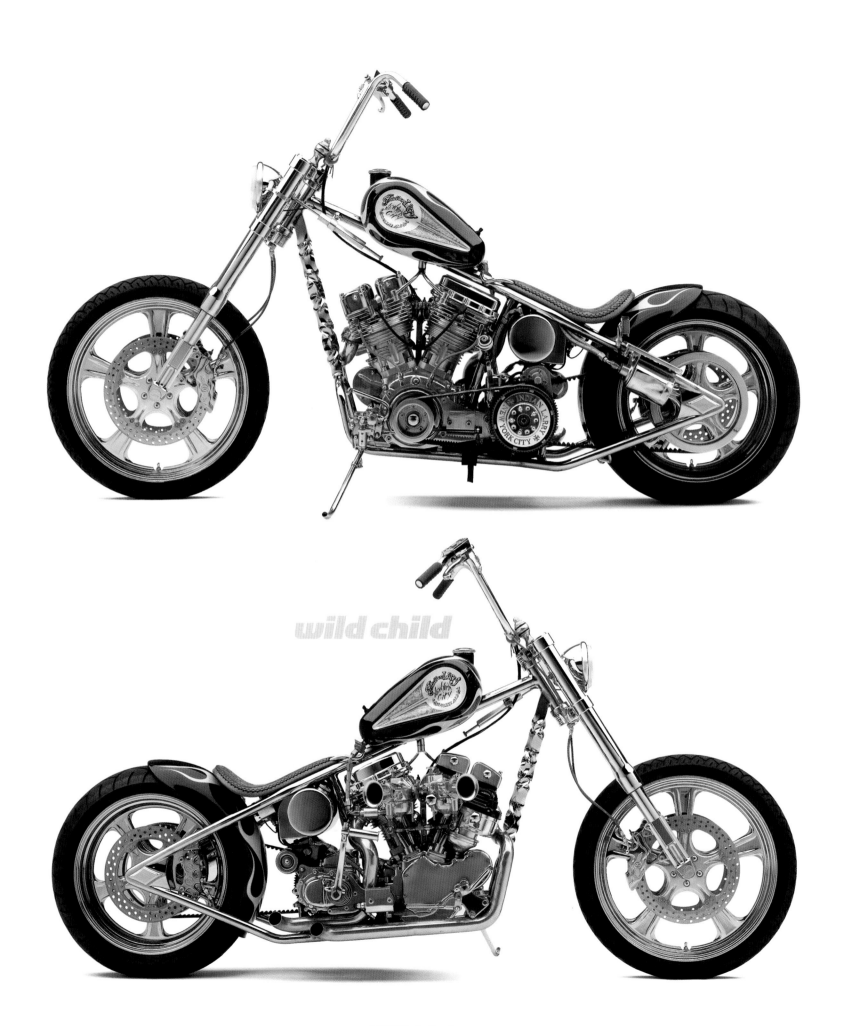

wild child

cal step in go-fast engineering, bikes were lightened, increasing their power-to-weight ratio by lopping off heavy sheet metal, resulting in a different look that caught on with customizers outside the racing circuit. Function began to take a backseat to form. "And then came the '60s!" Larry exclaimed. Riders who by then may have been sitting taller in the saddle were also high in another sense. Larry mimicked the insignificance of their revelations: "Hey! A two-inch rise on the forks; four is better! What about six? Wow! Let's do twenty inches over stock." The long-bike movement took off with a bong and then a bang, which was "complete bullshit" as far as purists like Larry were concerned. He thought chopper design had degenerated into a "pissing contest," as he put it. "Style? I don't think so." Exaggerated stretch, which had started out as a performance-oriented modification, had, in Larry's opinion, gone berserk.

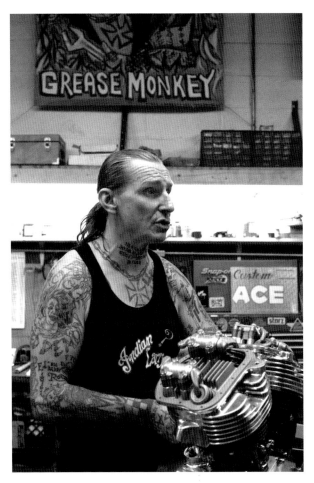

By 1967, mainstream American culture was introduced not only to choppers but also to hippies. The Summer of Love lasted for two whole years until after Woodstock and ended with the melee at Altamont in 1969, involving the Rolling Stones, the Hells Angels, and a mysterious murder victim. The film *Easy Rider* was released that same year. It really was the era of sex, drugs, and rock and roll, and riding a chopper was as good as a backstage pass.

"It's loud, and it's fun. It's about freedom. It was definitely a lure for women," said Larry. "A chopper is all about sex. Get a girl on the back of a bike, and it's just like that!" And he snapped his fingers. "Case closed." He qualified that testimonial as part of his freewheeling past. Since then, he got older and got married. "But I still chase girls," he said, without letting on if he could catch them. "My wife doesn't quite like it. But that's just who I am."

Larry's two obsessions had always been motorcycles and women. He expressed his philosophy about both in the same terms: "Strip 'em and stroke 'em! I don't like to lose my focus." He also offered, "There's a million guys out there with fancy-pants choppers who can't get laid with a hundred-dollar bill stuck to their forehead." But that was Larry the purist talking, not Larry the Lothario. He didn't care for poseurs on choppers, especially those who berated the idea of riding bikes without rear suspension — the classic chopper style in Larry's book. "In this country, men act like limp-wristed weasels," he said. "The slightest bit of discomfort is too much. And if they get wet: 'Oh, I'd better get a car!' " Larry was a mensch.

Larry set up his first shop in the Lower East Side of Manhattan in 1991 and called it Psycho Cycles. Ultimately, he needed larger digs and by the turn of the millennium had moved across the East River to Brooklyn. His new place went by the name of Gasoline Alley. But as Larry's name gained recognition, the shop simply came to be called Indian Larry. As his experience and reputation continued to grow, he remained true to his artistic integrity. His bikes remained unmistakably classical by design without

taking a reactionary approach. *Old-school* doesn't mean old-fashioned. Compared to those of some of his peers, though, especially young bucks with a radical bent, Larry's bikes look almost petite. But it would be wrong to say that. They are larger than life, as was the man who made them. Their effect on a rider's soul is inspiring. While on a less expansive note, his top tubes are closer to the ground, the front ends are shorter, and the tires are relatively skinny. Heaven forbid there should be a speedometer or gauge of any kind! "By the time the oil pressure is gone," Larry said, "you're wiped anyway." An Indian Larry bike is, in his words, "stripped down to the essence of what a motorcycle should be."

Larry had no disdain for decoration, though. He applied a number of signature touches to his choppers. For instance, he often painted graphics on an open primary belt, and there is always a suicide clutch and jockey shifter. Kickstarters make more than mere cameo appearances, but when Larry once broke his foot, he began to include electric starters, too. A sissy bar is the place to hang a bed roll and a jacket. CJ Allan's engravings on Larry's motors rival the hieroglyphic art of ancient Egypt. And it's a virtual Indian Larry trademark to have a Fram PH-4 oil filter hanging off the side behind the transmission, instead of being mounted conventionally in front of the crankcase.

He loved what he called the "gizmoness" of choppers. When it came down to balancing functionality with looks, you might say Larry preferred a functional look. Then there's the paint. Larry was big on '60s-style color and metalflake. Robert Pradke made it vibrant again. There is also a requisite hardtail frame, but always with some crazy-ass twist — literally. Larry could bend, snake, and twirl red-hot steel into such complex shapes that you might think he swiped an ornate wrought-iron gate and made a bike out of it.

Larry thought all of his bikes should be a cross between a Top Fuel dragster and a road racer. While looks were important, he would never sacrifice performance for visual effect. If a chopper's appearance interferes with its purpose, it is, as Larry would say, "nothing more than a cobbled-up contraption." He would tell you that if he gave a damn about pandering to public expectations, his bikes would be raked out like so many others seen on television — "ratings tools," he called them. Instead, he refused to be validated by other people's opinions. He would define his own criteria for artistic success. Ironically, of course, his own television exposure helped him to do that.

Larry's quest for the perfect bike was a metaphysical pursuit. He understood that perfection was unattainable, that it was a journey-is-the-reward kind of thing instead. "If I lived in the 1500s," he would say, "I'd probably be building cathedrals." He came to believe the hard way that a man's work was his spiritual recreation. He enjoyed imagining the possibility of a future archaeologist

discovering one of his motors and likening its intricacies to the inner workings of a mechanical universe created by an advanced but lost civilization. The motor itself became his cathedral. And Larry believed that the part of his soul that he put into the motors he made differentiated him from his fellow artists, many of whom he admired for their mastery of sheet-metal fabrication. He thought some of them should be making sailboats because their designs were so sleek. He also knew that some of the bikes he created, although built to be ridden, would wind up on display in private collections. As an artist, it pleased him to know that they would be preserved for posterity.

Larry experienced a spiritual bond with his machines that affected him more than the adrenaline rush of cheating death. He knew each and every part inside and out and gave his mind to the articulation of rocker arms, bearings, pistons, and the meshing of gears as he rode, not just in the shop. He opined, "I don't think a real chopper can be separated from the man who built it. It's almost like a meld of the two entities — a cyborg, man and machine."

Larry claimed to have slept rarely, insisting that though his body might tire, his mind continued to spin in high gear. He downshifted mentally by practicing meditation. And if he told you he could build a bike in his sleep, he meant it almost literally. In the wee hours, Larry might slip into what he called his "not-so-secret shop" under a stairway in the basement garage of the apartment he shared with his wife, Bambi, on Manhattan's Lower East Side. It was five feet wide and eighteen feet deep, chock full of tools. It was a sanctuary where he worked his magic on rip-snorting, dual-carbureted engines and felt comfortable wearing pajama bottoms and flip-flops to work.

Larry spent as much time as he could alone or with Bambi, who, true to Larry's predilections, had been an ecdysiast of some renown. That's not to say that he didn't enjoy people or that he shunned socializing. Despite his Lone Wolf reputation, one has to love people to be as well loved as Larry had become. In fact, as *Indian* Larry, which had become his professional persona, he gave himself to his fans, making himself available for as long as it took to shake every hand, sign every autograph, and pose for every snapshot. Larry cultivated his talent for selling himself to an audience. He was conscious of everything he said and did publicly in that regard. But there was nothing phony about it, for Larry recognized that he was as much in the business of being a celebrity as he was an artist. One hand washes the other.

Speaking of hands, Larry lost a finger as a kid, when he tried to build a skyrocket for the Fourth of July. Resembling more a pipe bomb, it exploded prematurely. His relationship with his father had deteriorated so badly by then that Larry felt better hiding his wound for weeks, bandaged in a sock, than allowing his father to learn what had happened by reporting to a hospital. Years

later, as Larry's torso became a canvas for scores of evocative tattoos, he had the letters *L O V E* stenciled below the knuckles of his right fist and, without room for a corresponding *H A T E* on his left, due to the missing pinky, he added *F T W* instead. To keep his temperament in check, he had four poignant lines painfully etched across his neck:

IN GOD WE TRUST

AENGEVNCE IS WINE

SVAELH LHE FORD

NO FEAR

The two middle lines were inked backward so Larry could read them while shaving in the mirror every day.

In recent years, the former inmate spent more time behind bars — handlebars, that is — than ever before. He thought riding a motorcycle was the closest thing to flying without the trouble and cost of owning an airplane. And he could take off anytime without filing a flight plan. His celebrity status allowed him to visit and ride in parts of the country he had never seen; he particularly

enjoyed blasting through a place called Storm King Mountain in upstate New York that provided him with treacherous switchbacks and plenty of steep precipices for sport. But Larry refused to be labeled a daredevil. "A daredevil," he said, "takes uncalculated risks." On August 30, 2004, in front of eight thousand fans at a rally in Concord, North Carolina, he forgot that distinction.

Larry was exhausted after an all-night-long ride to the event. He had had even less sleep than usual. As the day wore on and the sun beat down, it became one of those oppressively hot, languid, sticky Southern summer afternoons, when you could feel the energy evaporate faster than the sweat from your dripping brow. But Larry was a hardwired romantic. As impractical as he was courteous, he refused to evade his admiring fans, who, once they found him amongst their throng, bounced him back and forth like the steel bearing in a pinball machine as they vied for his attention.

Under such circumstances, one can see how Larry might have forgotten to take a drink of cold water or sit down for a spell in the shade. By the time he was scheduled to entertain this uncompromising crowd with his signature stunt, he was running on empty.

The stunt was to ride a motorcycle while standing on its seat, which means maintaining a steady clip after accelerating to an optimal speed. You have to go just fast enough to remain stable, just long enough to do the trick, so to speak. Too slow, and a big, heavy chopper starts to wobble like a kid's bicycle, unable to stay balanced.

Larry knew that as soon he stood up and released the handlebars, he needed plenty of room ahead. Not wanting to disappoint the crowd, though, and with fatigue perhaps clouding his judgment, he chose a course too short to lock the throttle up to speed. With a staccato burst of acceleration, barely enough to sustain his leap onto the saddle, Larry passed his friend Paul Cox, who noticed that Larry's stance was awkward and his expression unresponsive to imminent danger. He was poised in a daze atop his chopper called Grease Monkey, with arms outstretched like a crucifix. The bike slowed to a snail's pace, and Larry's lethargy took its toll.

The bike lost its forward momentum. Larry, stepping off not a moment before the quavering bike tipped over, landed on his feet and made an awkward twist to one side, as if he had slipped on ice or in the bathtub. His feet went out from under him, and he hit his head hard on the ground. That was the end of the show.

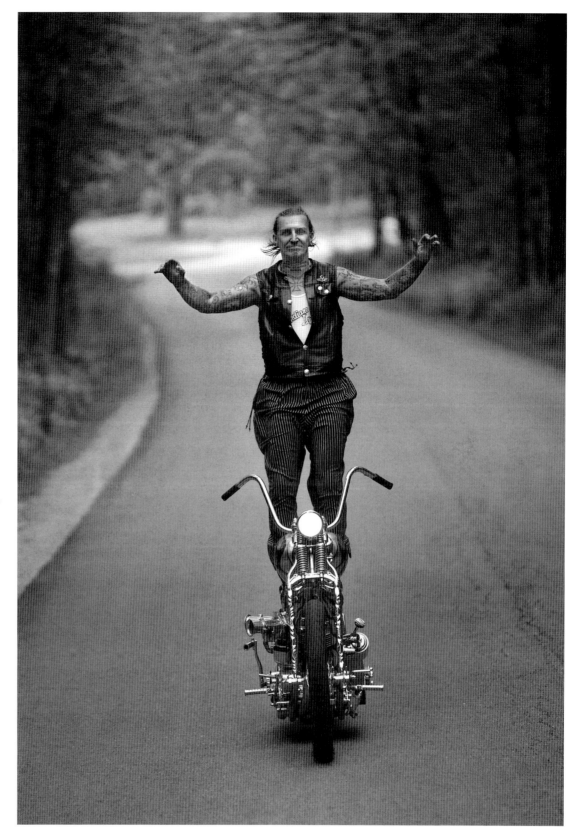

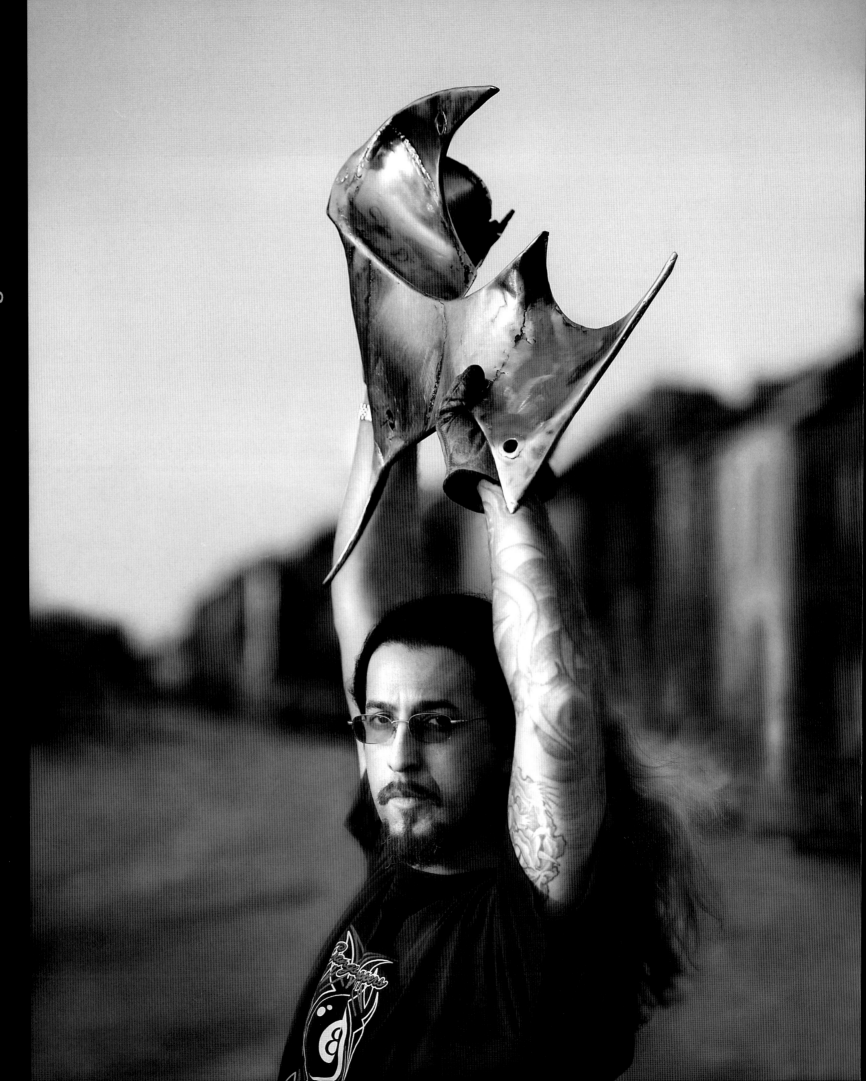

How many Belgians can you name? Don't waffle, now! There is a fictitious detective, Hercule Poirot. Great painters include Peter Paul Rubens and René Magritte. Action-film star Jean-Claude Van Damme is known as "the Muscles from Brussels." Leo Baekeland invented plastic. Gerard Mercator made the world flat again by projecting the globe onto a map, and Adolphe Sax created an instrument that helped define the genre of jazz.

Belgium also hosted Napoleon's defeat by the British at Waterloo and is today the headquarters of a modern military alliance: NATO. Okay, motorcycles! Roger DeCoster is the king of motocross. Jean Joseph Etienne Lenoir invented the internal-combustion engine, and Edward de Smedt invented asphalt for paving roads. Where would bikers be without Belgians? Their tiny country situated between France and Holland, with a population the size of New York City's, has also given us Alain Libioulle, simply known as Alan Lee.

By his definition, uttered in unmistakably French-inflected English that barely unties his tongue, "A *shop-air* is a motorbike — I mean two wheels and a motor in the *meedle* — *weeth* maximum, as possible, artistic touch." Examples from the 1970s seem splendidly "delirious" to Lee's analytical eye, their style no doubt influenced by the hallucinogenic atmosphere of the times. These bikes, he jokes, amazed the police as much as they amazed their admirers. As a boy in Europe, far from the psychedelic American experience, he never witnessed the phenomenon firsthand. But those choppers were the antecedents of an art form that erupted in Europe a decade later and ultimately kindled his own interest.

When America's exported chopper style became an underground sensation in northern Europe, it underwent a transformation. "We have a different vision of the chopper, that's sure," says Lee. He maintains, for instance, that fat back tires were a German and Dutch innovation of the early 1980s, ultimately sent back to America.

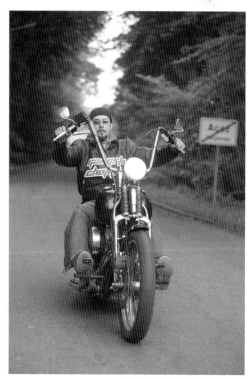

Lee is influenced by architecture and painting. Coincidentally, another Belgian, architect Victor Horta, invented a style that came to be known as art nouveau in the nineteenth century. Horta imbued man-made objects with natural grace, while Lee has imposed a similar style on motorcycles. "That's the simple way to take something from the natural — I mean a flower or part of a tree — and try to put something back like a coffee cup or a table — or a motorcycle." In other words, Alan Lee would rather chop metal until it resembles the organic forms he sees in trees than literally chop one down to make something.

When Lee begins a project, there are no sketches to go by and no comparisons with existing choppers, not even a similar frame or gas tank. He simply begins and expects to finish

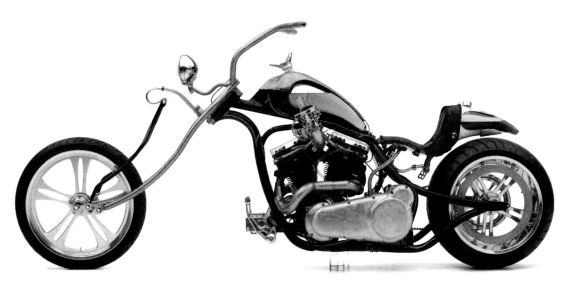

molotov cocktail

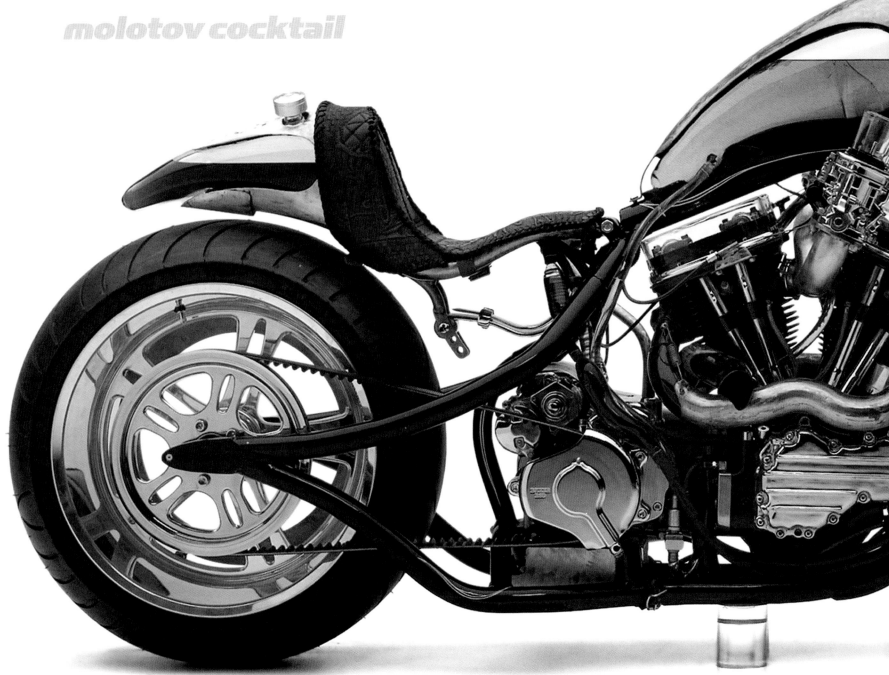

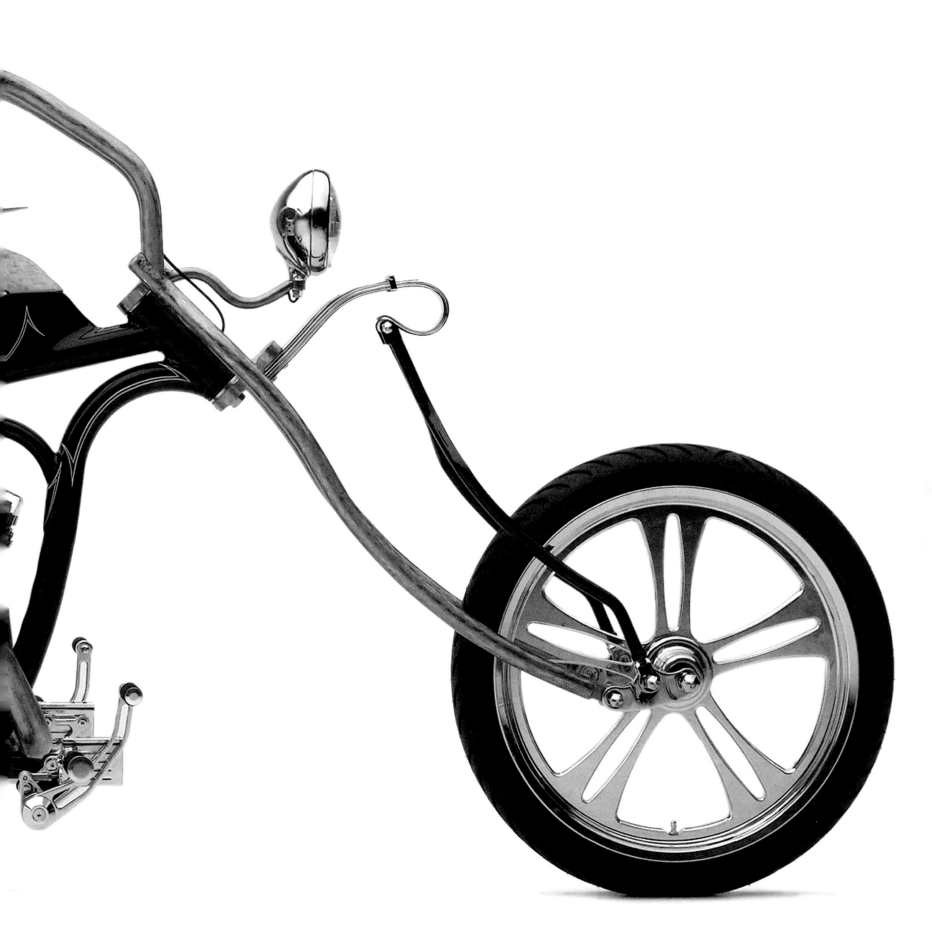

while an idea is still fresh in his mind's eye. The pieces he makes must keep pace with his thoughts or be abandoned. "My bikes are difficult to make," he admits, "but it's me against the bike, and the bike cannot win."

The resulting shapes are fluid but not as symmetrical and smooth as, say, a Matt Hotch example. Yet being evocative of natural forms, they bring animals to mind. "For example," says Lee, "one looks like a bulldog or a dinosaur. One looks like an insect or

a deer. My new one looks to me like a bat." Individual parts he sculpts for each bike resemble primordial fossils but from a planet that evolved creatures with skeletons made of steel.

Artistic creation, as Plato perceived it, is a form of inspired madness. Art is two steps removed from reality, meaning that whatever act or thing inspires an artist is one step removed. That which is real is no more and no less than an ideal, not real in any sense but the imagination, as compared to whatever manifestation of reality is revealed by an artist. Art is, literally, artificial. You may think Plato is one olive removed from a Greek salad, but this way of thinking profoundly affects the motorcycles Alan Lee makes. "I'm not an inventor. I just do what I want to do. I'm happy not to be a copycat," he says. Indeed, his motorcycles are a step removed from reality. They not only epitomize chopper style but also represent ideals of geometric elegance, reflecting naturally occurring beauty. His initial effort was featured on the cover of every European motorcycle magazine.

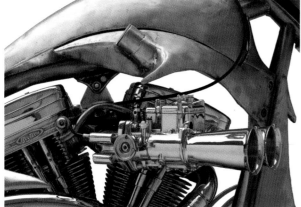

Getting started was "an extreme personal idea, to do something for me," Lee explains. In 1999, he was running a modestly successful auto-body business in Liege, specializing in Italian sports cars. He had already learned to express himself with a welding torch as well as any sculptor does with a chisel. And the wind, he says, was blowing him in the direction of becoming an artist. As such, he could create motorcycles from scratch to demonstrate his own brand of organic grace combined with rugged eccentricities and put his name on them, whereas a Ferrari is still a Ferrari and a Ford is still a Ford, no matter what you do to it. So motorcycles it was. "Right now," he says, "it's interesting for me. I'm not stuck in that. Maybe it's something different in the future."

Lee's business experience will help him, he chides himself, "to think about things on earth and not be an artist on his cloud." He also relies on his experience as a soldier, having served in the Belgian Army's special forces for two years, learning self-reliance and allegiance to authority. But authority, for him, has always been a double-edged bayonet. Especially in Europe, his involvement with motorcycles meant unavoidable association, but not affiliation, with motorcycle clubs.

"In clubs you find lots of strong people, one hundred percent sure they are right," says Lee. "And they just screw the rest of

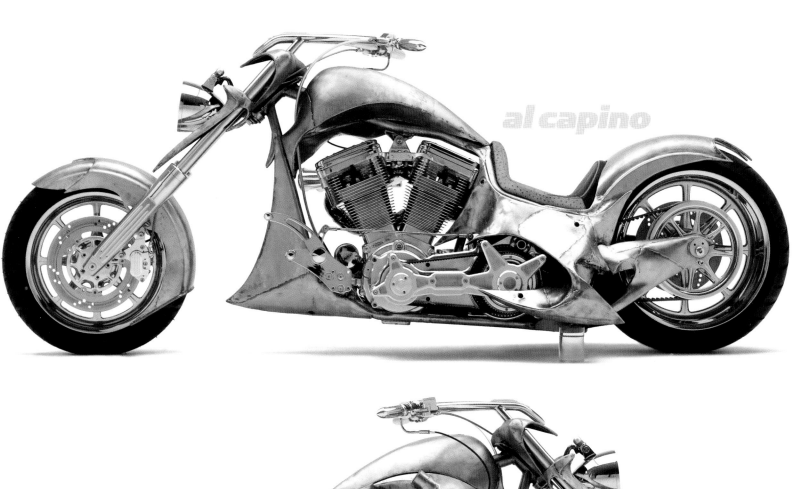

al capino

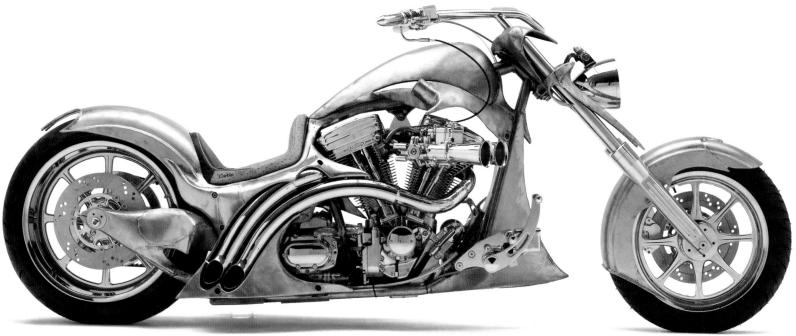

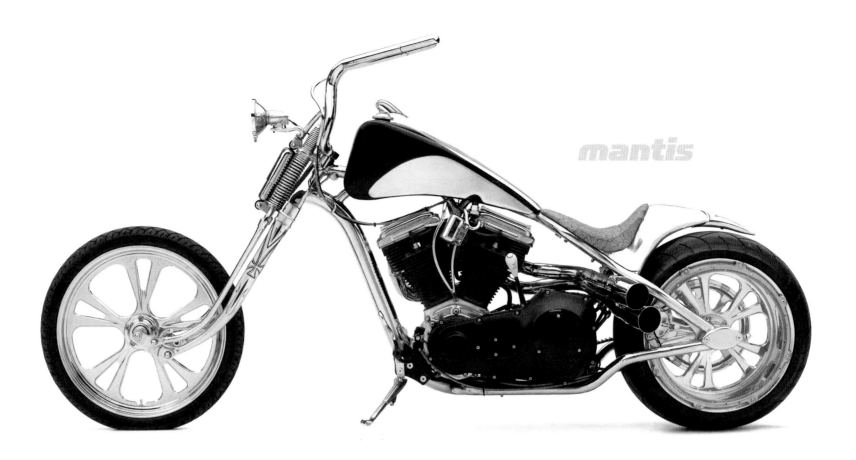

mantis

the world." Their odious relationship with the law is pure tribalism. The cops are simply competition, and the distinction between a

patch and a badge is often blurred. Lee knows that by winning the respect of these guys, he can rely on them to leave him alone.

Lee says, "I'm not a member. It's a difficult life. It's more than a duty. You are a member twenty-four hours a day, seven days

a week." For an independent-minded person, an entrepreneur like Lee, it would be impossible to pursue any kind of individual suc-

cess in a club. A club subsumes its members, who think and act for the collective. Loyalty is valued above all other virtues. Violate

that trust, and you will be punished severely. That kind of discipline, in spite of the fact that it is the source of their strength, scares

people away. "My life is different from their life. We cross paths. That's all."

People have a tendency to attach labels to virtually everything, to other people and the work they do. We have, for

instance, French cooking, Italian shoes, and Swiss clocks. There are Swedish choppers, old-school choppers, bobbers, and so on. It

used to be that a bike exhibiting copious bodywork, as some of Alan Lee's own work does, wasn't considered minimalist enough by

some pundits to be called a chopper. But Lee says, "If a guy comes into my shop and asks to look at my 'chopper,' I'm not going to

say [*gruff voice*] it's not a chopper! [*disgusted mutter*] I just don't care. Chopper. Not chopper. Piece of art!"

Lee does not consider himself a mechanic. If something is broken, he can fix it. If something exists only in his imagination,

he can make it. But as an artist, he will tell you, "I take a motor, and I build something *around* it." He admits he is less adept with

horsepower and would like to learn some more tricks of the trade. And he will. "If I want my ideas to become reality," he says, "I

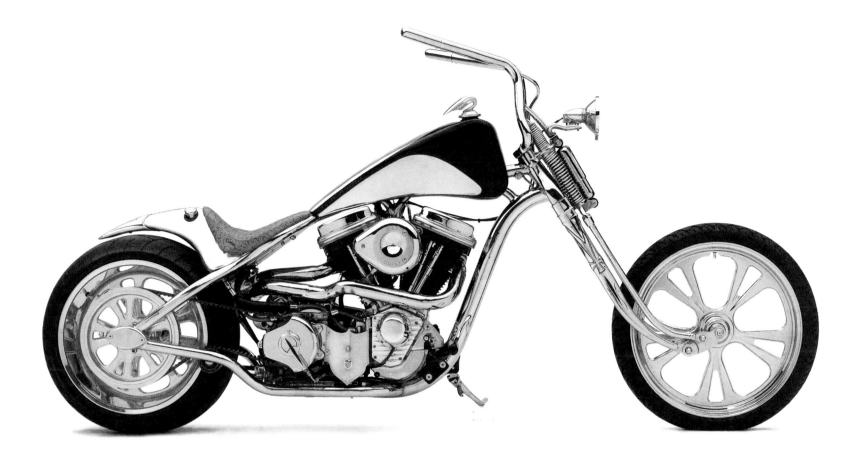

have to do all the work myself. I need to know how." Still, the mechanical aspects of a chopper are of secondary importance to him compared with style.

From the day he abandoned his auto-body business in Liege, Alan Lee has been dead set on moving to Southern California, because it is the traditional hotbed of hotrods, both the two- and the four-wheel variety. He never set up a storefront bike shop in Belgium. Instead, working in a friend's garage with intermittent help, he raced against time, battling stress and fatigue, to create a body of work that reflects the many ideas vying with one another to burst from his head. He set out to build a small collection of choppers that would establish his name and make it possible for him to thrive in America. He and his girlfriend, Calypso, struggle together, living like gypsies.

Lee feels compelled to leave Europe because there is little tolerance for nonconformity there, and nonconformity spells *chopper*. It is illegal to ride a motorcycle with a tire wider than stock in Italy. Open primaries are *verboten* in Germany. In Sweden, you will find a plethora of choppers with ancient Panhead and Knucklehead motors, not just because they're cool but because the authorities recognize that if you ride an Evolution motor in a rigid frame, it is incongruous with a stock Harley-Davidson. The *snuts* will not let you ride it. In Sweden, a softail chopper, one with rear suspension, is

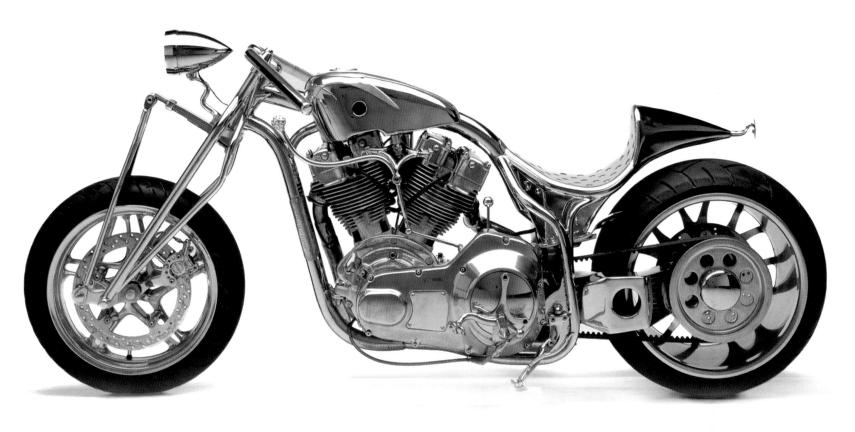

chrome magnum

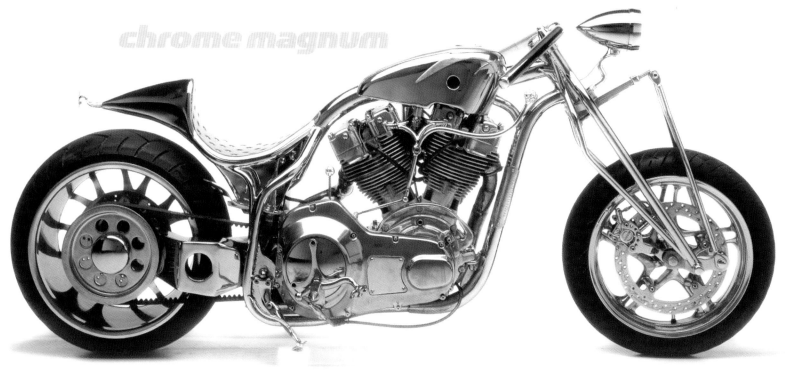

an oxymoron. Some European countries charge one hundred percent import duties on bikes and parts from the United States and elsewhere. And as for taxes, Alan laments, "You have only the right to keep your eyes so you can cry."

Alan was born in 1967 in the city of Namur, an only child. His parents moved often from one town to another to accommodate his mother's job. She managed a chain of delicatessen-groceries throughout southern Belgium, near the French border. His father was a journeyman construction worker who, for Alan, "didn't especially exist." He wasn't abusive, just more self-indulgent than ambitious. Alan recognized during his rebellious teenage years that he needed a stronger role model. Ultimately, it became the army.

Before Alan's birth and during a previous marriage, his mother lived in the Congo, then a Belgian colony in Africa. There she took up painting to while away her time on a cotton plantation. Years later, she taught Alan how to paint, to keep him occupied and out of trouble. Thus began his interest in art.

Ahead of his schoolmates academically, a jaded Alan left regular classes at the age of fifteen. He enrolled at a trade school to study drawing and painting instead. He was younger than all of the other mostly delinquent students. Such schools in Belgium are apparently where problem kids are sent "to not disturb the teachers," as Alan recalls. It was a warehouse for troublemakers, most of whom were three, four, and five years older than Alan. They were virtually adults, driving their own cars. Alan was still riding a bicycle. When he opened his mouth in class, it was "Hey, kid, shut up!" He told his mother he didn't want to go to this school anymore, either. She told him to find a job.

He found work right away in a body-repair shop. At first Alan was excited, because he had enjoyed reading American magazines about custom cars and admired the fancy airbrushed paint jobs. This is what he thought he would learn. His was a rude surprise. It was all grease and no glamour for the young apprentice. He stuck it out anyway for a few years until he was nineteen and ready to fulfill his military service obligation.

When Lee got out of the army, he was twenty-one. It was 1987, and he just "scratched his nuts" until the spring of 1988, when he came to America for the first time as a tourist. He traveled alone by bus for three weeks from New York to Florida. Later, back in Belgium, he bought his first Harley-Davidson, a well-used 1977 Shovelhead in reasonably good shape. But the first thing he had to do was change out the stock handlebars for narrower drag bars so he could fit it through the front door of his parents' house in Liege. He worked on the bike in the corner of a small room. His task: to make it cool. Off came lights, fenders, license plate, turn

signals, brakes — you name it. Alan took the bike out for a trial spin and failed to stop for a red light for the simple reason that he hadn't yet reinstalled the brakes. He was stopped by a cop, literally, who grabbed him by the shoulders while still rolling — not too fast, we presume. For the thirteen infractions in addition to his lack of brakes, the irate gendarme threatened to confiscate the bike. As far as Alan was concerned, that meant it would be mishandled at best and pilfered for parts at worst in a corrupt impound yard. So this strong-minded, young special forces veteran girded himself for a showdown and insisted that if the cop tried to take his bike, there would certainly be an arrest for something more severe than a traffic violation. Reason prevailed, and Alan was allowed to arrange for a van to bring the bike home.

He knew he was in trouble — either a big fine with a suspended license, jail time, or both. But one evening, after several weeks of sweating out the consequences with his lawyer, the sympathetic policeman bragged to an acquaintance about having nailed a young biker to the wall for multiple traffic violations. The acquaintance happened to be the father of Alan's best friend. A favor was arranged. The citation for Alan's rather obtuse misdeed disappeared in the bureaucratic mire. The cop himself called Alan to tell him about his good fortune. The two remained on good terms after that.

About this time, Lee found a job working for a large company. But he was too full of piss and vinegar and focused on his own ambition to survive in a corporate culture. He got out fast and hustled from one job to another. He even worked as a fashion model successfully for several years until he crashed a Ducati and had to stay off his feet for a while. Modeling had been a wonderful experience for him. It pulled him out of the seedier side of society, allowed him to meet alluring women, and offered him a glimpse of the glamorous life. He moved on, buying and selling used Harleys for a dealer in Brussels. Eventually, in 1991, he opened the aforementioned body shop but got out after ten years of haggling with cheapskate customers who owned expensive cars. Their egos were as big as their bank accounts, but their characters didn't measure up. Next, he opened a Harley dealership in Waterloo. With the automotive skills he acquired, he began to work on bikes again for fun. But running a dealership meant bolting parts onto new bikes and glad-handing customers. There was little time for fun, and it seemed like a dead end for an artist. Anyway, he had partner troubles. By the next year, 2002, Lee sold his interest in the dealership and devoted himself to building a motorcycle according to his dreams. He was a free man. He took his first completed bike, Chrome Magnum, the same one featured on all of those European biker magazines, to the Rat's Hole show in Daytona Beach in the spring of 2003, and it debuted equally auspiciously. It was illustrated in the introduction to the first volume of *Art of the*

Chopper, where it was seen, sought after, and purchased by movie star Brad Pitt. Alan Lee's new career had taken off.

Lee dreads the day when "true artists" are forced to "make a thing that looks like a motorbike to let people remember what was a motorbike." He says he's not smart enough to conjure up an idea of what the future portends. He just hopes it will still be possible twenty years from now to ride an "amazing vehicle" without government restrictions relegating all existing choppers to historical relics. He doesn't want characterless air-quality codes that don't account for the negligible impact of these machines on the environment to forbid the further creative evolution of the art. On the other hand, he is sanguine about the inevitability of progress. "With no progress, we are looking only at bikes from the 1970s today."

Part of the art of the chopper is the tradition of a V-twin, air-cooled motor. Lee explains, "You feel different when you drive a Harley from when you drive another bike. The noise; the vibration; it's really alive. When you drive your own chopper, made by yourself, it's a bigger experience than when you drive a stock Harley." He is concerned about the way the political winds are blowing — regulations, statutes, rules — even in America. Especially in America. But he believes it is the responsibility of every individual entrepreneur in the motorcycle industry to look in different directions to sustain his own survival. "Like a rodeo cowboy," he says, "you stay on your horse no matter that it tries to buck you off. You circle around in all directions. You go up and down. If you die, you die with your boots on."

"A chopper is a motorcycle that has been modified — period," declares Scott Long. That definition leaves a lot of wiggle room. Long fills it with a singularity of style that transcends even his own diverse approach to chopper design, which runs the gamut from funky hotrod to slinky sled.

Actually, the word *modified* itself is too subtle to convey how a mere motorcycle becomes a chopper. The distinguishing characteristics are more than faint. *Transformed* is better. After all, a cake bears little resemblance to its ingredients. Long makes a distinction, as do all accomplished practitioners of the art, not only between choppers and ordinary motorcycles but also between *custom* choppers and run-of-the-mill varieties including that oxymoron, the "factory chopper." The inimitability of a custom chopper relies on the tried and true tenet of every artist and engineer: The whole is greater than the sum of its parts. With that in mind, a design must never accommodate the parts; the parts must accommodate the design. The whole idea of a custom bike, and of paramount importance to its owner, is that it be like no other. "If it doesn't make your heart skip a beat when you first see it, it's not a chopper," says Long. "It's just a rearranged conglomeration of parts."

Long says, "A *custom* chopper starts with a clean sheet of paper." He begins each project with a drawing derived entirely from his imagination. From that comes the fabrication of sheet metal and tubing, then the requisition of ancillary components from nuts and bolts to brakes, hoses, tires, wires, and powertrain. If the right parts don't already exist, Scott Long will make them.

Once the hardware starts to take shape on a lift, like a work of sculpture on a pedestal, Long says, "it starts talking to me. It starts asking for certain things." It may demand a change, say, in the dimensions of a gas tank because its lines don't flow as expected with the geometry of a given frame, or conversely, Long may reshape a frame to favor the tank. At that point the engineering and fabrication expertise of Harry Cournoyer and Darin Morris comes into play. Their contributions may sometimes steer the evolution of a chaste blueprint in surprising new directions. Each project is a collaborative exercise of experimentation leading to invention.

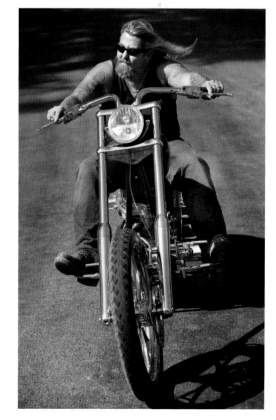

A chopper is an extravagant thing. It is designed to be noticed. "If people don't want to look at it," says Long, "then I've wasted a lot of time." But he doesn't feel a need to beat people over their heads to gain their attention with loud, crazy paint jobs or by twisting exhaust pipes into pretzels. He prefers a subtle approach. "When you look at one of my bikes from a distance, you might say, 'Oh, that's pretty cool,' as it draws you in. But the closer you look, the more you see details and subtleties." As do many of his peers, Long will sometimes use tricks of the trade to make humdrum components, such as a motor mount, a fender brace, or cabling,

less conspicuous. In fact, many builders enjoy fooling less sophisticated critics who wonder how a bike can run at all, since they

can't readily see electrical components, clutch and brake levers, a throttle, or even a carburetor. Although Long entertains himself

by hiding crucial parts from self-anointed mechanical experts, he may opt to highlight an otherwise mundane component by imbu-

ing it with special character to *draw* attention. That notion goes beyond the old-school philosophy that emphasizes the mechanical

aspects of a bike for the sake of illustrating how form follows function. Long's unexpected and sometimes understated twist on the

design of any given part may make it the defining element for a chopper with a decidedly modern flair. But sometimes style can get

in the way of practicability, such as when a bike's profile begs for an itsy-bitsy gas tank that doesn't have the capacity to carry a

rider as far as the next saloon. It is a hard call. But Long may defer to his patron's preference in that case, because it would not be

good to hold up other riders by stopping for gas every forty-five minutes. The customer is always right!

Long enjoys the looks of vintage choppers from the 1960s, the ones that the Hells Angels were riding then. He

says they didn't have overly extended front ends because they wouldn't have been practical for

splitting lanes on the San Francisco/Oakland Bay Bridge going

seventy-five to eighty

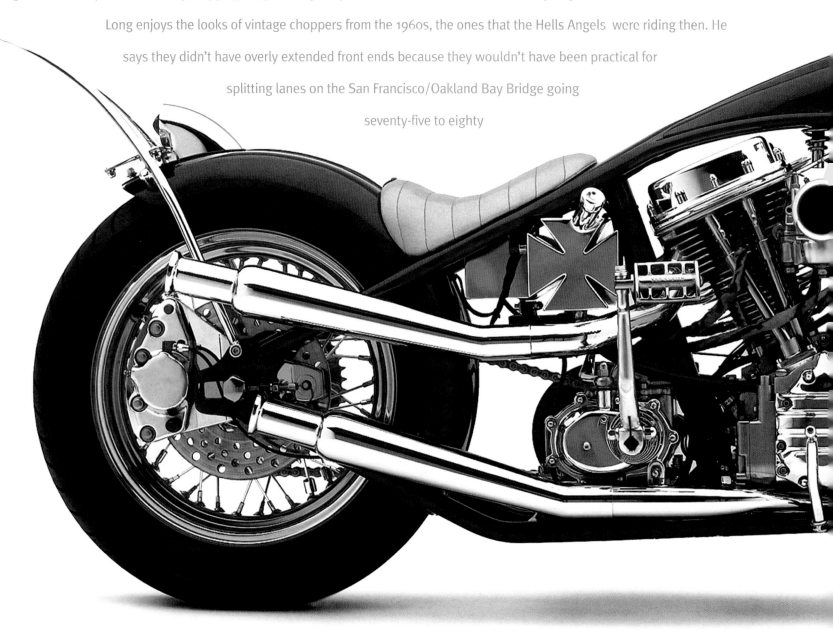

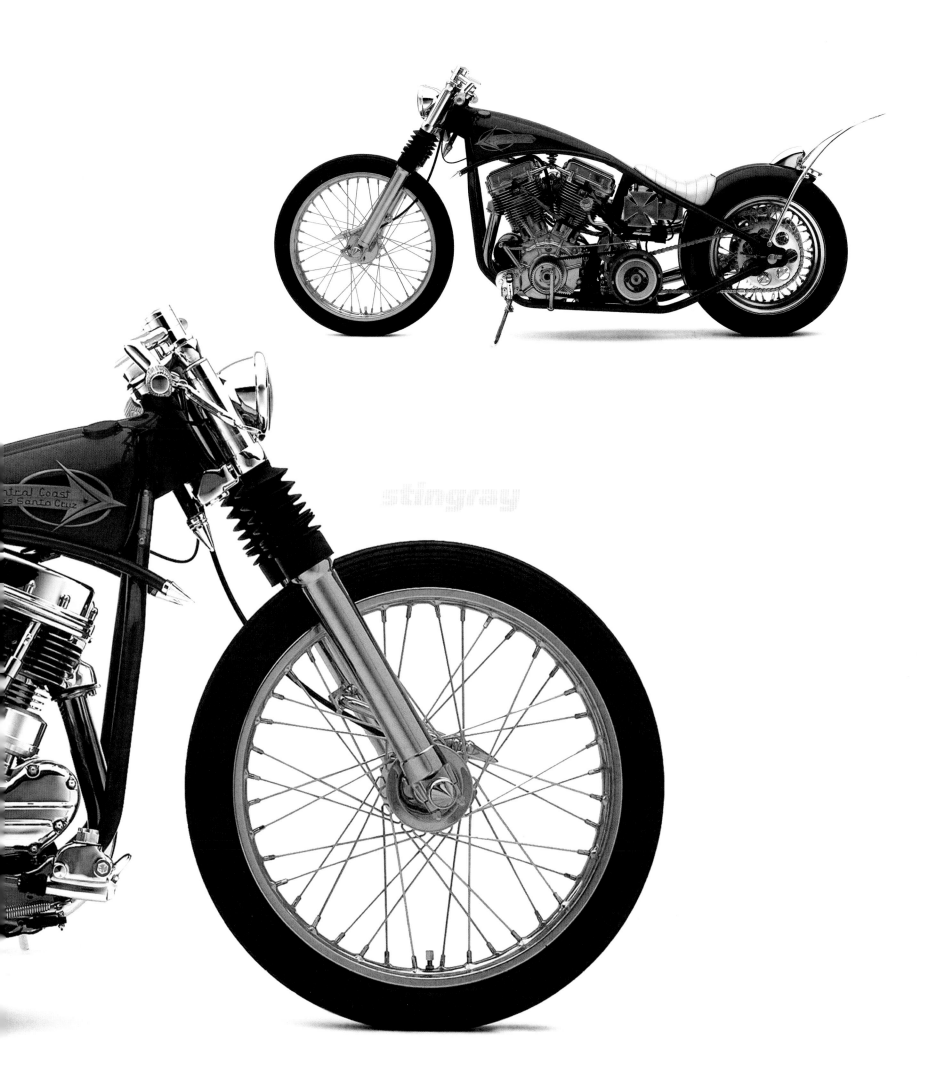

stingray

miles per hour. Today, Long says, he likes to ride fast and hard. He insists that the bikes he builds will accommodate that demand. Some of the most enjoyable rides Long has ever made have been right in his own backyard, in the hills behind Santa Cruz and along central California's Pacific Coast Highway. He is also fond of a ride he once made wearing shorts and a tank top through Beartooth Pass in Yellowstone National Park on the way to Sturgis. "It was like a video game," he says. "You have to be in the right mood for it. You just keep picking off more riders and get more points."

In the late '90s, Long was riding a '66 Shovelhead. It was an okay-looking ride and all hopped up, but he got bored with it after a while. It was like so many other bikes on the road. He thought he could make himself happier by building something from the ground up. The bee was in his bonnet. He did his homework, sketched the dimensions of a frame, and gave it to a buddy to fabricate. He found a fat tire and some wheels through an existing acquaintanceship with Billy Lane. Whatever work he could not do at home in his own garage he farmed out from shop to shop both locally and not so locally. That proved to be an exercise in frustration, as he paid deposits to vendors and waited interminably for parts to arrive.

Poor service, Scott discovered, was endemic in the motorcycle business. Since his existing landscape-contracting business had grown successfully by bringing many services in-house for his customers' benefit, he thought the same principle would apply if he opened his own custom motorcycle shop. The planets and stars must have been aligned, because he found a local shop for sale with lots of machinery and the right zoning permit to boot. With the availability of Cournoyer and Morris to help run the place, Long snatched it up.

Central Coast Cycles in Santa Cruz, California, opened it doors in 2001. Scott Long and his crew have the capacity to build six to ten custom bikes per year in-house. Long will make sure that at least one of them becomes what he calls a "shop bike," a project over which his own imagination reigns with no pandering to the whims of any client. That's called R&D in the custom bike biz, because working with customers introduces inherent and obvious constraints.

Long says that CCC has done "a lot of weird stuff" to please patrons. The process usually starts with an incoming telephone call and a disclaimer: "This may sound like a stupid question, but can you do . . . ?" In his office, Long keeps a library purported to contain every issue of every motorcycle magazine printed since the 1960s. He encourages customers to take copies home with them to look for examples of what they like and don't like, to communicate more effectively with him during a design conference. "It cuts down the learning curve," Long says. Sometimes a customer comes up with an idea that Long would never use on a bike if he had his druthers. But he understands how a feature can be freighted with personal significance for the person who wants it. And again, the customer is always right. "They write the checks," Long reminds himself. But he adds, "You can only talk them out of so many different things." Regardless, every modification has to be both safe and functional. "If the owner plans to trailer his

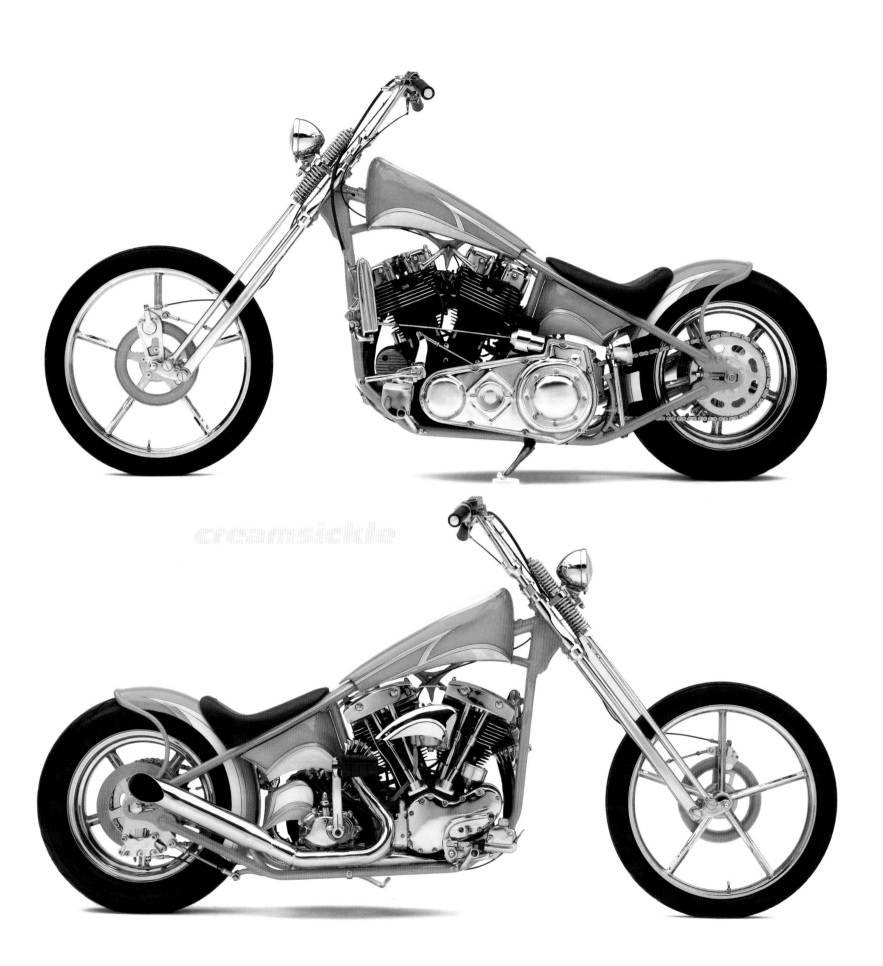

creamsicle

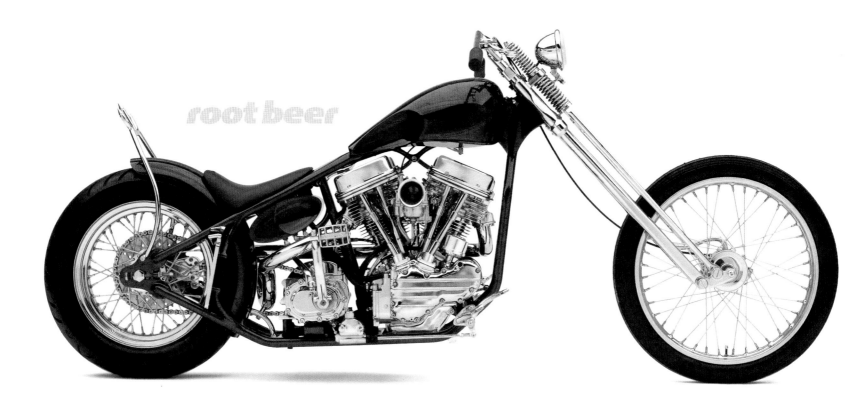

root beer

bike between parking-lot shows, that's one thing. But if someone is going to throw a leg over it and ride from California to Sturgis, not only does the bike have to survive, but so does the rider."

The price of a bike depends on "how creative they want us to be," says Long about his customers. "We want to give them a bike that they're going to be really happy with and that we're going to be happy with, too." But it's tough to build a bike on the cheap. If Scott's resources are tied up for several days fabricating a gas tank, it will look like no other gas tank ever made. Yet one-off craftsmanship costs real money. "The days of the $25,000-to-$30,000 bike are gone," he admits. Count on twice that amount as a starting point.

Long is uncomfortable with being labeled an artist. In fact, he wonders if *visionary* might be a more appropriate title, if not still too affected. Certainly, he believes that his motorcycles exist as works of art. But he doesn't see himself living the lifestyle of an artist, at least not as he imagines it typically to be. In his mind there are many miles between a helmet and a beret, and he wonders if the "biker mentality" is congruous with that of an aesthete. Lest it be forgotten, Scott is indeed a biker through and through. Until recently, he wore the colors of the Ghost Mountain Riders, a bunch of rough-and-tumble, raggedy-ass, good old boys. His member-ship in the club contributed as much to his cultural identity as the kinds of bikes he rides. "Otherwise," he says, "I'd ride around on a Heritage, a Road King, or a Fat Boy." As his burgeoning business has demanded more of his time, he has regretfully relinquished his formal affiliation with the club. He still hangs out from time to time.

But there's another side to Scott Long that makes his identity harder to pin down than to characterize him as either a biker

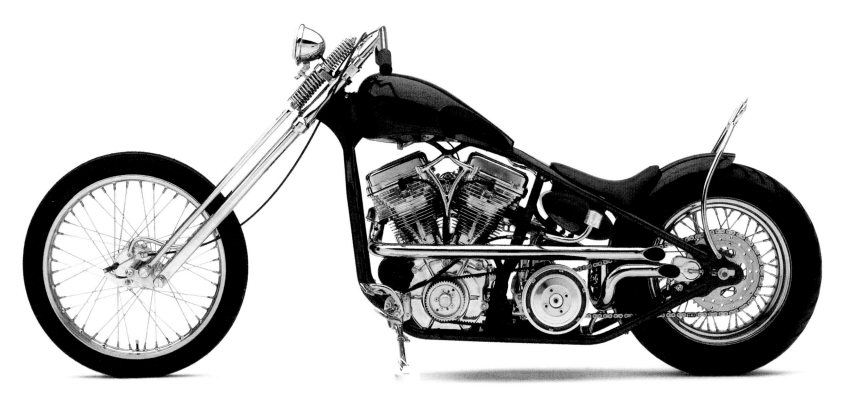

or an artist. His landscaping enterprise caters to the upper crust of Silicon Valley society. He is the doting father of two teenage children, and his beautiful wife, Sue, has stuck by his side since their high-school-sweetheart days. Their son, Cameron, is a musician and their daughter, Chanel, has already begun a successful fashion-modeling career while still in high school.

Like many people attracted to motorcycles, Long lives life large. His initial enjoyment of riding motorcycles led to professional racing. Road-course racing was out of the question, because he was physically too big, so he made a competitive name for himself with dirt bikes and motocross. Later, he pursued the nitro life, piloting Funny Cars down the quarter-mile at breathless speeds. The danger didn't exactly please Sue — certainly no more than the tattoos he began to sport as the cult of custom cars and motorbikes took hold of him. "She got over it," he says. The tattoos, by the way, are a long-standing work in progress. Scott doesn't know anyone who rides who has only one tattoo.

Long has other hobbies. He keeps his burly body in imposing condition by weightlifting and practicing Brazilian jujitsu, a grappling and ground-fighting sport. He has an abiding passion for street rods, too. Although he can't find enough time these days to dote on four-wheel machines, he still dreams about the "ultimate lead sled," which, he says, "to me is a '49-to-'51 Merc that's so chopped the only thing you can stick out of the window is your elbow." He already has a '64 Impala lurking in the garage at home that is so low the potholes come up to him.

Scott Long was born in 1959 in Whittier, California, a suburb of Los Angeles. His father was a task-force commander with

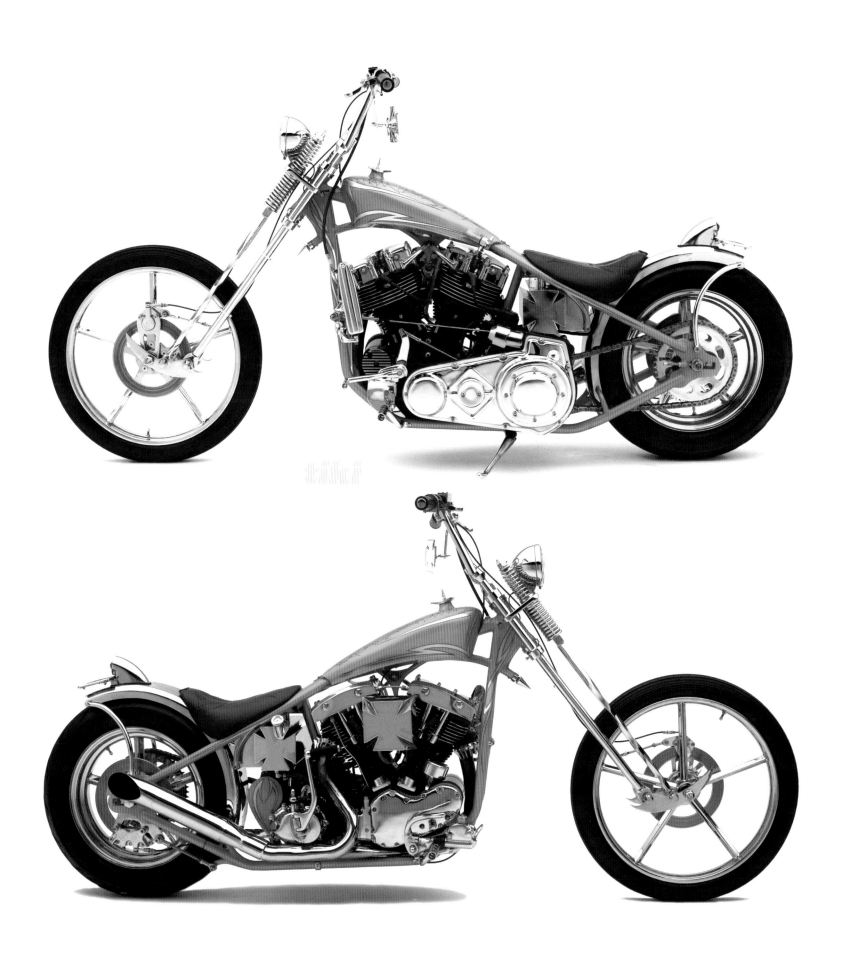

the fire department whose on-again-off-again schedule permitted him to spend lots of time with his children. It was from his father that Scott inherited the motorhead gene. Dad gave him a minibike when he was five. Then came a Honda 70 followed by an XR 75. The senior Long raced Greeve and BSA dirt bikes in desert scrambles back in the '60s. Scott's mother's job was taking care of him and his three young sisters, running them all around with sports and other activities.

Growing up, Scott burned out playing football and baseball, because it was almost a full-time job for a big kid with talent in

the milieu of suburban Southern California. He quit team play altogether by the age of fifteen. Besides, he had already taken up surfing, hitching rides up and down the coast from Orange County to Malibu. He was a "pier rat," hanging out at the homes of older friends in Huntington Beach, his seashore truant hideaway.

Around that time, in the early '70s, Scott's father took a leave of absence from the fire department and founded a company called Malibu Grand Prix. It became a chain of family destinations for racing go-karts that looked like tiny Formula 1 cars. He later sold it for a bundle. Scott got his early motor and fabrication experience working part-time in the shop at the mini-racetrack-cum-amusement-park. He learned how to weld while earning enough cash to buy a surfboard. And as you might expect, his experience at Malibu Grand Prix jump-started his fascination with racing cars.

Between surfing, motorcycles, and girls, Scott barely made it through high school. He didn't even consider college. "There were other things to do besides sit there in class," he chuckles. But he had promised his parents he would graduate. And he did — sort of. He was "asked to leave," as Scott puts it, because the faculty considered him a bad influence on the other students. He went on to earn his diploma in night school. "My friends were blowing dope, eating Cheerios, and waiting for the next wave. Some of us survived," he said.

Scott Long's relationship with Harleys goes back to his first hands-on experience at the age of eighteen, when he was working as a gas station attendant. The manager owned a chopped Panhead. He wanted desperately to date a girl who refused to ride on the back of a motorcycle, yet his only alternative, a truck, was broken down. Scott offered to let the boss borrow his car, if he could ride the Panhead. Done! Since Scott was already an experienced motocross rider, it took him just a few jolting loops around the parking lot to get the hang of a big twin with a jockey shifter. Off he went, ripping through the neighborhood, picking up girls for rides. "This is it!" Scott thought.

By the time he was nineteen, Scott was working part-time as a carpenter on tract-housing sites and surfing the rest of the day. He went to work wearing swim trunks. He and his coworkers who also surfed hurried construction on the first floors of as many

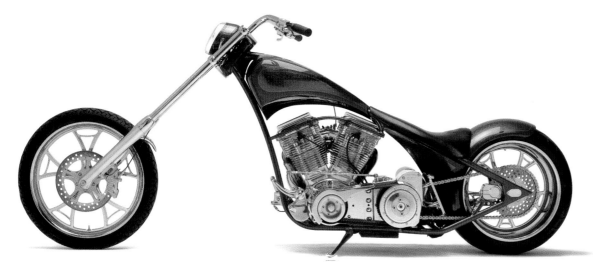

two-story homes as they could, so they could take their time working on the upper-floor joists. That way, they could see when the surf was up three blocks away. It was time to hang up their tool bags and hang ten. Since they worked fast and were paid for piecework, the boss couldn't really get cross with them. Long began to read about the men who are today the graybeards of bikerdom: Arlen Ness, Ron Simms, Dave Perewitz, Donnie Smith, and Mondo Porras all influenced him as a young man. "When those guys are gone," Scott says, "they're going to be laughing their asses off, looking down and watching the rest of us carry on. It's going to carry on, and it's getting crazy." Long likens the public's obsession with choppers to his experiences in drag racing. He does so rhetorically. "Why do people run up to the starting line at a drag race," he wonders, "to get so close to a Top Fuel car that it makes your eyes water, your spine go numb, and nearly ruptures your eardrums? And the smoke! It's the most toxic environment you could ever be around." He believes that being close to a ground-pounding chopper gives you the same physical and emotional rush without the toxic downside. Moreover, he concludes, "the custom motorcycle business is like dessert; people will always want some whether they can have it or not."

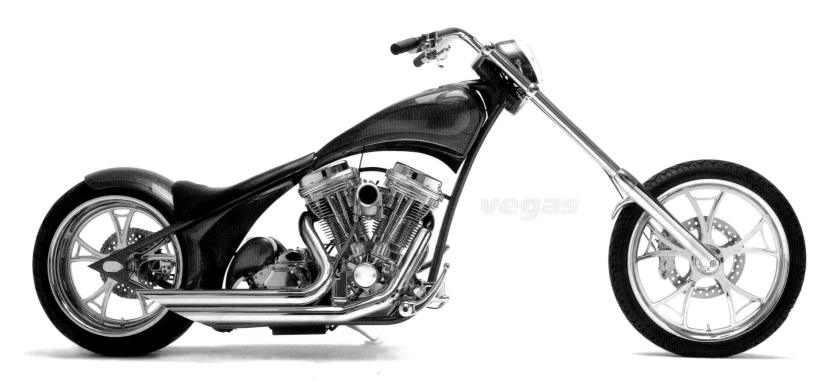

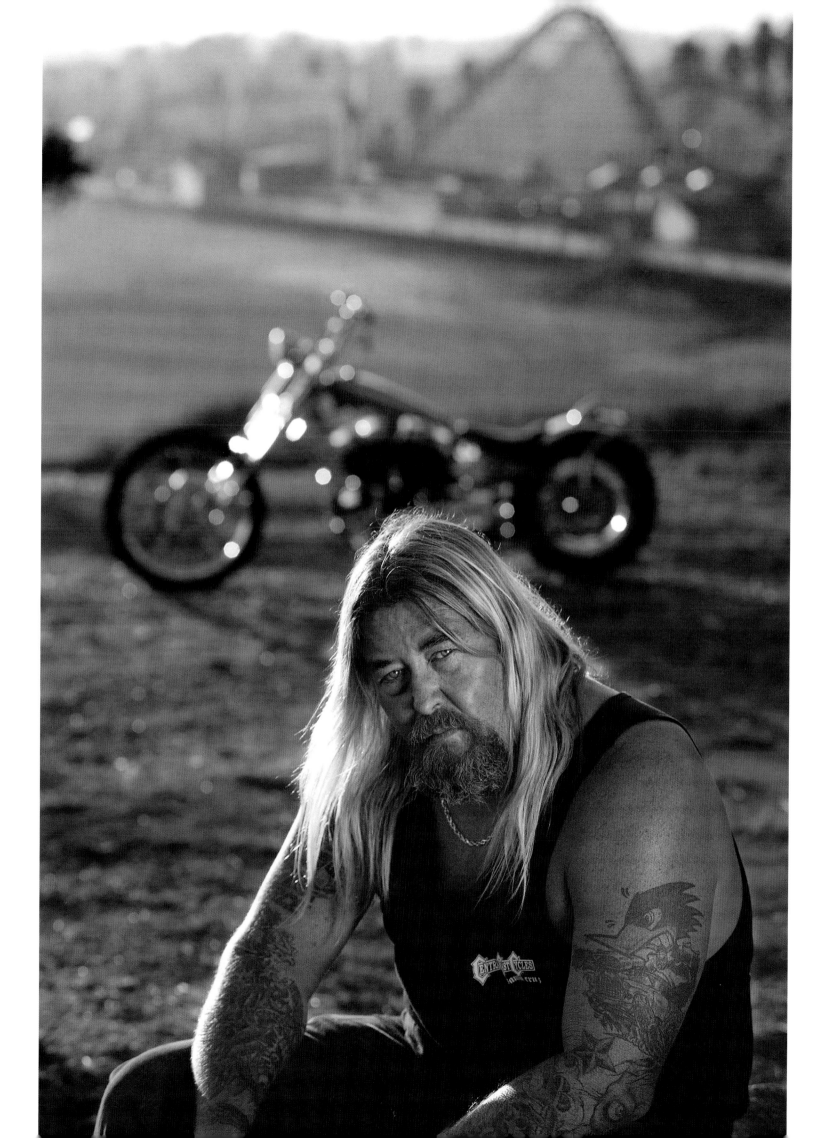

mondo
keeper of the frame

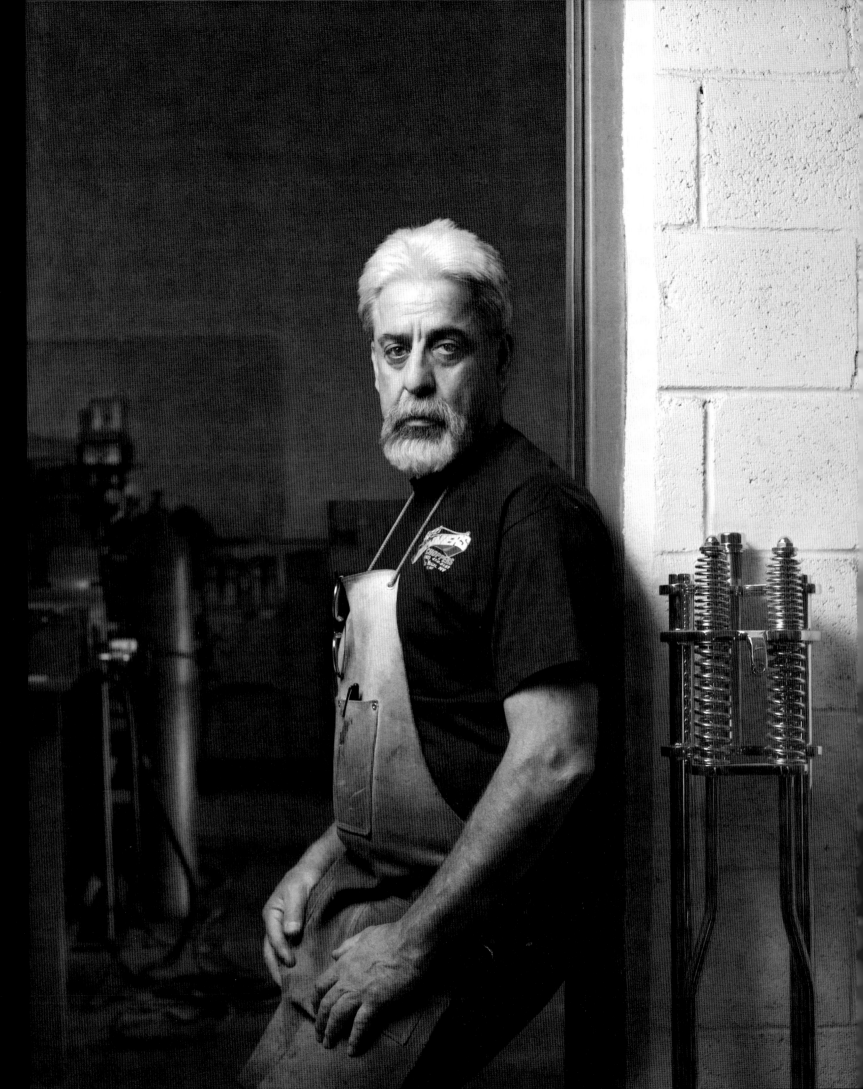

A ghost will greet you when you ride into Las Vegas. Surely a whole desert full of souls haunts this improbable place, but this is a benevolent spirit nurtured by a man called Mondo who believes that friendship never dies. Each bike that comes out of his Sin City shop is a shrine to the best friend he ever had, a founding father of chopper culture and a brother to all bikers: Denver Mullins. It is a proud legacy for Armando "Mondo" Porras, the proprietor of Denver's Choppers, to carry a torch for his late mentor.

In the early 1960s, when Vegas was still a small, classy resort town run by wise guys from Chicago and New York, Denver Mullins owned a shop called Denver's Custom Paint & Auto Body in San Bernardino, California. He was *the* custom-car guy in San Berdoo. Armando Porras was a thirteen-year-old squirt obsessed with hotrods when he started hanging out at Denver's. Mullins, in his early twenties, took a shine to the kid and taught him the ropes. When Armando was fifteen, Mullins offered him his first part-time job.

The auto-body business was good, and custom cars were popular. But gradually, as the employees acquired motorcycles, their imaginations turned away from cars to the irresistible simplicity of two wheels. Denver's did, too. It was a sign of the times. Armando followed suit and bought his first motorcycle, a Panhead, at the age of sixteen in 1965 from a Hells Angel. (San Berdoo is the birthplace of the club.) "Of course, back then, you could get a running motorcycle for three hundred bucks," says Mondo. "You could just ride the wheels off it." The crew began to experiment with used parts and scrap lying around the shop. "We didn't have CNC machines back then," Mondo reminds us.

It was still several years before the release of the movie *Easy Rider* and the idea of a chopper, per se, had not come into sharp focus yet in anyone's mind, not even among the denizens of Denver's shop who, no doubt, unconsciously influenced that film. But they had cut their teeth customizing hotrods and were intrigued by the challenge of getting down to business with bikes.

Denver's recruits coalesced into a tight-knit team. Armando acquired the nickname "Bondo Mondo" because his job was to mold rough steel frames into smooth, sculptural shapes by applying Bondo (a brand of putty) and to prepare them for painting. Together, the young men took front fenders off old bikes and welded them onto the back instead. The front tire went fenderless. They usually removed the front brake, too, leaving the wheel clean and simple — safety be damned! Horns and turn signals also disappeared. They added upswept pipes that looked like headers sprouting from contemporaneous custom cars and then a sissy bar and a plain Bates leather seat. The jockey shifter remained a steadfast embellishment. They fashioned handlebars

out of grocery-store shopping carts. They were just the right bend, the right gauge, already chromed. Finally, they rattle-canned some black primer on the sheet metal, and that was a chopper.

Denver's team was the midwife for the birth of the chopper. These whiz kids helped invent the rubric by which choppers came to be known as a new and radical kind of motorcycle. By 1967, the popularity of choppers had burgeoned to such an extent that Denver opened a separate shop down the street dedicated exclusively to customizing motorcycles. He called it, of course, Denver's Choppers. It soon eclipsed his auto-body business.

The bare-bones look of a chopper, despite some razzle-dazzle now and again, is attributable to tricks of the trade, which, by their very nature, are less than obvious. As Mondo says today, "We like to build a chopper that looks like it doesn't even run." Therefore, what you *don't* see is often what you get. Nonetheless, first and foremost, literally up front, you will see the hard-core hallmark of every Denver's chopper: solid steel forks flanking a pair of coiled chrome springs and rockers that suspend the front axle. Mondo, using his own hands and with Denver Mullins's inspiration, makes every weld in these "springers" himself today.

"We're still building bikes that look just like the bikes we built years ago," Mondo continues, speaking as though Mullins were by his side. That means a narrow, eighteen-inch back wheel, a mechan-

ical brake, upswept

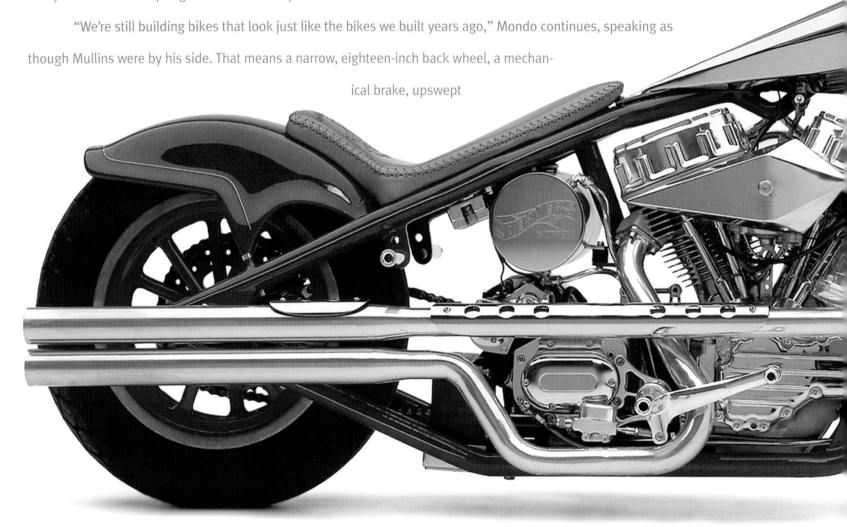

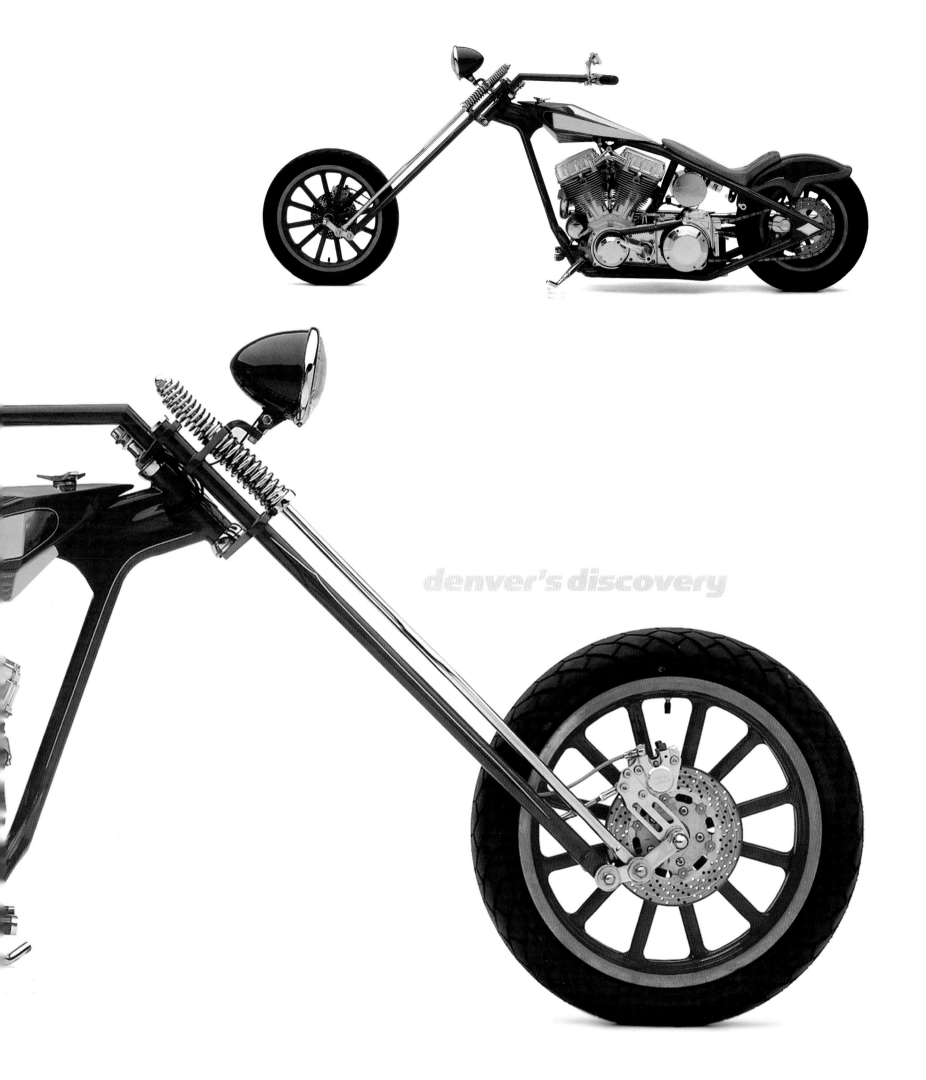

denver's discovery

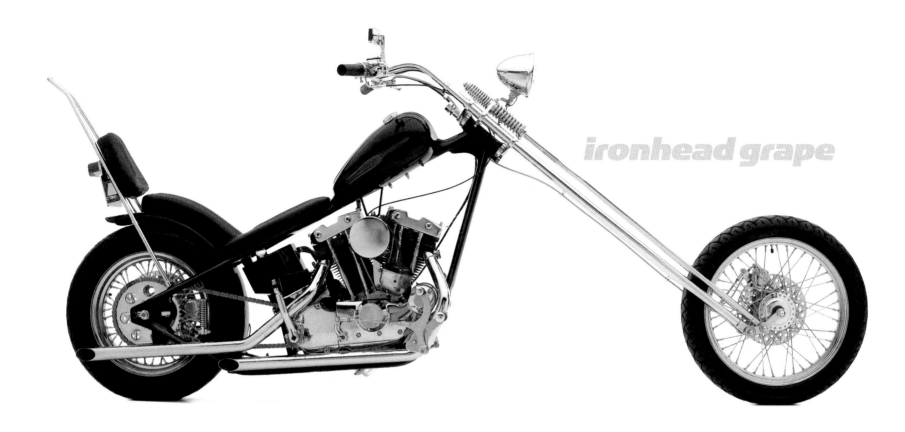

ironhead grape

pipes, and a hand-molded stretched frame. "That's what separates us from everybody else," he says. "It's the fact that we aren't

actually young guys trying to copy what was done in the old days; we *are* the old guys doing what we did best in the old days.

Our minds were kind of hazy back then," he admits, "but we still remember what we were doing." He does not subscribe to the

notion that if you can remember the '60s you weren't there! On the contrary, he treasures them as the best years of his life.

Mondo was building and riding bikes when there was no speed limit across the California-Nevada border and no helmet

laws anywhere. If you had your knees to the breeze, you had brothers to watch your back. A five-gallon tank and a buck fifty

would take you two hundred miles.

Choppers were pretty much all built the same way back in the days of leaded gas. The odd Triumph or BSA notwithstand-

ing, most of the parts were interchangeable. On a run, if your bike broke down and ended up in the chase truck, it became the

parts bike for the rest of the guys. Your generator would be gone. Your carburetor would be gone. Your front wheel would be

gone. Your misfortune kept everybody else on the road. But it all worked out, because, as Mondo remembers, "Everyone had

their turn in the barrel." Afterward, it was a smile-on-your-face, pain-in-the-ass ritual to knock around for about a week trying to

get all your stuff back, but in those days you could bolt it all back together again in a day, because everybody pitched in.

Before AAA, cell phones, and factory quality control, if you found a lone rider broken down by the side of the super slab,

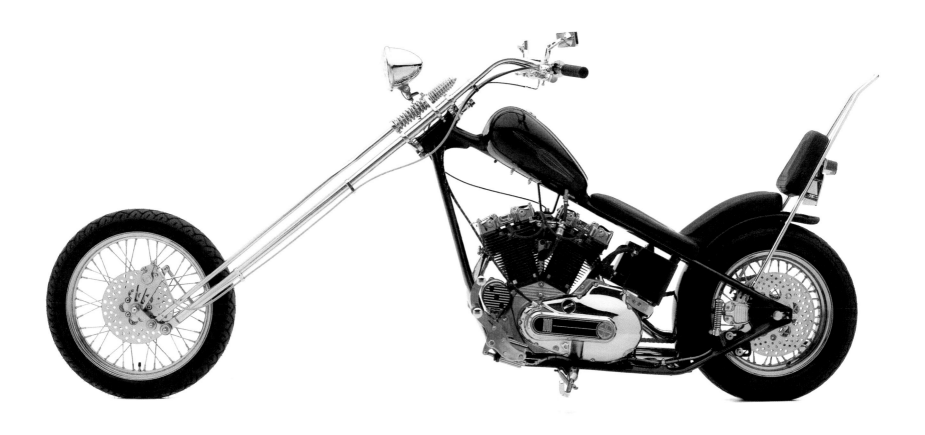

you loaded him up in a truck, took him to your house, fed him, fixed his bike, and put him back on the road. These days, according to Mondo, there are too many self-indulgent, weekend bad-asses — just jack-asses, really — who mistakenly believe that "real bikers" are too tough to be sympathetic. They are really just pathetic. "If nothing else," scoffs Mondo, "they'd have got their ass kicked next time the guy saw them for *not* pulling over."

In those days, too, the Hells Angels influenced chopper design in a roundabout way, particularly in the San Francisco Bay Area. Harley-Davidson Sportster models were the chop of choice for club members because they were faster and more nimble than big-twin cruisers. You can decide for yourself why those attributes were important. Pullback handlebars that allowed a rider to get comfortable by leaning back against either his bed roll or his babe were also typical. These were called "buzzard bars" after a Hells Angel nicknamed Beautiful Buzzard who inaugurated the fashion. Period Bay Area choppers are also noteworthy for relatively tiny gas tanks mounted high up on the frame. Collectively, these characteristics are referred to as Frisco style. With that in mind, what best distinguished the Southern California style of Denver Mullins and company from choppers built Up North was a flash of inspiration.

Mullins's idea was to splice sections of steel tubing into stock frames to make bikes longer. It was a custom-car-chassis trick. The upshot was impressive. A consequence, however, was, well, the upshot itself. That is to say, a stretched frame attached

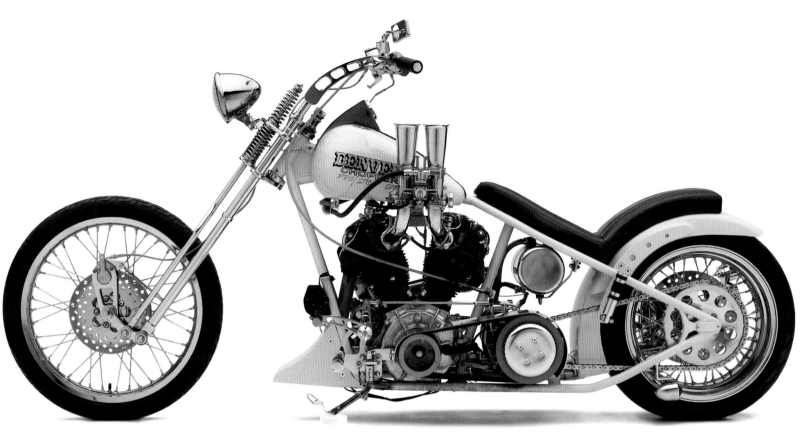

pro/street series

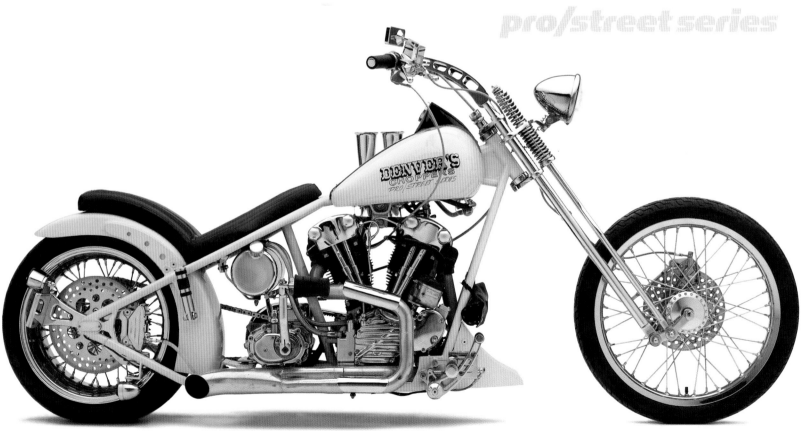

to standard forks, without compensating for the exaggerated angle created between them, looked as if it were poised for a launch into the stratosphere. It was determined that by elongating the forks at the same time and adjusting the angle, or rake, at which they were reattached to the frame, the bottom "runners" of the "sled" would once again be parallel to the ground. The bike would be level. But this also made the front wheel stick out — way out. What they had done to motorcycles, they realized all of a sudden, looked so *different.* And it led to the second space race of the 1960s. The first space race, of course, culminated in landing men on

the moon. The second one put as much space between a front wheel and the rest of a motorcycle as there were miles between Frisco and San Berdoo.

Their efforts escalated into a highly competitive challenge to see who could make the longest bike. The competition spread beyond the shop to become a nationwide cultural phenomenon. It even spread to northern Europe. In fact, there exists today in Sweden a three-patch club called Denver, founded decades ago to honor the shop that pioneered long bikes. Anyway, as far as the handling of these elongated lopers was concerned, low-speed steering often proved them to be floppers instead of choppers. Finally, builders got the hang of the geometry to make them work. Denver's Choppers was creating thirty- and forty-over front ends — that's *inches.* By the mid-1970s, as more and more Japanese bikes were imported to America, Denver's chops were applied to four-cylinder Honda, Yamaha, and Suzuki motorcycles, too. The long bikes made a big splash at bike shows, which led to the next level of competition: fancy paint jobs.

Mondo believes that some of the choppers considered art today would have been laughed at for being "hoity-toity" back in Denver's day. "To an old-time biker," he says, "yeah, they're pretty. They look like works of art. But try to jump on that thing and ride it to Sturgis!" He is obviously of a mind, as are other builders, that part of the art of the chopper is riding it.

"In the old days," says Mondo, "the only people who rode bikes were *bikers.*" He means that one had to earn the right to ride a chopper. First, you couldn't just go out and buy one. These were basically homemade machines. You were required at least to know how to service it, even if a shop built it for you. That little leather tool bag was not for decoration. It was your salvation. Moreover, if you wanted to ride a chopper, every other biker in town took it upon himself to check you out. If you didn't fit the mold, you might get your ass kicked, and your bike could be taken away and used for parts. "You don't have to have a patch on your back to be a brother," Mondo says, adding that the clubs would accept you if you were cool and your bike was cool and you didn't try to buy your way into the lifestyle. Today the guidelines are a lot looser, but you'll hear no complaints about that from

Mondo. The one-percenters don't pay his bills, after all. Economically, he depends on those whom other bikers have not-quite-affectionately dubbed rich urban biker scum (RUBS). They are mainstream members of society who try to imitate people who go out of their way to avoid them. We call it a demographic today. "But more power to 'em!" says Mondo. "If they're on a bike and it's got two wheels, I don't care what kind of bike it is. That puts a smile on my face."

When he was still a youngster, Bondo Mondo picked up twenty bucks a pop to mold frames for Denver Mullins. Those jobs sold at retail for between eighty-five and one hundred twenty-five dollars. But Mondo did not mind. In those days, a double sawbuck would buy four sacks of groceries, and a C-note would pay your mortgage for a month. Nevertheless, having found himself married and a father, he needed some extra income, so he moonlighted at a second job building frames of another kind. He freelanced as a house framer. He would get off work on a construction site by three-thirty in the afternoon, pick up a bike frame at Denver's, work on it at home until midnight, get up early in the morning, and return to the site. He would drop off one bike frame and pick up another again in the afternoon. On top of that, he worked all day every Saturday at the bike shop. He remained tied to

Denver's and the motorcycle trade.

In 1976, at the age of twenty-seven, Mondo got his general contractor's license and moved to Reno, where there was lots of work and where he could enjoy riding through the Sierra Nevadas. Once established there, he also acquired a framing license and a license to pour concrete. Before long, he found himself the owner of three separate construction companies employing more than a hundred workers building apartment complexes and custom homes. It was one of the biggest enterprises of its kind in northern Nevada.

Despite the geographic distance between himself and Denver Mullins, they remained close friends and visited each other as often as possible. Now they could build bikes together just for shits and giggles.

Their shared passion for motorsports never lost its competitive dimension. As if motorcycles were not loud enough, fast enough, or long enough, boats were better on all counts. Both men became obsessed with drag-boat racing. They decided to get involved on a professional level by buying a boat together and taking turns racing it. But Mondo was itching to race and was anxious for Denver to step up to the dock. When it didn't look as if that was forthcoming, Mondo went out and bought a full-on drag boat himself, a used one. Denver took the hint. He bought a boat, too. But it was a brand-new top-of-the-line model. Now, not only were they going to race, they were going to race *against* each other. However, since Denver's boat was newer and faster, he thought that outclassing his friend showed bad form. He surprised Mondo one day with the present of a brand-new boat just like his own.

Drag-boat racing is a very dangerous sport. Many people have been killed in competition. Knowing this, the two men

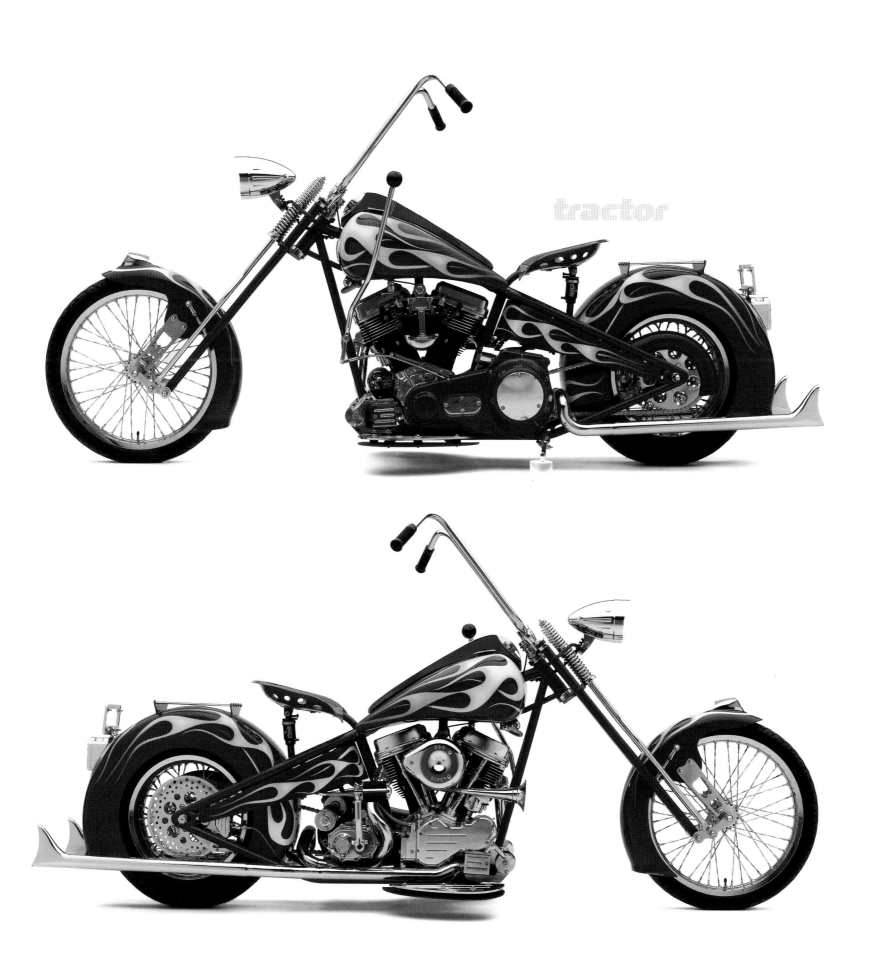

tractor

made a pact. If anything bad happened to either one of them, the survivor would make sure the other's family made out okay financially. They promised to keep each other's business a going concern, too. In the meantime, lo and behold, the two racing mavens moved up quickly through classes, all the way up to Top Fuel. These boats blast across the liquid quarter-mile at 220 mph, running a fuel mixture of nitro-methane and alcohol that generates up to 4,000 horsepower with a screw turning at 20,000 rpm behind your back. The motor guzzles eight gallons of fuel and twelve quarts of oil on every pass. And talk about loud pipes!

When Mondo and Denver were new to the sport, competitors were racing in open boats. At those speeds, if you crashed or flipped, you were either critically injured or killed. Period. You didn't just swim away. So Denver and Mondo innovated an escape pod for boat drivers. Theoretically, it allows a driver to survive any crash by incorporating the windshield of an Air Force jet fighter, a full roll cage, a five-point safety harness, and an oxygen supply to help if the driver is trapped inside the capsule underwater. As full partners this time, Denver and Mondo opened a drag-boat shop back in San Bernardino to manufacture these safety capsules. They and a handful of other manufacturers helped save a sport that otherwise might have died along with its participants. Their capsule was the first to be adopted by the International Hot Boat Association.

Denver and Mondo showed up at racing events, each with his own eighteen-wheel rig carrying a shiny black boat bedizened with flames and skulls — the proverbial bad-ass biker graphics — as a gambit to intimidate rivals. Their flamboyant fleet included a phalanx of choppers to guard the pit area, too. At first, they scared people away, until they became familiar fixtures on the circuit.

In 1992, Denver crashed his boat. The capsule separated from the craft and floated away as it was designed to do, and he walked onto the dock without a scratch. However, that episode demonstrated to Denver himself that he was desperately claustrophobic. It terrorized him to be restrained inside a tiny capsule breathing oxygen through a mask as he was hurled violently underwater. Unfortunately, six months later, he wrecked again; this time, the boat went straight to the bottom. The water was as black as his boat. Rescue divers could not see him right away. Denver, too frightened to remain in the capsule where he was safe, opened the hatch and tried to swim away. The boat rolled over and pinned him. It killed him.

Mondo closed down his construction company and bought Denver's Choppers from Mullins's family, as well as Denver's interest in the boat shop. It was not an easy transition for Mondo. He raced boats for another year and quit because it wasn't fun anymore without Denver. He devoted himself full-time to Denver's Choppers and moved the company

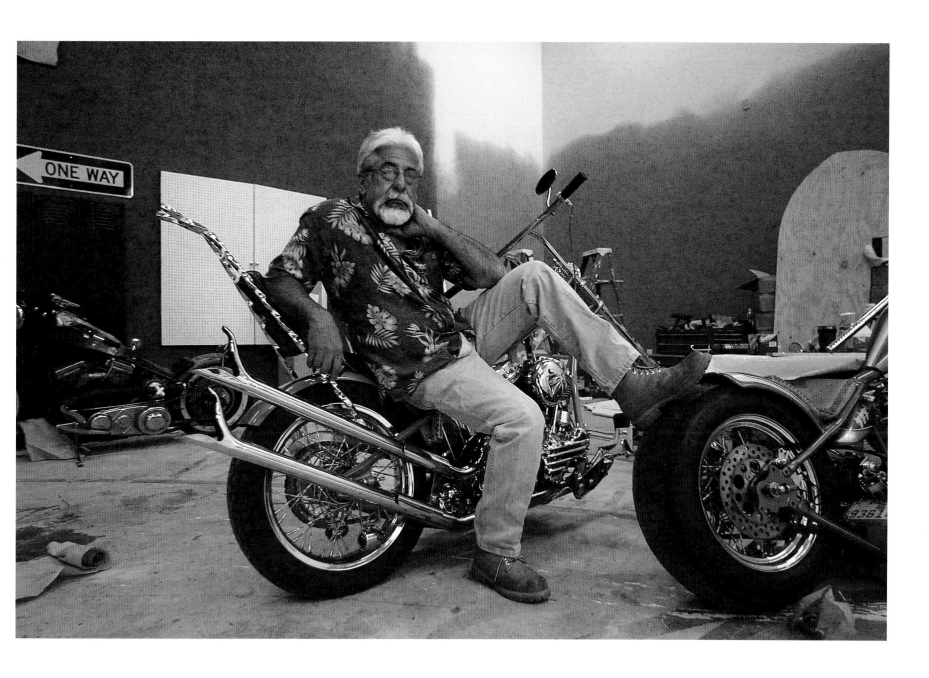

to Las Vegas, where he continues to build choppers with his own talented team of experts. Everything gets done his way, which means just the way Denver would have done it.

Mondo was born in El Paso, Texas, in 1949. His family moved to California when he was five. He was raised in San Bernardino with his three brothers. His father ran an insurance business, and his mother took charge of the household and the boys. One brother became an orthopedic surgeon, one a corporate attorney, and one a computer programmer. A bit of a black sheep, Mondo always wanted to make his living with his hands, to make things physically. He has a daughter who was Miss Rodeo Nevada, and a darling granddaughter. "That *is* my family," he says. His ex-wife took his beloved basset hounds.

Mondo has a checklist of goals to achieve during his lifetime, a number of which involve the acquisition and restoration of fanciful vehicles from his youth. Many have already been checked off. "I want to be able to sit back on the porch when I'm older and say I got to do every damn thing I wanted to do in my life and had a good time. I don't want to be one of those people who wish they would have, should have, or could have done all the things they didn't." Mondo wants to live fast and die old.

dawn norakas and butch mitchell dynamic duo

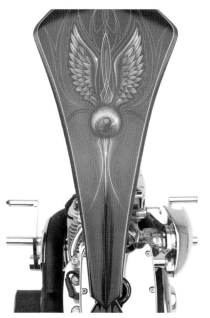

During a recent Bike Week in Daytona Beach, Dawn Norakas was riding a long chopper that she and her partner, Butch Mitchell, had built together. Butch was riding alongside her, astride a shorter, chopped Buell they had also made. "You two need to switch!" someone yelled from curbside. The jury is out on the issue of whether it's a blessing or a curse to be the only builder who looks good in lipstick.

Norakas and Mitchell believe a chopper is defined by the way it makes you feel, not by the way it looks. Presumably, if a bike doesn't make you feel right, it must be an ordinary motorcycle. But there's the rub. The emotional experience of owning and riding a chopper is governed by nuance and opinion, which reign over any plausibly concise definition. One person's relatively conservative-looking motorcycle may be another's paramount example of chopperotica. Whatever chopper dogma you subscribe to, you are probably barking up the wrong tree, as far as someone else is concerned.

Norakas and Mitchell agree that the gestalt of the chopper, let alone the art of the chopper, has to come from something more substantial than, say, changing out the handlebars. Some actual chopping has to be done. And something of the personality of its owner must be infused into its precious metal through the letting of blood, sweat, and tears. Norakas says, "I think a chopper defines *you*. There's a bike out there for everyone, and we don't know everybody's tastes. It often defines something *within* you that is trying to get out."

Mitchell finds irony in the fact that builders can create choppers today that exist only as a result of state-of-the-art technology, yet at the same time, they look as though they have reappeared from an era many decades past. He invokes the work of Roger Goldammer from Canada, who uses reengineered motors, wheels of slender girth and enormous circumference, disk brakes, sophisticated electronics, suspension systems hidden *within* the frame, coatings, alloys, and whatnot to create bikes that nevertheless look as if they once raced around on wooden tracks. It is unlikely that such machines could have been created without the help of computers. Norakas says, "I think his *brain* is state-of-the-art."

Norakas and Mitchell are mutually and equally responsible for the designs originating at Stinger Custom Cycles. That is the name of the company they founded in Cedar City, Utah, in 2002. Mitchell is a fan of old-school fashion. "I like very raw-looking stuff," he says. He wants to relive the experience of rolling with "one-percenters" back in the day. He pulls back the curtain, not only of time, but to show what makes a bike tick; wires and cables are left proudly out in the open. "That's just where they are. So for me to try to hide them doesn't make sense," he reasons.

Norakas, on the other hand, is an exponent of the clean look. She runs wires and cables inside the frame tubing, playing

hide and seek with fundamental parts. To alleviate the fatigue of pulling a clutch lever for two thousand miles on the way to Sturgis,

she has designed and fabricated an internal, hidden twist clutch. She uses a proportioning valve on a single master cylinder that

operates both the front and rear brakes with a foot pedal — no levers on the handlebars, not even a jockey shifter. There is nothing

to detract from the sinuous lines of her sheet metal, which is covered in drip-deep, wet-fingernail-polish colors with a lapidary

surface.

Both Dawn and Butch have the same idea when it comes to paint. "A paint job can make or break a bike," says Butch. But

he fudges by saying it doesn't always do so. To clarify an apparent equivocation, he says, "You can't have a crap bike and put a cool

paint job on it and make the bike look cool. If you don't have the right lines to a bike, there's nothing. But if you have great lines,

paint can make it better."

Two other notable features of Stinger bikes that both Dawn and Butch agree on stylistically are fuel tanks and

handlebars. Their bars invariably feature sharp angles in the fashion of Ron Finch's vintage Z bars. And instead

of bulbous gas tanks that look like blown-glass globes pinched and

pulled at one end into a teardrop

shape and mounted

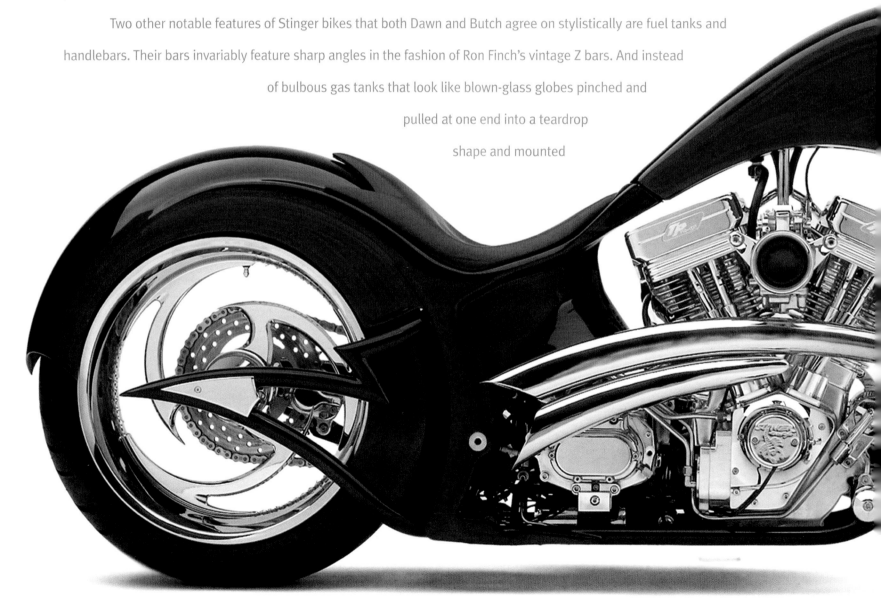

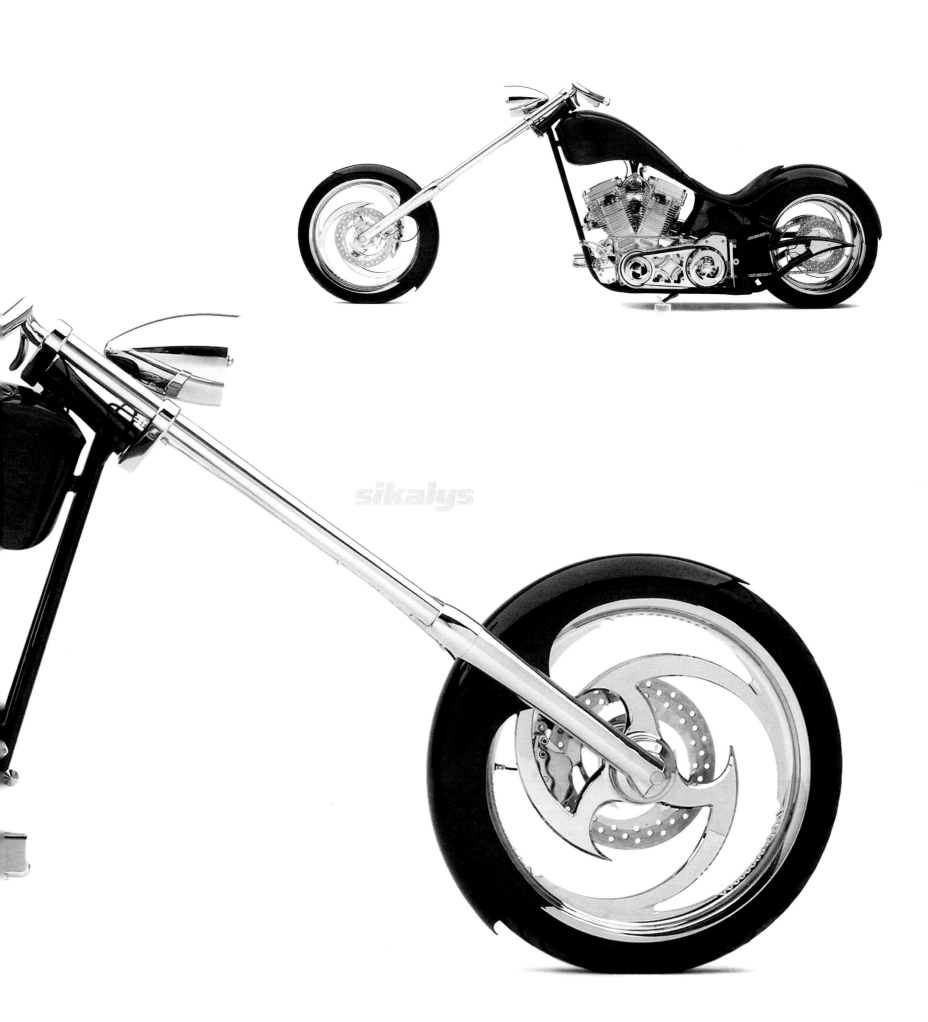

low on a frame, these models sit high. They also take on a certain "kick," as Norakas and Mitchell both call the effect they have created. The kick is typified by using alternating concave and convex surfaces. Lines that trace the peripheries of these shapes are evident where the tank's constituent sheets of steel have been welded together and burnished smooth at the seams. No metal stamping is involved in the process, nor are welds visible unless left there intentionally. Your eyes tend to follow these lines as they flow into other aspects of the bodywork and frame.

When they first opened Stinger, Butch and Dawn agreed that they would build a bike for anyone who walked in the door and build it any way the customer wanted it. They have changed their minds. They will turn work away if it does not suit their own prerogatives of style, despite the fact that it will hurt them financially in the short run. It rarely happens that way, anyhow. The two

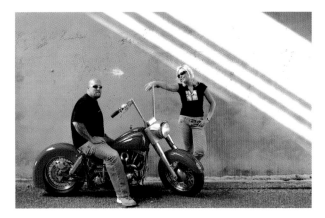

of them will spend many hours together interviewing a prospective customer about his likes and dislikes but always offering choices within the domain of their mutual design sensibilities. Besides, people come to them for the Stinger style, which includes its range from smooth to rugged — from Dawn to Butch. But don't mistake smooth for feminine! A tough guy would be proud to be seen riding one of her creations, just as a woman would suffer no embarrassment to be seen riding one of Butch's. Stinger is not about a chick bike builder hooking up with a guy for security. She follows her own lead,

just as her partner follows his. It just so happens that the two of them share similar ideas about the direction of chopper design, despite the individuality of their approaches.

Once a customer asked for a "rich-guy gangster bike," according to Butch. He and Dawn decided to handle the project together, by turning out something definitely Stinger in style but without sinking under the collective weight of their own individually consistent anchors. The rich-guy aspects were represented by the contours of Norakas's opulent bodywork, which beautifully supports Mitchell's in-your-face, exposed gadgetry, satisfying the requisite gangster guise of the chopper. Helping to merge their styles, a black powder-coated motor was employed, something neither of them would have chosen separately. They also utilized black pipes with chrome accents and excluded a front fender. "I always use a front fender," says Dawn, "but Butch never does." The gas tank was mounted "half Frisco," not too high and not too low on the top tube. A medium fender was fabricated for the back end, representing less than Norakas might have favored on her own but certainly more than Mitchell would have used. Instead of Norakas's typically flush gas cap, the bike sports a spout with attitude. In the end, there was nothing about this chopper that reflected compromise. It was a meeting of the minds to create a work that was altogether different.

Norakas and Mitchell believe they are making a fashion statement and illustrate that point of view by indicating how many other builders buy Stinger parts, especially gas tanks, handlebars, and internal components such as the twist clutch. Their results

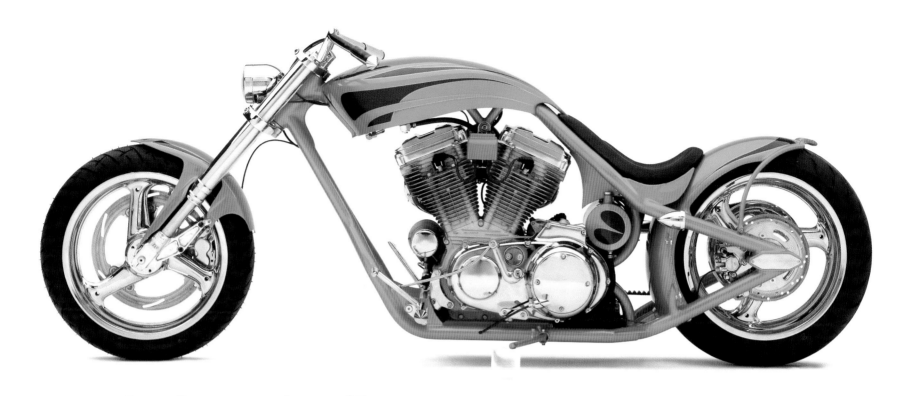

badamys buell

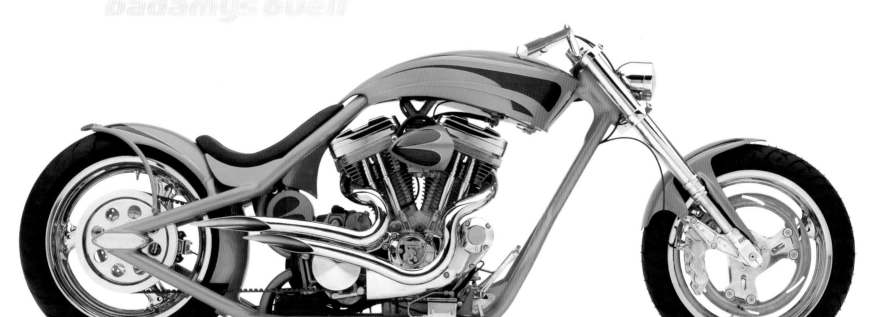

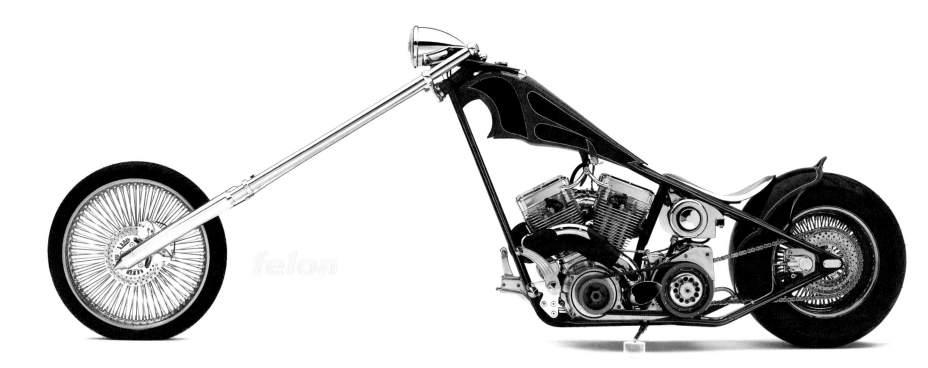

will not look like Stinger bikes; they will bear the inimitable stamps of the builders whose names go on the manufacturer's state-ment of origin. But the influence is still there. Butch is proud to say, "We've made an impact on what today's cool, high-end chop-pers and low-end bikes are doing."

Dawn admits she cannot pull a motor apart. She will leave that kind of work, if necessary, to Butch. "I can wire a bike! I can weld, too!" she chimes in. Butch owns up himself, "I suck at wiring." But what they don't know how to do they quickly learn. Although all design responsibilities lie with Norakas and Mitchell, Andy Funderburk, along with his journeyman crew, contributes his invaluable fabrication talents. Dawn dictates exactly what she wants to see, and Andy will bring her a drawing. She will modify it as necessary before delving into the manufacturing process. She also knows that she can entrust fabrication chores to Andy if it becomes necessary for her or Butch to travel or get caught up in the "administrivia" of running the business. "Andy can read me," Dawn says. Andy is family to Dawn and Butch, their combination brother and son.

Butch feels ready to quit in frustration three-quarters of the way through every build. His temper rises like magma and explodes. He finds himself throwing wrenches at the wall in the dark hours of the morning, trying to prepare a bike for delivery behind schedule. Often at the last minute, he will crank a motor to life and test-ride a new bike while snow lies on the ground, just minutes before loading it onto a trailer and taking it to a bike show. "Our guys are sleeping in their chairs, and we're in there bleedin' and wrenchin' . . . arrrggghhh!" says Dawn about these last-minute skirmishes. In spite of all that, Butch says he will finally make it home to bed and wake up the next morning eager to get back to work.

Perhaps because of his own striking appearance, Mitchell is deliberate not to judge people at first sight. He knows that a

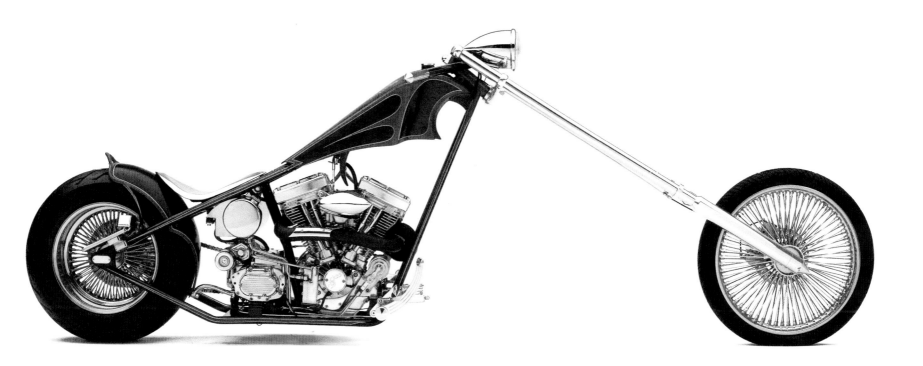

suit-and-tie guy can turn hardcore on the throttle — or on the bottle — while some tough-looking hombres cannot back up their convictions with any strength of character at all. As for a woman walking through the door wanting to buy a chopper, Norakas says, "I get judged all the time — *all* the time. At events, I help every day to set up and tear down that dang booth. I have every bit of input on every bike sitting in that booth. But I am not qualified to talk to a male biker." Or so such chauvinists believe, their own ignorance manifested by ignoring her expert-ise. "They can't get by the blond hair, blue eyes, and freckles," she complains. Many sexist bozos, who don't know the difference between a hardtail and a softail, can't get past Dawn's tail. Butch says, "Yeah, I have to work twice as hard. Guys walk right by her if they have a technical question and come to me for everything." He usually sends them right back to Dawn. But they sometimes walk away sulking, as if they had just been given the brush-off. When Dawn was interviewed for a possible appearance on the *Biker Build-Off* television show, the producer wanted her to be either a lesbian or a mother with kids; a straight, single chick who likes bikes was too implausible for so-called reality TV. Moreover, he didn't want to risk the possibility of a male builder actually losing to Dawn Norakas. In reality, she does not believe there is one male colleague who would refuse to compete with her.

Dawn used to be the marketing director for Global Motorsports, the parent company of wholesale parts distributor Custom Chrome. Her responsibilities included managing corporate participation at motorcycle rallies, dealer shows, and public-relations extravaganzas nationwide. She worked with the media, writing press releases, negotiating advertising space, and producing photo shoots. She got into building bikes initially by managing the activities of other builders, whom she commissioned to create motor-

cycles using parts found exclusively in the Custom Chrome catalog. These bikes were showcased at public events, augmenting the company's marketing campaign. Ford Stell, a master builder with whom she worked at Custom Chrome, was directly responsible for stirring her curiosity about the art. Her father and brother, before that, influenced her with their own mechanical prowess. From them she acquired a working knowledge of engines. She worked her way up the corporate ladder in the motorcycle industry because her tomboy background fit right in. She didn't party her way to the top, to put it euphemistically. Now, on the other side of the fence, she finds it discouraging to have lost the clout of a corporate executive, only to experience a glass garage floor instead of a ceiling.

Dawn rides wicked, high-performance machines, more radical than most men have ever dared to imagine themselves astride at speed. "I almost do it to try and be accepted," she says. But she also does it because she loves it. You'll see Dawn on a 250-tire-frame, raked out fifty-four degrees with a twist clutch blasting down the highway for hundreds of miles at a time. She can pull a jockey shifter, too. She can do anything that some ignoramuses with too much testosterone who call themselves bikers would be too afraid to try. "I always have to have big-cubic-inch motors, and Butch doesn't really care what he has," claims Dawn.

"If I didn't know Butch and I walked in here to buy a bike . . ." She trails off and then implores Butch straight in the eye. "Answer? Honestly. Come on!" Butch simply says, "I'd check her out!" Dawn laughs and asks, "Would you take me seriously, even if I walked in with cash and said it was for me, and I wanted to help design it?" She thinks that if she walked cold into a custom shop, she would have to get on a bike, looking as if she knew what she was doing, and feign to ride it out the front door. She might get some attention then for doing something that would provoke an ass-clobbering if she were a man. "You can answer honestly," she continues to plead with Butch, who hems and haws. Finally, he says, "Some guys haven't evolved beyond the Stone Age. I'm happy to admit that I have evolved."

"I'll be honest," Dawn continues. "When we showed up at Indian Larry's and Paul Yaffe's build-off, Larry had his doubts about riding with me." She says he kept asking her if she was sure she could keep up. But by the first time they all stopped for gas, he got the picture.

Dawn rides fast and hard but exercises caution. For instance, she always uses hand signals when turning. "This one uses his foot," she says sarcastically, tossing her head toward Butch. So if you don't know that Butch rides by Hells Angels rules, you might wind up rear-ending his bike. Incidentally, he chose not to accept a number of invitations to join outlaw clubs. "It's not my lifestyle," he says. As an entrepreneur and an independent-minded rider, he could not tolerate becoming assimilated into the collective club ethos. It would be like volunteering to join the Borg in leathers instead of lasers. He has his own outlaw past, anyway.

Butch Mitchell is a convicted felon and is obligated to check in with a parole officer every time he travels out of state. He is enrolled in an anger-management class and regularly submits to drug tests, although he hasn't abused drugs since he was a boy

experimenting with marijuana in high school. Dawn giggles about his candor and how ironic his predicament seems to her now, because temper tantrums leveled at inanimate bike parts notwithstanding, he has a gentle disposition. But he once kicked the living daylights out of someone who owed him money and refused to pay. That landed him in the clinker. Dawn defends Butch's frustrated vigilantism by saying that he had exhausted all legal and administrative means to collect the debt. He would have been applauded for what he did in a state like Texas. But Utah is, well, different. "It didn't help," says Dawn, "that Butch went into court the first day in short sleeves." The local DA and the cops do not appreciate tattoos and shaved heads. His character was prejudicially assessed to be literally no more than skin deep. Regardless, it is apparent that this couple holds no grudges. They laugh about the incident, and Butch's parole officer has become a close friend. At his regular appointments, Dawn and their shop dog, Scooter the Chihuahua, tag along.

There is a conservative streak in Butch. He believes that law enforcement is necessary to keep motorcyclists in check. Things can get out of hand without a touchstone of responsibility. Butch says he has no reason to get anywhere a minute ahead of anybody else. He won't ride faster than Dawn. But she sets a pretty good pace.

"I'm a gearhead girl. That's the way I was raised," Dawn says. But she didn't get a buzz specifically from motorcycles until her time at Custom Chrome. Her defining moment came when the company's president at the time, Ed Martin, told her, "Girl, you've got talent!" She had been making product-marketing suggestions based on her intuition and her empirical knowledge about motors and motorcycle riders.

She began working at Custom Chrome in 1999, after answering an ad in a Fort Worth newspaper that asked the question "Are you a square peg trying to fit in a round hole?" She left the company in 2001 when the marketing department was moved from Texas to California. Without a substantial raise, she didn't think she could afford the California lifestyle. That's when she found herself in Nevada to check out a new job offer.

Butch and Dawn met each other on a Thursday-night ride in Las Vegas. They hooked up coincidentally with a group of successful professionals who get together regularly and burn up the Strip for fun. Butch owns a flooring and dry-wall construction company in Vegas and still keeps a house there, as well as his home in Cedar City. New to the group, it was his first ride with them that night. It was Dawn's first ride with them, too.

It was not love at first sight. Actually, a Las Vegas district attorney was already putting the moves on Dawn. Butch, Mr. Tattooed Baldy, had not made a great first impression on either of them. (The DA was later a character witness for Butch at his trial.)

But, since Butch and Dawn were the only newbies in the group, they struck up a conversation. Butch was building a bike. Dawn offered to help him get some hard-to-find parts from Custom Chrome. They stayed in touch.

When the company that offered Dawn her job in Las Vegas went belly-up, she found herself in a bad predicament. Butch, who had saved up enough capital by now to pursue his dream of many years to open a custom bike shop, suggested that Dawn bring her marketing skills and motorcycling connections to partner with him. She agreed.

Dawn and Butch do not talk about their personal relationship publicly. In spite of their feelings for each other, they want to be perceived, rightfully, as business partners first and foremost. Their customers must be assured that the unlikely dissolution of their romance would not spell the end of Stinger. Still, one wonders if the chicken came before the egg or vice versa. It is Butch who beats Dawn to the punch and confesses that it was romance first and then business. Both prospects seemed irresistible.

The two were born six days apart, in November 1970. Their company's name, Stinger, is derived from the fact that they are both Scorpios. They each had a scorpion tattoo when they met.

Butch was born in Ontario, California. He has an older brother and a younger brother. His parents, who were seldom able to make ends meet, thought their three boys must be doing something illegal to be as successful as they became. Now Butch's parents work for his younger brother. Butch and his other brother have taken turns taking care of their parents. For a while, the senior Mitchell owned a dry-wall and painting company. But it drowned in his own drink. From California to Florida to Virginia and back West, the family moved around for various reasons before they settled in Lake Havasu, Arizona. Butch became an all-star foot-ball player at Lake Havasu High School, winning all the "fancy-dancy" awards, as he puts it. The evil weed almost got the better of him during his senior year. He almost didn't graduate. But he got his act together and, with remedial classes, received his diploma.

Backtracking to the '70s, men who worked in the construction industry, like Butch's father, tended to ride motorcycles. It was part of the scene. Running with motorcycle clubs was the recreational activity of choice during off-work hours. Butch does not speak highly of his father, a "known associate" of the Hells Angels, but because of him, Butch grew up around bikes. He wanted one as long ago as he can remember. By 1994, he was able to afford some high-dollar bling. He dove right into the deep end with a custom Harley adorned by all the bells and whistles. Dawn remembers it had good parts on it. But she is laughing uproariously. "I can really slam you now. Your first bike was pink!" Butch denies it. "It was purple — well, fuchsia." Yeah, well, she also reminds him it had a Hawaiian waterfall paint job. He paid $34,000 for it in 1994. Back then, Butch wore tight pants, and the hair he still grew on top of his head was in the style of a mullet. The bike fit.

Butch is a little less flashy today. He thinks anybody who wears a Rolex watch is trying to "money-whip" you. But he enjoys collecting wristwatches, two-dollar bills, and fancy knives. The knives are on hold until after parole. He owns two separate businesses: the dry-wall construction outfit and a bar in Cedar City.

Dawn was born in St. Charles, Missouri. The family moved to Ennis, Texas, just south of Dallas, when she was seven. She was Daddy's girl, and she remembers sitting in the garage with him back in Ennis while he was chopping an Ironhead Sportster. It was way past her bedtime. During breaks away from the bike, her dad sipped his coffee and played his guitar for her. Her brother was asleep; her mom was in the kitchen. Her father owned a full-service gas station, where Dawn and her brother paid their dues pumping gas, changing oil, and patching tires. Dawn ran the pit crew for her brother's foray into dirt-track motorcycle racing. Today her father is the safety director for a Chevron plastic pipe company. Her mother is an escrow officer at a title company.

Dawn graduated from the University of North Texas with a degree in journalism and public relations. "Here's a shocker." She giggles again. "I went to college on a golf scholarship!"

Today, Stinger Custom Cycles is a going concern and going strong. Norakas and Mitchell enjoy their Cedar City outpost on Interstate 15, between Las Vegas and Salt Lake City. It seems their dreams are coming true.

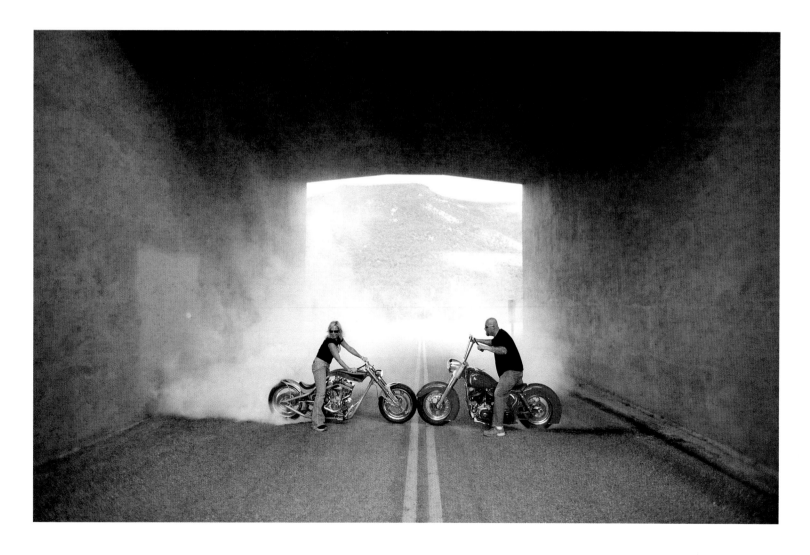

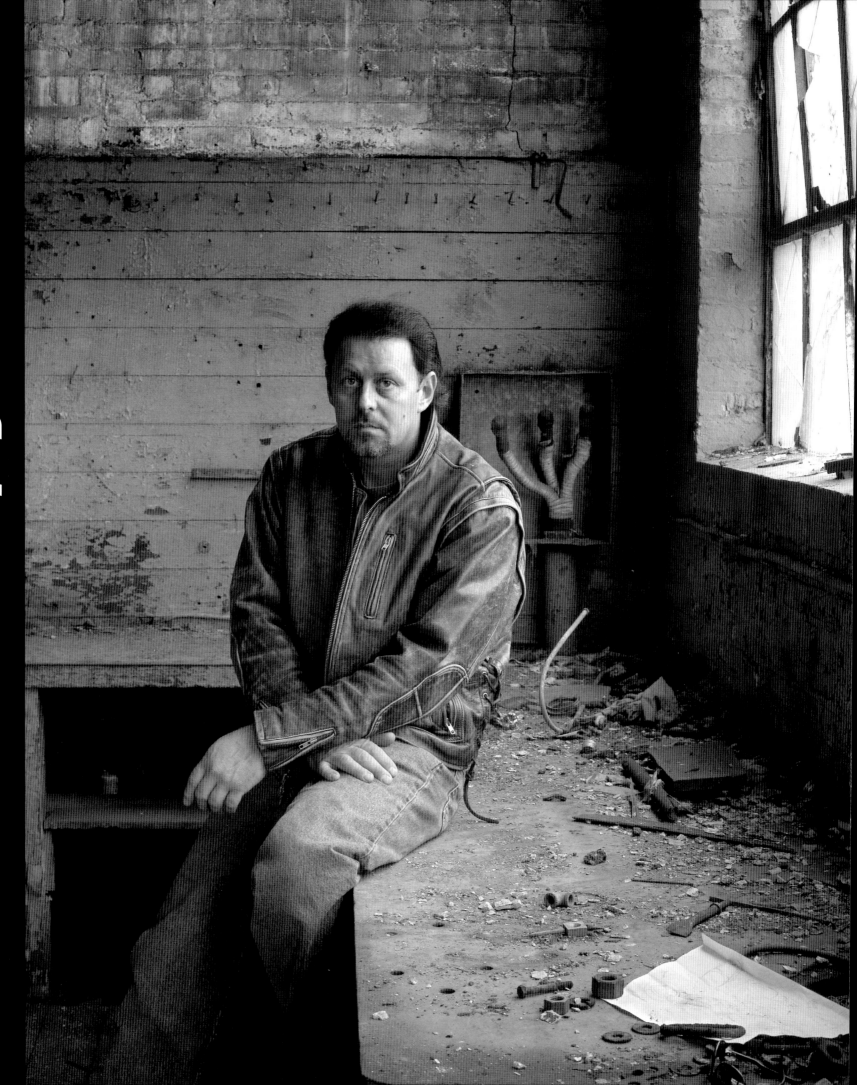

Across the Verrazano Narrows from Brooklyn at the entrance to New York Harbor lies Staten Island, the most suburban of New York City's five boroughs. It is also home to the only top-seeded bike builder who does not wield a wrench for a living. Mike Pugliese is a true amateur. Yes, and Albert Einstein was an amateur physicist working in the Swiss patent office. Mike, for his part, is content to be in the business of residential construction and real estate development.

Conceptually, for Mike Pugliese, a chopper is a motorcycle with a massive front end mated to a simple design. He means simple-*looking,* of course, because there is nothing simple about what he does. If anything, his bikes are simply intimidating to those whose professional curiosity makes them wonder how they just got kicked in the groin. Despite their extravagant beauty and detailed craftsmanship, every one of Pugliese's bikes was fabricated and assembled in a modest two-car garage adjacent to the condominium apartment where he lives with his wife and three children. (He built the condos, too, by the way.)

A motorcycle is a rather naked machine; its internal organs and circulatory system are exposed, supported by a skeleton of steel. It is a straightforward proposition to see how it runs. However, when you look at a Pugliese chopper, what strikes you immediately is what you don't see. *How'd you do this? Where's that?* Questions like those are part and parcel of the contradictions inherent in every true chopper, a model of minimalism that belies complex engineering. "It looks fake," Pugliese intones with a voice right out of a Martin Scorsese gangster flick. "It looks like it doesn't run." That is what the uninitiated will believe anyway. And that is just fine with Pugliese. He can be as deceptively coy as Tony Soprano talking to the feds, and he enjoys playing hide-and-seek with naive expectations. "Any sufficiently advanced technology is indistinguishable from magic," according to physicist and philosopher Arthur C. Clarke, the author of *2001: A Space Odyssey.* Pugliese's bikes epitomize that idea.

Unlike the "body bikes" of the '80s and '90s, Pugliese's motorcycles don't have their guts covered up with painted panels. Only the great Arlen Ness can get away with that; he invented the style. The imitations he spawned are never as sleek; they are just slick, like the charlatan Professor Marvel pretending to be the Wizard of Oz and pulling levers behind a curtain. Instead, a master magician like the Great Pugliese misdirects your eyes with form so you miss the function. Everything is right there in front of you. But it takes a sophisticated knowledge of engineering prestidigitation to catch his craftiness. "I maybe use a little more sheet metal than the rest of the guys," he says about the way his bodywork mimics the French curves you remember from high-school drafting class. He will certainly use swoopy lines to conceal his handiwork, but not as

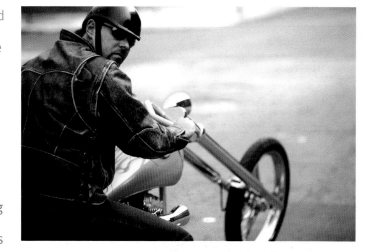

you might expect. Mike Pugliese's magic touch adds new meaning to the phrase *tricked out* in the context of customization.

If you do not see a brake, it is probably attached unobtrusively to a jackshaft, directly to the part of a motor that spins, transferring motion to the drivetrain. Therefore, you will not see a brake lever on the handlebars, either. Alternatively, if he deigned to install a front brake, you would need X-ray vision to see where he routed the cable. Pugliese disdains the necessary evil of cables. "If they show," he says, "it's like taking a picture of your bike and running a Magic Marker across it."

A Pugliese chopper takes shape as the artist compares it to a life-size schematic diagram painstakingly drafted and tacked to the wall in his garage. He examines his work as he goes along section by section with a critical eye, making it cleaner or smoother by hiding something here or removing something there. Each assembly must pull its own weight both aesthetically and as a matter of contributing to performance. He is meticulous, a "stickler for details," he says. He will ask himself, "Okay, gas cap. How can I make that better? Controls. How can I make them better?" and so on, until he has scoured the entire motorcycle for design and operational deficiencies. He will perfect the fit and finish of every component, no matter how tiny, even in places that can't be seen unless you get down on your hands and knees.

The way his choppers look is obviously important to Pugliese. Nonetheless, he takes greater pride in his not-as-obvious engineering

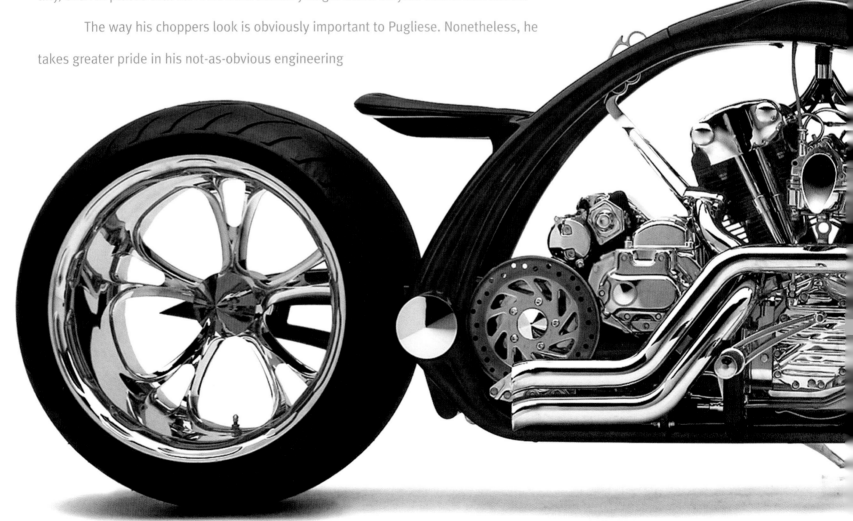

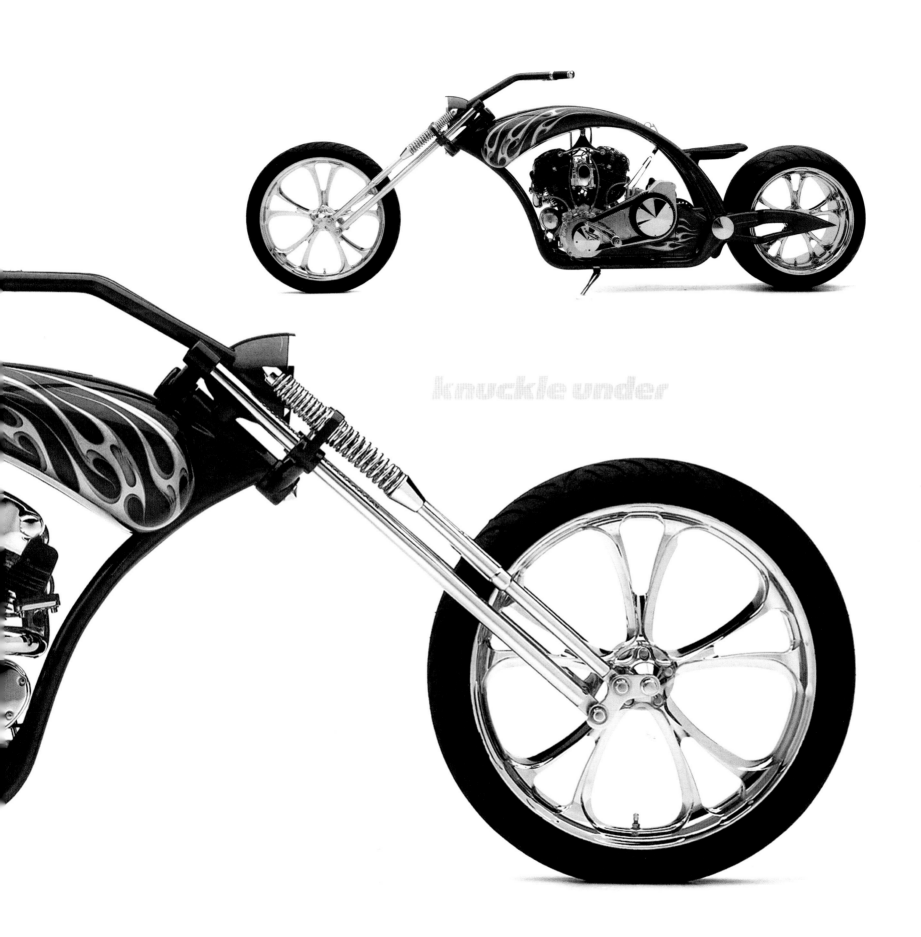

knuckle under

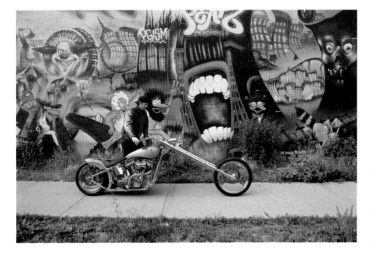

accomplishments. Performing technical sleights of hand is his favorite pastime, but bear in mind that when either factor, appearance or performance, takes its cues from the other, they benefit reciprocally. Pugliese's mechanical dexterity gives him the freedom to execute a whole new range of designs. You cannot play a musical instrument or paint a canvas without first mastering the techniques involved. The engineering innovations of Mike Pugliese may be compared to the practiced fingerings and bowings of a virtuoso violinist or the manipulated brushstrokes of a master portrait painter. A mastery of technique allows the creation of beauty to become transparent.

Except for the engine, transmission, nuts and bolts, electronics, and rubber, Pugliese buys virtually nothing ready-made, although wheels may be an occasional exception. But he will modify them anyway. He fabricates his own frames, controls, triple trees, axles, brake rotors, motor mounts, and handlebars, in addition to tanks and fenders. He even shoots a base coat of primer on the whole works before sending it off to Mike Terwilliger for final paint and airbrushed graphics. Bits and pieces get sent out for chrome, of course. All that, and yet it is not conceit that drives him to such extremes. Always the amateur and always the artist, Pugliese relishes the physical exertion of sculpting raw metal into shapes that have never been seen before. He finds enormous satisfaction in fitting all the pieces together like a puzzle because he made them. As many times as he thinks about it, he is astonished by the fact that each bike begins with bare and shapeless pieces of metal. "Cheap stuff," Pugliese insists. "Whatever you got you use."

Anyone can pick out a nice combination of parts from a catalog to dress up a stock bike or even to assemble an entire motorcycle. But Pugliese believes that if you can make *anything* yourself — it doesn't matter what, as long as it is one of a kind — and if it becomes indispensable to the character of your bike, that's when a builder becomes a true customizer and an artist. From there on, it is a matter of degrees.

"I'm a street engineer, self-taught, and a half-ass artist," insists Pugliese. His modesty does not supplant self-confidence; he knows he is good. Still, he gets nervous before every bike show. In fact, he relies on his jitters to keep him honest. He knows that when the butterflies stop, so will he.

Pugliese also knows that perfectionism does not lend itself to perfect results. That can readily be demonstrated by how he won't shy away from comic relief at his own expense. Once, for example, he took his bike, Hellraiser, out for a photo shoot. The bike had been sitting unridden for weeks. While thundering along confidently at the head of a pack of paisans, something went wrong with an oil line. Before the riders got too far down the road, they had a Texas-style gusher on their hands. Mike was worst off — he looked like an *Exxon Valdez* victim. "Take me home and wash me down like a seal!" he cracked.

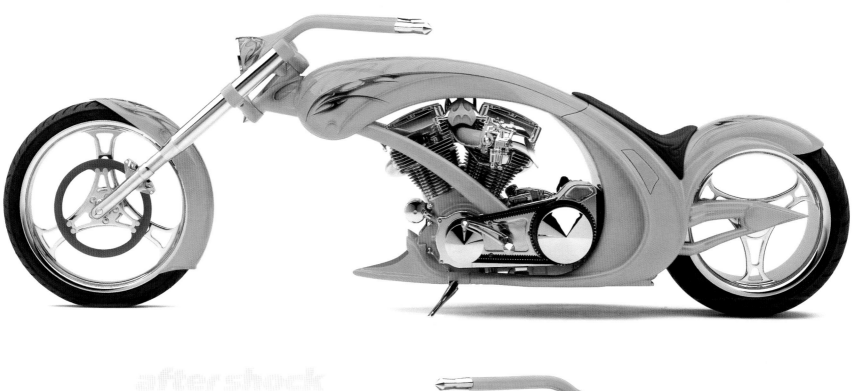
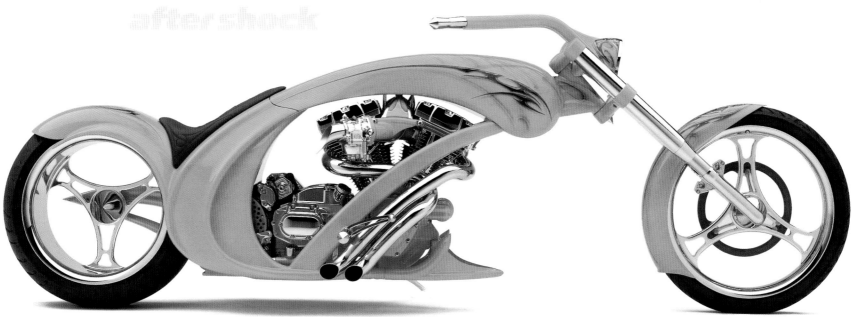

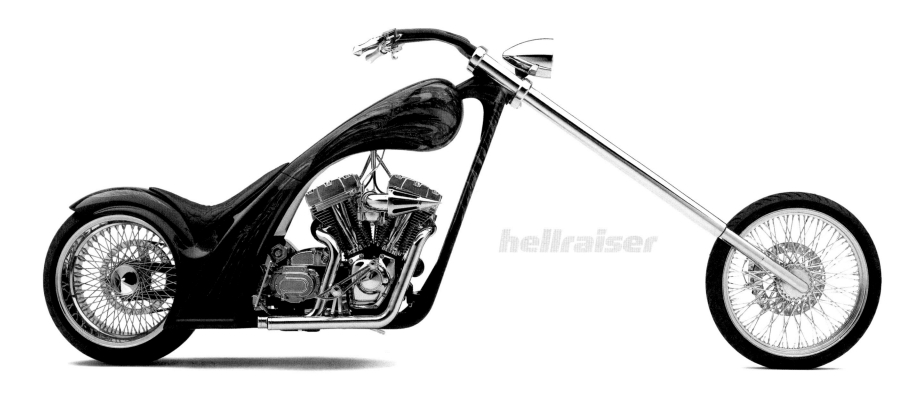

hellraiser

Mike Pugliese is a steadfast Staten Islander. He was born there in 1960. He will probably be pushing up Staten Island daisies one day long into the future. In the meantime, he's already proved he's a tough guy, having survived open-heart surgery. That was a scare, but he's as good as new again.

He was raised on the Island with his three brothers and a sister. Like father, like son, the senior Pugliese set the example of working in the construction business. Mike's mother stayed at home to take care of him and the other children. Mike's uncle George had an enviable job providing entertainment at a drag strip on weekends, pulling wheelies and sending sparks shooting out the back as he sped down the quarter-mile track in his "Little Yellow Wagon" novelty car. Occasionally, when Uncle George got stuck babysitting, he would steal off with Mike and the other kids to a machine shop, where he could squeeze out some extra horsepower. Young Mike began his mechanical apprenticeship by plugging in extension cords, but what he observed was enough to rouse his abiding interest. Even as a child, he enjoyed the acrid smells and loud noises of a garage.

By the time Mike was in the fifth grade, he felt compelled to turn his bicycle into a pedal-powered chopper. He bolted on a set of extended forks and gave it a rattle-can coat of candy-apple red with a gold fade. He substituted a smaller wire wheel in front and added a sissy bar in the back. He was learning by the seat of his pants, curiosity motivating his improvisations. With such a cool set of wheels to showcase his talent, he wound up repainting bicycles for every kid in the neighborhood. Some of the bikes that found their way into his junior chop shop were of dubious provenance, but his parents never found out. Happy as

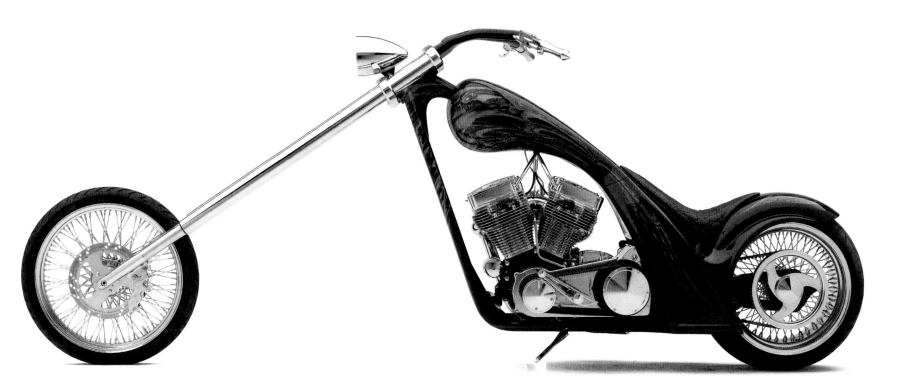

a clam, Mike sailed through childhood and adolescence, completed high school at age eighteen, and found a job at a local body shop. There he polished his skills, learning to cut, grind, weld, pound, and paint.

Staten Island may be a part of New York City, but the feeling is definitely small-town. He loves it. "It's not the prettiest place in the world," Pugliese will tell you, "but it's the people." There is no place Mike Pugliese can go on Staten Island without attracting friends. "They feed me and buy me drinks," he says. That keeps him in good spirits while he keeps their bikes in fine fettle. It is a happy arrangement. Whether friends or merely acquaintances, every day he runs into people he grew up with. Add to this community the high profile of a guy who's been on TV and rides motorcycles that look like Pamela Anderson in a room full of librarians and — bada-boom! — Mike is the grand goombah.

Food is a huge part of life in the Italian-American community on Staten Island. Walk into any *ristorante* with Pugliese and his *camerati,* who act as if they own the joint, and you will eat until your eyeballs pop out and your buttons burst. The name of every course ends in a vowel and tastes as good as it sounds. Menus? *Fuggedaboudit!* What's more, when these guys congregate outside a local bakery on a typical Sunday morning, it's like watching the scene from Hitchcock's *The Birds* where, one by one, ravens perch on a schoolyard jungle gym until suddenly there are thousands of them. Although less ominous, they will show you where all the neighborhood gangsters live. We're not talking Hells Angels; we're talking La Cosa Nostra.

Once, in his early twenties, before he got married, Mike took a vacation in Rome with nine other miscreant friends and

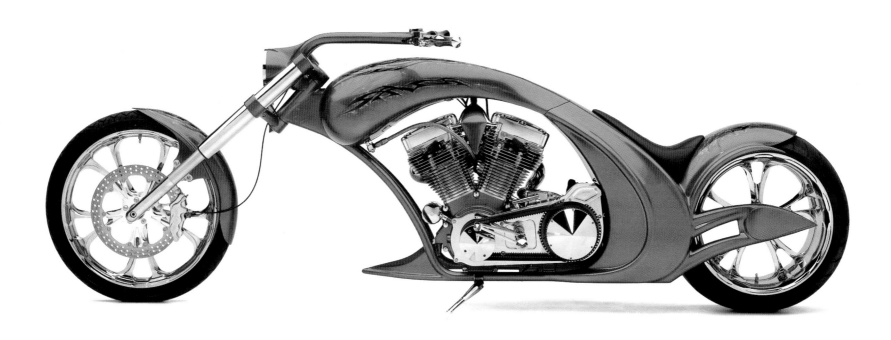

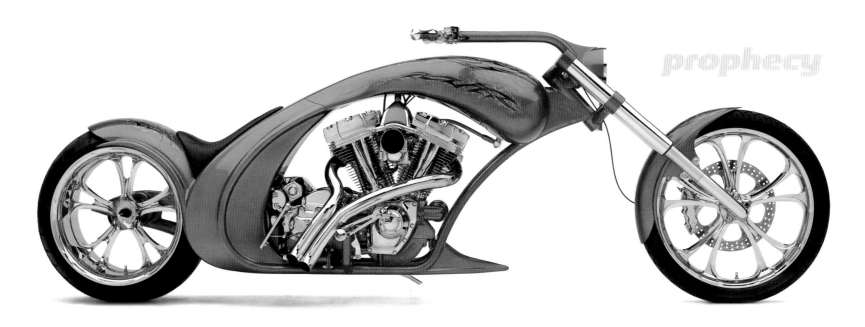

prophecy

ended up spending ten days in prison. Their misadventure started out after

dinner with some girls they had met while drinking in a nightclub. On the way

out, one rowdy fellow tried to make a call from a public phone booth and

didn't have a token. He smashed the telephone and stormed away just as

two guys in ski masks jumped out of a car and came at the group with guns

drawn. It looked like a robbery, so one drunken reveler took a swing at his

apparent assailant and got knocked senseless by brass knuckles. It turned

out the robbers were undercover *carabiniere* stalking the notorious Red

Brigade terrorist gang. Still at gunpoint, Mike and the Inebriated Nine were

thrown up against a wall and handcuffed as police reinforcements arrived.

One assumes the guys put up a gallant diversion to allow their female com-

panions to escape.

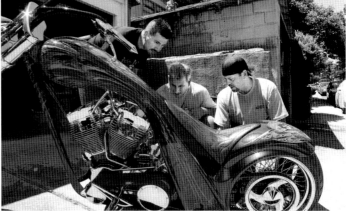

All were taken to a four-hundred-year-old prison, Regina Coeli, and told in English, "You runna, we shoota you!" Mike says,

"They stuck us in there with maniacs." Men were singing opera and dancing with each other. It began to look like a Felliniesque

remake of *Midnight Express*. It was grim when it wasn't darkly hilarious. Mike wound up in a large cell with a bunch of prisoners

from North Africa, Canada, Thailand, France, and Italy. "It was like the United Nations," he sniggers. Surely there was no pretense

of diplomatic behavior.

In Italy, prisoners are allowed to cook in their cells. They had wine to drink out of little cardboard boxes, just like the

juice that kids put in their lunch bags. But one guy from Morocco was chugging olive oil out of a bottle and barfing up bags of

heroin. "It was a nuthouse," reiterates Mike, adding, "I'm playing it down!" The junkies didn't have needles or syringes to

mainline their smack, so they'd cook it up in a spoon, stick a ballpoint Bic in their arms, and blow it into a vein. Another inmate

was beaten inside the cell. Mike thought, "We're gonna die!" Finally, his father flew in from the States. A guard told him,

"Signor Pool-YEH-ze, your *padre* is downstairs." Padre was crying his eyes out. Mike was lit up on *vino* by this time and enjoy-

ing his homemade prison pasta with a cream sauce that wasn't half bad. "Don't worry, son. I'm going to get you out," said his

father, weeping. Mike shot back, "Don't worry, Pop, it's not all that bad in here." Such were ten days in the can. The next year's

field trip: Brazil.

Eventually, Mike outgrew the headstrong hedonism of his youth, went into the construction business with his brother,

got married, and started a family. Although he had already been riding Japanese motorcycles since 1980, it wasn't until his

thirty-first year, in 1991, that he found his niche. He bought a Harley-Davidson Fat Boy, rode it around for a month or so, and

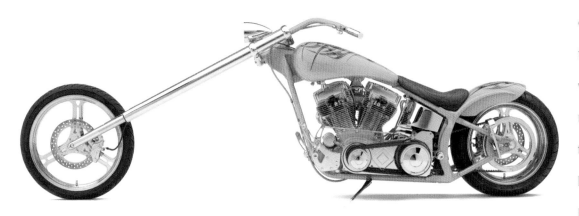

said to himself in frustration, "That's it. I can't keep it like this!" It was blue and tan, "the worst color combination." He waited impatiently until the end of summer, tore the bike down, added a wide tire, stretched the tank by utilizing his old body-shop skills, and brought it to Daytona Beach the following spring. "That's where it all started," he says, "at Bike Week 1992." By the next year, he had built his first full-blown custom bike. He took it, too, down to Bike Week. Once he realized how many trophies he could win, he added other bike shows to his itinerary.

"When you're building a bike, you can't help but make sacrifices," Pugliese laments today. With competition deadlines looming, he will shine on his social life temporarily, except for holding out welcoming arms to those loyal enough to keep him company in the garage. He might have to miss one of his kid's ball games and stick his wife, Justine, with extra chores until the tempest of activity in the garage dies down. "My wife gets a little crazy about it," he says. He does not blame her — the bike-building obsession is overwhelming. But, as we have learned, he could have worse vices.

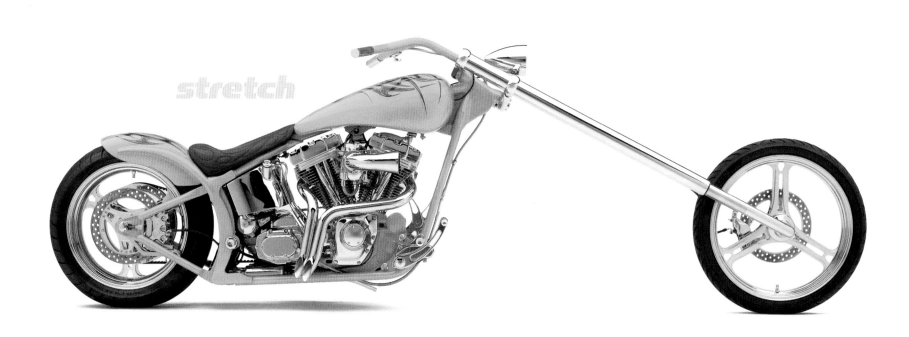

stretch

Mike Pugliese has some advice for would-be builders: "If you want to build a bike, don't worry about what everybody else is going to like. Just do what you think is cool. If everybody likes it, fine. If they don't, so what? Don't be afraid. If you don't like what you did, *it's metal*! Throw it away, and start again!"

Pugliese's award-winning choppers have introduced the public, and the industry, to many technical and stylistic innovations that seem commonplace now. Back in 1996, such goodies as flush-mounted gas caps, hidden ignition switches, belt-drive covers, and other staples of trick customization originated in Mike Pugliese's two-car garage. Subsequently, other builders have taken his ideas, modified them slightly, and commercialized them. "People tell me I'm crazy to let them," he admits, "but I can't do everything. They're in that business. Let them make money." He eschews patents, but he goes crazy when other people try to claim that they invented something he came up with first. The pros look to Mike Pugliese for inspiration. "If I make it a business," he reasons, "maybe it won't be fun anymore. I like going down Main Street in Daytona and the cameras start flashing. Like maybe I did something right. You know?"

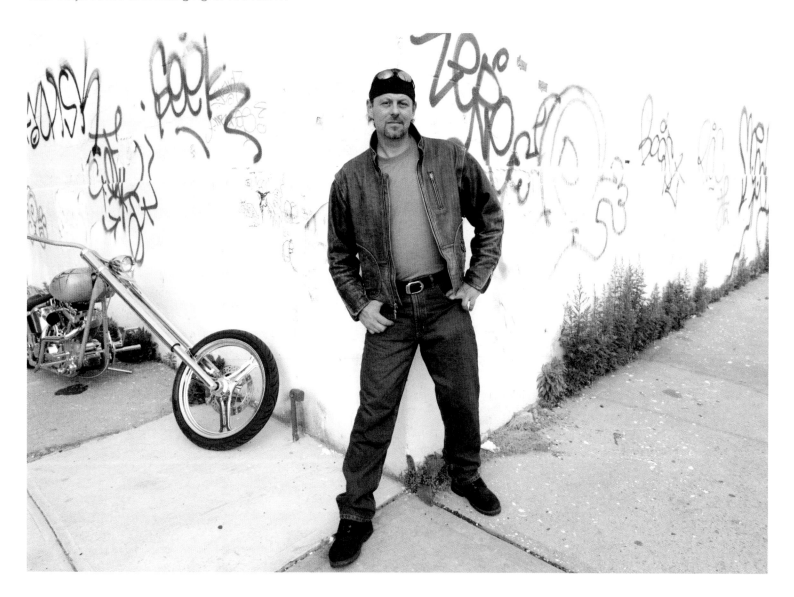

Who would have thought that a full-blown, fire-breathing, rip-snorting motorcycle could evoke the old Schwinn Sting-Ray with a banana seat and a playing card flipping between the spokes that you used to ride to school? Didn't those bicycles want to grow up to be choppers anyway? They did. Kudos to Jesse Rooke for taking off the pedals and putting hormones in the gasoline.

Rooke believes that choppers reflect their builders' histories and, ultimately, their personalities. His own history, that of a lad barely looking back at thirty, is steeped in skateboards, BMX, motocross, and high-speed kart racing. He has always been an ambitious competitor, although the laid-back, Pacific Coast patois of a surfer dude who lives far from the waves seems to belie that fact. Rooke suggests, "The bike that has personality is always going to be a chopper." And just like himself, his own bikes suggest the personification of X culture (think Generation X and X Games) and an appeal to riders of an age still oblivious to mortality. "I'm generating an emotion," says Rooke, whose sentiment derives from mainlining adrenaline.

Rooke is modest about his ideas and how he has already begun to influence the motorcycle industry right out of the gate. "I may be wrong, because I'm brand new to the whole deal," he says. "I don't know that I consider myself an artist. I don't know what I am yet." He builds bikes the way he feels, and by that criterion, they must be choppers, therefore an expression of art. "I do it and don't even know I'm doing it," he avers. But one has to wonder how unconscious a decision it is to make the most of such an obviously good thing; for what may have begun as a novelty — his where-is-the-gas-tank? bicycle look — has led to so much applause that it was a no-brainer to expand on this theme with the self-indulgent audacity of an artist turned entrepreneur.

Jesse Rooke was born in Phoenix, Arizona, in 1975. He was raised there along with his brother and a sister by parents who were themselves dedicated motorsport enthusiasts. Legend has it that his mother used to pop the clutch and head out on one wheel from time to time. Jesse is still hoping for a demonstration, though. He began riding tiny dirt bikes himself at the age of three, encouraged by his father, who owned a motorcycle shop. Tools were as available as toys. Jesse and his father built forts and skateboard ramps together.

Long before choppers entered his consciousness, Jesse was an adolescent outlaw of sorts, persecuted for riding skateboards. As the once ubiquitous bumper stickers declared, "Skateboarding is not a crime!" Because of his strident stand, and that of other like-minded advocates, the indignant gripe of skateboarders everywhere was heeded by civic leaders to the extent that skateboard parks now exist in communities throughout the country. Still, Jesse thinks

the authorities are just trying to keep it contained that way, a cynical view perhaps. But some people still consider ardent skate-boarders, who are not content to be fenced in, a nuisance. That sentiment mirrors the conflict between those who ride choppers and those who berate them. After all, riding the real deal on public streets is illegal, if you get technical about motor vehicle codes. Rooke doesn't even have a motorcycle license. Don't tell anyone!

With all of the enthusiasm and courage he displayed as a young athlete, including a statewide high school wrestling title, Jesse faced a problem more challenging than trying to win a checkered flag when he was just fifteen years old. Injuries sustained from a dirt bike accident left him unable to walk, much less ride, for a long time. "It was one of those stupid things," he says, "when you're out horsing around." He was riding on an almost flat front tire and didn't think much of it. But without the maneuvering capability of a properly inflated tire, he crashed and broke his leg severely. It was no simple fracture, and he had to grow

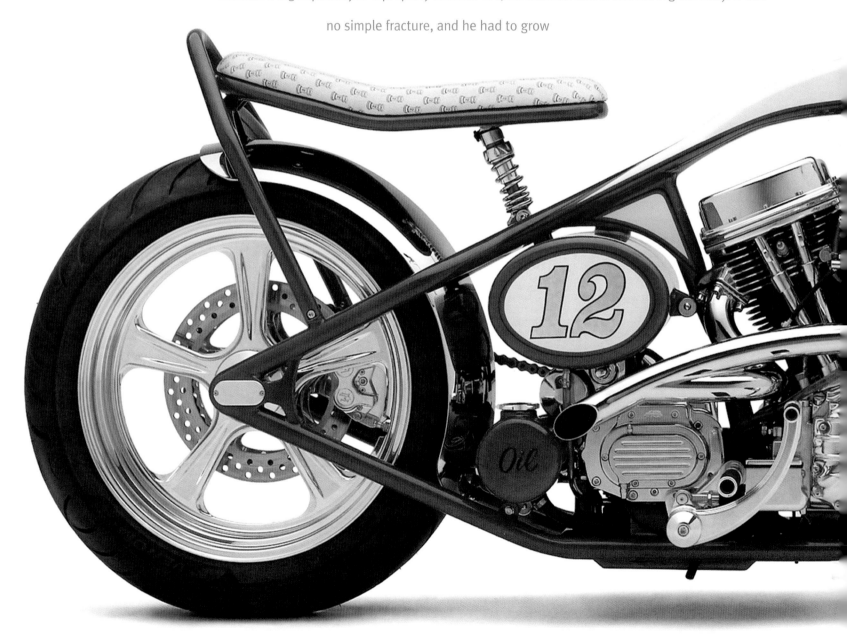

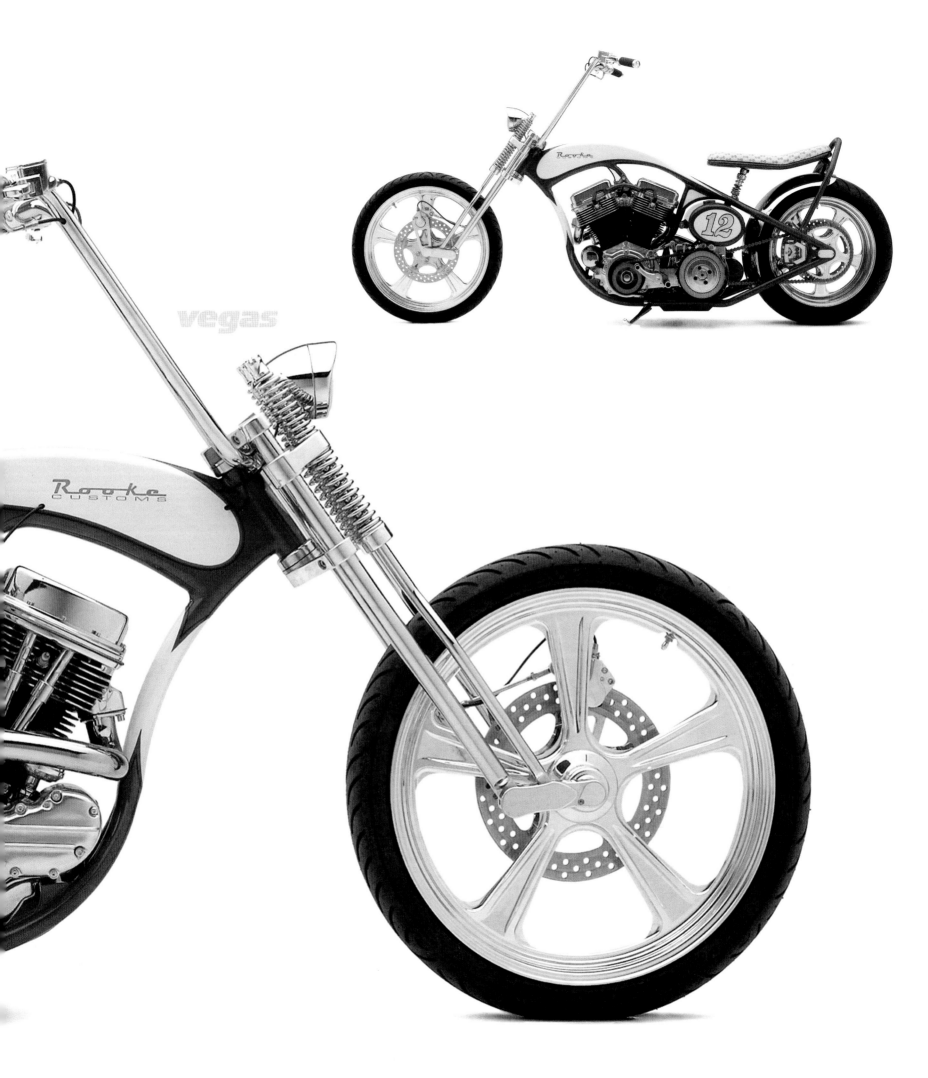

vegas

Rooke
CUSTOMS

three inches of bone in a femur that had been destroyed. That meant enduring three years of orthopedic pain before he could walk again. Despite the fact that he had more rebar in his leg than a freeway overpass, Jesse could not stay away from bikes. He knew that if he broke his leg again and bent the surgically implanted rods, they could not be removed. It would mean amputation. So he stayed away from racing, knowing full well that if you ride fast, you *will* crash. But even before he could walk unhindered, he got back on a bike for some easy scoots.

After graduating high school, Jesse got the lead out, so to speak: all the metal was removed from his leg, and he went through two years of college while recuperating. Then Jesse's father introduced him to kart racing. These little whoop-ass descendants of lawnmower-motor go-carts of the 1960s can zoom from zero to 100 mph and back to a stop again in under seven seconds. It's like taking off in a jet fighter, except a jet cannot stop that fast and keep you alive.

Jesse started racing karts (with a *k* now) and was signed up by a team out of Washington State, Seattle Speed and Custom. Jesse helped pioneer manual shifters on go-karts for the SSC team at racetracks worldwide; and with his past experience racing motorcycles, he knew how to go fast off the starting line, passing ten drivers before the first turn. He did well for a while and then busted his other leg — not so badly this time.

SSC had enough faith in Jesse's racing skill and his seat-of-his-pants engineering expertise to offer him a job in Seattle designing a new kart chassis while he recovered. Rooke, a desert rat, was at odds with the Seattle climate. So after he finished his assignment, he was given an opportunity to set up a racing parts distributorship in Southern California. After successfully completing that mission, he got an urge to start his own business. In 1998, Rooke, now twenty-one years old, headed back to Phoenix and founded a retail store called MPH, Inc. It specialized in selling the 125cc shifter karts that Rooke had championed.

Even with all of his business activities, Rooke made time to sneak back on the track. "My religion is racing," he exults. "When I'm in the garage or on the track, this is church. This is the deal." Eventually, he led an effort for the SSC team, now backed by Kawasaki, racing his own chassis design at the karting world championships. He figured it was time to sell his retail business and devote his career to racing.

By the time he was twenty-six, Rooke was hoping to land a seat in a full-size, open-wheel race car, just as his childhood

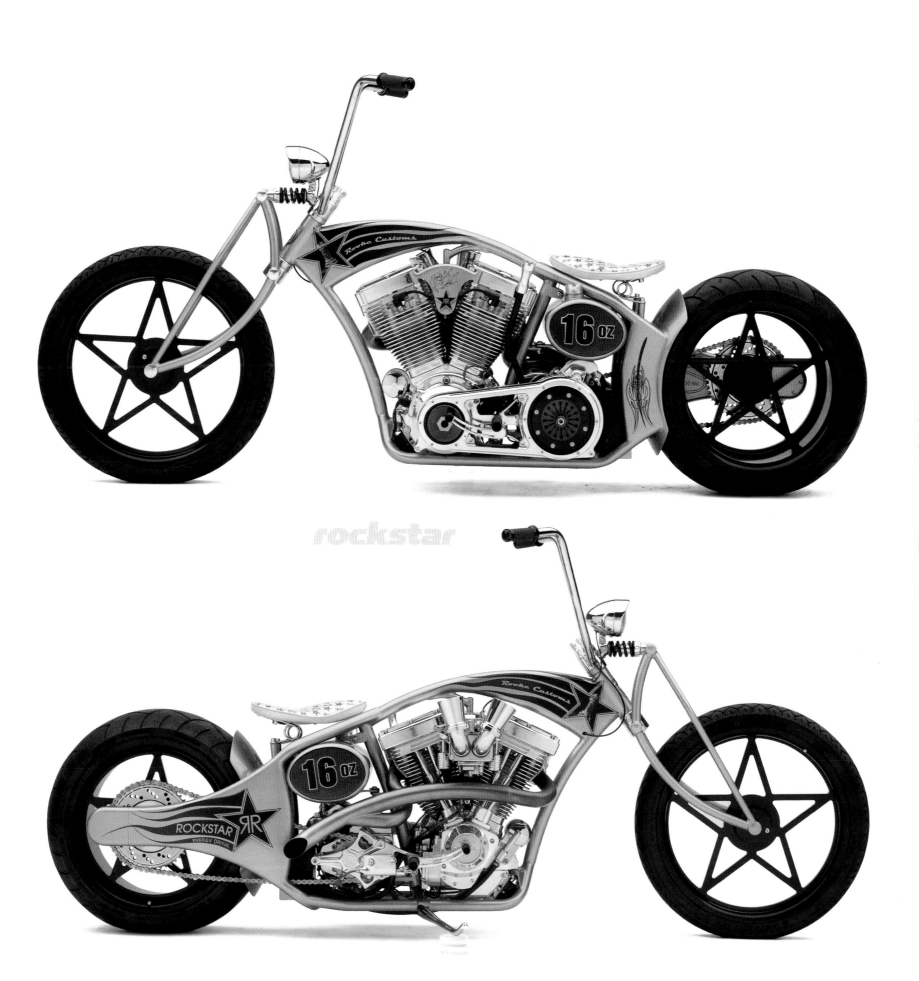

rockstar

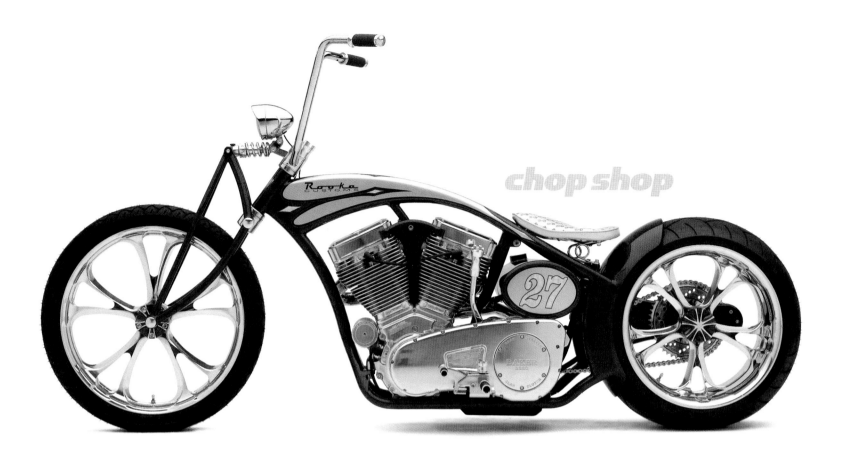

friend and kart-racing competitor, Buddy Rice, had done. Rice went on to win the Indy 500 in 2004. But in the meantime,

something else caught Rooke's attention. He was impressed by a friend's custom chopper from the shop of big-gun builder

and local hero, Jim Nasi. The temptation to own a bike like that was irresistible. But even if he could afford to buy one, there

was a long waiting list for a Nasi original. Then something else happened. Rooke caught the seminal *Motorcycle Mania* show

on TV, featuring Jesse James of West Coast Choppers virtually building a bike from scratch. Rooke's mouth was wide open.

What set the hook was watching James bend a piece of metal tubing on a wooden template, just by heating it with a torch to

get the shape he wanted.

 Rooke inferred correctly that James didn't have a ring roller, an expensive tool designed for that purpose. But it had

been Rooke's experience, as well as a common way of thinking within the racing community, that "you did whatever it took to

make it work." If you can't buy, rent, or borrow whatever it is you need, improvise! Rooke saw that kind of dedicated resourceful-

ness in the work of Jesse James. It was an inspiration. Rooke knew he could do the same thing that James did. He had to prove it

to himself. He was twenty-seven years old. Racing took a detour.

 Rooke began his first bike project with little firsthand knowledge of what to do. Without a full complement of tools, he

did indeed have to improvise. He thrived on the challenge. For his first gas tank, Rooke just dived in with no way to know if he

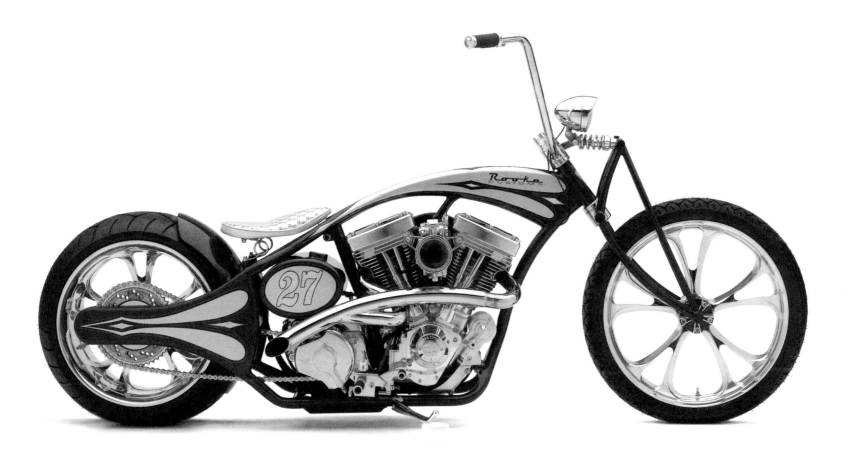

was going about it the right way. But he figured that if he could first cut out a template in cardboard, he could shape it out of metal, too. It worked. But without the right machine, it took the strength of three men to bend one thin sheet of steel alloy to finish the tank.

It didn't take long for the industrious and inventive Jesse Rooke to become the most celebrated new kid on the chopping block. Six months after he set his sights on building a custom chopper for the first time, the result, a bike dubbed Dinah, took the bike show circuit by storm. Now he is turning down commissions, having only enough time away from public appearances to build ten bikes each year.

The cutthroat competitiveness that exists on the race track comes to a truce when the drivers cross the finish line. Off the track, they are brothers. They hang out together. But Rooke has not seen that kind of camaraderie in the motorcycle industry yet. With bike builders, the equivalent of a race is a bike show. There are no pits where the drivers congregate and work together. "In the bike industry, the best guys don't want to park next to each other," says Rooke. At custom bike shows, each builder wants to set up as far away from his competitors as he can. They defend their turf.

In kart racing — and auto racing, for that matter — mutual respect and camaraderie are displayed by trading helmets. Rooke has good relationships with Jesse James, Jim Nasi, Billy Lane, and several other builders. He is a known associate of

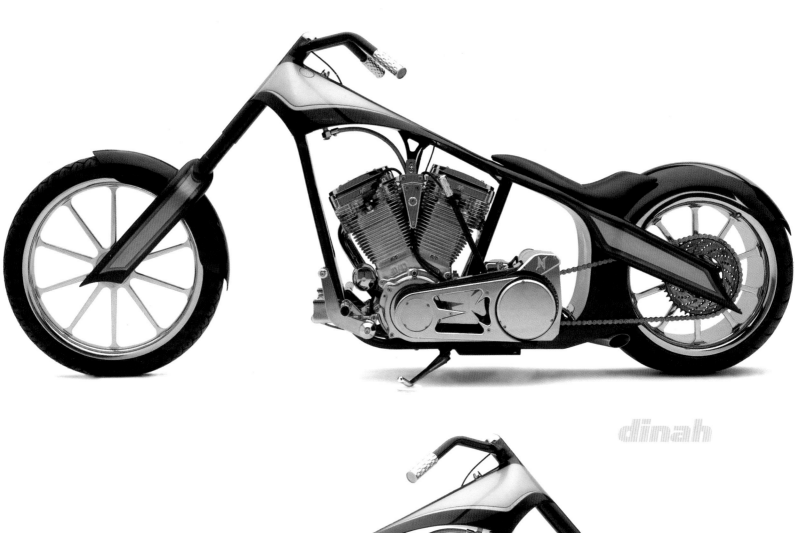

dinah

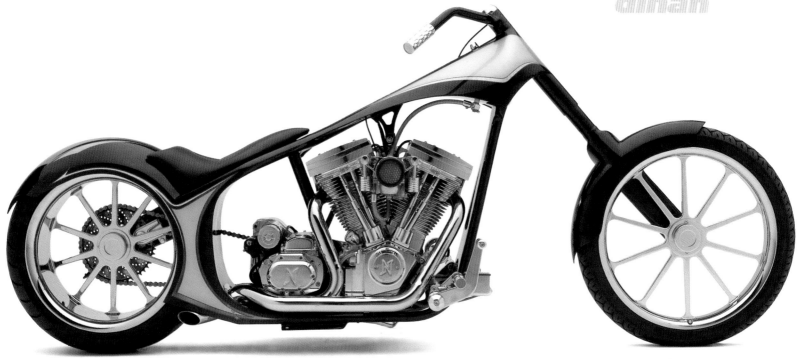

Roland Sands and Johnny Chop. But since helmets are eschewed in the chopper community, there is no comparable sign of solidarity. Rooke wants to establish some kind of ceremonial biker wampum, but he hasn't figured out yet what the equivalent currency of helmet trading will be. Maybe billet wheels!

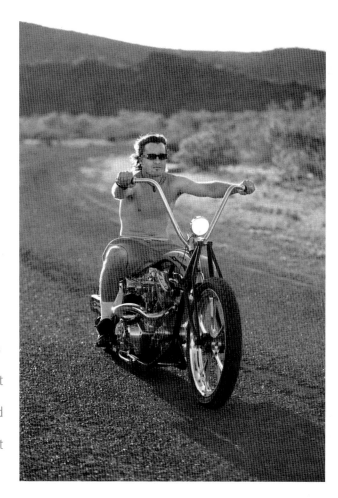

Rooke is loyal to those who helped him start his career. "A lot of the other builders, you know, they have really cool products. I'm not opposed to use those. You'll see them in my bikes," he says. He cites Jim Nasi in particular. "We ran all of his logos on my first bike, and we always will. That's the stuff that I bought, and he's the guy who answered my questions." And Rooke still tries to learn from "what's out there, what's available," to make his bikes better. In the meantime, he has innovated his own single-sided swing arm and designed gorgeous billet wheels. He started out buying motors from Kendall Johnson. That may change, as Rooke has plans to build his own motors in the future. "The industry is so huge, and there are so many options. We're taking it all in right now," he says. *We* refers to Jesse himself and his brother James, who is his closest business partner. "You know," Jesse says, "I have my dad involved here and there, too. It's difficult to work with my father." When the inevitable comparison to the Teutuls is made, Jesse grins and says, "They don't even have to script us. Put the cameras over here in our shop. There's blood, tools flying every day, yelling. It's family!" Jesse would like to see his father become more involved in the business, especially with building engines. But whereas it is important to Jesse to make a machine with finesse, whether it's a skateboard, a go-kart, or a motorcycle, his father doesn't care if it's decorated with rattle-can paint and put together with duct tape and baling wire, as long as it goes fast.

Rooke enjoys his home in Arizona. It is a great place to have a motorcycle. He says, "You can ride anywhere, right from your house. There are a lot of open spots." Yeah, like straightaways until roughly Utah. But there are mountain twisties, too, with spectacular scenery.

Rooke has adopted a convention of often, but not always, giving his choppers the names of women and girls. His bike Phyllis, for example, was named after an older woman he had met casually who had broken her hip. It was simply an act of kindness motivated by empathy to help the healing process. It made her feel happy, and it worked. Another bike is named after his mother Margi.

Because Rooke's bikes are so unconventionally designed, they rub some whiners the wrong way. "These bikes are not the norm," admits Rooke, referring to choppers. "They're fancy. They're chrome and shiny. And there're bikers out there who don't like that." He emphasizes, however, that chopper builders themselves will continue to define the genre.

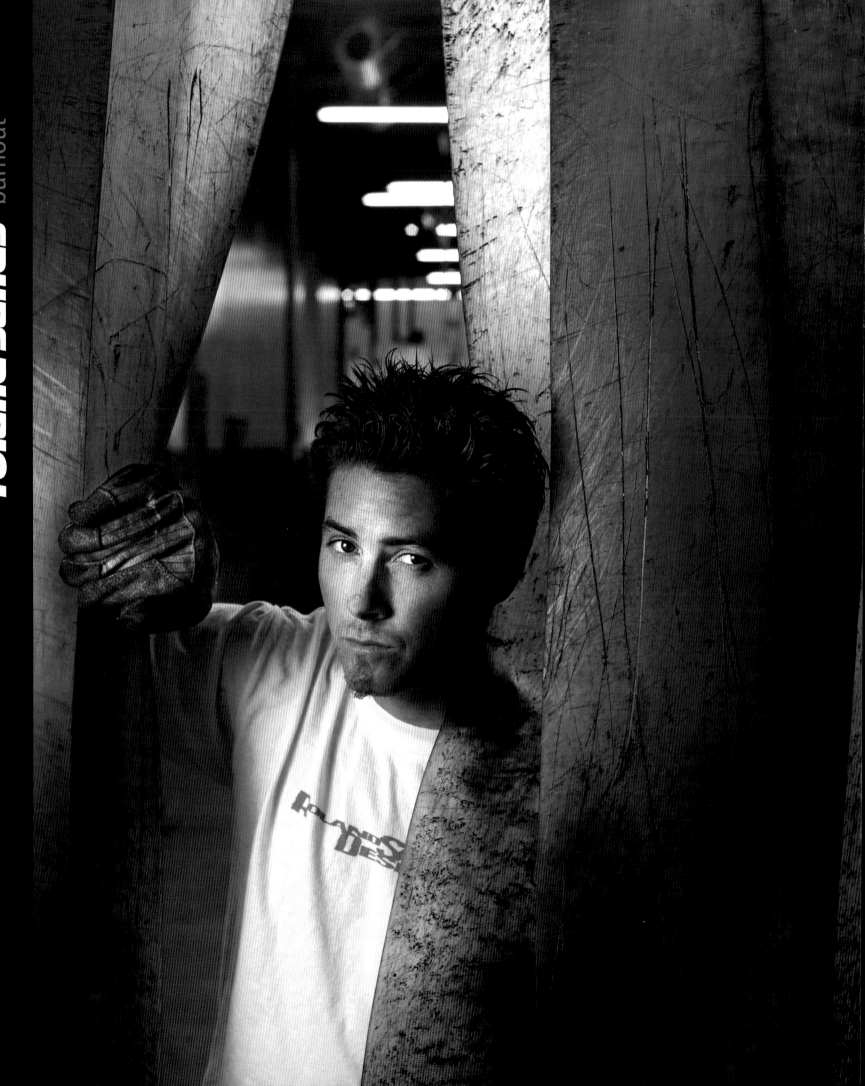

Don't let the "homie" lingo, the skateboard, the boyish face, a penchant for tall women wearing Lucite footwear, and a hopeless addiction to speed belie the fact that Roland Sands is a dedicated professional with an intellectual's approach to the design and production of motorcycles.

To Sands's way of thinking, the semantic distinction between a chopper and any other kind of custom motorcycle is moot. "The word *chopper* has kind of played out," he says, its meaning having become too severe. Other young builders will agree with his generalization: "A chopper is whatever you start with and wherever you finish." But he cites additionally a more eclectic rationale than his cohorts have for hacking apart perfectly good motorcycles, namely his inherent dissatisfaction with art for art's sake.

For Sands, it takes more than a motorcycle's aesthetic qualities to stir his soul; it also requires breathtaking performance. Riding a traditional chopper is just not fulfilling for Sands, because he can't throw it around like a racing bike. A long bike with minimal suspension dominates its rider instead of the other way around. So his holy grail is a bike with the hybrid characteristics of a kamikaze crotch rocket and a Harley-style sled, one that performs on the road without compromise while retaining the ineffable qualities that make it look cool on a kickstand. Beauty, we know, is skin deep. A woman with the IQ of an avocado who gratuitously exploits her looks is no more interesting, after all, than a 130-horsepower bike that goes down the road like a wheelbarrow. Sands delves beneath the superficial appeal of choppers to imbue them with the high-performance technology of their sport-bike cousins, from suspension to drivetrain, all without diminishing their stature as works of art.

"I really want to build 'concept bikes,' " says Sands, which means that each new example is a research-and-development project as well as a cultural artifact. His priority isn't building custom bikes for private customers. He doesn't need to, considering his job as chief designer for Performance Machine, the company founded by his father and uncle, a leading manufacturer of aftermarket motorcycle wheels and brakes. Sands wants, in his words, "to build something revolutionary and new that has a purpose. Not just for style; not just for looks. I want it to work better." His purpose is to collect data and apply it to the design and manufacture of commercially available components that will ultimately affect the dynamics of the motorcycle marketplace. He believes that sound engineering principles applied to the smoking-hot looks of a chopped bike, well promoted through the accumulation of accolades, will trickle down and affect the way all motorcycles look and ride in the future.

Choppers are supposed to be outrageous, so it's no easy task maintaining a hip-hop chop shop within a corporate culture. Without offending or, at least, annoying *someone,* choppers don't succeed.

Although Sands shies away from gratuitous embellishment, he does not believe extravagant good looks and superlative engineering preclude each other. In fact, he is adamant that they must complement each other. If a design fails on either count, it's back to the drawing board, an idea that goes back to the roots of chopper culture: if something isn't cool or doesn't make it go, it must go away.

Sands's bikes all have the beguiling raunchiness of a chopper without being burdened by redundant adornments. "To

me, it looks like other bikes are sick," he complains. "They're trying to puke up all this extra shit that's hanging off them. They're like weighed down by all this fucking crap! It's disturbing." He concedes, however, "I guess people like it." Oddly enough, his own style may offend the self-anointed purists who consider themselves keepers of the flame. But this young gun is shooting down stereotypes with his high-caliber innovations. Not only are they engineered to be agile, but from every angle they look fast standing still. They may be offbeat, but they are no less influential to a new generation of riders than the revolutionary bikes built by another young Turk named Arlen Ness back in the 1970s.

Despite his puckish congeniality, Roland's attitude turns hard-core on the throttle. "I ride pissed off," he says, emphasizing his competitive fortitude, a vestige of his road-racing career. He now uses it to his advantage by engineering his personal experience from the racetrack directly through the seat of his pants and into every prototype he builds.

Roland was nineteen when he made his debut at Willow Springs International Raceway in Rosamond, California, in 1992. He rode a two-stroke Yamaha TZ250 from the starting line right into the winner's circle and got his first champagne shower before he was legally allowed to drink. But that's the least of it. "I was gone after that," says Sands. "It was just like heroin. That's all I could think about." The next eight years of his life were focused on racing. There was *nothing* else. "The future is just, like, the next corner." That was as far ahead as he could think at any given time. He only cared about surviving long enough to get through it and rush on to the next straightaway. Then he'd concern himself with getting through the next corner once again. One good turn deserves another. Between races . . . well, what *was* there between races?

It takes a supreme commitment and lots of Vicodin to tolerate twenty-nine broken bones, a bruised lung, and a lacerated liver and keep racing, despite ten national wins plus an American Motorcycle Association championship. "Throwing up blood is awesome!" Roland quips. "Nasty shit happens when you fall off a motorcycle at 120 mph." Ultimately, he "pussed out." But he was just kidding himself. On an intellectual level, Roland knew his decision to quit was about personal survival. He also began to have psychological doubts. He felt shallow, respected only for how fast he could ride a motorcycle around a racetrack. He wanted to create a more substantial legacy, not just to make something of himself but to make something physically. He

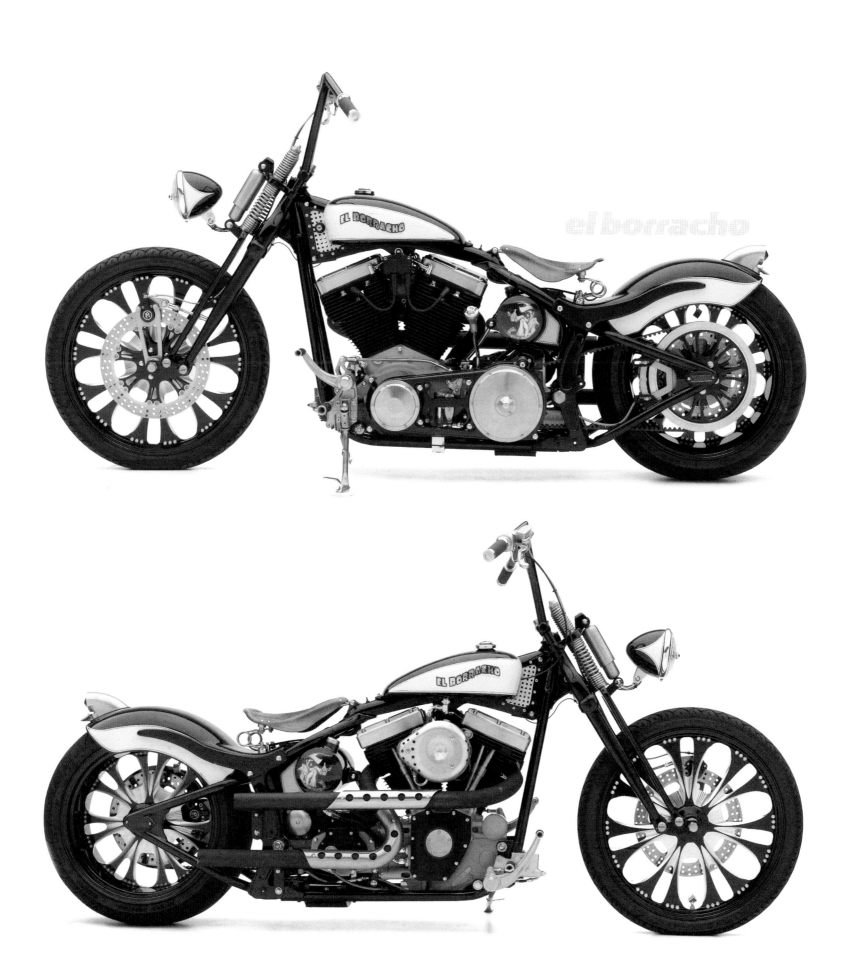

el borracho

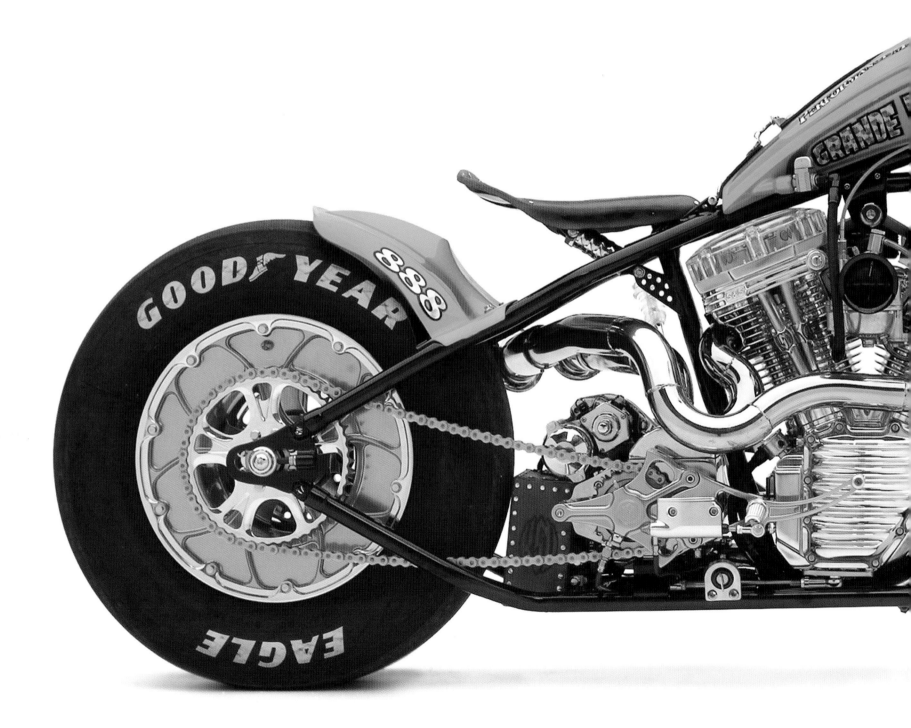

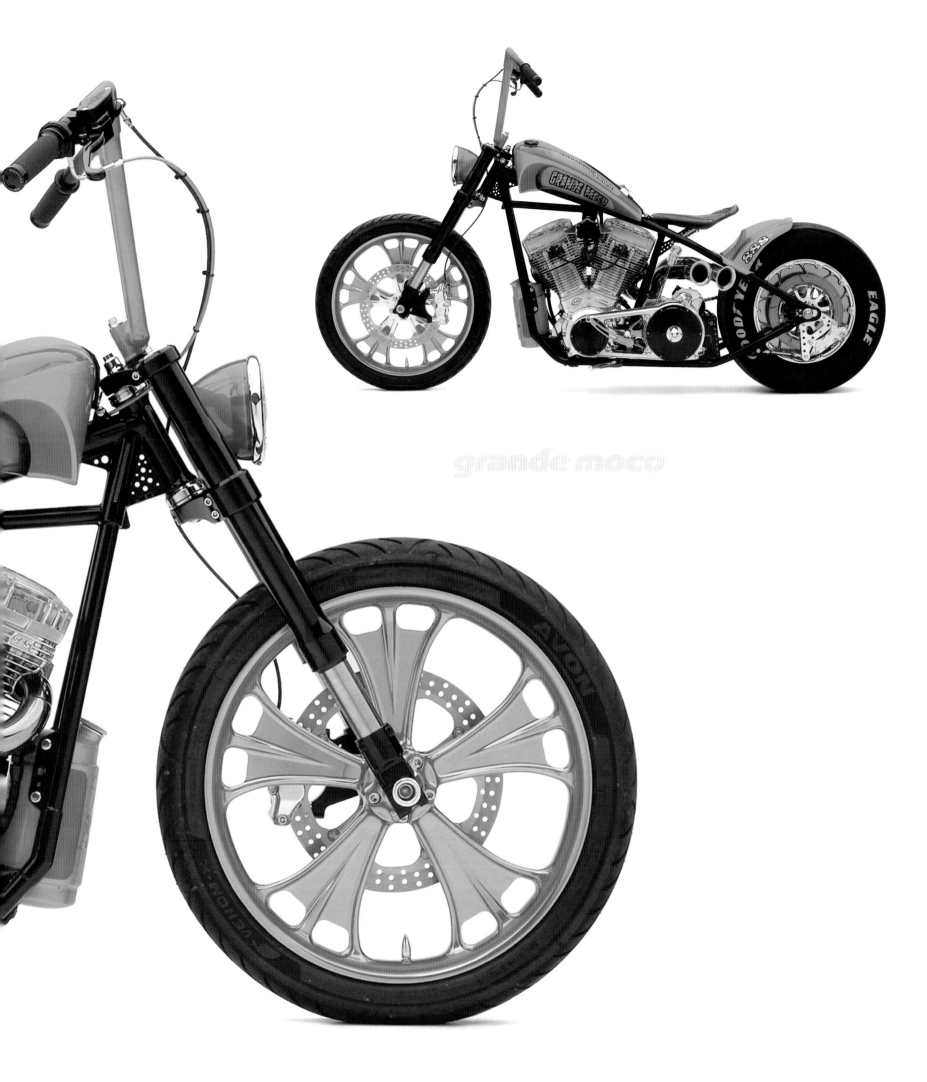

grande moto

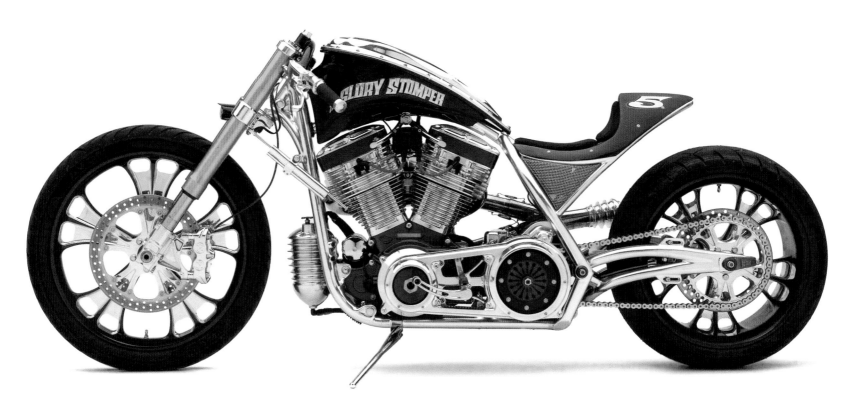

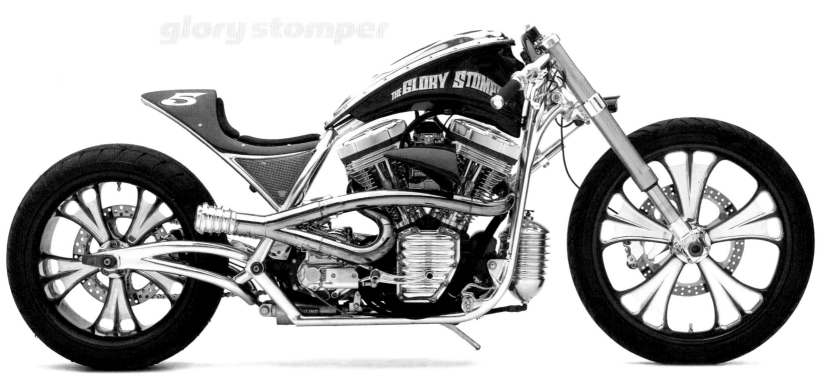

knew he was ready to quit in 2002 when he won his last championship title, because emotionally he just didn't care anymore. As B. B. King sang, "The thrill is gone." Roland succumbed to a bad case of the blues. He realized that he didn't want to wind up as desperate as his late friend and teammate, Randy Renfro, who had had a toe surgically amputated and then reattached to his hand where his thumb used to be, just so he could keep a grip on the throttle. (The original digit had been ground down to a nub during a high-speed slide after a crash.) Such is the compulsion of racing, once it gets in your blood. Renfro paid the ultimate price for his obsession the same year Roland made his decision to retire.

Sands got into racing, in part, because after starting to work at Performance Machine, he didn't enjoy being known as the boss's son. When he gave it up, he felt as though he had given up his hard-won identity, too. That increased his depression. Trying to find himself, he leaned on the mechanical skills he had learned as a boy working with his father in the family business.

Roland's father, Perry Sands, was one of the first customizers to graft Japanese superbike front suspensions and wheels onto American V-twin bikes. He also pioneered the use of disk brakes on choppers. Young Roland often accompanied his dad to the shop in La Palma, just east of Long Beach, California. Eventually, he was getting paid to help out. Although his father bought Roland his first dirt bike, the kid was on his own after that; he was expected to take care of his own expenses for mechanical necessities. If he wanted to ride his bike or his Jet Ski, he had to maintain it. If he broke something, he had to fix it. His father gave him the gift of self-reliance. "He wanted me to appreciate motorcycles, not just to abuse them," says Sands. "That kind of went all wrong when I started racing," he quips. In the years leading up to his track debut, Roland learned how to perform every job in the plant. It was a perfect apprenticeship. By the age of sixteen, he was already designing wheels.

Performance Machine was right there when Roland needed help most, with an opportunity to redirect his career while he chilled out from racing, cold turkey. Suddenly, he had to turn his attention to the V-twin market, because that's the direction his father and uncle had taken the company. Sands, just like his father, already had an appreciation for how V-twin engines, the focal point of every custom motorcycle, lent themselves beautifully to custom building, more so than power plants exhibiting more modern designs. However, his sentiments didn't lie with V-twin biker culture. His heroes rode with their knees scraping the ground, men like Kenny Roberts, Kevin Schwantz, Wayne Rainey, and Bubba Shobert. His road-racing friends called him a defector, only half in

jest. "What are you doing building choppers, man?" They thought he was smoking too much of something other than rubber. While he was racing, Sands, too, was bewildered by bikers who sat up straight in the saddle with their feet straight out in front of them. "Like *why?*" he wondered.

That was a while ago. Sands concentrated his pent-up energy to build his first bike, based on a Sportster. It made him happy. He started to come out of his funk. Then he created Whiskey Tango. He calls it the kind of bike a rider would "back into a

neighborhood bar and do a huge burnout, scalding young hotties with burning rubber and sending local patrons running for fresh air." Then came his third project, called Hardway. Describing it as almost like a fine wine, Roland says, "The Hardway has a lot to say without saying too much. It's understated yet aggressive to the point of violence. I designed the bike with an early-'70s Top Fuel dragster in mind. It ended up being a clash between a 'blown-gas altered' and a road-race bike." Before Hardway, he says, "I didn't know how good I could be or if people would like what I'd done."

This was no catalog bike. Sands designed the frame (fabricated by Jesse Rooke), wheels, controls, handlebars, pipes — the whole kit and caboodle. When it won top honors at its debut in Sturgis, he knew he would continue to build bikes. He was back on track — the right track. "I'm young," he says, "but I've been in the industry since I was two feet high."

As a relative newcomer to custom bikes, Roland Sands still sees himself in the throes of establishing his own style. He recognizes how, for example, Joe Martin puts his efforts into futuristic yet gothically glamorous shapes. Chica puts his efforts into nouveau-retro, Cal-Asian concoctions, equally unmistakable. Billy Lane epitomizes cool as kitsch. Jesse Rooke bottles BMX with gasoline. And Indian Larry put everything he had into his ground-pounding motors embraced by utilitarian appurtenances and a kiss of period culture. Sands is establishing his own mode of inimitability by emphasizing frame geometry in conjunction with modern drivetrain technology. He talks about the particular genus of any given motorcycle as its "platform" — sport-bike frame versus chopper frame, for instance. The geometry that establishes how well it handles is generally described by how well it "sits." But the latter term also refers to a bike's overall stance, taking ergonomics and sheet-metal configurations into account.

As a kid, Roland was always drawing motorcycles; now he uses sophisticated computer-aided design (CAD) software. Unlike many builders who set out to create a custom chopper with only a picture in their mind's eye or, perhaps, a sketch on a napkin, Sands prefers an exacting, highly technical approach with each new project, working with blueprints and schematics. He doesn't work alone, though. He is magnanimous with praise for the team of experts at Performance Machine who support his efforts. Still, he says, "Shit doesn't get done unless I'm out there doing it!" Sands doesn't worry about keeping his hands clean. "When people see you're amped on a project, then they get amped, too, and it gets finished."

Roland Sands was born in 1974 in Long Beach. "When I was young, it was pretty ghetto," he recalls. "We lived in the back of the shop. My mom was over that!" For a while, the family, including his younger sister, lived in a trailer park in Compton before moving into an apartment in downtown Long Beach. By the time Roland was ten, Performance Machine had found its stride, and the family bought a house in Bixby Knolls, an upscale Long Beach development.

Roland was and remains a good-natured show-off. He likes to shock people with stunts he pulls while riding. As a teenager, he had to sleep in the slammer a few nights for playing carom with parked cars, using his hot rod as a cue ball. "I didn't do anything I ever got caught for on a bike," he sort of confesses, "but I've been chased a few times." This motorcycle miscreant's experience dictates that you've got to get away in the first minute, or you're done for; they'll have your license number, and it's helicopter and handcuffs time.

Roland went through the Long Beach public school system, alternately studying, surfing, and skateboarding. He took classes with Snoop Dogg and Cameron Diaz at Poly High in Long Beach. "Poly was a rough school," he says. He went on to Long Beach City College, but school competed for too much time away from racing and his job at Performance Machine. He left the hallowed halls of higher education for good once he started racking up points on the racetrack.

Roland Sands has made a name for himself as one of the most avant-garde builders in the business. Not only are his motorcycles inspirational, but the parts he designs and makes available to other custom builders have inspired many other wonderful motorcycles. He modestly says, "In this industry, I'll always be Perry's son." He's just a California street squid who made good.

Kansas City here I come. You might be singing that song on your way to the City of Fountains, Bryant's Barbeque, the Count Basie beat, and Kim Suter's choppers.

What a chopper is varies from person to person, opinion to opinion, increasingly so as the popularity of custom cycles swells. By the time a fan comes to Kim Suter, he is obliged to ask that person what *kind* of chopper he really wants. Not that anyone holds sway over his artistic prerogatives — Suter will build whatever he wants to. He just doesn't want to go so far off base that he cannot please the person who signs the check.

No less a pragmatist for having been at the forefront of a movement to create alternatively, the longest, lowest, tallest, or fattest machines in the Midwest, every once in a while he wants to go in a different direction. For one thing, he is considering more subdued choppers, "short little bar-hoppers," he calls them. He is also planning to stretch frames by three or four inches in the back, instead of extending the rake in front, in the manner of two-wheel, Top Fuel dragsters. And with his signature "Big Inch" beast mounted under the tank, Suter concocts a rip-snorting fiend with hair growing out of its exhaust pipes that will shut down most contenders lying in its path. As the reliability of extravagantly muscle-bound motors has increased by utilizing bigger bores with shorter strokes, Suter has pioneered their use on the plains of Kansas and Missouri. He has found that a continuing escalation of horsepower is necessary to satisfy the demands of high-dollar adrenaline addicts who perpetuate a game of one-upmanship. "It's all a fashion statement; it's about being seen," says Suter, who is slow-talking but quick on the draw.

Suter, a barrel-chested champion of high octane, speaks with the easygoing and plaintive twang of a cowboy movie star. "Some of the guys in the industry refer to me as the John Wayne of the motorcycle world," he acknowledges. He does not have much to say, but when he does speak, people listen. He listens to his own clients, too, each of whom cares about pulling up to a favorite watering hole heralded by a roaring exhaust note to ensure that ten or fifteen people are already gawking out a window at his bike by the time he saunters insolently inside. "That's kind of a cool deal," says Suter.

From the age of eleven or twelve, having seen his share of biker movies, Suter has wanted to ride. In 1976, two of his high school friends and he bought used Harleys. "We were like Fonzies, the whole deal," Kim reminisces, referring to the too-cool-to-drool ex-biker-gang-leader Arthur Fonzarelli from *Happy Days*. Since the TV series' action was set in the 1950s, Kim and his pals took on the leather-jacket guise of greasers and rode their bikes throughout that summer. "They were pretty much stock," Suter says. "The next winter, we all got together at one

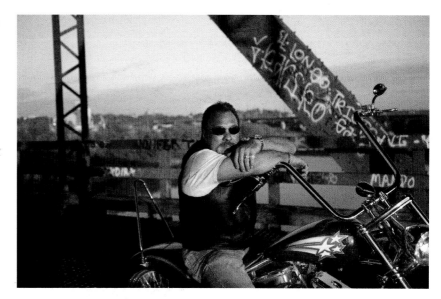

house and took the three bikes apart at the same time." As one might imagine, a lot of parts got mixed up. "It took another year or two to sort all that out." Suter chuckles. "That's how we learned, really." It became a ritual every winter to take their bikes apart, make them a bit faster and a bit flashier, and have them ready to roll by March.

Born right in the heart of KC in 1958, Suter has called it home ever since. "Every place I go, I think it would be a great place to live," he says. But family and familiarity keep him tied to his roots. The entire Suter family rides, either cruisers or dirt bikes, and enjoys family outings on motorcycles.

While he was growing up, Kim always had a spot in the family business, Saco Petroleum, a wholesaler of gasoline to service stations throughout the Heartland. In addition, the company owns a number of convenience stores and its own service stations. Kim and his two younger brothers performed odd jobs, including bagging a couple of thousand pounds of crushed ice each day at a nickel per bag and pumping gas.

As is legal in Kansas and Missouri, a fourteen-year-old can get a driver's license. And Kim did, along with a brand-new '73 Camaro, for which his father cosigned the loan. It was a

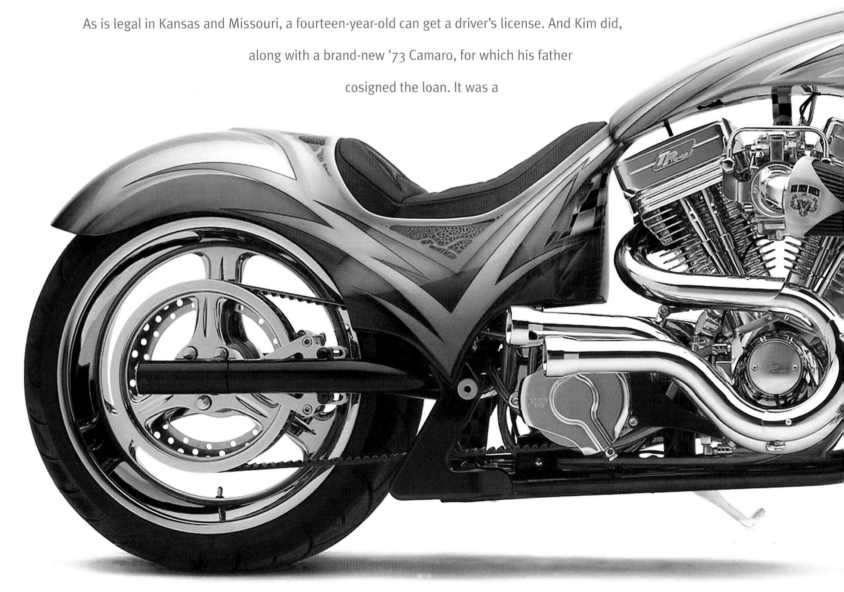

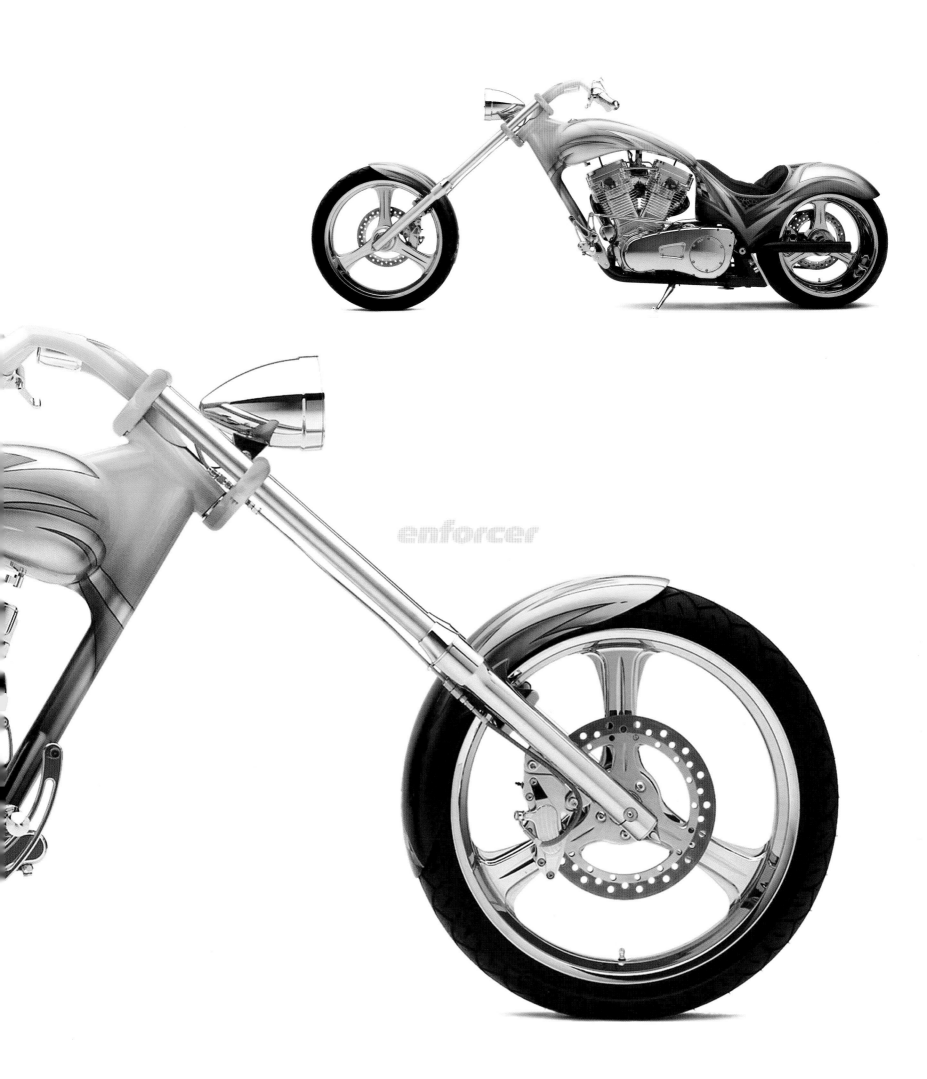

enforcer

restrictive license; you could go to and from school or a job. Of course, to Kim, going to a job meant everywhere, since there were Saco gas stations all over town. One late night after a football game, he was driving some friends around who had "acquired some beer," apparently purloined from a cooler at a Catholic wake. The floorboard in back was littered with beer cans. It was not a good time to see a red spotlight in your rearview mirror. Kim stopped, got out of his Camaro, and walked over to the patrol car — usually not a good thing to do (it worked out okay this time, because the cop never saw the beer). Kim had other infractions to explain and wanted to get right to it: expired plates, no insurance, and he was out past curfew. He got the ticket, of course. In court, the judge let him off but fined his father. Somehow he managed to survive all further puerile delinquencies.

Kim had a management position at Saco waiting for him straight out of high school. He was, however, looking for-

ward to exchanging his academic bondage for further hotrod revelry. Not long after graduation, though, his father suffered a heart attack that laid him up for months. Kim was only eighteen and thrown headlong into a role of responsibility to maintain the company until his father regained his health. Kim found himself trying to manage 110 employees, some of them twenty years his senior, the same people who had trained him as a boy. Some of the men refused to offer him the support a new boss should expect, even a temporary one. Others had the character to follow Kim's tentative leadership, even if for no other reason than deference for his father. Those who showed more disrespect than deference got fired when the senior Suter came back to work. Kim remained and eventually became vice president and general manager of the company.

Kim's mother worked there, too. So did Kim's wife, Cheryl, who has been with him now for almost three decades. Their own two children, now grown, came up working at Saco Petroleum. Kim's oldest son, a recent college graduate, still works there. Kim's youngest brother is in the thick of it now, and an infant granddaughter is waiting in the wings. Kim, who did not go to college but had recently paid off his son's tuition, implored his own father, "Why don't you just give me a check for a hundred grand? Look at all the money I saved you!" His father drolly replied, "Thanks."

Suter, like most master builders, began his motorcycle career at home, in his garage, actually. He had a drive-in basement. He was moonlighting at his job at Saco, realizing more and more that motorcycles were his true calling. It was the mid-1980s, and Suter discovered how lucrative it was to buy used Harleys, fix them up, and resell them. He also did a brisk business installing hot cams, stroker kits, and wide tires. Because of a special arrangement he had with a chrome shop, he could get his customers' parts plated more quickly than could the competition, and before long, Kim had a nice sideline going, not so much building bikes as customizing existing ones.

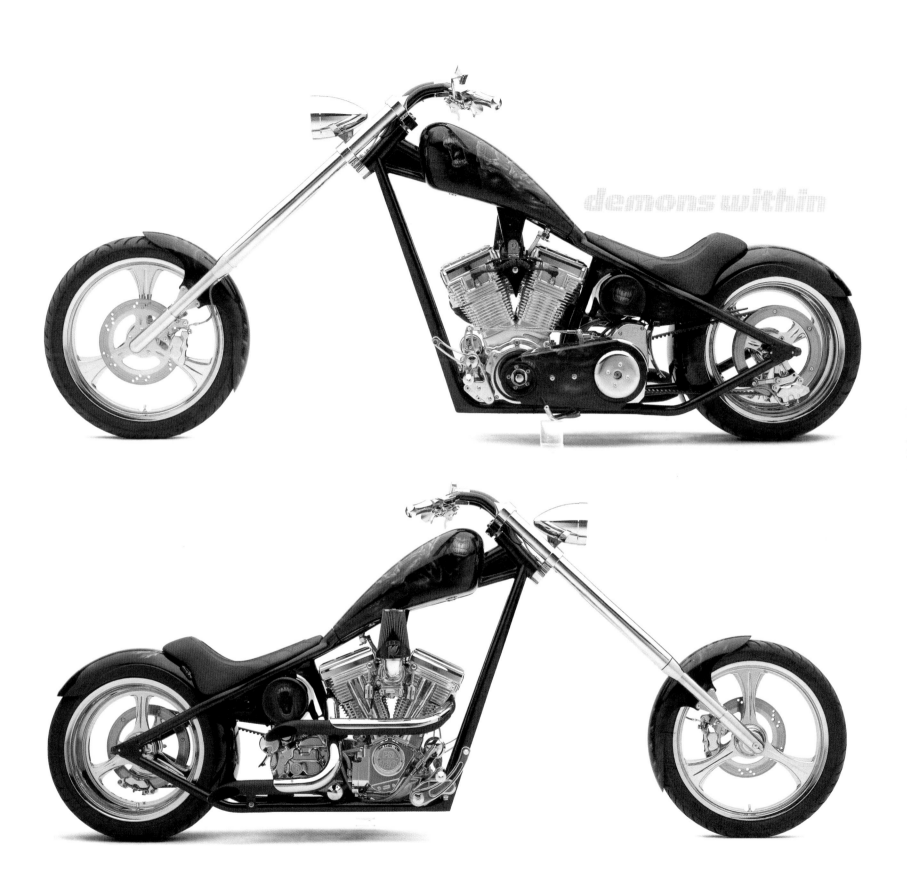

demons within

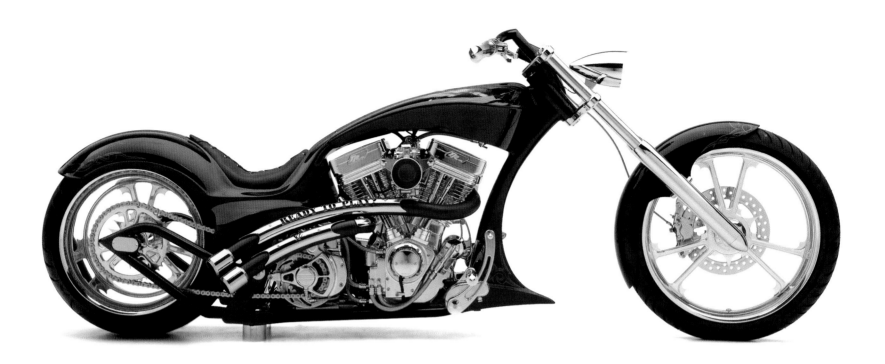

There were usually five bikes in the basement at any given time in various stages of repair. He had them torn apart in every corner, including the spot where Cheryl parked her car. "Well," she eventually told him, "this is kind of like a business now. You probably ought to get this out of my garage and get a shop."

The rest of the family was anything but enthusiastic about Kim leaving Saco to open up, of all things, a *motorcycle* shop. They wondered how he could support his wife and kids with that kind of piecemeal work. They expected him to come back. But they could not argue against the fact that his heart was more attuned to motorcycles than gasoline delivery trucks.

In 1986, Kim rode his Harley-Davidson Softail Custom to Sturgis. "What really got my attention was five bikes parked in front of a bar that looked exactly like mine, except for the license plate," he grumbles. He realized there was nothing custom about his bike at all. Since he had already made inroads into the bike biz, he arranged to buy some custom parts, including a prototype rubber-mount frame from legendary '60s customizers Kenny Boyce and the late John Harmon. Suter realized he could mount an eighty-nine-inch motor, pretty big for those days, and create a unique bike with his own stamp on it. Its successful reception within the riding community gave Suter the confidence to develop a market for custom motorcycles in the Kansas City area.

Suter's reputation was based on big tires and big motors. A big tire just a decade ago was 150 millimeters wide, and a really big motor was 95 cubic inches. Compared to today's steamroller-like 360-millimeter tires and 145-cubic-inch motors,

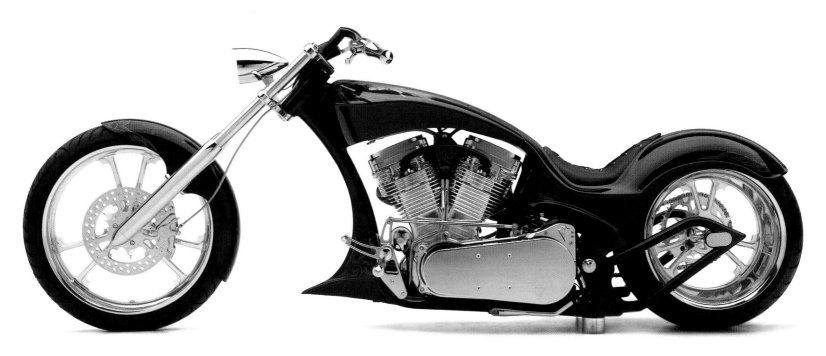

ready to play

things have changed dramatically. As they did, Suter developed a penchant for voluptuous sheet metal and flashy paint to adorn his muscle bikes.

The first KC Creations store opened in 1995, little more than eight hundred square feet of retail space situated adjacent to a car wash. A family friend soon poked his head in, shook it with disdain, and walked away. Three years later, Suter moved his business to a six-thousand-square-foot facility with a proper showroom and plenty of service bays. The same family friend came by, poked his head in again, and uttered, "Who'd a thunk it!" And he left. Kim's abandonment of the family business for *motorsickles* remained a topic of derisive gossip. No one thought he could hold out. But the larger location, too, was rendered obsolete by a boom in business. In January 2001, Suter moved his digs to their present location, a huge modern complex right off the interstate in the Kansas City suburb of Overland Park.

Suter builds four or five "showboats" annually for marketing purposes. But each one is sold before it is finished. At a poker game attended by the same old family friend and others acquainted with Kim, the topic of KC Creations came up once again with a hint of mockery. The old friend soundly rebuked Kim's critics: "It ain't a joke no more, boys!" He had pronounced Kim's business a resounding success once and for all.

Suter still has a hand in other ventures, including ownership of a trucking company. "There's a guy that's been with me

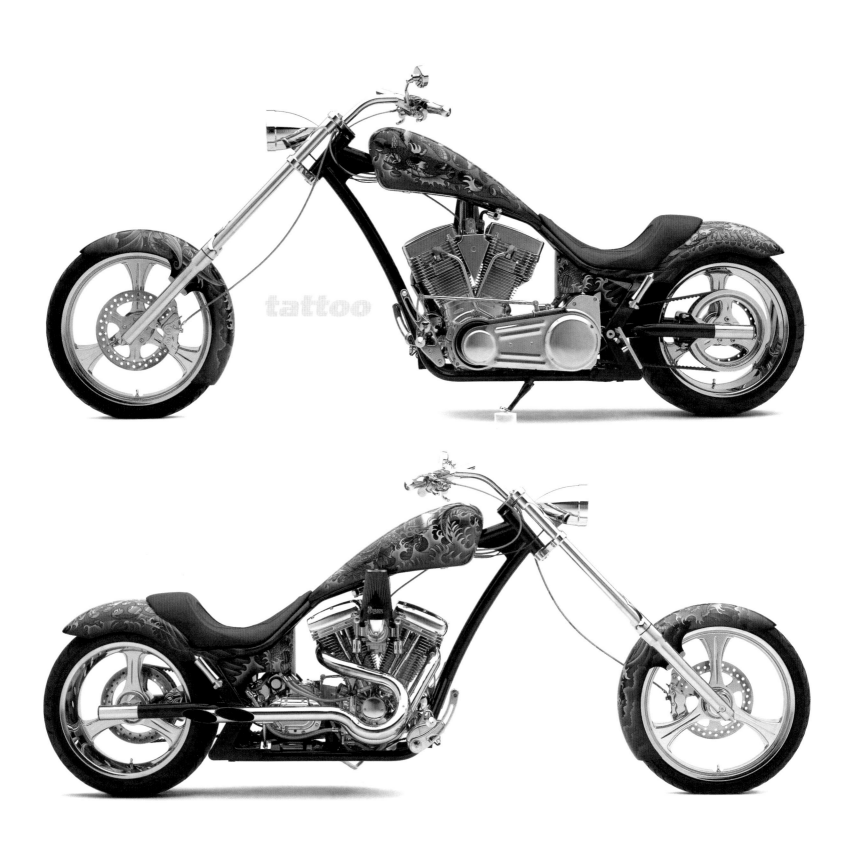

twenty years that thinks it's his," he jokes. Although Kim does not have to

keep tabs on it daily, he says, "It's a brutal business that works out good.

It's getting pretty substantial." Suter is also cohosting *The Big Inch Bikes*

Motorcycle Radio Show, a talk-radio show broadcast Saturday mornings

on KCMO throughout Kansas, Missouri, and Oklahoma. Sometimes he will

broadcast live from a remote location on the bike-show circuit and include

interviews with other builders, and listeners can call in and speak with

them on the air.

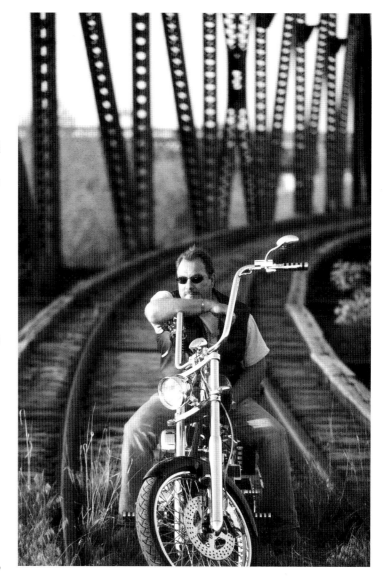

When Suter is on the road promoting, he is on the road riding, and

vice versa. He particularly enjoys rolling through the Florida Keys, the

Sedona area in Arizona, and Highway 1 on the California coast. Cheryl often

pushes him to ride more often so she can tag along on the pillion. He

enjoys the road trips, whether in the saddle or on a bar stool. He rides with

the Hamsters when he can. His great pal, Donnie Smith, was instrumental

in making him a member of that do-good gang of bikers. "I bought Donnie

several hundred rum-and-Cokes over the years," he deadpans. As for him-

self, he is addicted to Diet Coke. He won't stay at a motel unless there is a

pop machine dispensing Diet Coke, or someplace close to buy it. Of course,

he enjoys adding the occasional splash of Jim Beam — when you're out with these guys and talking about finding a fifth, you

know they're not talking about gears.

No matter where he goes in Kansas City, whether to a bar or the local hardware store, with or without a motorcycle, Kim

Suter is recognized by riders, and they all want to talk shop. He doesn't mind that kind of interaction when he is visiting Sturgis,

Daytona Beach, Laughlin, and all the other venues on the circuit — in fact, he encourages it — but he wishes he could separate

his personal life from motorcycles just once in a while. That is true for many, if not all, master builders. He imagines himself

temporarily in a world away from choppers. He manages to sneak away now and again to the Lake of the Ozarks in central

Missouri with his twenty-eight-foot deck boat sporting a 496-cubic-inch, 420-horsepower engine. With twelve hundred miles of

shoreline occupied by seventy-two bars and restaurants, he says he can bar-hop with a boat as well as he can with a chopper.

Few people know him at the lake. So he hammers all of his custom-boat builder friends with questions of his own. "Come and

look at my boat! Can you fix this? Can you fix that?"

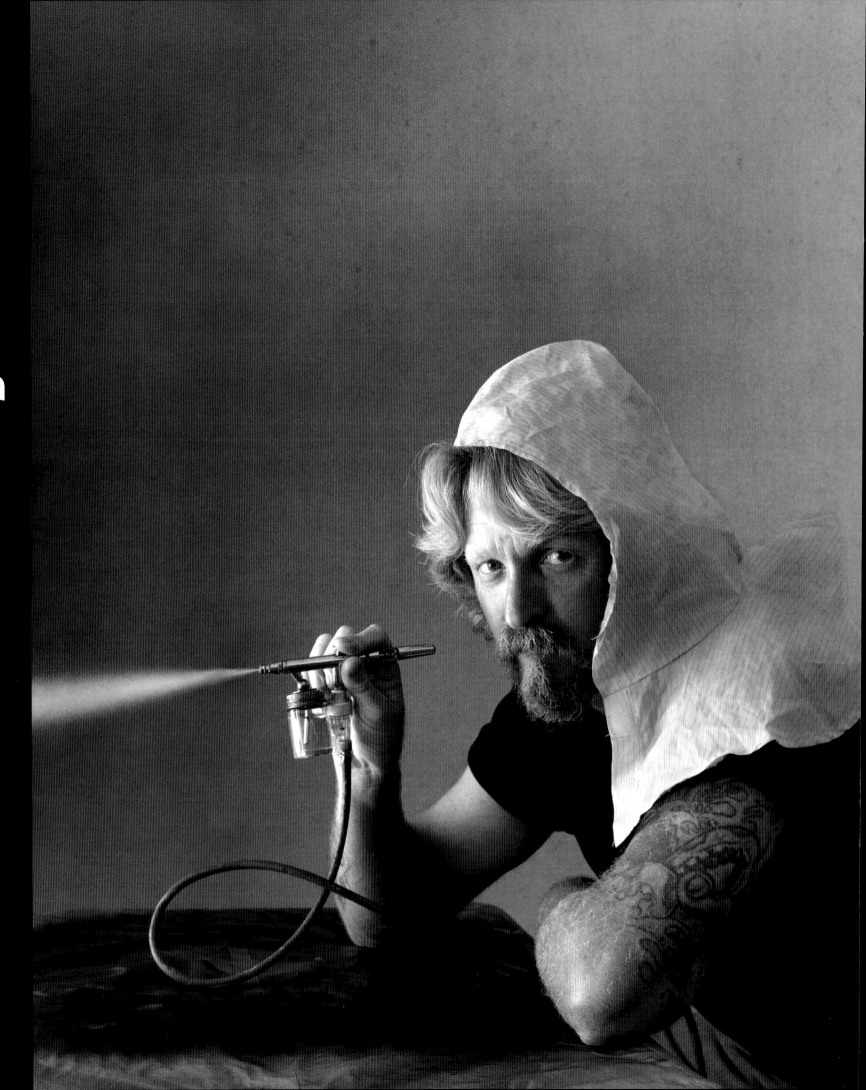

For Kirk Taylor, riding a chopper is therapy. It's the best way to blow off steam when routine daily pressure pushes past tolerance levels. No other kind of bike does the trick. "Bottom line," says Kirk, "it's just plain sexy." As for alternative means of motorcycling, he argues, "There's nothing sexy about riding in the fetal position." For Taylor, choppers are the American bad-ass machine; he would rather not see some other guy's bad ass sticking up in the air on a Japanese crotch rocket. "You may meet the nicest people on a Honda," he says, "but it ain't gonna get you laid!"

Booking down the road on one of these chromed contrivances is, in itself, an expression of art — performance art at its most egalitarian. Riding a chopper conveys an irrepressible sense of freedom, virtually thumbing your nose at authority. It may also win you a host of traffic tickets. But it's a safer way to flout convention than daring death for an adrenaline rush by tearing along the dotted line with your kneecap at ninety miles per hour.

Kirk Taylor's best creative resource is networking with other builders at trade shows around the country. If he keeps his nose close to the grindstone, he can't focus, so he stops working once in a while to check out the competition. "I know other guys refuse to let outside influences affect their creative process," Taylor avers. "But I draw from it all. I look to other guys for inspiration, because sometimes you need a jump start." He can look at another builder's chopper and say to himself with reverential enthusiasm, "This guy understands." For himself, Taylor says, "Trophies aside, when another builder comes up and goes, 'You know what? That's one fine bike,' that's the best compliment of all."

Taylor's first inclination was to paint bikes, not to build them. Now he appreciates the advantage of being able to envision and build a bike he will later paint. Knowing exactly what it will look like gives him a better idea of how to start. As a traditionalist, he doesn't create elaborate graphics. In his opinion, while paint will indeed set a chopper apart, it should not be the only thing that does so. Taylor doesn't want one aspect of a bike to overpower another, and although he believes you should be very conscious of the motor, he doesn't appreciate being blinded by one with, as he puts it, "sixteen thousand engraved curlicues, diamond-cut fins, and gold plating." He will not countenance a gratuitously extravagant paint job, either. He'll take subtle pinstriping over $15,000 worth of "demonic skull warriors" any day, and he has always been a fan of traditional metalflake — what he calls the "dune-buggy and drum-set look of the '60s."

Taylor also feels that when graphic symmetry looks perfect, it is emotionless and mechanical, as if traced with a stencil. He believes that to be off just a little bit reflects human imperfection and is more congruous with the heart and the hand of an artist. "Have you ever looked at a pinstriper's patterns?" he asks. "At a cursory

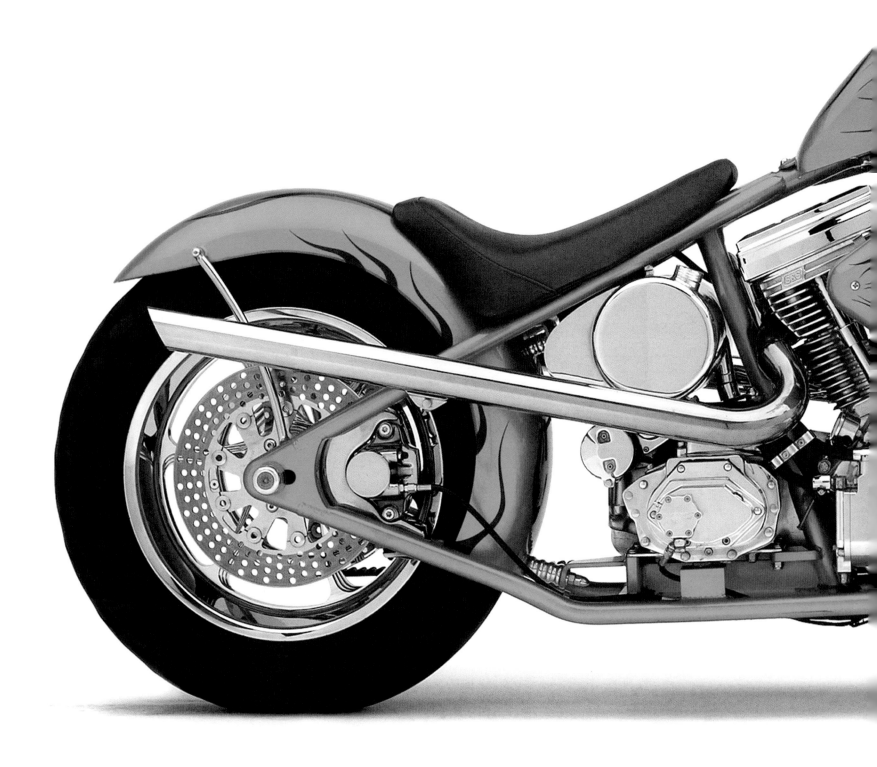

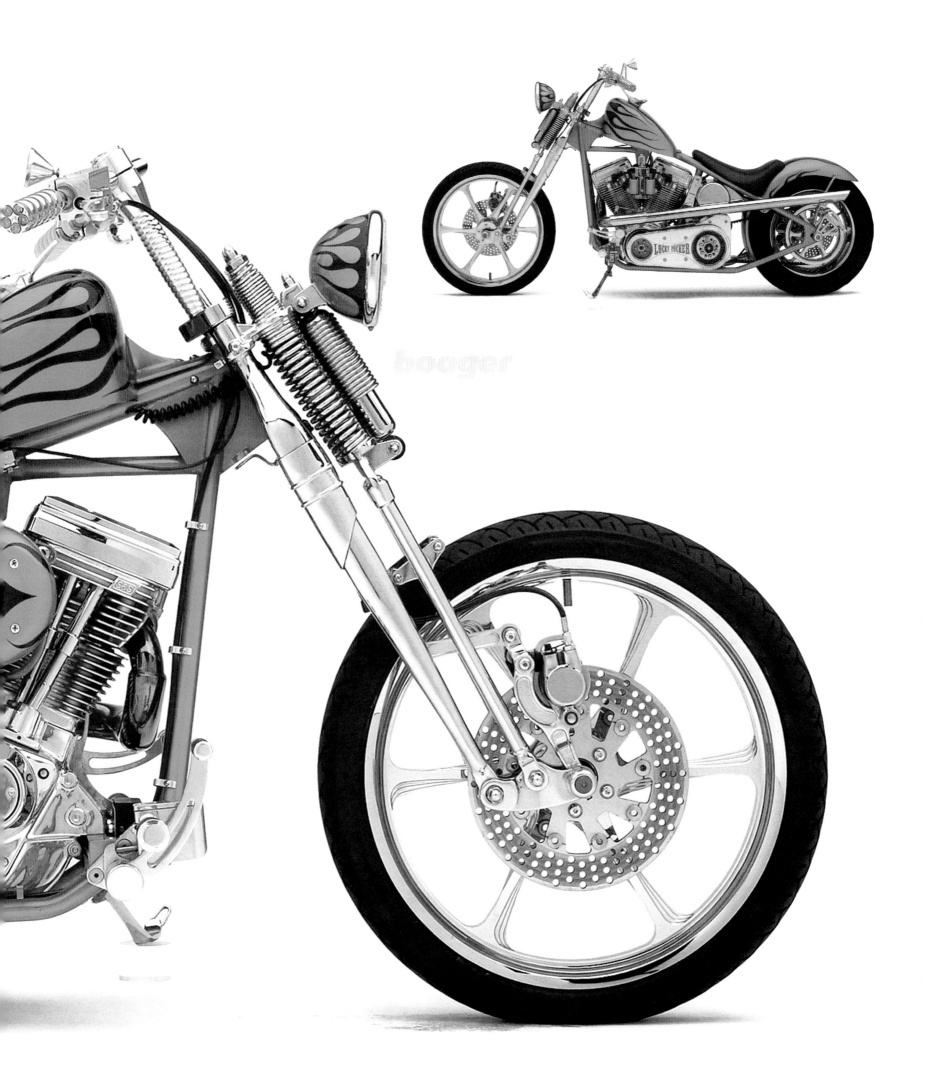

glance, they look perfectly symmetrical. But the more you look, the sooner you realize it's not perfect. To me, that's the beauty."

Even though major components can be, and sometimes are, made from scratch at Taylor's Custom Design Studios, profit margins shrink in direct proportion to how much time is invested in one bike. For most builders, it is more practical to start with something store-bought, at least for the major components, and customize them than to create a unique set of wheels or a chassis for every bike they build. That's what chopping is all about anyway — modifying existing components — and it is this traditionalist approach that Taylor prefers.

Artistic integrity is the responsibility of the artist but the province of critics to discern. Therefore, the most distinctive

aspects of any given chopper are lent credibility by critical acclaim for its handcrafted character. In Taylor's opinion, one must find at least a dozen or so significant parts associated with any given chopper which, when conceived as a whole, define its character as unique. Such parts cannot be found in any catalog — that is to say, they will no longer resemble their catalog conformity once an artist gets his hands on them. There are different degrees of "ground-up" or "scratch-built" choppers — you *can* customize a kit bike — but in the end, the only criterion for quality is inimitability. The fact that other builders are influenced by a chopper's innovative styling is a sure sign of success.

Although preoccupied with paint and fabrication, Taylor can tear down and assemble a motor with relative expertise, but it is not his forte. Donny English does most of the motor work, but Taylor has found that putting together new engines is no more cost-effective than fabricating frames and wheels. A vast array of top-flight, big-inch, fire-breathing mills are available for a phone call. "I can build something out of this world and put a standard eighty-inch engine in it, and nobody's going to know it's an eighty-inch engine," Kirk claims. "It's a waste of energy to put a 130-inch motor into a chopper, because you can't utilize the power. A better-handling bike can."

Booger, improbably named for its slime-green complexion, is the bike Kirk Taylor built for himself and will not sell. "It was pretty much everything I thought a chopper should be," he says. "And I get to ride it!" Booger exhibits a signature Taylor touch in addition to color: a single stainless-steel, straight-shot exhaust pipe on each side of the frame, which creates a stereophonic exhaust note in syncopated rhythm, sounding almost like a tap dancer on top of a tom-tom. "If you stand behind it," Taylor says, "it's like music. One's going like a bass drum: *bop-bop-bop*. And the other one's going *boppitybop-boppitybop-boppitybop*."

Taylor works in what he calls his "hole in the wall." It's actually three holes in the wall: three bays in an industrial park in the San Francisco suburb of Novato, about twenty miles north of the Golden Gate Bridge. Taylor keeps expanding his shop space to grow his business. "People are like fish," he says. "They grow to the size of their tank." Taylor's modest expansion now requires the services of five employees plus his wife Lisa, "the brains," who presides over the parts counter. Duke, their "Boston terrorist,"

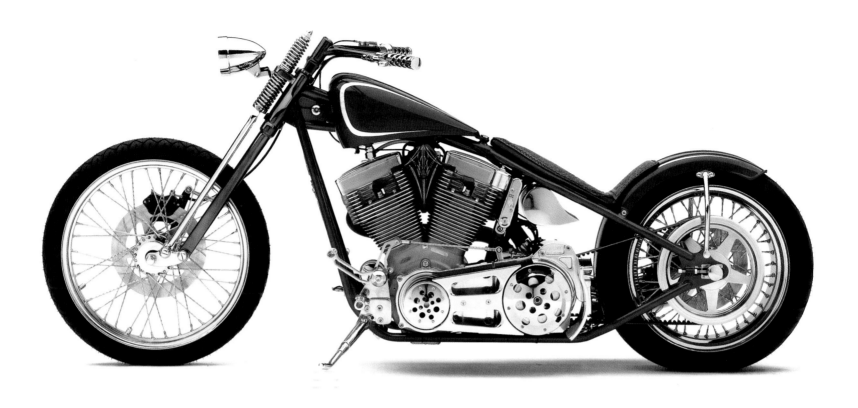

speedway springer

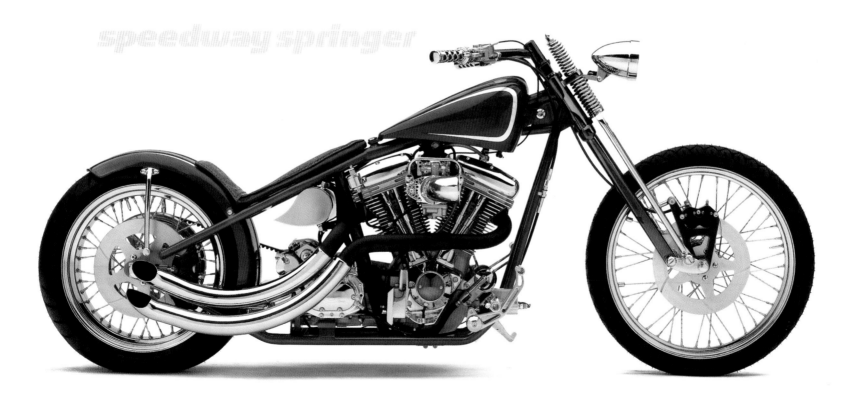

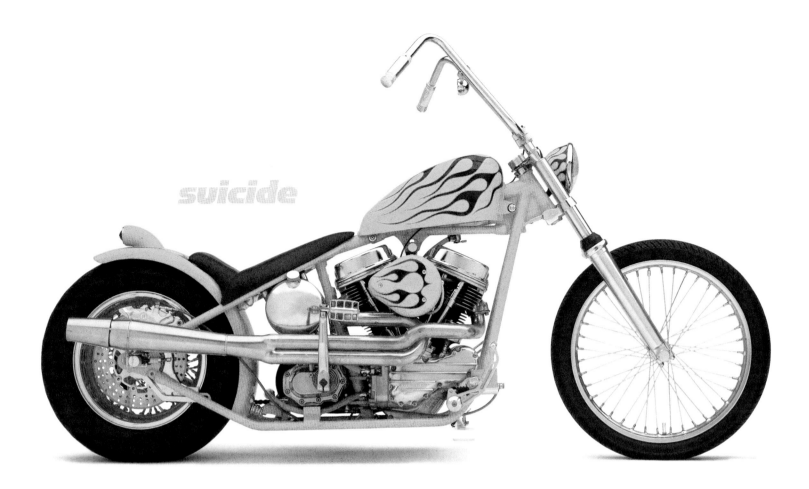

suicide

who thinks he's a pit bull, takes care of security. It is a boutique operation. There are no frills, not even an air conditioner to moderate the sweltering temperatures of summertime. Flanked by the cordial proprietors of body shops, upholsterers, and a few hotrod hangars, they are also situated next-door to a manufacturer of ice cream bars who is so uncool as not to even offer a few free samples when the mercury hits triple digits.

The maximum output of show-quality bikes at Custom Design Studios is six per annum. To increase production, Taylor believes, would either compromise quality or force him to expand again. Right now, he is happy with the size of his fish tank. He prefers to work methodically, continually on guard to avoid becoming preoccupied with a design that *looks* cool while losing focus on engineering goals. A radically modified fork, for instance, may look terrific but steer like an airport luggage cart. Does that matter if it's art? Kirk Taylor thinks so. "It depends on if you're trying to make a living at it," he says. Choppers are supposed to be functional art. If they're not practical to ride, they lose their allure. Handling and dependability may have been pretty dicey several decades ago, and the machines that survived are now museum pieces, but there is no excuse to build a chopper today that looks good and handles poorly.

Customers bring perfectly good stock bikes to Custom Design Studios to be virtually destroyed as they undergo a process of transmogrification to become something different, something better, something Kirk Taylor. "You take something from here," says Kirk, gesticulating something imaginary from his forehead, "and translate it into something real and present it to

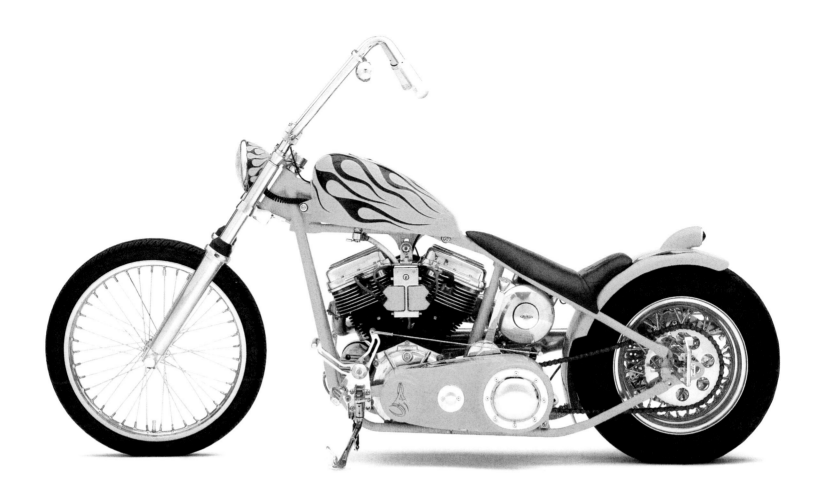

somebody. And they say, 'That's it! It's exactly what I wanted.' That's really gratifying."

Once in a while, a rider brings in a late-model, low-mileage, $22,000 Harley-Davidson with an extra $10,000 worth of everything extra a dealer can bolt on, to see what Kirk can do with it. His standard quip is "You should have come to see me $10,000 ago. Stop! Don't put any more money into this bike!" He's sent more than one disillusioned customer packing by telling him his bike should be sold and that he should start from scratch. He wants people to know they can have the chopper of their dreams for

nearly what they're willing to spend on an accessorized Harley-Davidson. Most of what's on a Harley is "take off and throw away." Kirk tells riders, "Start with your dream, and go from there. Don't start with Harley's dream."

His own dream began in 1970, when he was about eleven years old. From that time on, Kirk was practically raised in a machine shop. His father was the son of a Navy pilot, his mother a coal miner's daughter from the hills of West Virginia. The senior Taylor was attending a scholarship program at the Chrysler engineering school in Detroit when they met, both straight out of high school. To avoid the draft, he enlisted in the Navy. The couple moved out West. Kirk was born in 1959 in Santa Barbara, California. He has a younger brother.

His father, out of the Navy and a big Triumph fan, opened a small business in Terra Linda, California, to prototype

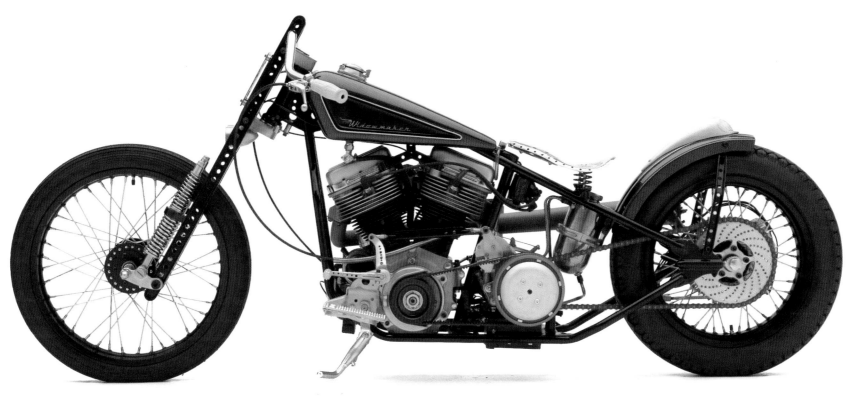

widowmaker

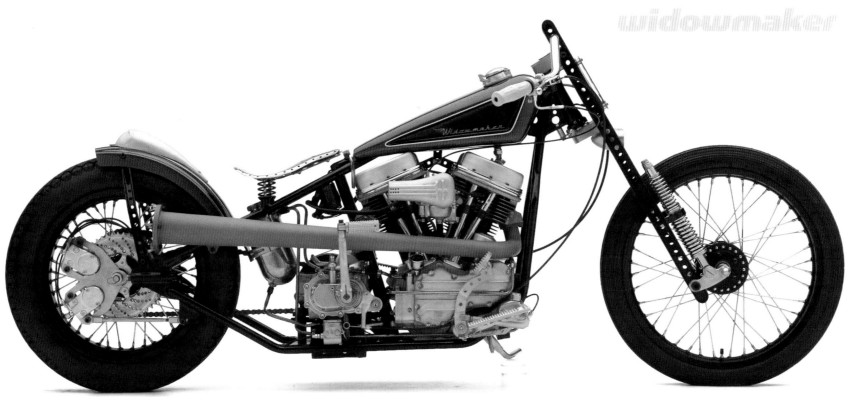

machine parts with contracts from corporate America. As a sideline, he manufactured custom springer and girder front ends for both Brit bikes and Harleys, which were popular with motorcycle clubs in the Bay Area. Young Kirk was smack dab in the middle of the golden era of choppers at an impressionable age, with an eye-popping view from the inside out. That view included his father's other sideline: the outlaw biker scene, replete with plenty of guns and dope deals going down. His father continued to operate the machine shop, even after his hiatus as a houseguest of the state, the illicit means by which he had augmented his family's income having been uncovered. By 1976, he had already shut down the motorcycle end of his business, because, as Kirk tells it, "The customers want it for nothing, they want it yesterday, and they don't always pay." Some things never change.

Kirk continued along, "marching to the beat of a different drummer," he says. Whereas his brother took the secure route with a steady job, a wife, and two kids, Kirk went out on a limb to try to make it on his own. But not without first getting hooked on cocaine. Even so, he got along well with other people, but "I always thought I had a better idea," he says. "I was always willing to share it. That wasn't always a good idea. It became more and more difficult to make ends meet."

His cocaine habit burgeoned in the 1980s, and he started riding with hoodlums. "When I got sick and tired of being sick and tired," he says, "I went to treatment, came out, decided I was going back to school." He wanted to learn how to airbrush pinup-girl graphics in the manner of his two illustrator idols, Alberto Vargas and Olivia De Berardinis. He worked during the day as a housepainter while studying at night for three years at a community college, taking classes in color theory, art history, and graphic design along with the general range of liberal arts courses. He couldn't find the exact kind of illustration instruction he wanted, so he left school just a couple of credits shy of his degree and took an internship with a local pinstriper. He then set out on his own career, moving from housepainting to guitars and gas tanks. With a business license on the wall, he started building bikes in his garage and basement in 1988. He remembers, though, having attempted his first flame job on a plastic model car when he was just eight years old. He was detail-driven, even then, using sewing thread for spark-plug wires on model engines.

The Bay Area still has an active club scene — not just cocktails and dancing. Kirk has received invitations from more than one three-patch club to don their colors. But he realized that the deeper in he got, the harder it would be to maintain any

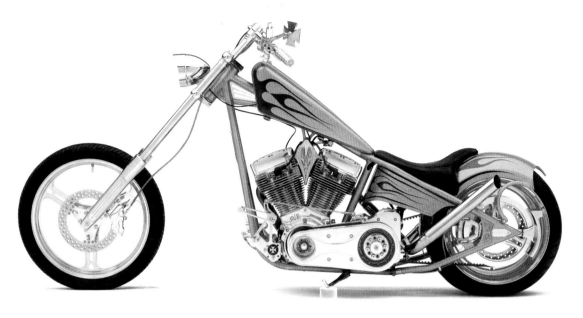

semblance of "political neutrality" as an entrepreneur who prefers to do business with everyone, and he declined to join. He is a prospect, or nominee, for a much more innocuous *car* club, staying on the safe side while catering to his secondary passion: lowriders and hotrods. (He paints them, too.) In fact, he owns two asphalt-scraping four-wheel cruisers — a 1960 Ford Sunliner convertible and a 1963 Buick Riviera — and one hotrod, a 1970 Chevy Camaro. The shop truck is a flat-black '83 stroker Chevy.

Owning and riding a chopper says something about human nature; individuals will go to extremes to stand out from the crowd. By the time a trend achieves widespread public attention, however, every individual follower has already been assimilated by the crowd. They are all riding the same bandwagon. It's time to get off and hitch another ride. It's time to take it in a new direction.

In the mid- to late 1980s, the popular paint jobs were faux granite and bubble gum. "Jet Ski paint jobs," Kirk calls them. Skulls — that's another story entirely. Then enthusiasts went retro and reintroduced flame jobs. Now it's pinstriping and metal-

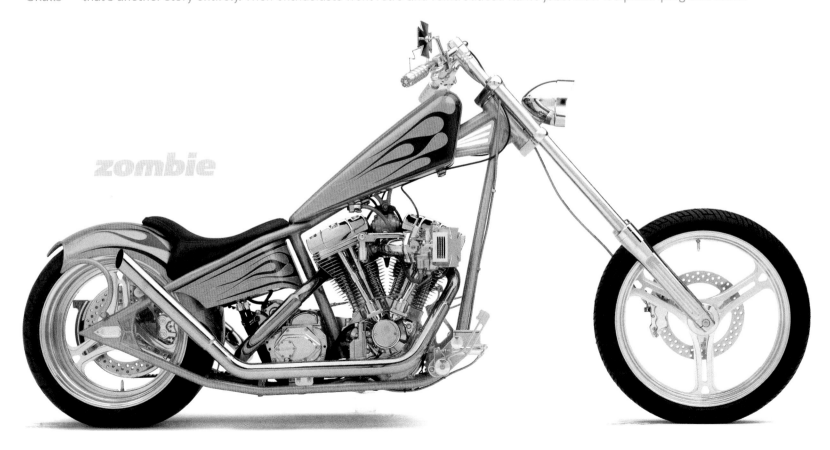

zombie

flake again. Kirk chimes in, "Flame jobs are forever, man! They're always cool."

Now that the commercialization of choppers has led to the mass production of

dealer-financed motorcycles modeled to look like choppers, the designers who

instigated the trend are moving away from it. Fat tires are getting slimmer, and

frames are getting shorter, with less rake.

Kirk is a proponent of bringing back the paint styles of the '60s and '70s

with more modern urethane paint. A big influence for Taylor at one time was the

way Honda choppers were painted with fades, psychedelic freak drops, and

flake-over-flame jobs. A freak drop is an old-school technique whereby the

painter shot a blob of acrylic color onto one spot and then shot air into the cen-

ter while it was still wet, making the paint explode outward in weird patterns.

Painters would also blow soot from an acetylene torch onto the surface of the

sheet metal and add clear coat right over it.

After a few more false starts and misadventures, including a failed four-year marriage, Kirk opened Custom Design Studio

in 1995, taking over his father's establishment when he retired. Two years later, he moved the shop just a few miles north to its

present location in Novato. Not long after that, he married Lisa. They had practically grown up together. She thought he was a

bully. Many years later, he knew he was in love with her when, on their first ride together, looking at the shadow following them

down the highway, he saw her flapping her arms in the breeze like a bird.

His favorite ride is during autumn on Skyline Boulevard near Santa Cruz, on down to Highway 9 and Alice's Restaurant.

"It's a rider's road," he says, "both scenic and well engineered." But he avoids the mass rides for the sake of his own health.

Screw-loose idiots and inexperienced riders alike will go down and take other riders with them like bowling pins.

Thirty-five years after his introduction to biker life, Kirk Taylor is happily ensconced in the chopper revival, sans the

firearms and controlled substances. "I've done the 'If it ain't kick-start, it ain't shit' and 'I'll ride anywhere anytime' thing. I've got

nothing to prove anymore." He enjoys good friends, inner peace, and the wind in his face without sixteen layers of leather on a

freezing-cold day to prove he's a bad-ass. "I get inner peace riding by myself or with a couple of close friends. You dip and roll into

turns at the same time side-by-side without so much as a hand signal; you think so much alike," he says fondly. "It's Zen." His

reputation is on a roll, too. Schoolteachers who used to try to keep guys like him away from school now invite him to make career

presentations to high-school students. He even partnered with rock and roller James Hetfield to build a bitchin' bike called the

Widowmaker. How things have changed.

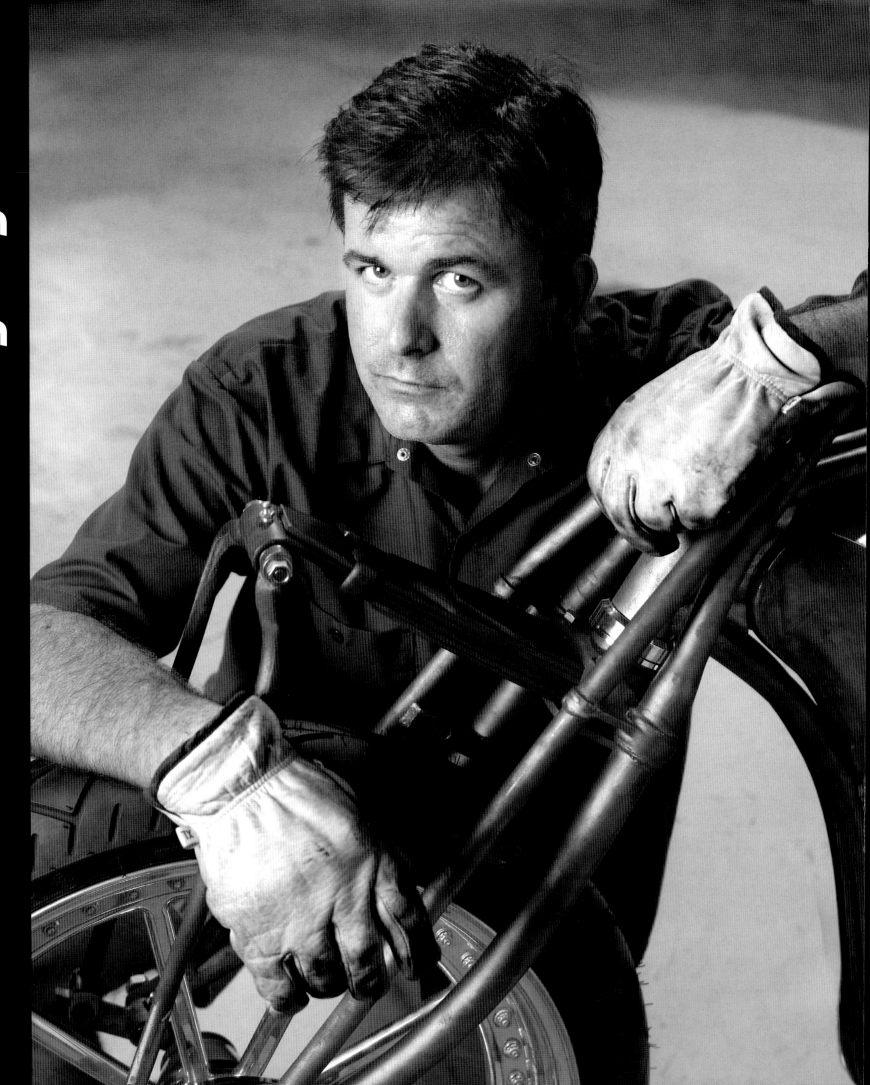

Hank Young is a rodder.

For some people, that description conjures up powerful cars with gleaming engines and lurid paint jobs (or no paint at all), handcrafted with a hodgepodge of vintage parts in suburban garages since the late 1940s by men with a bent for style and speed. Hank's earliest recollections are of cars like that.

The Young family hails from Marietta, Georgia, where Hank and his younger brother grew up during the 1960s and '70s. As a man who finds comfort in his deep roots, he has remained there; his shop is located only two miles from the hospital in which he was born in 1964. Hank's father, a machinist at Lockheed Aircraft for more than a decade, quit to pursue his hobby of building hotrods professionally. But after two years, he realized that he disliked dealing with the often unreasonable demands of customers as much as with his bosses at Lockheed, so he became a firefighter. Working in shifts of twenty-four hours on and forty-eight hours off still gave him plenty of time to tinker with cars. Hank was at his father's side every day, tethered by curiosity, in the family's expansive basement garage. When Dad was on duty at the firehouse, Mom always knew where to find Hank: alone in the garage inspecting the cars. She sometimes found him inside one car or another, literally asleep at the wheel.

Young says he ate, slept, and breathed hotrods. "I was born into it. I grew up in it." His father's obsession rubbed off on him but not on his brother. Hank knew what he was going to do for a living by the time he was eight years old. "*Everybody* knew what I was going to do," he says.

In spite of a flirtation with motocross, Hank's attention was attuned to cars. The 1934 Ford coupe he had wrenched on with his dad since age fourteen became his when he turned sixteen. Following high school and a few semesters of college, Hank went to work for a family friend, Joe Smith, who ran a place called Joe Smith's Antique Ford and Street Rod Parts. He stayed there for twelve years until the boss was ready to retire; in 1995, Hank bought him out. Joe Smith's had developed a reputation as the place to call when it was time to liquidate Grandpa's beater or if someone uncovered an old car and needed some cash. Joe Smith had also established a nationally distributed catalog and mail-order parts business for street rods and antique car restorations. Meanwhile, whenever Hank could find time away from the parts counter, he would slip out back to worship in his temple of tools and build hotrods. The World War II vintage machinery he inherited with the business — including drill presses, lathes, and milling machines — is massive and beautifully sculptural with a rich patina. Hank owns a beloved power saw so old, he says, "it looks like it came over on Noah's ark. It's got more moving pieces and gadgets — a hundred different things it's doing to do one little operation." Perhaps he is enamored with it because it mimics his marvelously convoluted style of building motorcycles.

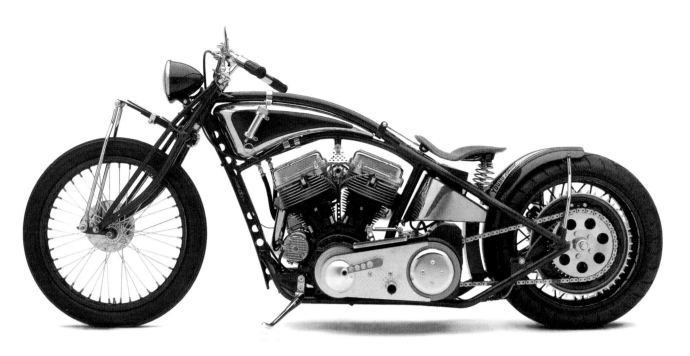

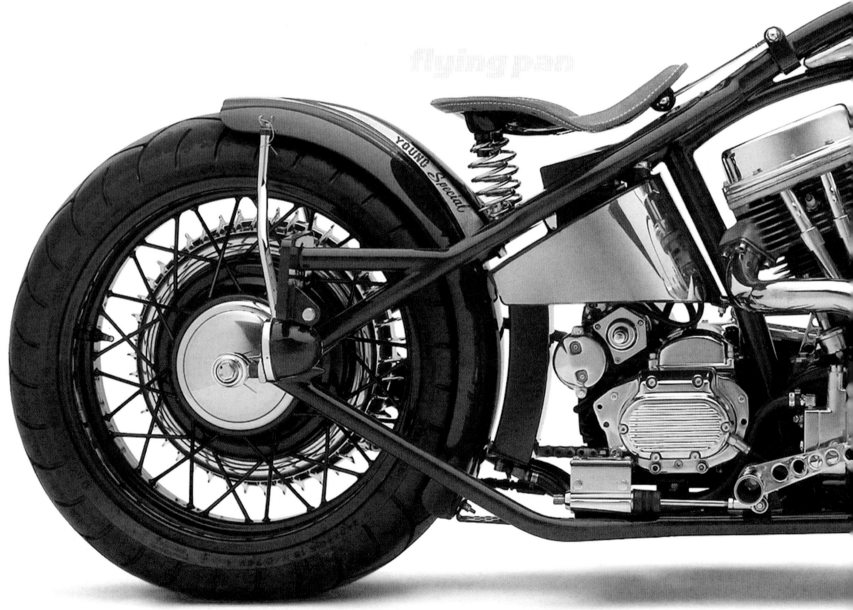

AOTC Hank Young **252**

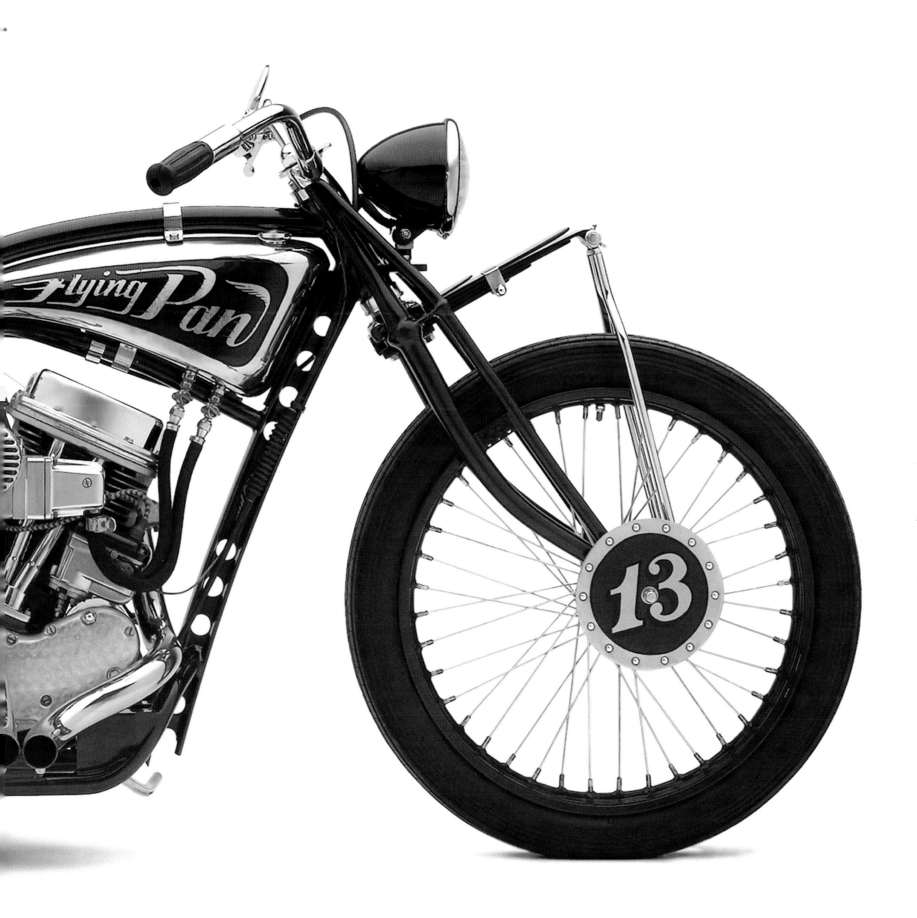

Hank Young has owned and built many hotrod cars over the years. He sold his pride and joy at one time to help finance the purchase of his first house. He anticipated it would be a while before he could afford to build another car just like it, so he decided to build a bike instead. Little did he know that it would cost as much to build a custom bike as a custom rod. His first motorcycle, which he put together himself in 1991 while still an employee of Joe Smith, was a bobber based on a 1940 Indian Chief. He wishes he still had it and would not be ashamed to debut it today as a bike just built.

Throughout the years, Young continued to build bikes off and on as a hobby, but eventually they overtook his interest in cars. Although he continued to run the antique-auto-parts business, he put all of his know-how into a bike dubbed the Flying Pan, as in *Panhead*, of course. It was his personal best. He rode it to Biketoberfest in Daytona Beach in 2002 with no commercial

intent, but as soon as he realized the bike's impact on crowds, and considering that the Godfather himself, Arlen Ness, walked a block out of his way to examine it closely, Hank realized the game was afoot. By the time he got back to Georgia, he had decided to go into the bike business. The Flying Pan put Hank Young on the motorcycle map.

Despite his provenance, Young divested the Joe Smith business early in 2005 and quit building cars for good in order to devote himself and his hotrod heart exclusively to motorcycles. For all intents and purposes, that means choppers, even though he laughs, "I really don't have a name for what I do."

The art of the chopper has evolved to a point where we can hardly say what a chopper is — it's easier to say what a chopper is not. Trying to get a handle on where his own work fits into the scheme of things, Young explains, "There are different choppers for different eras." His statement recognizes, of course, how choppers have evolved into various styles reflecting the prerogatives, and sometimes the chronology, of the artists who have built them. The trouble is, from a conservative point of view, Young is hesitant to call his bikes *choppers* because they are reminiscent of a time before choppers existed.

Young's ideas reflect a period when all automobiles and motorcycles were virtually handmade. Despite Mr. Ford's Model T, it was once as common to see a handmade car or bike in the big city as one having come off a newfangled assembly line. They were symbols of self-indulgent opulence, no matter that they were more like limited editions than one of a kind — the Stutz Bearcat, Pierce-Arrow, Duesenberg, Bugatti, and Packard marques, for example. Hank Young's bikes, although more elegant, bring to mind the board-track racers — the early Harley-Davidsons, Indians, Crockers, and Vincents — which were the super-bikes of their day. The point is, before World War II, not only were middle-class car owners concerned exclusively with utilitarian

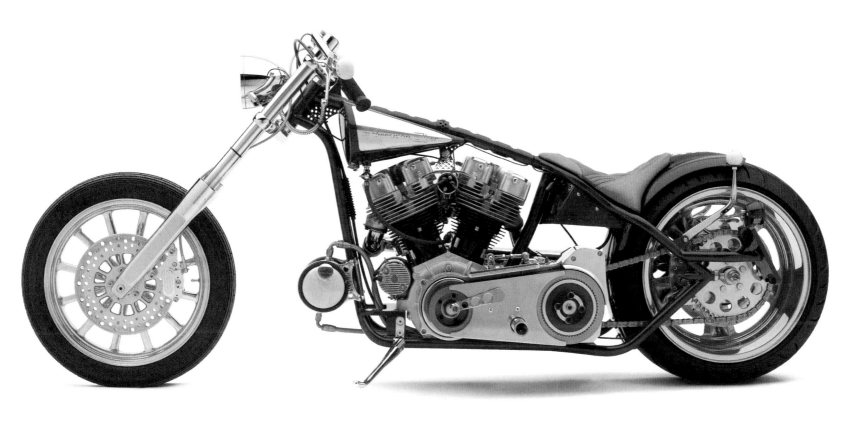

american flyer

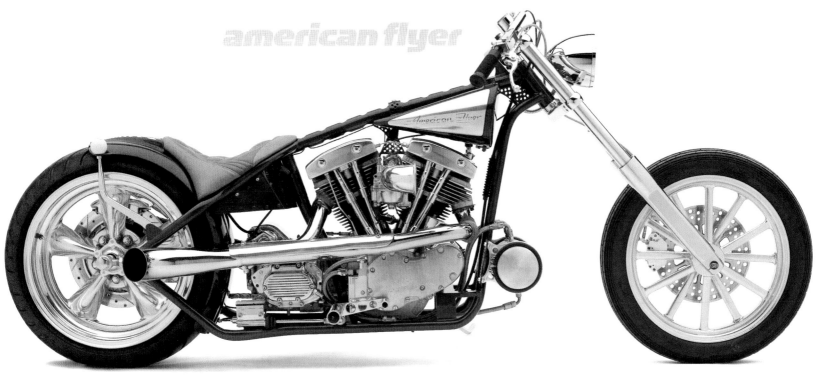

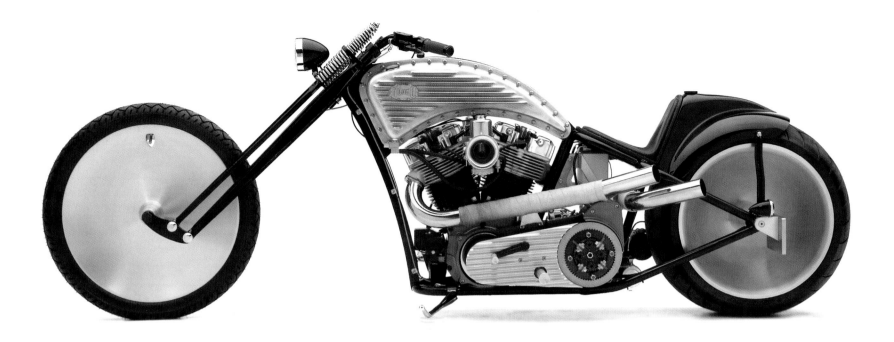

transportation, but those old autos and motorbikes were still new and in use. There was nothing to chop.

Young creates internal-combustion confections that allude to the legendary grandeur of the past; he has appropriated a sweet spot in our collective consciousness for the way automobiles and motorcycles of the Jazz Age flaunted their *mechanismo*. Whereas a chopper, by consensus, is supposed to assault one's sensibilities on all counts, a Hank Young example takes a more subtle and less intimidating approach. It makes you want to pull up a chair, pour some whiskey into a tumbler, and ponder its intricacies at your leisure. Only then would you be truly ready to appreciate riding it.

Like a Swiss chronograph with multiple complications (stop hands, date, alarm, moon phase, alternative time zones, windows, and subdials), a Hank Young motorcycle exemplifies an excess of effort to reach a more modest result, beauty notwithstanding. True to chopper culture, there is nothing practical about his results, no more so than one needs a $50,000 wristwatch to tell time, but they show how what is *un*necessary can also be the mother of invention, if sublime satisfaction is the upshot. Whereas an alternative, perhaps more "modern," chopper style might incorporate cutting-edge technology and then, as is also fashionable, try to hide it, Young's corollary is to spotlight technology that is past its prime by letting it linger as a quaint curiosity. For instance, he once cobbled a circa-1930s Buick brake drum onto the back wheel of a bike just because he could. The result was transcendent.

These bikes are neither replicas nor facsimiles, nor can they be called hotrods with any more conviction than they can

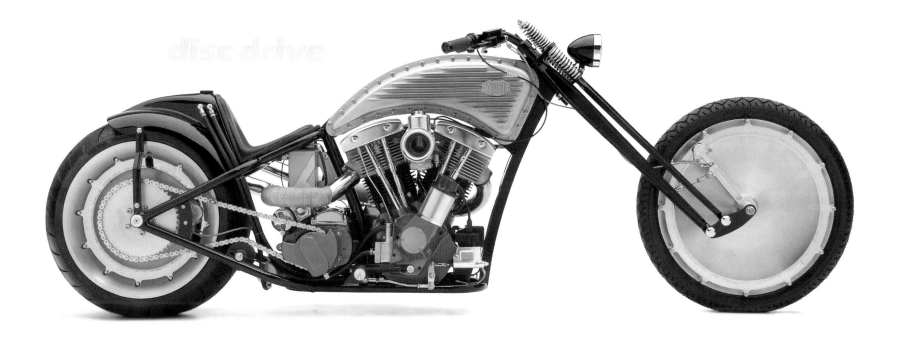

disc drive

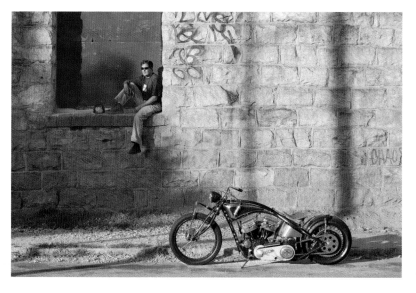

be called choppers, because *hotrod* implies *funky*. There is nothing funky about these creations. They are classy, if not classical. They are the tangible evidence of an imagination that evokes old motorcycles by reinventing them. In other words, they never looked this good before. Hank Young celebrates motorcycles with an attention to historical detail in a postmodern context. Plainly products of the present day, they nonetheless look as though they might have been ridden by Jules Verne, ahead of their time as far back as the end of the nineteenth century.

Although Young has consistently demonstrated his ingenuity by building "from-the-ground-up" motorcycles, his preference is to start with an old original bike — say, a 1932 Harley-Davidson UL frame and front end with a Flathead motor. "The problem with that kind of bike," he says, "is that the market is so slim. When you build something like that, you're pretty much building it for yourself, so plan to get stuck with it!"

Antique authenticity notwithstanding, Young could buy many of the parts with which he might turn out anywhere from twenty to fifty bikes each year instead of his current limit of six. He could make more money that way. However, his fulfillment

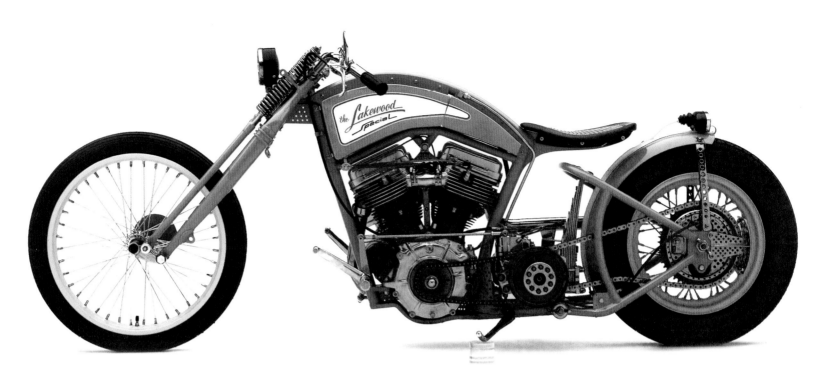

lakewood special

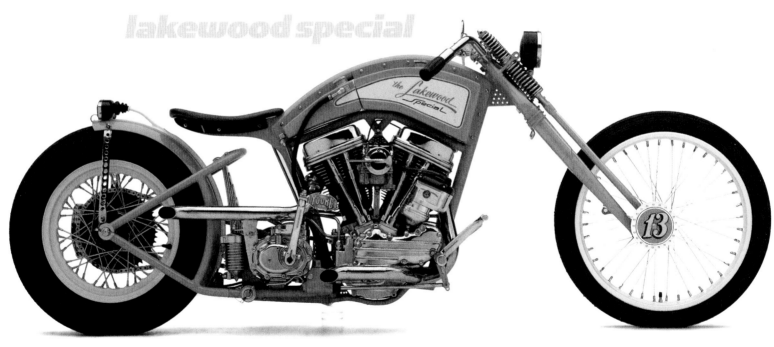

comes not from the profitability of high volume and low margin but from fabricating and assembling all the parts of a motorcycle, from frame to fasteners. If the engine and transmission he chooses are original Harley-Davidson, he will rebuild those, too, although he says, "Any mechanic can do that." His lack of enthusiasm for tinkering with motors stems from the fact that there is only one way to do the job correctly. A repetitive task precludes any kind of personal interpretation and presents no challenge to him. "Turn me loose, and I build what I want." Young bears proud scars and fresh cuts on his hands to memorialize his dedication to creating his own new challenges.

Because he personally creates everything on his bikes except for the drivetrain and the paint job, Young does not have to lay out as much cash for each project as some of his peers might. Still, he sinks proportionately more labor and time into each bike for the same reason. It is the proverbial labor of love. Young explains that he dropped out of college because "what they were teaching me was to be the boss and stay in the office and watch the other guys do the machinist's work. I wanted my hands on!" The more he toils on a bike, the happier he is. He says he would much rather build a bike than own it.

With the exception of those few bikes he has built to keep, such as the seminal Flying Pan, he would just as soon move projects out the door as quickly after completion as possible, so he can move on to the next round of his delightfully proletarian pastime. "The enjoyment is from the day I start to the day it's finished and cranked and running." Once he takes a new bike around the block a few times to make sure everything works, "it's over!" he declares. However, he also says, "I like to have one or two around so I can have something to ride."

"What I do is a form of self-expression. So I guess that's art. Yeah," he affirms — sort of. Despite his equivocation, he takes pains to emphasize that his motorcycles fulfill a rider's yearnings as much as they appeal to the sensibilities of visual art adherents. Nonetheless, most of the people who buy his bikes do not use them as they were intended: to be ridden. They are kept as decorative art or investments instead, a fact that confounds him.

While talking about his work, Young's easygoing son-of-the-South inflection may become infused with nervous laughter because it is hard for him to articulate the way he feels about his bikes. He knows with certainty that the only way to describe what is in a rodder's heart and soul is to build something and show it off. Now he divides his time between

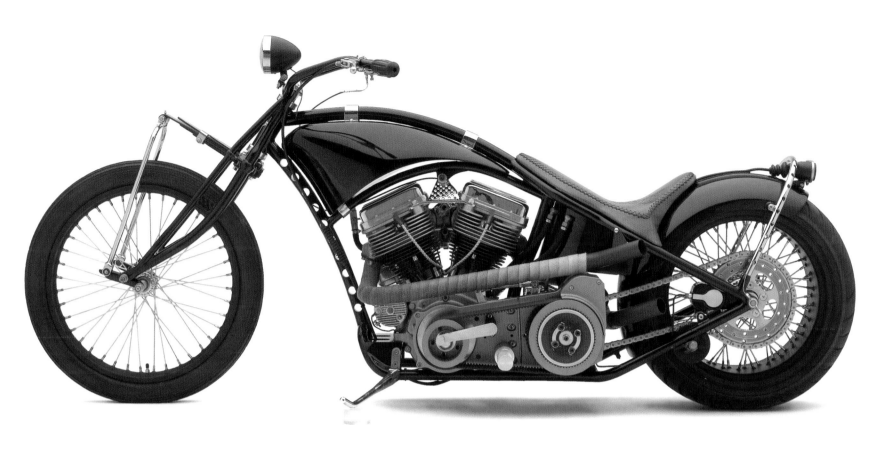

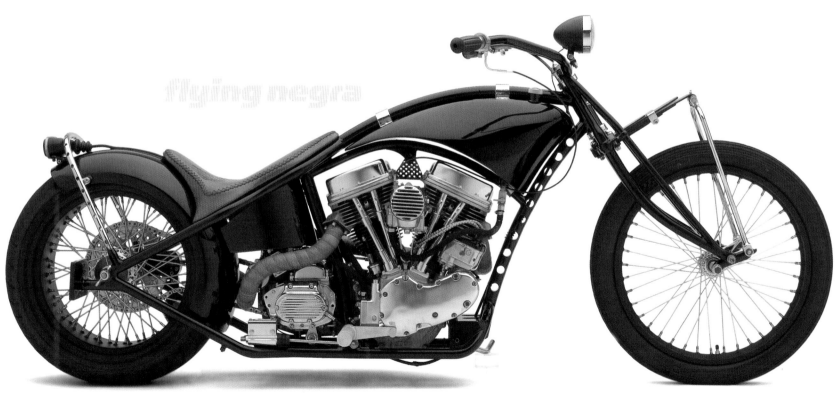

the bike-show circuit and his shop, while spending as much time as he can in between with his son, Tyler, who loves Hummers and Hyabusas more than hotrods, to his dad's chagrin. With his clean-cut, all-American good looks, Young resembles a golf pro more than a bike builder. He has had to get used to rubbing elbows, posing for pictures, signing autographs, and selling T-shirts at events crisscrossing the country.

Young makes sure that his own bikes, no matter how trick, get some serious mileage wherever he roams. They often have no front fender, front brake, turn signals, speedometer, or horn, and you can surely hear them coming; consequently, he is resigned to being stopped repeatedly by traffic cops. They scold him for this and that but rarely give him a ticket. Such is the admiration for his work. If you can pay around seventy-five grand for a Hank Young masterpiece, think about what you might save in traffic fines!

acknowledgments

First, I want to thank my publisher, Jill Cohen, and my editor, Karyn Gerhard, for allowing me to persevere; Roger Gorman for wrapping my work in a pretty package; Denise LaCongo for making sure it went on press; and Matthew Ballast for helping people to find it. Eric, Louis, and Sid — you know what you did. In addition, this book was made possible through generous contributions of time, equipment, studio space, funding, and encouragement by the following people, to whom I owe a greater debt of gratitude than can be expressed here.

Sally Goggin has been an inspiration. My photo assistants, Phil Stewart and Wayne Wallace, stuck by my side during our respective transcontinental journeys. Duke Naiphon came through in a crunch. David Slaughter is one of the most generous and patient people who ever breathed. Bill Delzell of Blue Sky Studios and Altura Ewers of Big House Studio provided space to shoot bikes in San Francisco. Matt Marchese offered the hospitality of Roush Racing's North Carolina studio. Thorsen Orendt made his studio in Germany available. Rick Hustead helped me squeeze in one more bike in So Cal, and the crew at Fast Ashley's Studio in Brooklyn made it possible to memorialize Indian Larry. Ed Phillips and Bob Kulesh of Matthews Studio Equipment helped me get a grip on things, while Peter Poremba and Terry Monahan of Dyna-Lite shed

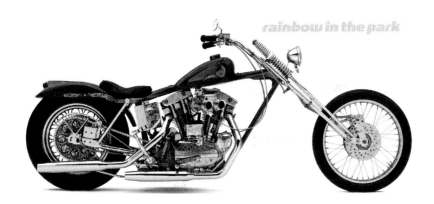

rainbow in the park

light on the entire project, along with the illuminating support of Eileen Healy at Chimera. Samy Kamienowicz of Samy's Camera remained steadfast with his help. Kirk and Lisa Taylor let me use their trailer.

Magnanimous hospitality was provided by Wendy Reeves and Steve Hauben in Scottsdale. Also providing invaluable accommodations to a peripatetic photographer were my sister Carla and her husband Dick in Las Vegas, my cousin Kat and her husband Larry in LA, and my cousin Lynn and her husband Ken in Santa Rosa. Vince and Carla Doll, Gard and Sharon Hollinger, Ron and Ruth Finch, Scott and Sue Long, the duo of Dawn and Butch, and Jesse Jurrens all humbled me with their hospitality. I must also thank those artists and builders who supported this effort and whose patience will be rewarded in a forthcoming final volume. You know who you are!

Cover bike credits: *Design by Alan Lee*

The "Two Bobs" (Simpson Senior and Junior) of RS Performance Coatings in Menlo Park, California, spent forty hours just to mask the wheels before sugarcoating the whole shebang — pipes and forks, too. Vince Doll provided the frame, Mondo the front end, and Jeffrey Phipps the extraordinary saddle. Ford Stell, with the folks at Custom Chrome, provided the drivetrain, wheels, and rubber. A special thanks goes

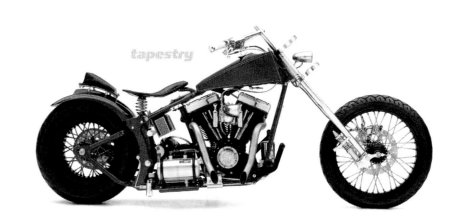

tapestry

to Mo Murray and Dave Scott. Various additional parts were contributed by Roland Sands, Eddie Trotta, Rick Fairless, Matt Hotch, Paul Yaffe, Mike Phillips, Tom Pirone, Dawn Norakas and Butch Mitchell, Dave Demarest at Weber, and Bill McCahill at Spyke. Danny Sutton of Markkings in Phoenix engraved the rear wheel. Thanks also go to pinstripers Tony Perez, also in Phoenix, and Courtney Schamach in Novato, California. John Stromberg of Lucky's 7 Customs in Amarillo, Texas, provided special paint. Additional painting supplies were furnished by Jorge Campo of Pro1 Automotive Finishes in Phoenix, with further help from Albert Espinoza, Neno Magallanes, Josh Prechel, and Josh Kelley.

I must also thank David Edwards of *Cycle World* for letting me illustrate his vintage BSA, and Dale Utterback for his classic chop; Shawn Enos, who gave me the power to make a crucial photograph in Venice, California; Amanda Bell with her family and friends in Laconia, New Hampshire, who helped make a classic photograph of Indian Larry possible; Good Samaritans Alicia Sorenson and Brian Dombrowski, who drove the camera truck to shoot Ron Finch on the Big Chopper in Detroit; Matthew Lotter, Dan Cavanaugh, and Tawnya Marty in Las Vegas, who moved bikes and held reflectors (and

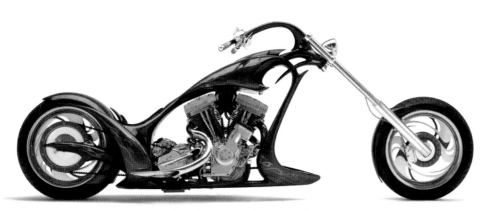

satanico pandermonium

provided an occasional massage). John Parham helped me hawk books in Sturgis; Lief, Frederick, Gianni, and Pinot helped in Belgium. Gary Miller of Mild-to-Wild Productions in Las Vegas cleaned up the backgrounds with his PhotoShop expertise. Finally, I thank all the friends I met on the road and in the wind who made this an adventure.

sponsors

about the photography

Before Volume I of *AOTC*, I had never photographed a motorcycle in a studio before. Now that I've learned a thing or two, I have also had to recognize a necessity for compromise. Whereas I might want to spend an entire day shooting just one bike, I set a record photographing nineteen choppers in the studio within a single sixteen-hour period. The compressed schedule of getting a book project to press on time made such an assembly-line process necessary. One obvious photographic compromise is the inclusion of kickstands in the down position. I would have preferred them up.

Digital technology helped speed production. But there is both more difficult and more time-consuming post-production work involved to make digitally captured images ready for publication and to store them afterward. Other compromises were made because I sometimes had to use other photographers' studios and lights when, for one reason or another, a builder's bikes could not be brought to me. I gladly used whatever studio and lighting facilities were available.

Equipment, Volume Two:
Canon EOS 1Ds with 20–35mm f2.8 zoom; 80–200mm f2.8 zoom; 50mm f1.8
Adobe PhotoShop CS software for editing and photofinishing
Macintosh 17" PowerBook G4

A Chimera F2 collapsible light bank, 10 feet wide by 20 feet long, provided illumination for the motorcycle illustrations.

Matthews Studio Equipment provided C-stands, high-rollers, booms, sandbags, flags, gobos, and other grip equipment used in various combinations.

Five Dyna-Lite electronic-flash units, including a couple of venerable M1000x models to augment newer M2000er models, plus nine separate fan heads and extension cables.

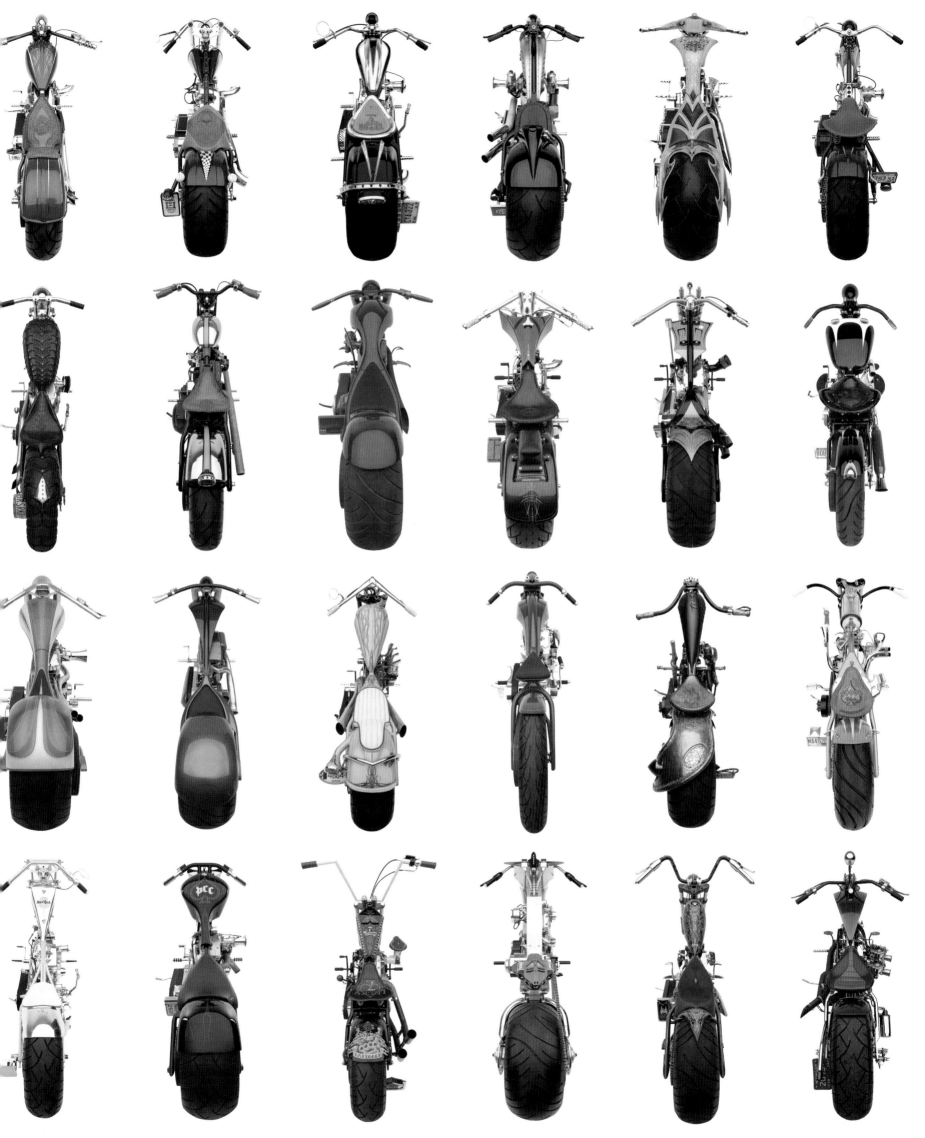

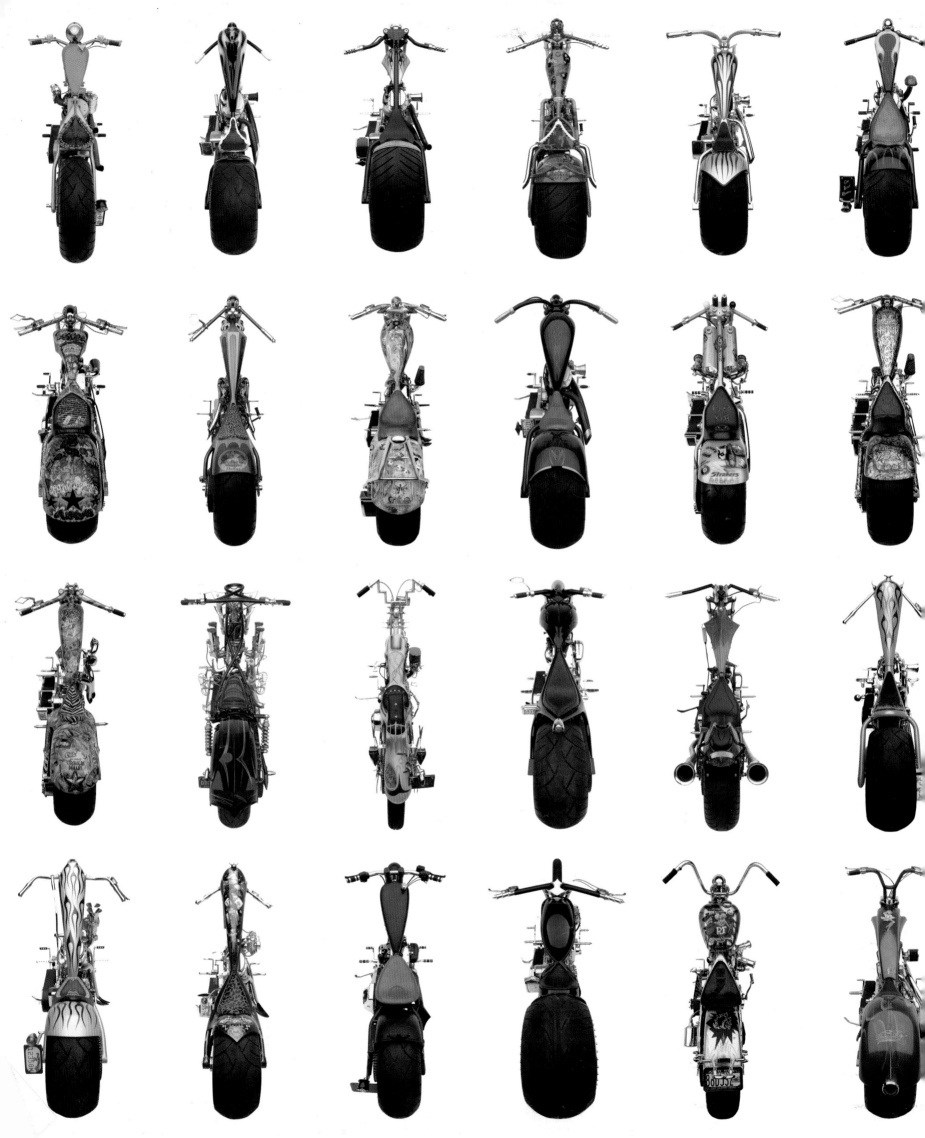